ANSEL ADAMS

KNOWING WHERE TO STAND

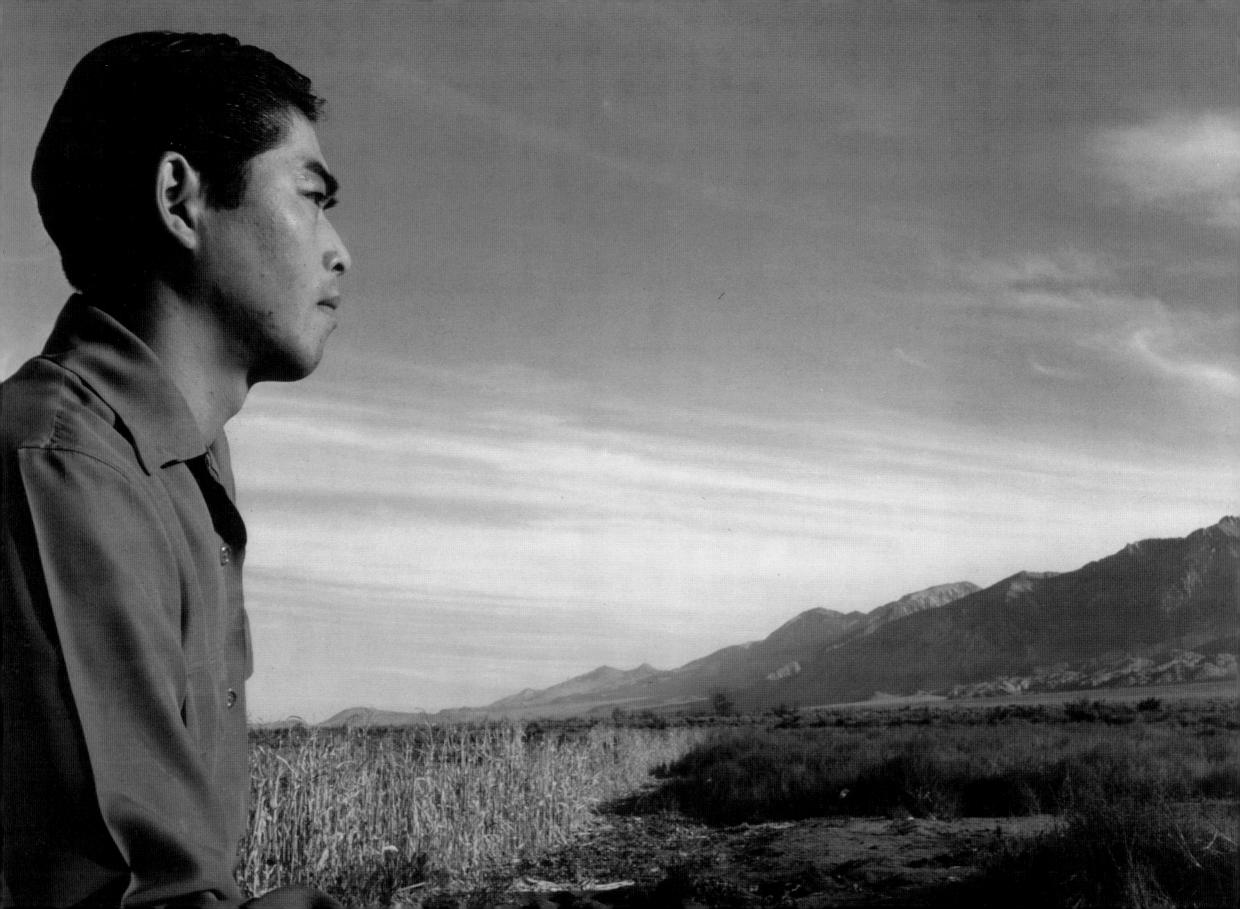

ANSEL ADAMS

KNOWING WHERE TO STAND

CHARTWELL
BOOKS

This edition published in 2015 by

CHARTWELL BOOKS
an imprint of Book Sales
a division of Quarto Publishing Group USA Inc.
142 West 36th Street, 4th Floor
New York, New York 10018
USA

ISBN: 978-0-7858-3295-9

Credits
Thanks to Sandra Forty for writing the Introduction and to Elly at Greene Media Ltd. for
design. Thanks to Leo Marriott for photography of some of the NARA images and to the
College Park staff for their assistance.

Photo Credits
The Ansel Adams photographs come from three sources: the Fiat Lux images come from
the Sweeney/Rubin Ansel Adams Fiat Lux collection, University of California, Riverside/
California Museum of Photography; the Manzanar images come from the Manzanar
War Relocation Center photographs, Library of Congress Prints and Photographs
Division Washington, D.C. 20540 USA; the rest are from the National Archives Still
Picture Branch, Records of the National Park Service, College Park, MD. The other
photographs are credited as follows (thanks to Nye Jones of Corbis for his help):
p. 1 and running heads Bettmann/ Corbis BE072720; p. 8 Roger Ressmeyer/Corbis
RR016972; pp. 9, 10, 12, 15, 19, 21 Library of Congress Prints and Photographs
Division Washington, D.C. 20540 USA; p. 11 Ansel Adams Publishing Rights Trust/
Corbis AD001456; p13 Ansel Adams Publishing Rights Trust/Corbis AD001356; p14
Ansel Adams Publishing Rights Trust/Corbis AD001365; p. 17 Ted Spiegel/Corbis
GL004100; p. 22 Bettmann/Corbis U2066817; pp. 25/26 Dcrjsr via Wikipedia.

Captions
Note, all captions in quotation marks are as written on the images by Ansel Adams as
supplied by the sources noted above.

Page 1: *Ansel Adams in 1961.*
Pages 2–3: *"Tom Kobayashi." This was the title page illustration for Adams'* Born Free
and Equal: The Story of Loyal Japanese-Americans.
Pages 4–5: *"Near Death Valley National Monument." (See p. 67.)*
Pages 6–7: *"Clouds over the Anza-Borrego Desert, c. 1966."*
(See p. 73.)

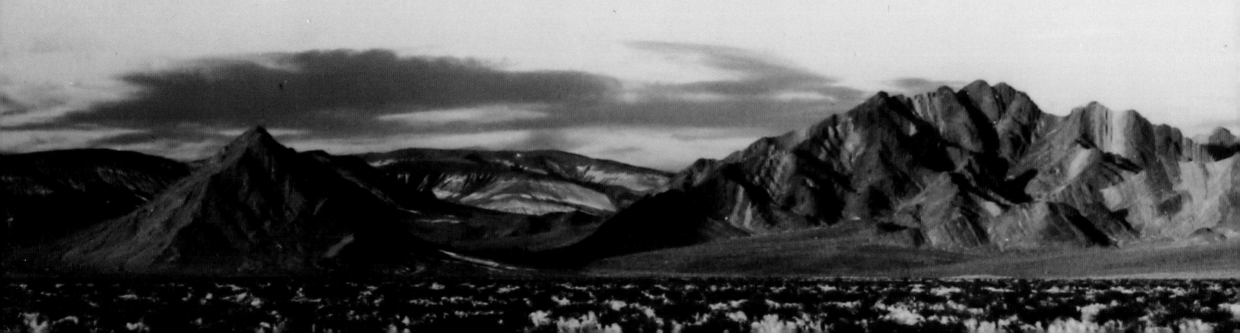

CONTENTS

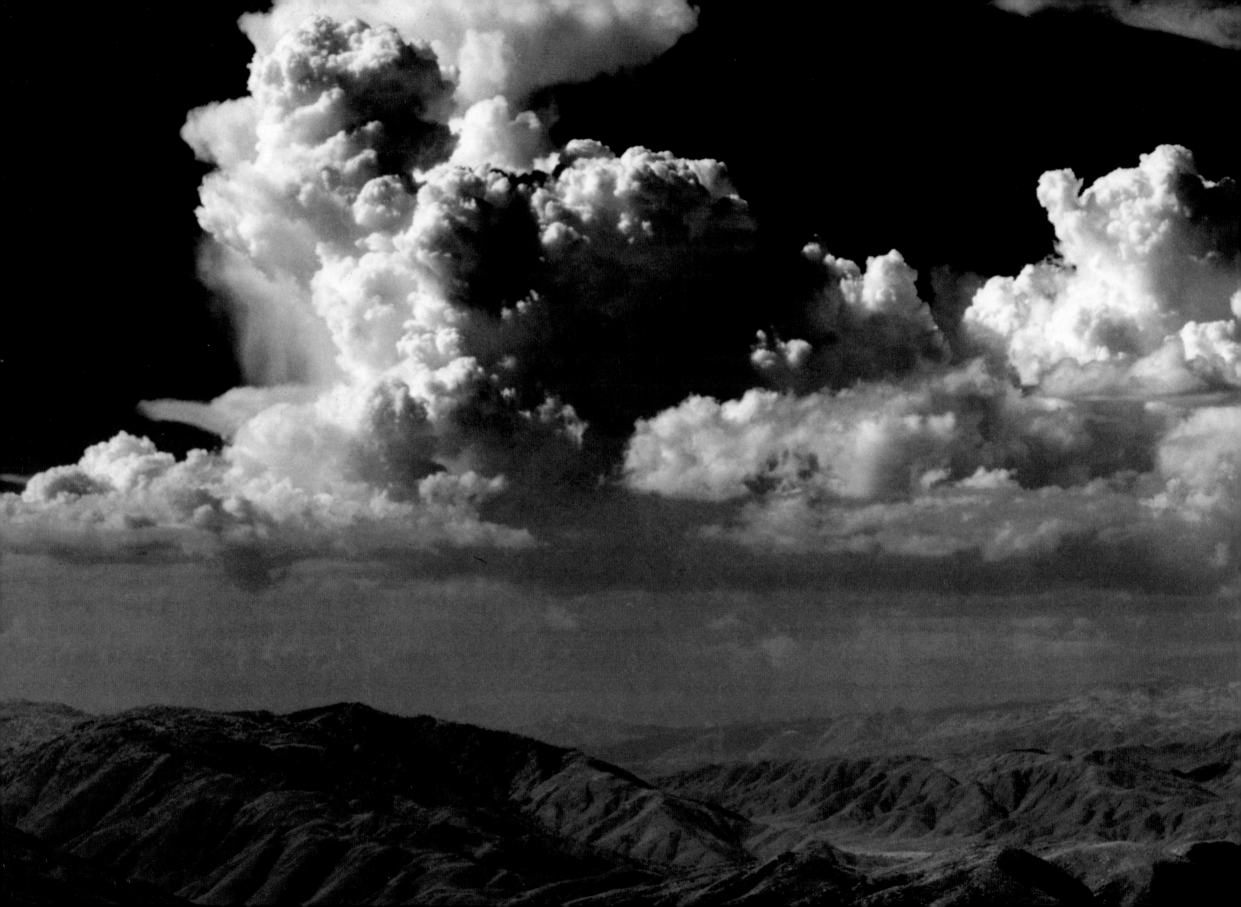

INTRODUCTION

The great Californian photographer Ansel Adams is celebrated for his sweeping black and white landscape pictures, particularly of the Sierra Nevada and the majestic mountains and valleys of Yosemite. Many critics consider him to be the greatest photographer to come out of the United States. After struggling at first to make a living and have his photographs accepted as art, he became a greatly respected and lauded photographer within his own lifetime. By the time of his death at the age of 82, his original prints were selling for thousands of dollars—a matter that irked him somewhat as he only collected the original fee.

However, Adams was so much more than a mere photographer: he was a passionate and dedicated environmentalist and advocate of the great unspoiled natural landscape of the United States—in particular of the Southwest. Through his tireless campaigning, he was directly responsible for the protection in perpetuity of great swathes of the natural wonders of the United States. Interestingly, although he lived all his life beside the vast Pacific Ocean, it was rarely his subject matter although he adored all its many moods.

He was a deep thinker, an enthusiastic teacher of his philosophy of photography and a determined proponent of photography as art. This latter stance made him many enemies among the general artistic establishment (whose own disciplines they jealously guarded), many in the academic establishment, and not by any means least, many other photographers who approached their subject in a very different way.

Although he lived through some of the most difficult times of the twentieth century, Adams considered himself fortunate. He had a long and happy marriage to Virginia, was too young to serve in World War I, and too old to serve in WWII. As a young family man he lived through the Great Depression but managed to scrape by without too much difficulty.

Many Americans were introduced to the astonishing spectacle and magnificence of their natural heritage through the fierce talent and commitment of Ansel Adams as they learned of their world through the prism of his lens.

Right: *Ansel Adams on his beloved Big Sur coastline, 1981.*

Opposite: *Arnold Genthe's photograph of the aftermath of the 1906 San Francisco earthquake and fire.*

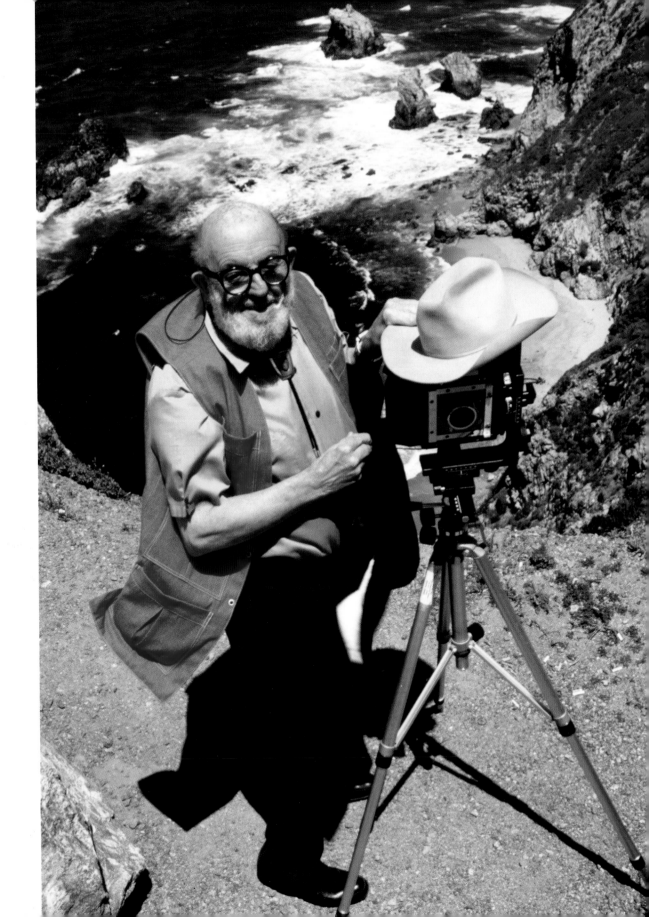

Early Years

Ansel Adams was born in his parents' bed in their large apartment in the Western Addition of San Francisco at about 3am on February 20, 1902. He was named for his wealthy uncle, Ansel Easton. During that period his father, Charles Adams, a prosperous businessman, was in the process of building their solid family home among the sand dunes near Baker Beach across the passage from Marin County—30 years before the famous Golden Gate Bridge was built.

Encouraged by his father, Adams spent his formative years running free around the sand dunes, exploring nearby Lobos Creek and its small canyons, climbing the cliffs above China Beach or running between the cypress trees. Here he developed a lifelong love and respect for the wonders and beauties of the natural world. His favorite hobby was collecting insects, especially bugs, much to the consternation of his elderly female relatives.

Adams was four years old when San Francisco was devastated by the great earthquake that hit in the early hours of April 17, 1906. The massive quake shook the newly built Adams house, shaking down the brick chimneys and throwing his bed around the room. Amazingly nobody was hurt, although the floors were thick with smashed glass and crockery. While San Francisco burned and thick smoke billowed over the rubble, numerous minor after quakes shook the region. During one such Ansel was playing in the garden and thrown to the ground knocking his face violently against a low brick garden wall. His nose was broken and when a doctor was able to examine his broken septum, he treated the wound and suggested leaving it to be reset later when he was older. The nose was never fixed, accounting for Adams' distinctive profile.

Adams was an only child with excess amounts of energy, repeatedly moved from school to school. To calm him down his doctor ordered that he spend two hours every afternoon lying in a darkened room to dampen his excitement: if anything, this recharged his batteries and made him even more determined to run wild. Eventually, his despairing parents decided to home-school him. Father taught him French and algebra, and an elderly minister, Dr. Herriott, was engaged to teach ancient Greek: he was bemused and horrified by the young Ansel's lack of religious faith.

When Adams was twelve, it was decided that the discipline of music would help him concentrate. He started piano lessons with the remarkably patient Miss Marie Butler. She insisted on repetitious scales and finger exercises. It took months but Adams gradually started to make sense of the notes and he started to appreciate the discipline. He slowly learned to express his emotions through playing—a revelation he later felt illuminated his approach and understanding of photography. In time, he was allowed to play Bach and then move on to Mozart, Beethoven, Chopin, and others. In 1918 Miss Butler announced she had taught him all she could and he should move to Frederick Zech, an elderly German musician. After five years of Zech's tuition, Adams was on course to become a professional concert pianist. He had the talent and he had the ear. He was now working with a new teacher, Benjamin Moore, and even started to give a few lessons himself. Ansel Adams credits these piano lessons as the making of him and continued to play every day, when possible, for the rest of his life: many of his greatest friends were also musicians. His biggest problem when indulging his love of the wilderness, and later photography, was how to keep up his regular practice.

In many ways the highlight of his youth was a year-long pass to the vast and intriguing Panama-Pacific International Exposition celebrating the opening of the Panama Canal, held in San Francisco between February 20 and December 4, 1915. It was bought as a present by his father, who issued his son with specific instructions to go there every day to explore and investigate the many wonderful exhibits, although back home he still had to study literature, piano, and French. His father regularly joined him, and together they explored the science and machinery exhibits. At the exposition Adams enjoyed the fun fair but particularly enjoyed the lunchtime organ concerts given by Edwin Lamar and frequently visited the Palace of Fine Arts, where the paintings of then avant-garde artists

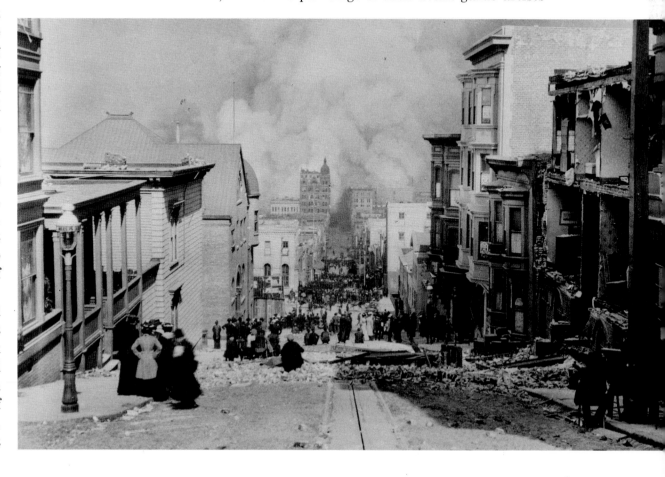

such as Monet, Van Gogh, Cézanne, and Gauguin were displayed for the first time on the West Coast. He got to know some of the exhibitors and even helped out a little. When the exposition closed, Adams returned to yet another school and continued his erratic education until he finally graduated from the eighth grade.

Adams was a sickly child and often confined to bed for periods of time. During one such confinement for a heavy cold in April 1916, his aunt Mary gave him a copy of *In the Heart of the Sierras* by J.M. Hutchings (published 1886). This described the indigenous peoples of the Sierra, the flora and fauna, the landscape, and all the mysteries and stories of the mountains. Adams was utterly entranced: he read and reread the stories especially about the Yosemite Valley and, in his words, devoured the pictures and illustrations. His parents had been planning a family vacation and he begged them to choose Yosemite. Eventually they relented, and on June 1, 1916, the family boarded the train at Oakland headed for Merced and El Portal.

As they neared the Sierra the temperature reached 100°F in the shade. The family stayed at Camp Curry near Glacier Point, and Adams was completely smitten with a profound love for Yosemite that would last his entire life. To make the vacation even more memorable, his parents gave him a Kodak Box Brownie—his very first camera. Needless to say, Half Dome was one of his first subjects. In spite of their financial problems, the Adams family vacationed in Yosemite again in 1917, but the following year 16-year-old Ansel was allowed to stay there alone, although some family friends kept an eye on him. He spent his days hiking and photographing the wild flowers he found, then sending the photos to his father who was an enthusiastic amateur botanist. Against the wishes of his doctor, Adams returned again in June 1919 to recuperate after a severe bout of flu. He again stayed at Camp Curry, and once there rapidly regained his strength and credited the bracing climate and lifestyle of Yosemite for his recovery. He spent his time hiking deep into the High Sierra, taking occasional photographs, and climbing the mountains roped together (with window-sash cord) with Francis Holman, aka Uncle Frank, the custodian of the Sierra Club in Yosemite and a man who knew and loved the rugged landscape.

His first professional photographic assignment was offered in about 1920, when his next-door neighbor, Miss Lavolier, asked him to photograph her class of six-year olds from the Baptist Chinese Grammar School in downtown San Francisco. From then on he was asked to do occasional weddings and portraits and able to earn a little money to support his hobby.

Right: *The 1915 Panama-Pacific International Exposition showed off San Francisco's recuperation after the 1906 earthquake, and was a highlight for young Ansel.*

Opposite: *A youthful Ansel Adams in Yosemite with his Kodak Box Brownie.*

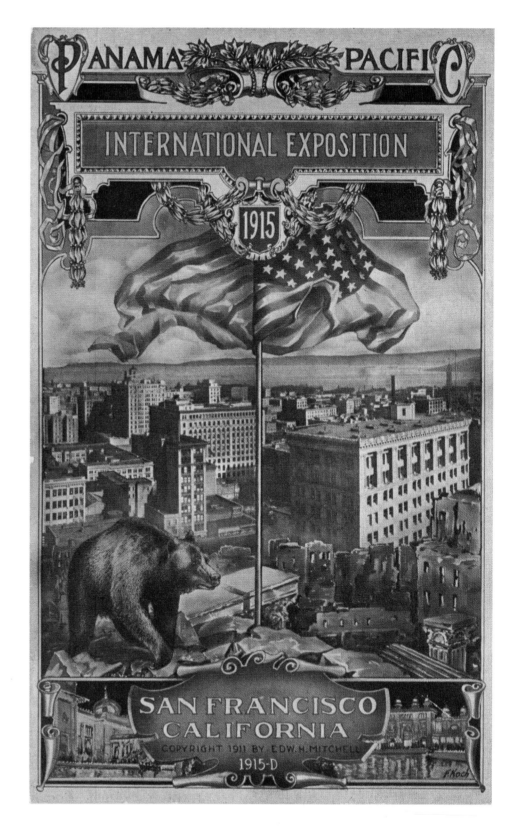

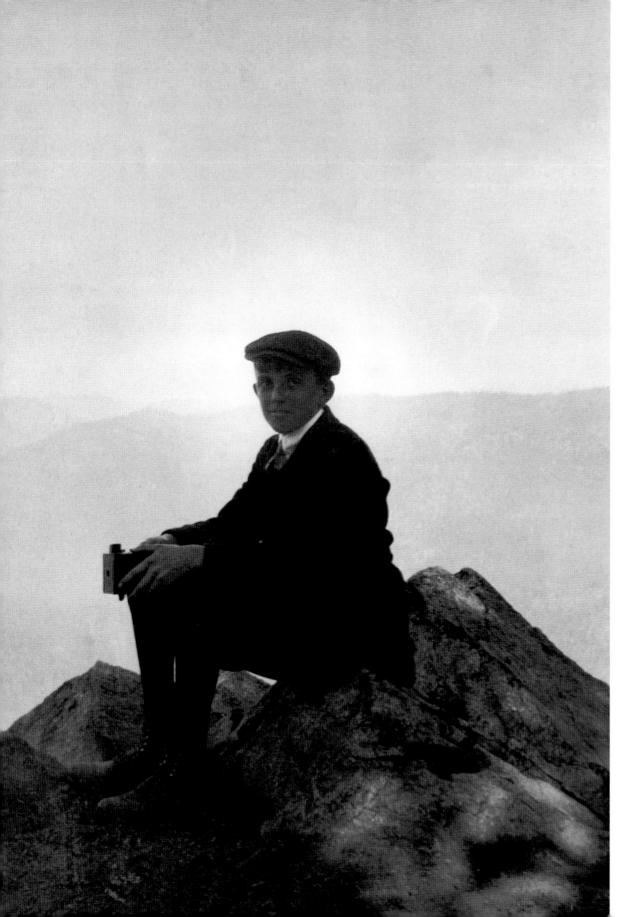

The Sierra Club

The real guardian of the mountains was the Sierra Club, which was founded in May 1892 by John Muir to "explore, enjoy, and protect the wild places of the earth ..." John Muir was the pioneering American environmentalist long before that term was coined. He started and led the fight to protect and preserve the environment and in particular of the Sierras. The original members were a group of like-minded mountaineers and outdoors enthusiasts, primarily from the University of California and Bay Area environmentalists. Their first great achievement was the creation of Yosemite National Park in 1890 following a successful national campaign. Thanks to John Muir and his supporters the club grew to be so influential that it caught government attention. In turn, this led to the establishment of the National Park Service and the creation of new national parks and monuments across the United States. The club's headquarters was the LeConte Memorial, near Glacier Point in Yosemite, named for Joseph LeConte an early conservationist and geologist who had died in 1901. Conservation and wilderness lay at the heart of the Sierra Club. They held regular meetings and organized an annual camp and climbing vacation in the mountains.

In 1919 it was announced that the Sierra Club needed a new custodian in Yosemite. The opportunity was too good to ignore: Adams immediately became a member and successfully applied for the post. He started work on April 17, 1920, engaged for three months. The job involved caretaking the Memorial Center (actually a simple stone cottage), answering tourists' enquiries, and taking occasional small tours around Yosemite. Adams remained the summer custodian until 1927.

Summer 1920 saw Adams (plus Uncle Frank and three others) journey for the first time into the true wilderness of the High Sierra, to Merced Lake, Mount Clark, and the Merced Range. It was the first of many such expeditions out into the wilderness, camping under the canopy of bright stars. It was also the start of his photographic love affair with the great outdoors. The photographs started as a visual diary of his trips, but blossomed into so much more. Inevitably, Adams became interested in the photographic process itself and decided to learn more by making his own prints. Accordingly, in 1917 he landed a part-time job earning $2 a day as a "darkroom monkey" working for a neighbor, Frank Dittman, who had a small photo-finishing business in his basement. The work entailed collecting film from the drugstores of San Francisco, and then developing the negatives, making prints, and returning them next day. It was an ideal education for an ambitious young photographer. Slowly, he began

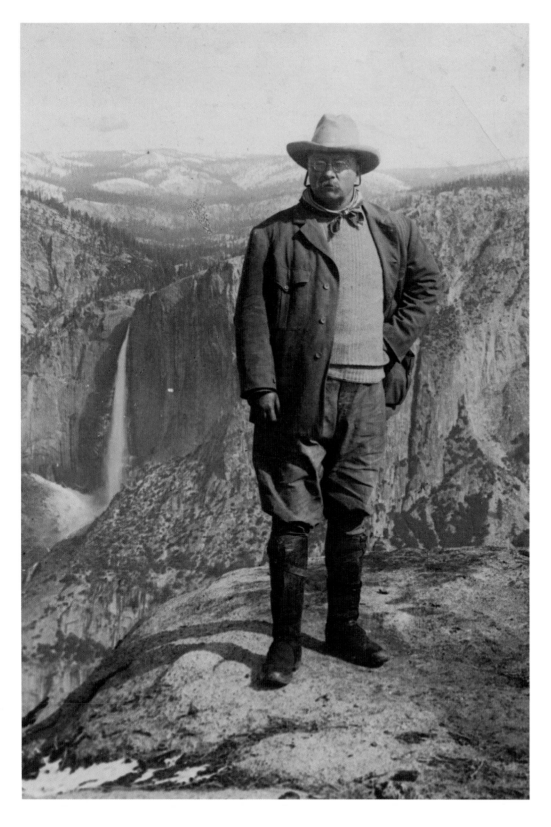

to appreciate the aesthetics of good composition and learn the rules of design, symmetry, form, texture, and tonality.

For his second summer as custodian in Yosemite Adams tackled the important problem of how to find a regular time and place to practice the piano. He was introduced to Harry Best, the owner and proprietor of a concession store in the heart of Yosemite. Best's Studio offered local paintings, woodcarvings, souvenirs, books, and general tourist requirements. Best—also an amateur photographer—had a Chickering square piano and a 17-year-old daughter named Virginia, who had a beautiful contralto voice and the ambition to be a professional classical singer. Ansel and Virginia quickly became attached to each other and were engaged on and off for six years before marrying on January 2, 1928, at Best's Studio.

That same year, the twenty-ninth annual Sierra Club outing was to the Canadian Rockies. Adams was invited along as official photographer with no fee—the budget was too tight—but all expenses paid. He accepted, and enjoyed the experience immensely. The choice of photos was left entirely to him, and at the end of the trip he made a number of portfolios as mementoes for the other trekkers that he sold at cost for $30 each. These photos proved so popular that he was asked to make the Sierra Club outing portfolios for the annual trips to the High Sierra in 1929, 1930, and 1932. Also, following the Canadian trip, Adams became assistant manager and one of the leaders of the Sierra Club outings. These annual expeditions would stay out in the wilderness for a month and comprise a pack train of around 50 or more mules carrying all the camping equipment, as well as a chef and various assistants to guide and provide for around 200 people. Adams' job was to select the route, find suitable campsites, provide the evening entertainments, and plan out the possible climbs. Moving out ahead of the rest in the early morning enabled Adams to sort out his duties and then left him free to disappear into the wilderness alone with his camera, only to return to the party late after the evening light had vanished.

President Theodore Roosevelt on Glacier Point, Yosemite, c.1903. He was a great champion of conservation. He created five national parks (doubling the previously existing number); signed the landmark Antiquities Act and created 18 national monuments, including the Grand Canyon; set aside 51 federal bird sanctuaries, 4 national game refuges, and more than 100 million acres' worth of national forests. He said, "There can be nothing in the world more beautiful than the Yosemite, the groves of the giant sequoias and redwoods, the Canyon of the Colorado, the Canyon of the Yellowstone, the Three Tetons; and our people should see to it that they are preserved for their children and their children's children forever, with their majestic beauty all unmarred." Adams did not meet Roosevelt, but in his autobiography, wished he had.

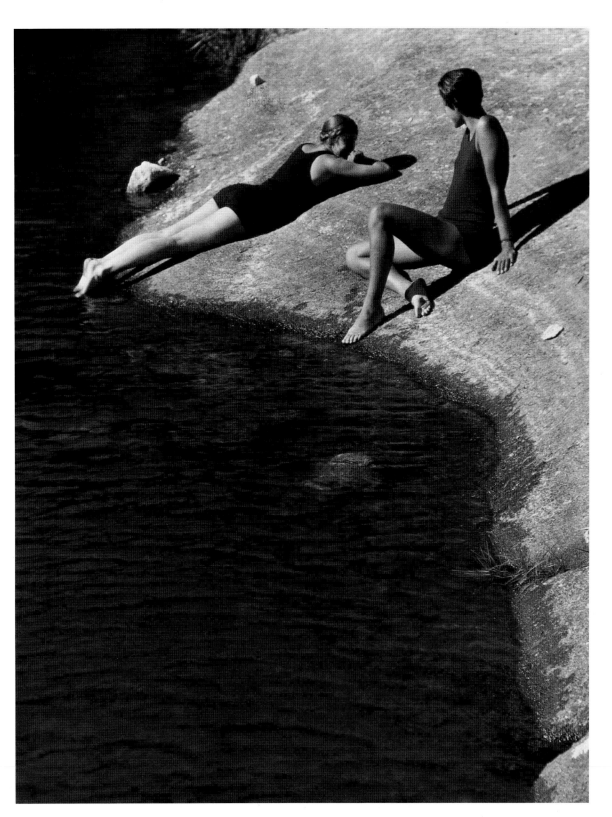

Adams became an important member of the Sierra Club and in 1931 when the club decided they needed to be more inclusive, Virginia Adams was elected onto the board. She stood down in 1934 following the birth of their son Michael and Adams replaced her on the board—a position he held for the next 37 years. The position emphasized his commitment to the fight to preserve and protect the great wildernesses of America.

Start of a professional career

In 1926 Adams was introduced to fellow San Franciscan Albert Bender, a successful businessman and serious patron of the arts. He studied Adams' prints closely and offered to produce a portfolio of them: there were to be 100 portfolios (plus ten artist's copies) of eighteen prints each, to be priced at $50 each published by Jean Chambers, with typography by the Grabhorn Press. With Bender's help and support over half the print run was sold, sight unseen, to many wealthy San Franciscans before anything was put together. The publication was titled *Parmelian Prints of the High Sierras*. Bender felt—much to Adams' dismay—this invention sounded better than "Photographic Prints." Through Bender, Adams was introduced to a wide circle of culturally active artists, writers, musicians, poets, theatrical performers, and many alert and engaged members of Californian (and beyond) high society.

However, such a commission was rare in these early years and Adams had to take on commercial work to make ends meet so he could support Virginia and a young family that soon comprised their two children, Michael and Anne. For two years after they were married, Adams felt torn between his twin passions of music and photography. By splitting his time between them and between their homes in San Francisco and Yosemite, he was doing neither the justice they deserved nor, crucially, earning a living from either. After a period photographing a Taos Pueblo project in New Mexico, his mind was made up: he would concentrate on photography. Virginia fully supported his decision, but his mother was horrified.

Decision made, in 1930 Adams built a house and photography studio next to his parents' house and hung out a sign announcing "Ansel

Adams and Virginia Best married in 1928. Adams made this photograph of his wife and Jane Paxson during a Sierra Club outing in c. 1930. Virginia was elected to the Sierra Club board in 1931.

Easton Adams, Photographer." Making a living from artistic photography and portfolios alone was unlikely, especially in the depths of the Great Depression, and Adams turned to the commercial sector, photographing everything from industrial reports, to catalogs, architecture, advertisements, and portraits—anything to pay the bills. Much of this commercial work was shot in color, not a medium he particularly liked, but one that most customers wanted. The work was erratic, but the Adams family just about scraped by, helped by Virginia earning a small but crucial amount working at Best's Studio during the Yosemite tourist season. Friends such as Alfred Bender recommended Adams to their friends and provided him with financial advice. In 1931 Adams had his first solo show at the Smithsonian Institution and the following year a joint exhibition with his friend Edward Weston at the M.H. de Young Memorial Museum in San Francisco. The first of Adams' many technical books, *Making a Photograph*, was published in 1935.

In 1936 Harry Best died, leaving Best's Studio to Virginia. The following spring, when they reopened the studio, Ansel and Virginia removed all the tourist tat and instead stocked up with good quality books, photographic supplies, and the best Native American crafts they could find. To their initial annoyance, the National Park Service would not agree to the Adams becoming publishers and printing their own books. Instead, along with three friends, they formed Five Associates to publish guidebooks to Yosemite and the Sierra, serious picture books, and a selection of black and white as well as color postcards and notecards.

Slowly Adams' workload improved as his name became better known, and in 1940 he ran an advertisement in *U.S. Camera*: "Ansel Adams. Photographs for publicity, advertising, and editorial use. Available for private instruction. Best's Studio, Yosemite National Park, California."

Fortune magazine became a regular source of work, especially for architectural assignments and for niche articles on companies and corporations such as the Pacific Gas and Electric Company and the American Telephone and Telegraph Company. *Life* magazine also contracted him for various assignments, such as for a story on "mad scientists." In time, Adams not only contributed pictures but also wrote numerous articles both for specialist magazines and general ones.

"Working in my darkroom, San Francisco, c. 1936."

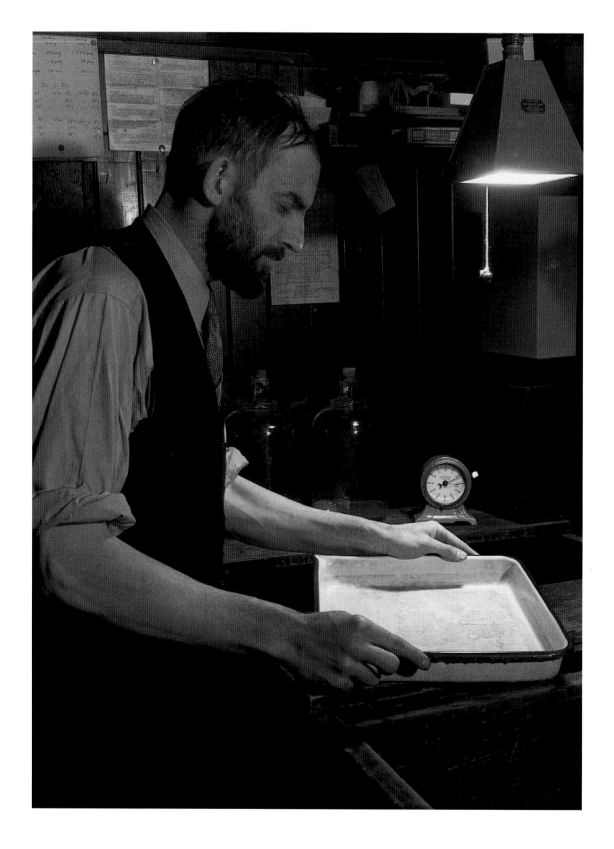

Group f/64

By the time Adams became a full-time photographer in 1932, he was despondent about the general state of professional work, which tended to be either a straightforward photograph of a given subject or an idealized artistic rendition. Neither of these he found satisfactory due to the complete lack of artistic input into the interpretation and lack of feeling behind the work. A few other photographers shared his ideals, and together they formed Group f/64. The group comprised Ansel Adams, Edward Weston, Willard van Dyke, Imogen Cunningham, Sonya Nosowiak, Henry Swift, and John Paul Edwards. They remained a loose group of like-minded friends and photographers offering support and advice to each other, but they rarely met up together.

Their ambition was to produce photographs that were not imitations of other art forms but viable art in their own right and by their own terms. The group was offered an exhibition by Lloyd Rollins, director of the M.H. de Young Memorial Museum in San Francisco, November 15–December 31, 1932. For the exhibition, eleven photographers showed between four and ten prints each, to a total of eighty prints. These were priced at $10 each except for Weston's that were $15. Additionally the group presented a written manifesto to explain its mission. The exhibition proved controversial. In response to it the museum received numerous letters of protest complaining that photography was not art and should not take up valuable museum space and resources.

One of Adams' biggest critics was William Mortensen, a Laguna Beach photographer who claimed his "inventive" use of the camera—pictures of near naked, semi-Classical figures, many of them Hollywood actresses in allegorical scenes—was the way true photography should go. He used painterly effects and manipulation to achieve his look—the polar opposite of what Adams was doing. Their mutual antipathy was long-standing (Adams referred to Mortensen as "the anti-Christ" and the "devil") and exchanged insults via courteous but withering letters: they disputed what Adams himself called "one of the fiercest verbal battles in photographic history." Mortensen shortly became very unfashionable and disappeared from the public view until he was reassessed decades later.

The most venerated and influential photographer and modern art dealer of the period was Alfred Stieglitz, who lived and worked in New York City. Not only was he the main promoter of photography as a valid and important art form, he was also married to the much younger but equally respected modernist artist Georgia O'Keeffe. Adams was determined to show Stieglitz his work and journeyed with Virginia to New York City in 1932. Adams cold-called Stieglitz at his gallery,

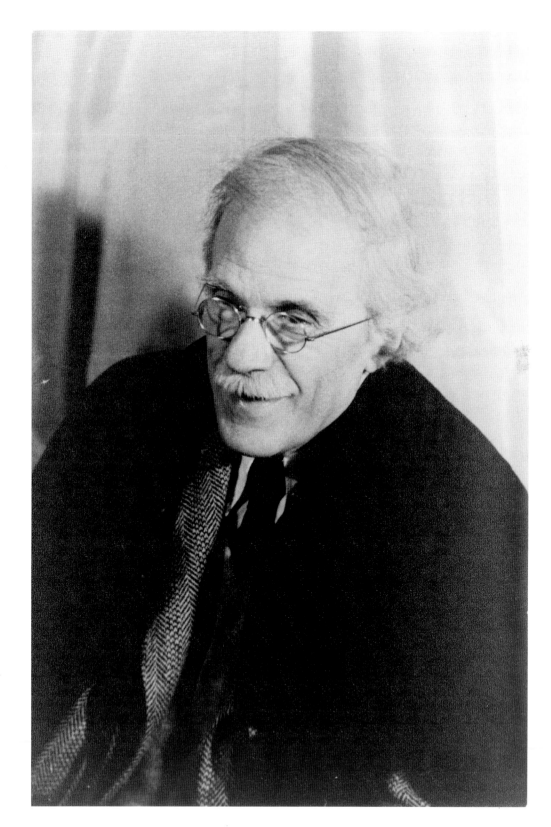

Carl van Vechten's portrait of Alfred Stieglitz dated April 17, 1935. Stieglitz and Adams met in 1933 and became firm friends.

"An American Place" on the seventeenth floor of 509 Madison Avenue, armed only with a letter of introduction from one of his patrons. Stieglitz carefully reviewed the proffered prints and pronounced them sensitive. Elated with the encouragement, Adams went to the Delphic Studios owned by Alma Reed, an art gallery that occasionally— and courageously—exhibited photographs. She agreed to an exhibition of fifty photographs in November 1933. This garnered good reviews, but Adams earned nothing from it although a few photos were sold.

When he returned to San Francisco in 1933 after meeting Stieglitz, Adams was determined to open his own small gallery to show not just photos but also selected paintings, prints, and sculpture. He found the ideal place in the city at 166 Geary Street. The gallery opened with the second (and last) exhibition from Group f/64. But after a year of exhibitions Adams decided that the gallery was too exhausting and demanding of his time: it was curtailing his own photography. Accordingly, he took a partner, Joseph Danysh, to help run the gallery, which became at first the Adams–Danysh Gallery and in time the Danysh Gallery when Adams withdrew altogether.

From then on Adams made an annual trip to New York City to see Stieglitz and show him his latest work. The pair became friends, as did their wives, and in November 1936 Stieglitz gave Adams a show at "An American Place." They remained close until Stieglitz died in 1946 and Adams and Virginia remained part of a select group of friends of Georgia O'Keeffe, occasionally allowed to visit her at her remote house in Abiquiu, New Mexico and receiving her at their home in California.

Campaigning

In 1934 Adams became a board member of the Sierra Club just as its energies turned to campaigning to make the Kings River area a national park. This area of beautiful but rugged terrain north of Sequoia National Park was territory that Adams knew well and had already photographed extensively during club outings in the 1930s. Two years later the Sierra Club board asked Adams to lobby for the establishment of Kings Canyon National Park in Washington D.C. by taking his photos to a conference that discussed the future of national and state parks. Adams showed his portfolio to congressmen and senators and, rather to his surprise as he felt himself lacking in political guile, he was asked to address the conference. His lobbying had little obvious effect, although it did raise consciousness of the issues across Washington. The most auspicious outcome was that he was introduced to Harold Ickes, the important and powerful Secretary of the Interior.

Around this period Adams was putting together *Sierra Nevada: The John Muir Trail*, and when it was published in 1938 he sent a copy to Ickes. Ickes greatly admired the photographs and showed it to President Franklin D. Roosevelt, who immediately appropriated it for the White House. (Adams sent Ickes another copy.) It obviously made an impression, because Roosevelt joined Ickes to pressure a reluctant Congress to pass the Kings Canyon National Park bill in 1940.

In 1941 Ickes asked Adams to accept a commission to photograph the national parks for the Department of the Interior. He wanted a selection of murals to hang along the corridors and in the principal offices of the department. The terms were that Adams was employed for no more than 180 days a year, at the maximum allowed daily salary of $22.22 with $5 expenses, plus travel vouchers, starting in October 1941. The other days were his own, to devote to other commissions. Unfortunately, the project was cancelled in July 1942 due to the pressures on resources for the war, but not before Adams had photographed a number of the sites that appear in this book. The project had excited Adams, and with no prospect of the government recommissioning the work, Adams applied for a John Simon Guggenheim Foundation grant in 1945 to continue the project. The grant was awarded in 1946 and renewed in 1948. Using the grant Adams journeyed to Alaska for the first time to photograph Glacier Bay and Mount McKinley National Parks. The whole experience was thrilling and, at times, dangerous and led to a book, *My Camera in the National Parks*, and a portfolio, *The National Parks and Monuments*, both published in 1950.

Adams only real brush with controversy came via the New York-based Photo League cooperative which was formed in 1936 with the intention of using photography to effect social change. Spending a lot of time in New York anyway, and knowing a number of the members already, Adams decided to join the group. They published a regular newsletter, ran exhibitions and lectures, and advocated a politically progressive social agenda. Virtually all the important New York photographers, both amateur and professional, were members. It was a lively group that included members with widely diverse political persuasions. It was, therefore, inevitable that the political agenda of its members would come to the attention of Senator McCarthy and his House Un-American Activities Committee. Much to his dismay, the left leanings of some members saw the Photo League blacklisted in 1947. At the last meeting Adams attended, he begged his fellow members to depoliticize and renounce all ties to the Communist Party. Receiving little support from his fellow members, Adams felt he had no option but to resign; the League disbanded in 1951.

In 1948 Adams met Edwin Land, the inventor of the Polaroid Land instant photographic process. They shared a sense of humor and hit it off immediately. Adams was invited to visit Lands in his laboratory so he could examine his startling instant photograph process. The pair became firm friends and correspondents, and one day Land asked Adams if he would test one of his experimental cameras, the associated equipment, and film. Land was striving to deliver the perfect instant picture-making process and Adams was an ideal collaborator. He rapidly became

a consultant, providing valuable feedback and ideas and remained committed to the process for the rest of his life. Adams' main concern was the quality and performance of the Polaroid with regards to professional photographers; other consultants were employed for other aspects of the process. Many professional photographers were puzzled at Adams' interest in Polaroids, and dismissed the concept as little more than a gimmick. To help gain their acceptance, Adams suggested that Land research and develop a Polaroid film pack in a new and larger format. The suggestion was taken up and in 1958 became available. Adams himself found the speed of the process invaluable, and frequently used Polaroids from their original production in the 1950s.

In 1959 Adams was granted his third Guggenheim grant: $3,000 a year for two years. Adams was elated, the money meant he could afford to turn down some of the mundane commercial assignments he would otherwise been forced to accept. Importantly, it allowed him time to make definitive prints of the many negatives he had not been able to thoroughly explore.

Photography

As a young man at the start of his career Adams signed himself Ansel Easton Adams—the Easton came from his maternal uncle. But twenty years later, he learned that this same trusted uncle had, in fact, badly betrayed his father by secretly selling his company shares to a rival and savagely undercutting his father's business. The subterfuge deal led to his father's financial ruin, a state of affairs from which he never recovered and one that played a significant part in his mother's subsequent depression and physical collapse. She died in 1950 aged 87 after a long and sad decline. His father died the following year. Dating from the time of this revelation Ansel dropped the use of Easton from his name. He signed his photos Ansel Easton Adams until 1932, then Ansel E. Adams in 1933, and then from 1934 simply Ansel Adams.

Adams started by signing only photographs that he had printed himself. The Special Edition prints sold only from Best's Studio were stamped and labeled as printed by his chosen assistants—so that it was clear that they were not his fine prints. To begin with he signed the Special Edition prints, but in time turned to initialing them, until he stopped altogether in 1974.

Adams almost always used a large-format camera for his landscapes as the high resolution helped the sharpness of the images. He never considered it in his remit to interpret a photograph for anyone. Everyone had their own personal opinion and his feelings were his own: accordingly, his prints were labeled with details of the location, date, and nothing else. Visualization became Adams' essential starting point for a photograph. He visualized how he wanted the final print to appear, assessing his intuitive search for meaning, shape, form, and

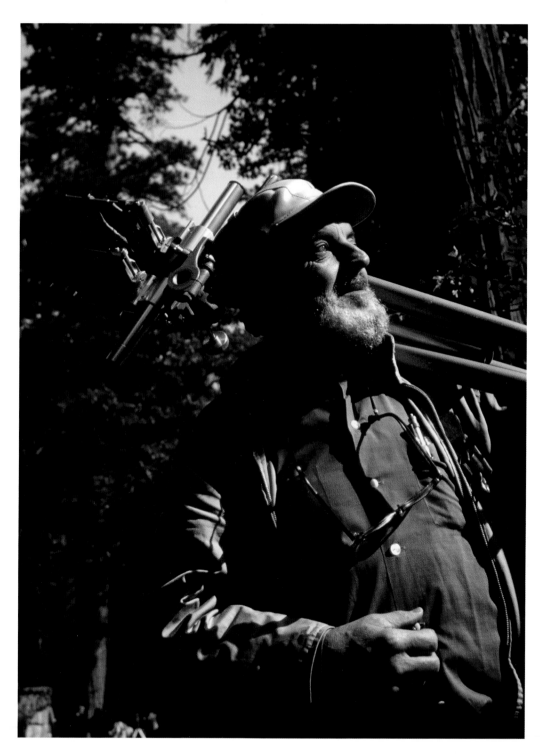

Yosemite held Adams in thrall all his life: here, he's seen in the park in 1965, photographed by Ted Spiegel.

texture, and how they would come together to produce the desired result in the print. This involved anticipation about the play of light and shadow and the sure touch of when to release the shutter, what exposure was needed, and the correct alchemy of chemicals back in the studio to achieve the desired result. If his feeling for a photo failed his criteria, he did not take the picture. He learned to trust his intuition and rarely failed to achieve the desired result.

After he decided to take up photography professionally, Adams changed from using textured photographic papers and turned instead to smooth, high-gloss papers, which he felt allowed more detail to be extracted from the negative as well as a greater range of tonal quality. It was all part of the precision he required to extract the very best from his negatives. He claimed that he never set out to make a creative photograph; instead, he liked to work with found objects. This was not of course always possible with his commercial photography.

Although he is widely celebrated for his black and white work, in fact Adams also used color throughout his career, but he disliked the imprecision in the dark room and found the technical control too lacking for his precise requirements. He used color because almost all of his commercial customers required it.

Teaching

Adams first seriously started teaching young photographers in 1940 at the Art Center School in Los Angeles. He was initially frustrated that his students simply took photos of what was in front of them without thinking the process through. They seemed incapable of discovering the art in photography. To counter this, Adams—and fellow photographer Fred Archer—developed what they called the Zone System. This was designed so a student could understand what they were trying to do: so they could ensure the correct exposure, adjust the contrast, and visualize the effect in advance of firing the shutter. Adams took his students out and about—to the beach, the streets, or the hills—to photograph what they found. At the school they also trained students from the U.S. Signal Corps in basic photography, in particular teaching them to anticipate movement and think quickly how to frame a photograph—as would be the case during war. Additionally, Adams and friends such as fellow photographer Edward Weston taught U.S. Camera forums for interested students at Yosemite itself and out among the mountains and lakes. Designed to get people talking and thinking about photography, these forums were set up to exchange ideas and techniques, not simply teach photography.

As a result of all his teaching Adams was asked in 1945 to help set up a Department of Photography at the California School of Fine Arts. The project was vehemently opposed by painters, sculptors, and various associated artists as being wholly inappropriate for an arts school and a criminal waste of money,

space, and resources. Nevertheless, the department was set up and within a few years the photographers came to be accepted.

In June 1955 Adams started the annual Ansel Adams Workshop in Yosemite, to teach the intricacies of his art. These continued through 1981 when the course was transferred to the workshop in Carmel. Over the years thousands of students attended the courses from all over the United States and abroad.

Manzanar War Relocation Camp

By the time the United States joined the fight against Hitler and Nazi Germany Ansel Adams was over forty and too old to join up. However, he was desperate to contribute to the war effort and volunteered for any war-related activity. There was virtually nothing suitable, but he was given the job of escorting hundreds of American troops around Yosemite Valley as they towed heavy artillery and practiced trekking. He wanted to make a more positive contribution and was eventually sent to teach practical photography at Fort Ord to the men of the 1604th Company. This led to him being assigned to the San Francisco Presidio to print top secret negatives of Japanese installations on the Aleutian islands: this necessitated his own full-time armed guard.

Then, a fellow Sierra Club member, Ralph Merritt, told him that he had been appointed director of the Manzanar War Relocation Center, located north of Lone Pine in the Owens Valley. Here, American-born citizens of Japanese descent, known as *Nisei*, were interned on President Roosevelt's Executive Order 9066 following the Japanese attack on Pearl Harbor. Uprooted from their homes and places of work, thousands of Japanese-Americans were treated as virtual prisoners of war (Italian-Americans were not interned). Manzanar Camp was one of the internment locations where they were denied their basic civil rights while "protected" by the military. Merritt was anxious to aid these citizens as best he could and help them make the best of their situation. He offered Adams food and accommodation in return for a photographic project that would illustrate the *Nisei* community and environment. Adams immediately accepted the unpaid commission, and made the 160-mile journey to Manzanar for the first time in fall 1943 (in winter the route took 400 miles around the mountains). He was granted an official gasoline and tire ration for the project.

The *Nisei* lived in black tar-paper shacks lined up in rows across a dry plain, surrounded by the stunning Sierra Nevada to the west and the Inyo Range to the east: very hot in summer and very cold in winter. But the people made the most of their meager circumstances, decorating their shacks as best they could,

School children at the Manzanar Relocation Center.

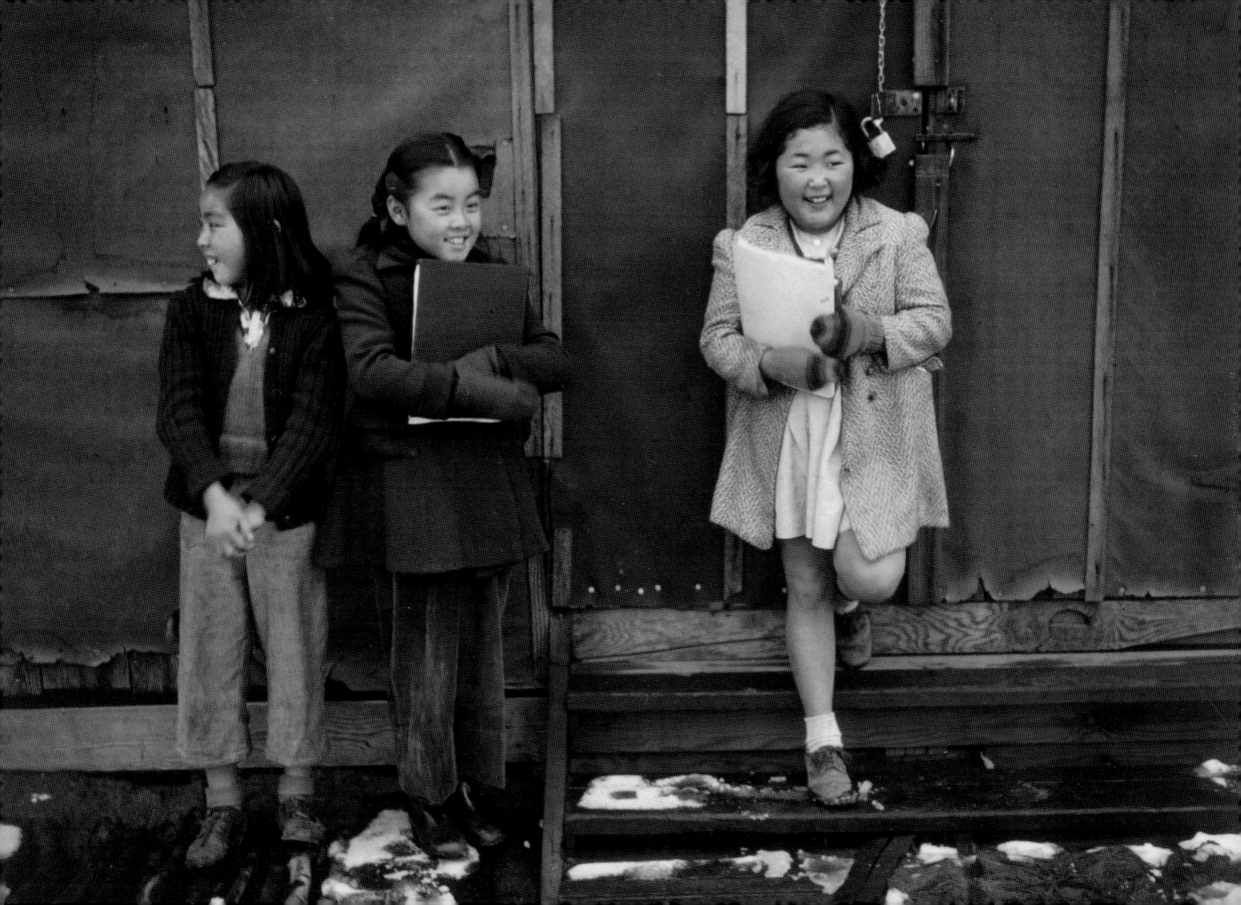

and running various clubs and services including churches, a medical facility, art studios, and even a printing press. Other people worked in the fields and the camp was agriculturally self-sustaining. Adams found the *Nisei* admirable, hard working and cheerful in spite of their circumstances. He warmed to them considerably and found their plight extremely moving, especially when their GI sons came to visit their families and saw how they were living.

The resulting photographs were exhibited in MOMA in a display space in the first basement area. In spite of this unobtrusive location the photographs created a lot of attention. Not all the public responses were positive, especially from people who had lost loved ones in the conflict with Japan. The exhibition led to the publication of a photographic essay, *Born Free and Equal*, in 1944, for which Adams wrote the text as well. In 1965 Adams donated the collection to the Library of Congress saying, "The purpose of my work was to show how these people, suffering under a great injustice, and loss of property, businesses and professions, had overcome the sense of defeat and dispair [sic] by building for themselves a vital community in an arid (but magnificent) environment ..."

Commissions and consultancy work

With his growing reputation it was inevitable that Adams would come into contact with the manufacturers of photographic equipment. In 1940, he got to know a number of important people working for Eastman Kodak, at the time the preeminent photographic company in the world. In particular, he became friends with George Waters, who worked in the photo-illustration department charged with general advertising for the company. He, in turn, commissioned photographers for the various campaigns, and Adams was one such.

The most eye-catching commission from Eastman Kodak was for the east balcony concourse at Grand Central Terminal, New York City where for over forty years they displayed the vast Colorama advertisement dubbed "The World's Largest Photograph." First appearing in 1948, the Colorama was 18 feet high by 60 feet long, a technical wonder initially composed of forty-one 20-inch strips of colored film taped together. The result was backlit by over a mile of florescent tubes and produced a vivid full-color photograph. Adams was one of many photographers invited to contribute and although he was not an enthusiastic color photographer, he contributed many views over the years even though he considered them "aesthetically inconsequential but technically remarkable." These adverts were a well-known and much-enjoyed feature of the station and 565 Coloramas appeared between 1950 and 1990.

Adams became a much-sought-after commercial photographer and worked for many great American companies and corporations. For example in 1947 and 1948 he photographed for the Standard Oil Company for their "See You West" promotion; when a customer filled up with gas at one of their service stations they were given an Ansel Adams picture.

For the last twenty years or so of his life Adams used Hasselblad cameras, appreciating their mechanical precision and superlative optical perfection. He had first been presented with one in 1950 after meeting Dr. Victor Hasselblad in New York. Hasselblad sent Adams a 1600F model with the request to try it out and send any comments to him in Sweden. This proved a long-lasting partnership, and Adams made some of his favorite photos using a Hasselblad—in particular *Moon and Half Dome, Yosemite National Park, 1960*. After Hasselblad's death the Hasselblad Foundation established a gold medal award. In 1981 Adams was informed that King Carl XVI Gustaf of Sweden would present him with the second Hasselblad Medal (the first had gone to the Swedish photographer Lennart Nilsson). The presentation ceremony was at MOMA.

Carmel Highlands

Ansel and Virginia split their time and energies between Yosemite and San Francisco, regularly shuttling the 180 miles or so between locations. By 1961 they weren't getting any younger and the drive was getting a bit much—they felt they needed a change. They were reluctant to leave Yosemite or the Pacific Ocean and were very tempted by Santa Fe, but realized it was too far from family, friends, and work opportunities. More practical was Carmel Highlands, where they already had friends among the thriving community of artists, photographers, poets, musicians, writers, and such like. One of these friends, Dick MacGraw, owned some land there, and offered them a lot overlooking the Pacific. To afford to build their new home, Adams reluctantly sold his old family home at the Golden Gate where he had lived all his life. The new house was completed in 1962: it was spacious, with high ceilings, vast panoramas of the ocean 200 feet below, and boasted a purpose-built studio, gallery, and workshop. The building was carefully constructed into the folds of the land and so appeared much smaller than it was. They settled comfortably into their new community, renewing many old friendships and striking up many new ones.

By late 1966 Adams was teaching photography at the Carmel Sunset Center through the auspices of the newly created the Friends of Photography, of which Adams was the first president. The voluntary enterprise proved a success and rapidly grew to have a local and international membership, staging regular exhibitions of serious photography and an award-winning publishing agenda.

Adams photographed the Manzanar museum (Ansel Adams exhibit) in 1943.

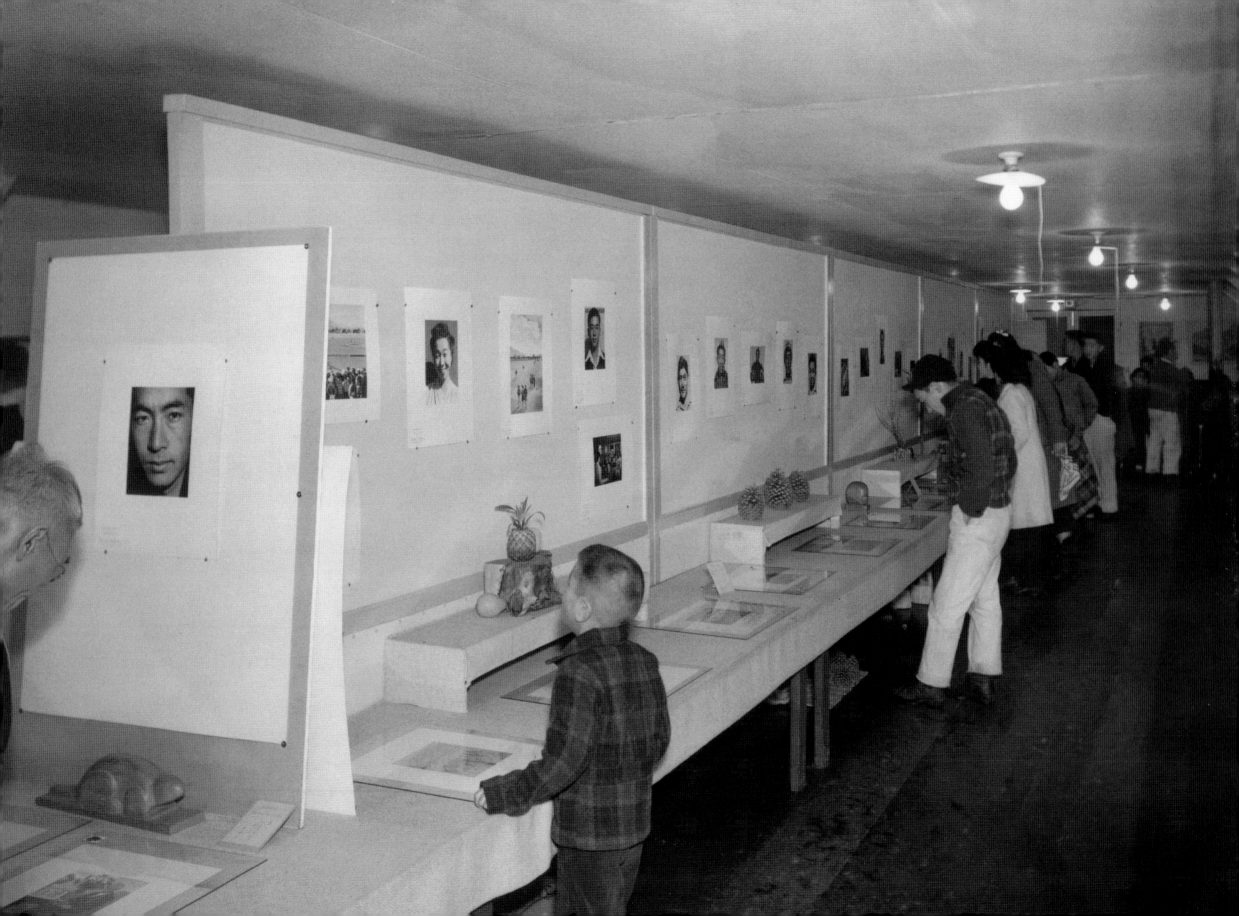

featuring many well-known photographers. In 1978 the Friends published *Ansel Adams: 50 Years of Portraits* and staged an accompanying exhibition exploring the little-known side of his work. Another important exhibition of Adams' works was staged by the Friends and sent to Shanghai and then Beijing's National Museum of Art, where it was admired by thousands of Chinese.

In 1977 the spacecraft Voyager was launched into orbit and shot out into the blackness of space. Inside it contained a Golden Record, a document intended to educate any aliens about the Earth. Adams' photograph of the Snake River was chosen as one of the 116 images of our planet.

In his later years, as a highly esteemed photographer Adams was able to give up commercial work when it did not interest him, although he was still open to the occasional inartistic commission. One such came in 1979 when the National Portrait Gallery asked him to make the official portraits of President Carter and Vice President Mondale—the first time a photographer had been asked. Because of time considerations Adams decided to use Polaroid film and a large format 20 x 24-inch camera lent by the company. The process took 70 seconds to develop. Four prints resulted: one for the Portrait Gallery, one for President Carter, one for Polaroid, and one for Adams. A year later, Adams received the Presidential

Medal of Freedom from President Carter in a ceremony at the White House. Part of his citation read: "He is regarded by environmentalists as a monument himself, and by photographers as a national institution. It is through his foresight and fortitude that so much of America has been saved for future Americans."

Adams, however, had a very low opinion of the Governor of California and later President, Ronald Reagan, as he blatantly had no interest or concern for the environment or conservation, preferring instead to accommodate the agendas of big business. Adams hit a sore spot when he was critical of the President in a *Playboy* interview, and he was requested to discuss matters with Reagan in person at the Beverly-Wilshire Hotel in Los Angeles. The meeting lasted 55 minutes and was very cordial, but there was no meeting of minds although the President claimed to be an environmentalist—not by any description that Adams recognized—and he continued to publicly criticize Reagan's administration. He had hoped to broach the subject of protection for the 90 miles of Big Sur Coast but never got the chance as Reagan smoothly ran the show.

Ansel Adams was in his seventies when he decided to donate his entire photographic archive to an institution where it would be available to serious scholars and students. He offered the collection to the University of California, but they declined. Following a solo exhibition at the Museum of Art at the University of Arizona, it was suggested by its president, Dr. John P. Schaefer, that the university would be the ideal location for his archive. The pair met to discuss the prospect at Carmel and the idea for the Center for Creative Photography was formed with Adams' archive providing the foundation. One of the caveats insisted on by Adams was that only advanced students and accredited scholars be allowed to print from his negatives, and then only with the approval of the trustees of the Ansel Adams Publishing Rights Trust. The resultant prints are clearly stamped as not being an Ansel Adams print; they are never be allowed to leave the center, and are never be sold.

Last years

Around 1970 Adams started to experience the occasional sharp chest pain, but upon examination it proved to be caused by his diaphragm not his heart. Later that decade, however, his heart did prove troublesome, and on February 14, 1979, he had a valve replacement and triple coronary bypass (after having to lose 15 pounds beforehand). He recovered quickly and convalesced in San Francisco with old friends before returning to Carmel feeling twenty years younger. A year later he had a pacemaker fitted and overall his health was improved.

By this time demand for Ansel Adams original prints was so continuous that he felt trapped in the darkroom, constantly reprinting his most popular negatives.

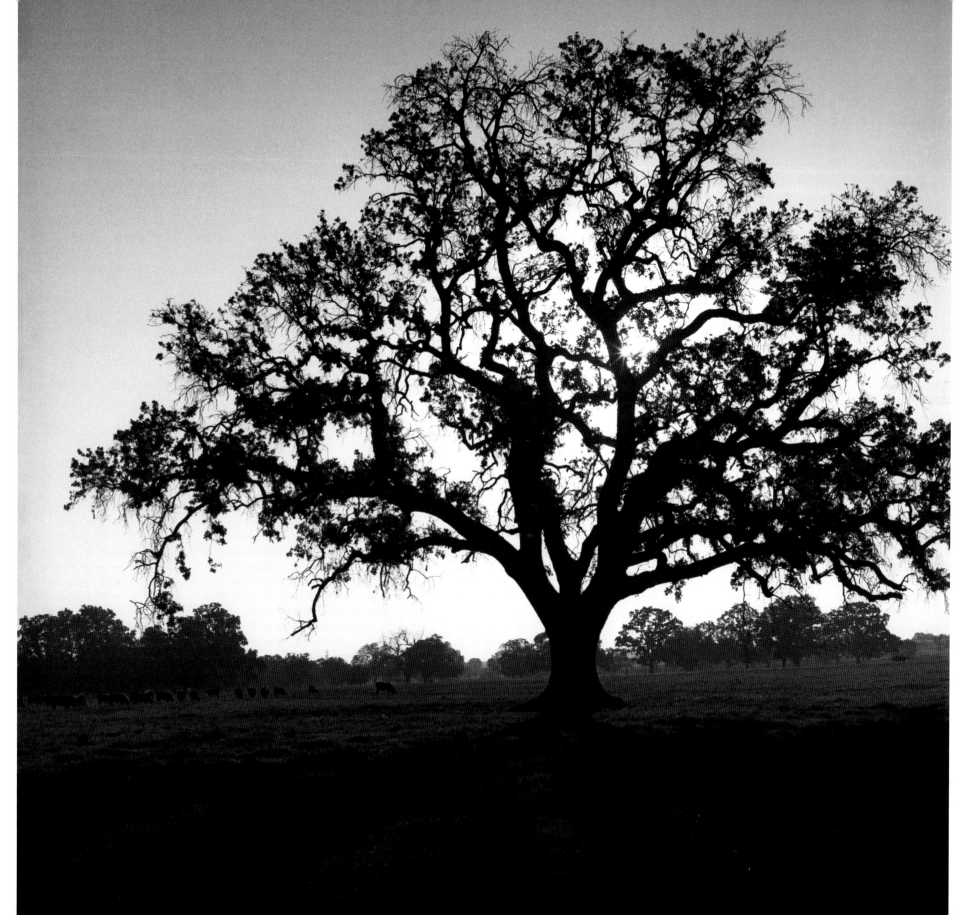

Right: *"Cattle, September 1966"*
This is one of the Fiat Lux Collection photographs (see pp. 70–107). The images were commissioned for a photographic book (titled Fiat Lux: The University of California) *published in 1967 to celebrate the university's centennial in 1968.*

Opposite: *Ansel Adams holds the Hasselblad Award and the Erna and Victor Hasselblad Gold Medal presented to him by Sweden's King Carl XVI Gustaf (R) and Queen Silvia (2nd, L) at the Museum of Modern Art. At left is Mrs. John D. Rockefeller III.*

At his age it was too much and he announced publicly that he would accept no more orders for prints for public sale after December 31, 1975. He set the price at $800 for a 16 x 20 inch print and was amazed to be overwhelmed by orders for over 3,000 prints. It took him the next three years to complete the orders.

Always the musician, Adams found great delight in the company of fellow musicians. For his eightieth birthday, Virginia arranged for the great pianist Vladimir Ashkenazy to play in their home. The pair became great friends and Ashkenazy even used Adams' portraits of him on his album covers. On Easter Sunday, April 22, 1984, Ashkenazy gave another concert at the Adams' home in Carmel. Ansel had been taken ill a few days earlier and had been admitted to the Community Hospital of the Monterey Peninsula. The concert went ahead anyway, attended by family and friends, and then a number of them, including Ashkenazy, visited him in the intensive care unit where he welcomed them with open arms. He died quietly of cardiovascular disease a few hours later. He was 82.

Ansel Adams was cremated in a private ceremony and his ashes were scattered by his son Michael at the summit of Mount Ansel Adams in Yosemite National Park, Sierra Nevada, California.

Legacy

Ansel Adams left a vast repository of negatives and photographic prints over his long and celebrated career. He started as a hobbyist but gradually got more and more obsessive about photography, learning that only 50 percent of the genius of a great picture lies with the photographer and the camera while the other 50 percent of magic lies in the technical alchemy of the darkroom. He said of his photographs, "I hope that my work will encourage self expression in others and stimulate the search for beauty and creative excitement in the great world around us."

For many people Adams was a visionary figure and a symbol of the American West. His life long love for the environment and his insistent campaigning helped focus attention on the American wilderness and its vulnerability to commercial exploitation. He lobbied the politicians locally, state-wide, and all the way through Congress and up to the President—to personally engage, educate, and inspire them to protect their own natural heritage. Although by no means working alone, Adams helped push the wild heritage agenda up the legislative path to full protected status in perpetuity which requires an act of Congress for each area. In 1968 he received the Interior Department's highest civilian honor, the Conservation Service Award, ... "in recognition of your many years of distinguished work as a photographer, artist, interpreter and conservationist, a role in which your efforts have been of profound importance in the conservation of our greatest natural resources."

Through his photographs Ansel Adams introduced Americans to their own wilderness heritage, places that the vast majority of the population would never get to see for themselves. Furthermore, his photographs made them care for these places and appreciate the efforts of others to preserve the wilderness from exploitation—this directly helped to make the National Park Service an important and popular arm of government. The United States now holds and preserves for posterity 59 protected areas that are designated national parks.

Adams became a teacher so he could pass on his knowledge, insights, and inspiration to others. Many of his students in turn became well known photographers and passed on their knowledge to a further generation of artists. His legacy lies not just in the sheer drama and beauty of his work but also how the great wildernesses of the United States looked before they were opened up to tourism.

After his death Ansel Adams memory was honored in the best way possible—a 231,005-acre stretch of California high up in the Sierra Nevada was named the Ansel Adams Wilderness in 1984 after Californian senators Pete Wilson and Alan Cranston lobbied for the change. It is part of the Sierra and Inyo National Forests, just south of Yosemite and includes the Ritter Range of mountains, including Mount Ritter, Banner Peak, and The Minarets. A smaller area was originally protected in 1964 when it was called the Minarets Wilderness. The new act extended the area and protects the core of the high sierra by establishing the contiguous wilderness areas of Ansel Adams, Yosemite, John Muir, and Kings Canyon. It is an area of stunning mountains, glacial gorges, and clear lakes and lies at altitudes between 7,000 feet and 14,000 feet. Although open to the public, entry is strictly controlled by quotas and permits.

A year and one day after his death a 11,760-foot peak in the Sierra Nevada range in Yosemite National Park was named Mount Ansel Adams. It lies near the park's south eastern boundary near the Lyell Fork of the Merced River. It is an area Adams knew and loved. The peak was first climbed in 1934 by Jack Riegelhuth, Glen Dawson, and Neil Ruge, who proposed Adams' name for the peak. Two days later they led a fifteen-strong Sierra Club High Trip party—including Adams and Virginia—up the mountain. On the summit they dedicated the peak to Ansel Adams, however the U.S. Geological Survey would not sanction the name as living people cannot have features named after them. His name, however, was used unofficially until sanctioned in 1984.

The Ansel Adams Wilderness, just south of Yosemite, includes much of the Ritter Range of California's Sierra Nevadas. This photograph shows Banner Peak rising above Thousand Island Lake.

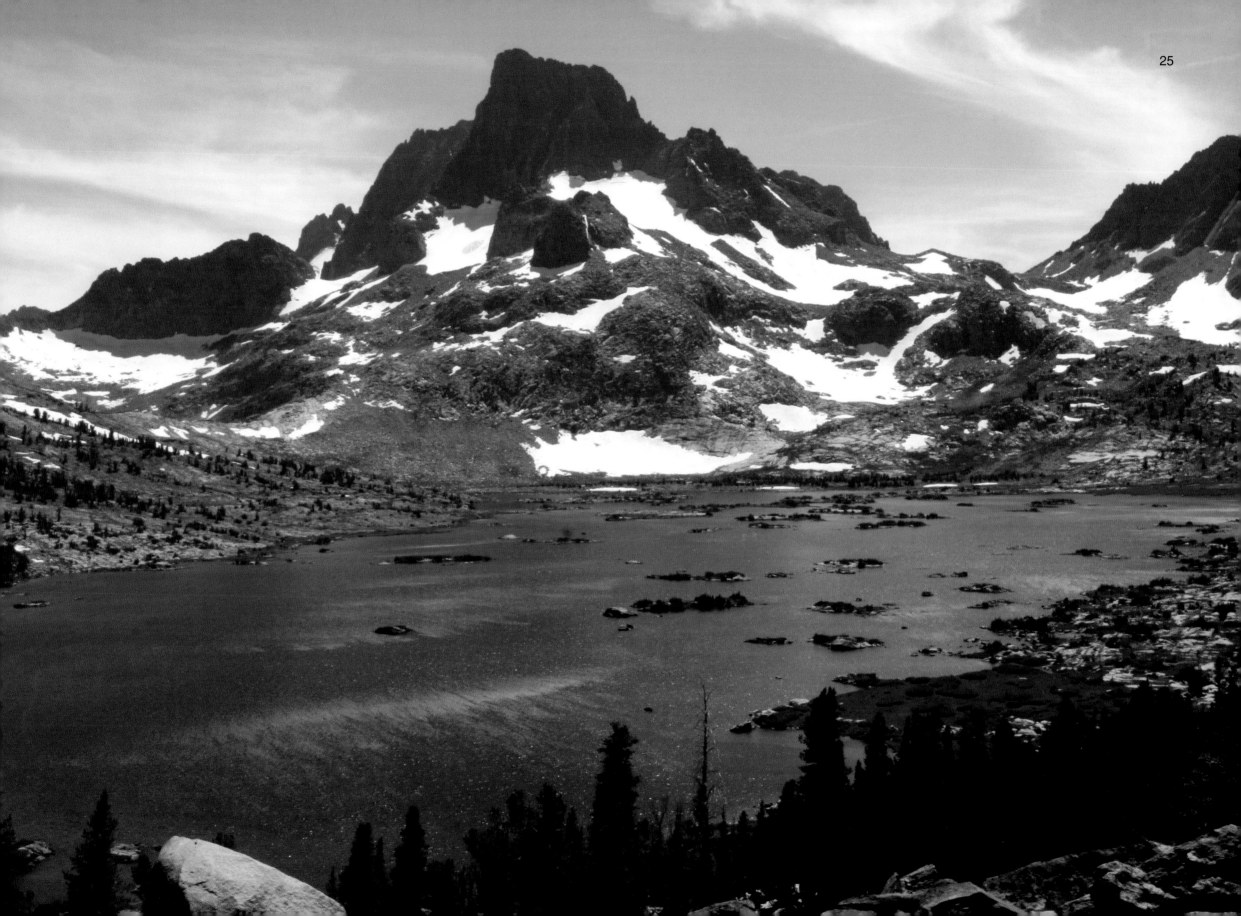

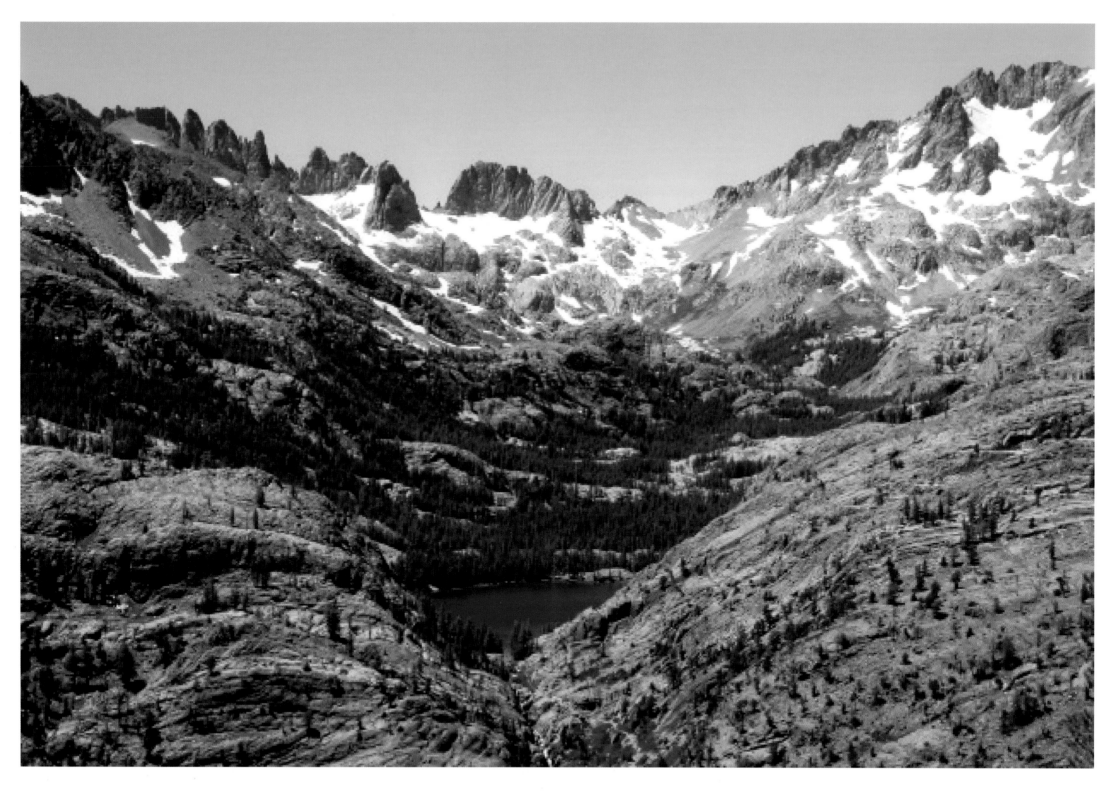

Shadow Lake and Minarets, viewed across the upper San Joaquin Valley from the High Trail (on Pacific Crest Trail).

ARIZONA

Arizona is the sixth largest state and was the last contiguous state to join the Union (in February 1912) after much of it was ceded from Mexico. Northern Arizona is quite temperate with evergreen forests, canyons and a few mountain ranges, while southern Arizona is true desert with fiercely hot summers, mild winters, and minimal precipitation. Arizona has a rich heritage of nationally important parks and monuments including four important national parks: Canyon De Chelly, Grand Canyon, Petrified Forest, and Saguaro. Its highest point is Humphreys Peak at 12,637 feet and the lowest is where the Colorado River crosses the Sonora border at 72 feet. Ansel Adams had a special connection to Arizona: it was in Tucson, at the University of Arizona, that the Center for Creative Photography was set up, with Adams as one of the founding members. The center holds the full archives of over sixty of the most famous American photographers, including Ansel Adams who placed his entire photographic collection and archive in the care of the institution. Today in a new building at the university, the Adams Archive includes "more than 2,500 fine prints, along with correspondence, interviews, unpublished writings, memorabilia, publications, negatives, transparencies, work prints, photographic equipment, and files documenting his commercial projects, exhibitions, affiliation with the Sierra Club and Friends of Photography." The variety of Adams' work in the state is notable: his stunning images of the natural lines of the Grand Canyon are juxtaposed against the man-made structures of the Boulder Dam and its electrical catenary; his work on the Native Americans of the Canyon De Chelly, Tuba City, and Walpi with the curious shapes of what was then the Saguaro National Monument.

The Saguaro National Monument was created on March 1, 1933, by President Herbert Hoover and became the Saguaro National Park in November 1994.

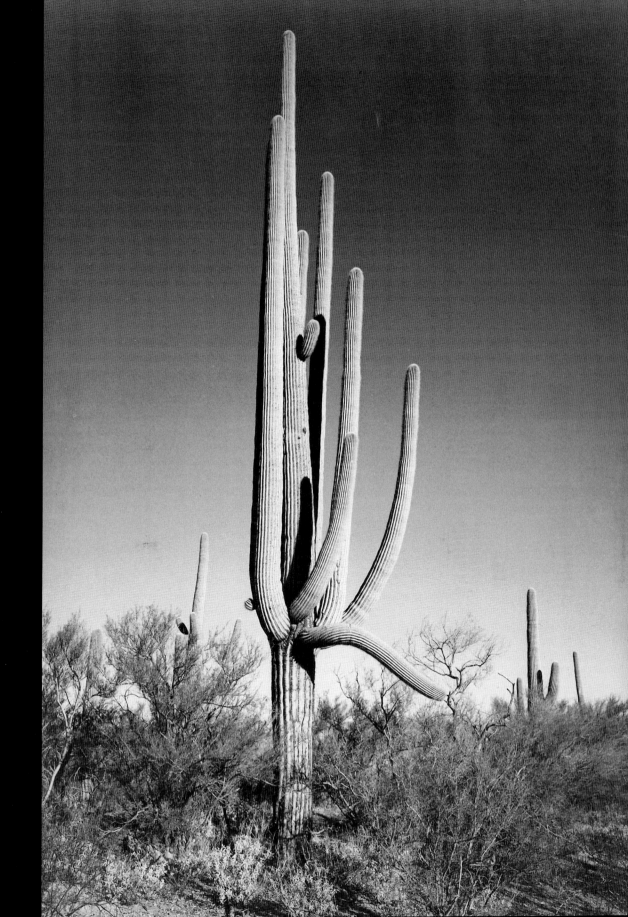

BOULDER DAM

Boulder Dam was built across the Colorado River at Black Canyon, on the border of Arizona and Nevada, between 1931 and 1936. This immense project, started on the orders of President Franklin D. Roosevelt, was designed to prevent flooding, provide work, and hydroelectric power during the Great Depression. Nearby Boulder City in Nevada was created to house the 16,000 or so previously unemployed men and women who worked on the project. Ansel Adams photographed the dam in 1941 and again in 1942 during his Mural Project assignment for the Department of the Interior. It was one of the few subjects for the commission that was not a national park or wilderness. Adams had first met Secretary Harold Ickes in 1936 after he had addressed a conference debating the future of the national and state parks of the United States—a subject very close to both their hearts. They became great friends. During the war there was lobbying from some quarters to close the national parks for the duration, but Ickes strongly disagreed, stressing that people directly needed the sancitity of the wilderness to alleviate the stresses of war: he won the argument and kept the parks open. Adams' photographic murals were finally hung and exhibited as intended in the Department of the Interior building in 2010 to celebrate the Department's 161st anniversary.

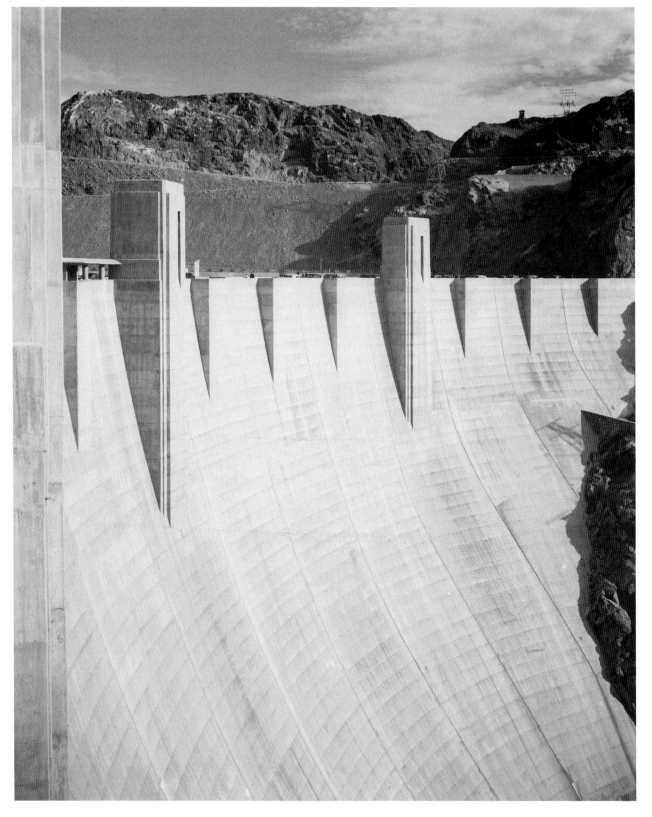

"Boulder Dam, 1941."

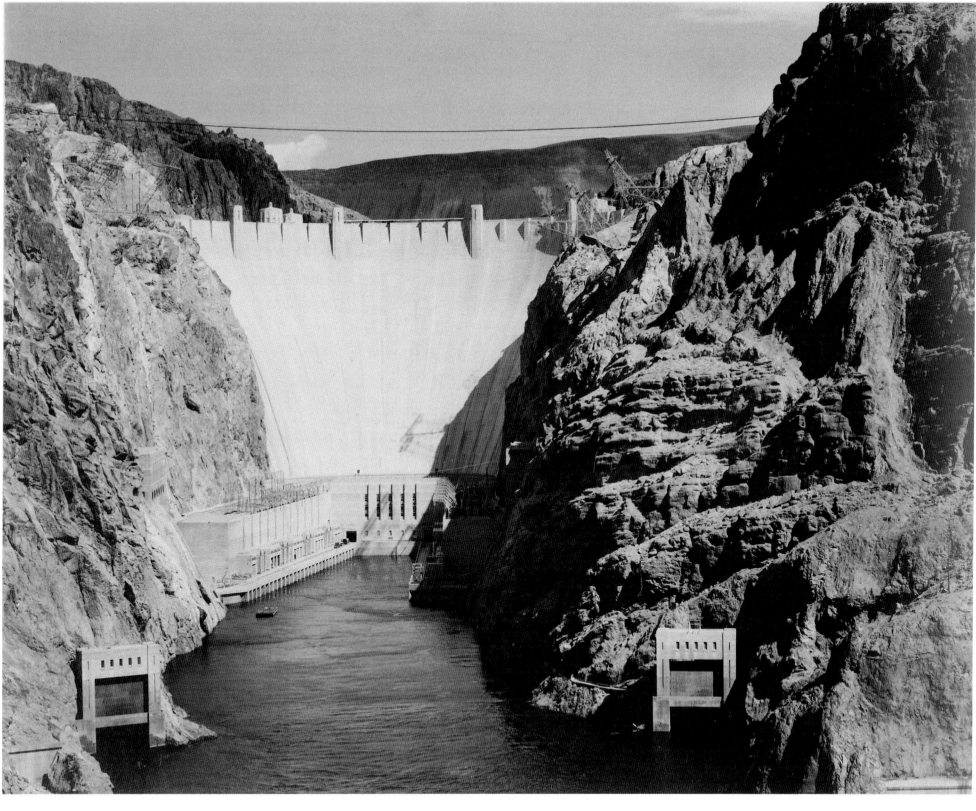

"Boulder Dam, 1941."

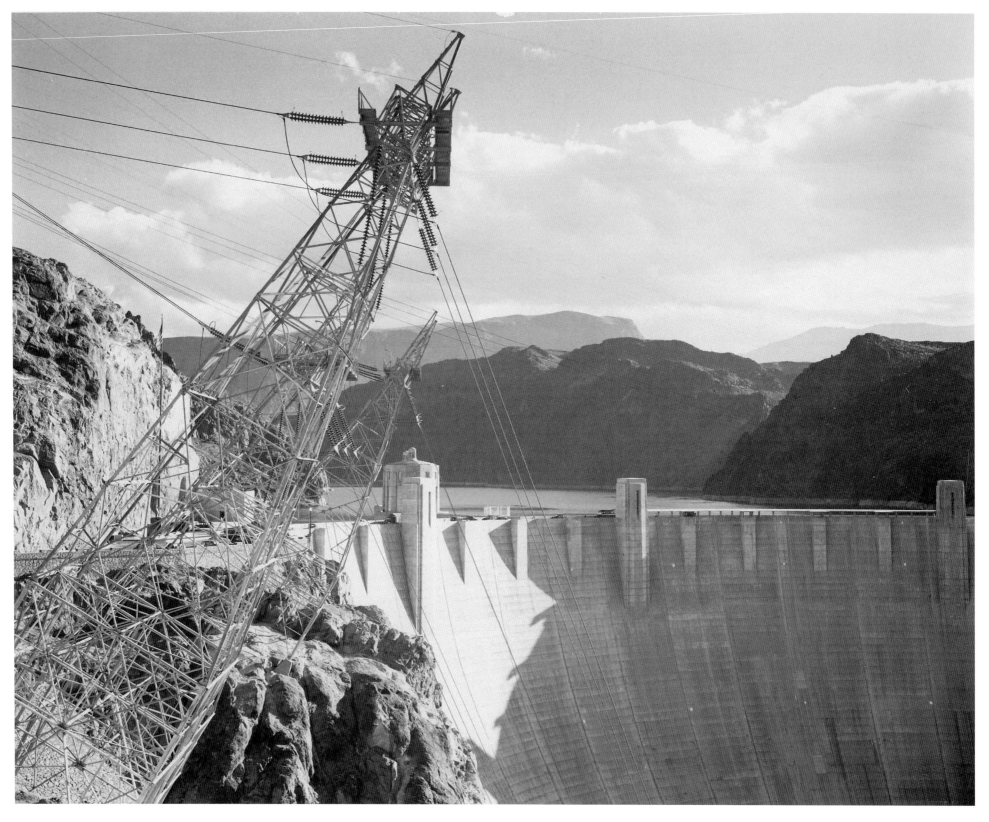

"Boulder Dam, 1941."

"Boulder Dam, 1941."

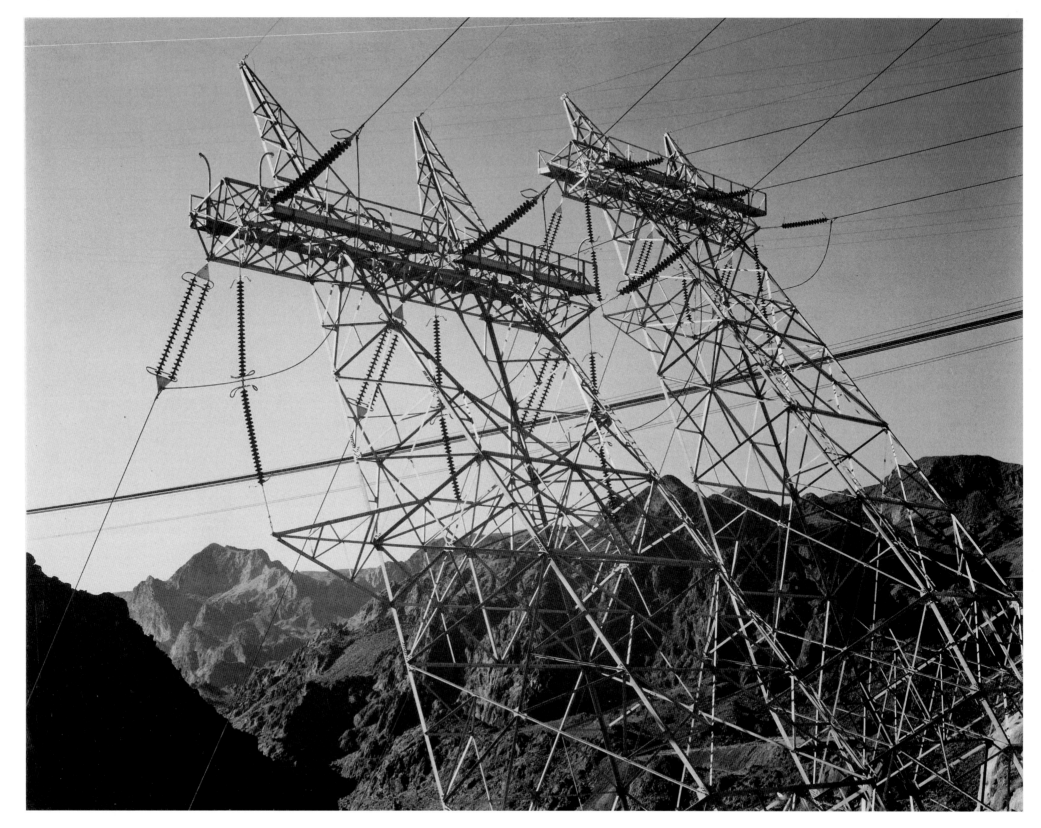

"Boulder Dam, 1941."

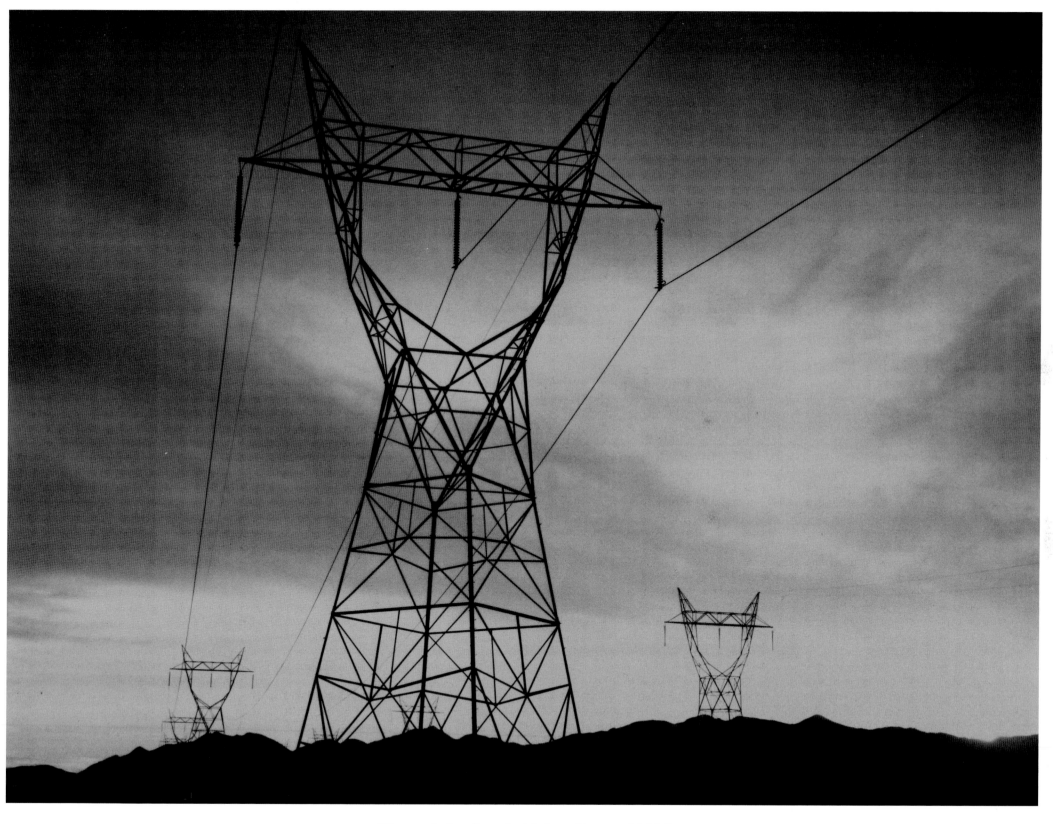

"Transmission lines in Mojave Desert, 1941."

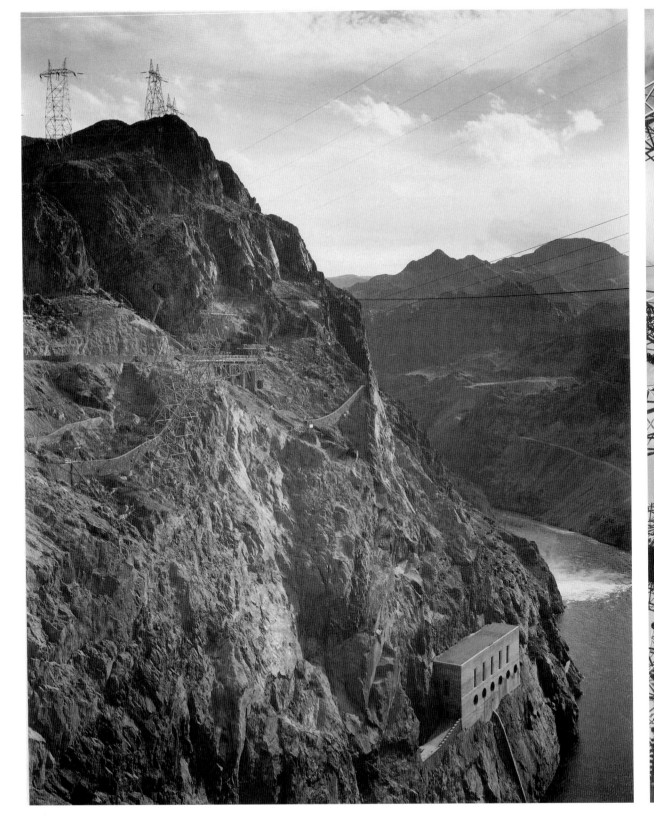

"Boulder Dam, 1941."

"Looking Up at Wires of the Boulder Dam Power Units, 1941."

"Boulder Dam Power Unit, 1941."

CANYON DE CHELLY NATIONAL MONUMENT

Adams deeply loved the high desert regions of the American Southwest and frequently explored them in the company of his friends taking photographs as they went. Remote Canyon De Chelly is a National Monument in northeast Arizona. The huge towering red cliffs are striated with color and eroded back to sculptural shapes that are constructed from the remnants of solidified sand dunes towering over the dry sandy riverbed floors at the bottom of deep-cut gorges. Members of the Native American Navajo tribe still live in the environs in complete harmony with nature. They gave the canyon its name *Tseyi* (pronounced *say-ee*) and this eventually—with mispronounciation and mis-spelling via French and English—became De Chelly. The Canyon De Chelly was established as a National Monument in April 1931 by President Herbert Hoover following approval by Congress and the Tribal Council of the Navajo Nation. It comprises three major canyons—De Chelly, del Muerto, and Monument and is entirely owned by the Navajo Tribal Trust of the Navajo Nation. It is one of the longest continuously inhabited landscapes in North America. Adams photographed the ruins of buildings deep in the canyon left by the ancient pueblo peoples as part of the Mural Project in the fall of 1941. He visited Canyon De Chelly in the company of the artist Georgia O'Keeffe and her friend David Hunter McAlpin, who was a wealthy banker and member of the powerful Rockefeller family. Adams spent two days photographing at De Chelly amid spectacularly stormy weather during what was claimed to be the worst rainy season for twenty-five years. In spite of this, he felt that he made some of his best photographs on and around the rim of De Chelly canyon.

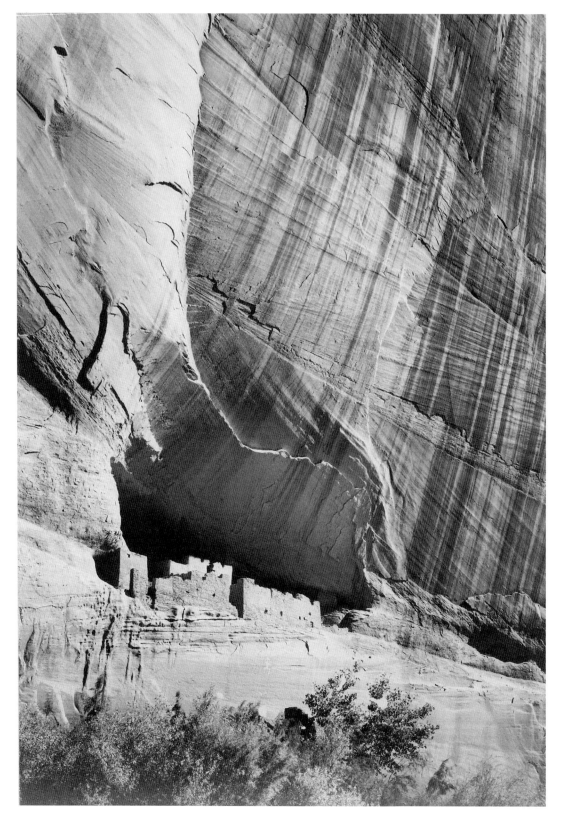

"Canyon De Chelly."

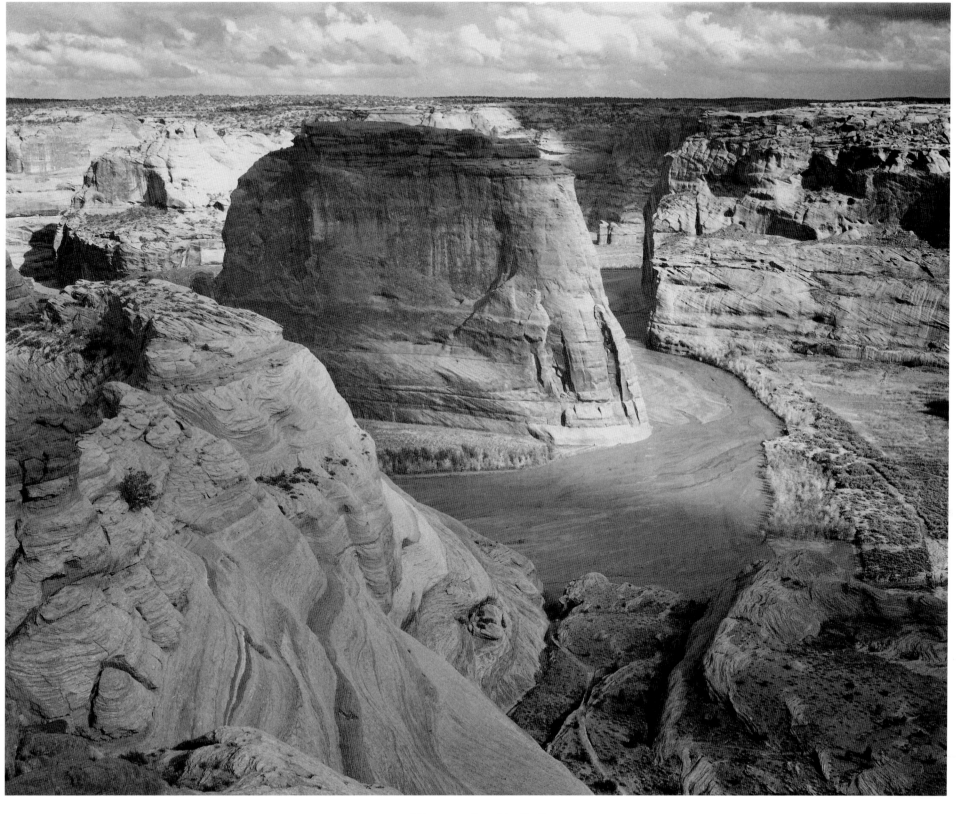

"Canyon De Chelly."

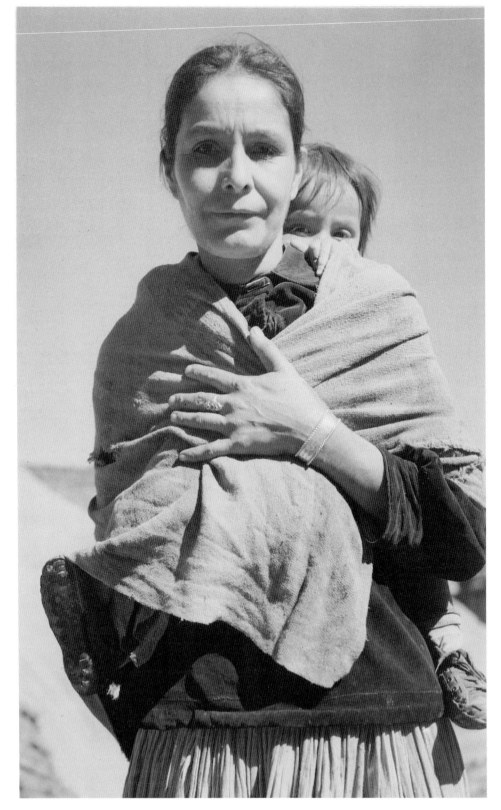

"Navajo Woman and Child, Canyon de Chelle [sic], Arizona."

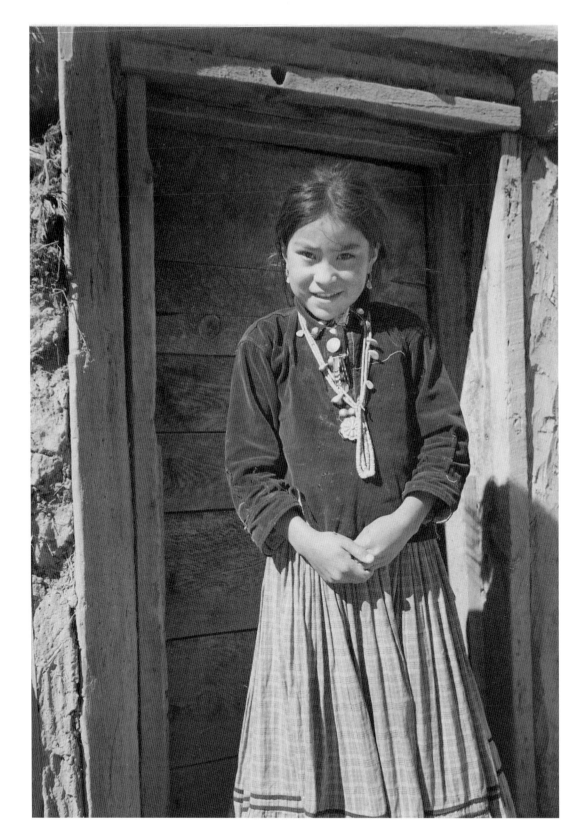

"Navajo Girl, Canyon de Chelle, Arizona."

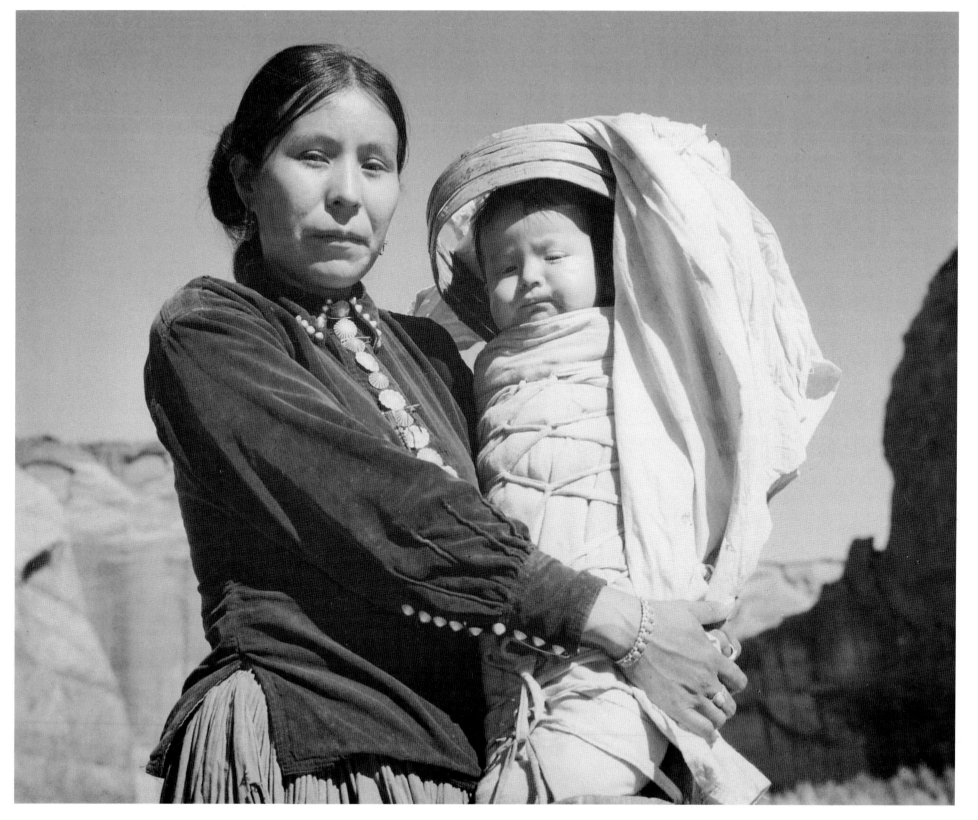

"Navajo Woman and Infant, Canyon de Chelle, Arizona."

GRAND CANYON NATIONAL PARK

Grand Canyon National Park in Arizona was formed over millions of years and now includes the 277 river miles of canyon carved by the Colorado River which can be up to a mile deep and eighteen miles wide. President Theodore Roosevelt loved the great American outdoors and was a fierce conservationist long before most people appreciated and understood such concerns. In particular he loved and admired the Grand Canyon which he first visited in 1903. Against great opposition he established the Grand Canyon Game Preserve in November 1906, which put in place restriction on the usage of the environs; he redesignated it a US National Monument in January 1908. For the next eleven years miners, land owners, and other interested parties intent on exploiting its resources fought off further regulation until President Woodrow Wilson, following an Act of Congress, was able to declare the Grand Canyon National Park in February 1919 and protect its integrity forever. As a pioneer of the conservation movement and the wilderness, Ansel Adams was instrumental in introducing the canyon in all its magnificence to the American public through his spectacular photographs. The Mural Project brief was to capture "nature as exemplified and protected in the U.S. National Parks." It took a photographer of Ansel Adams' remarkable ability to capture the sheer grandeur and scale of this magnificent and unique landscape. During World War II Grand Canyon was one of the National Parks to provide rest and recuperation camps for battle weary soldiers.

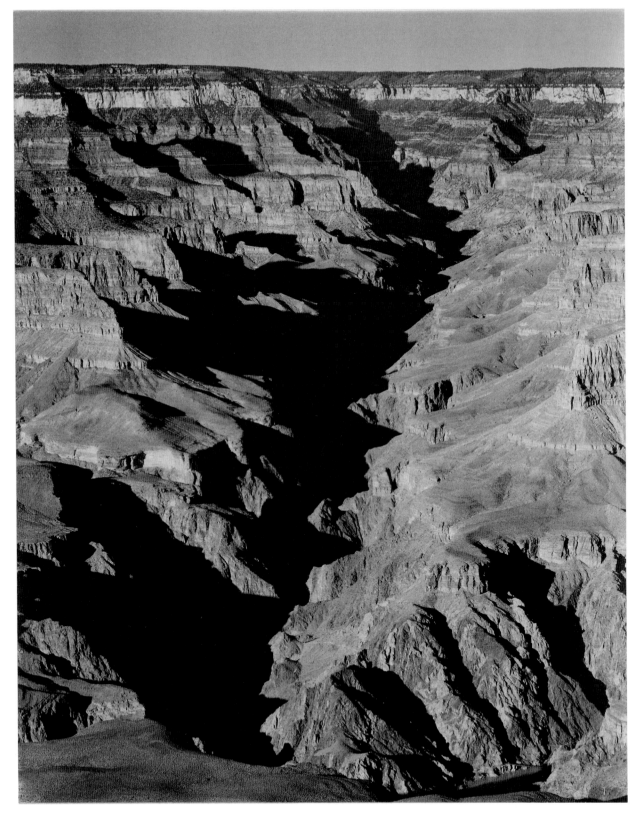

"Grand Canyon from S(outh). Rim, 1941."

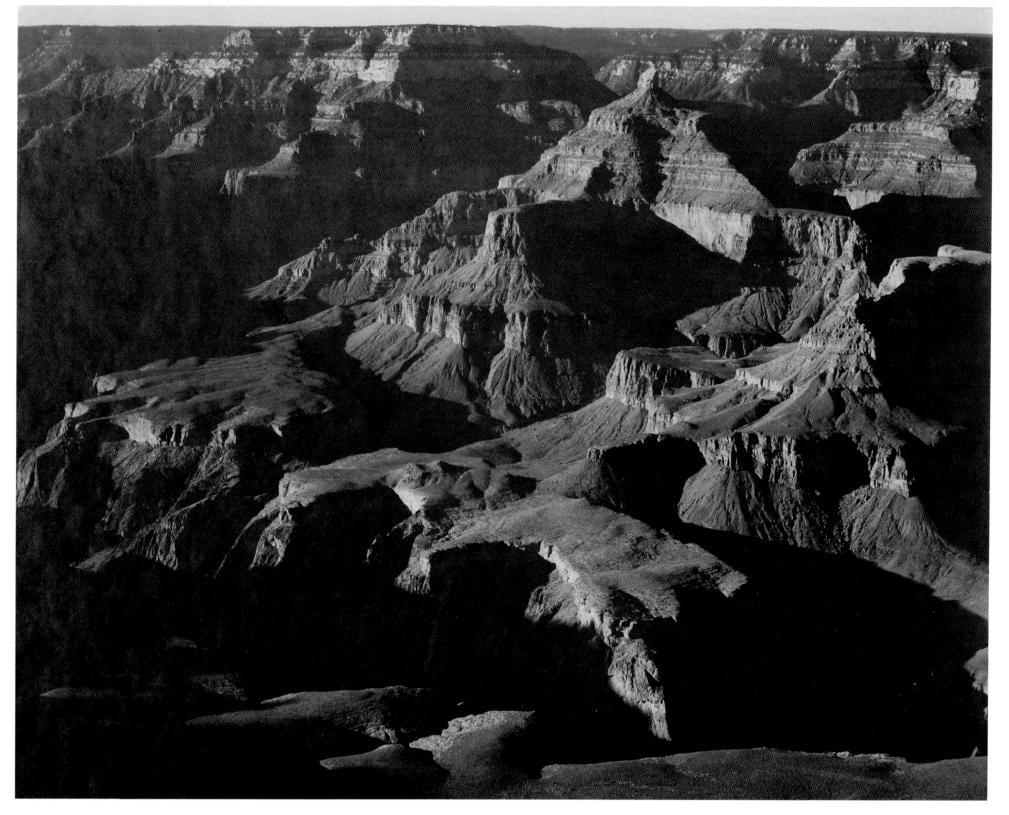

"Grand Canyon."

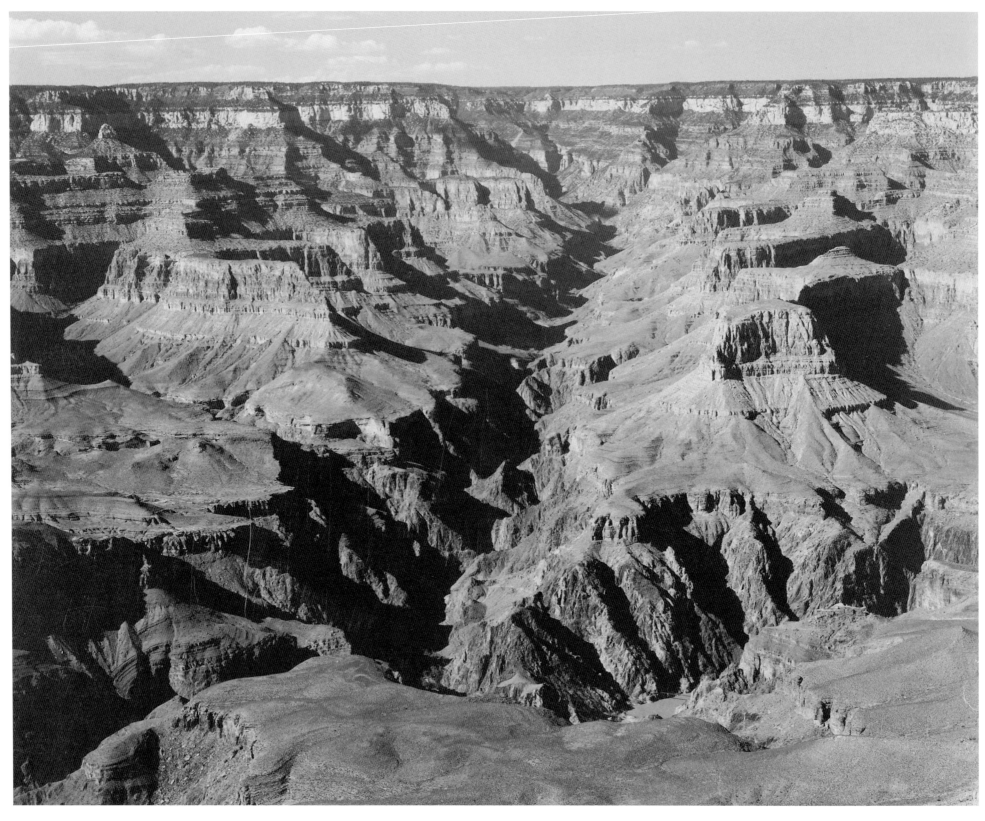

"Grand Canyon National Park."

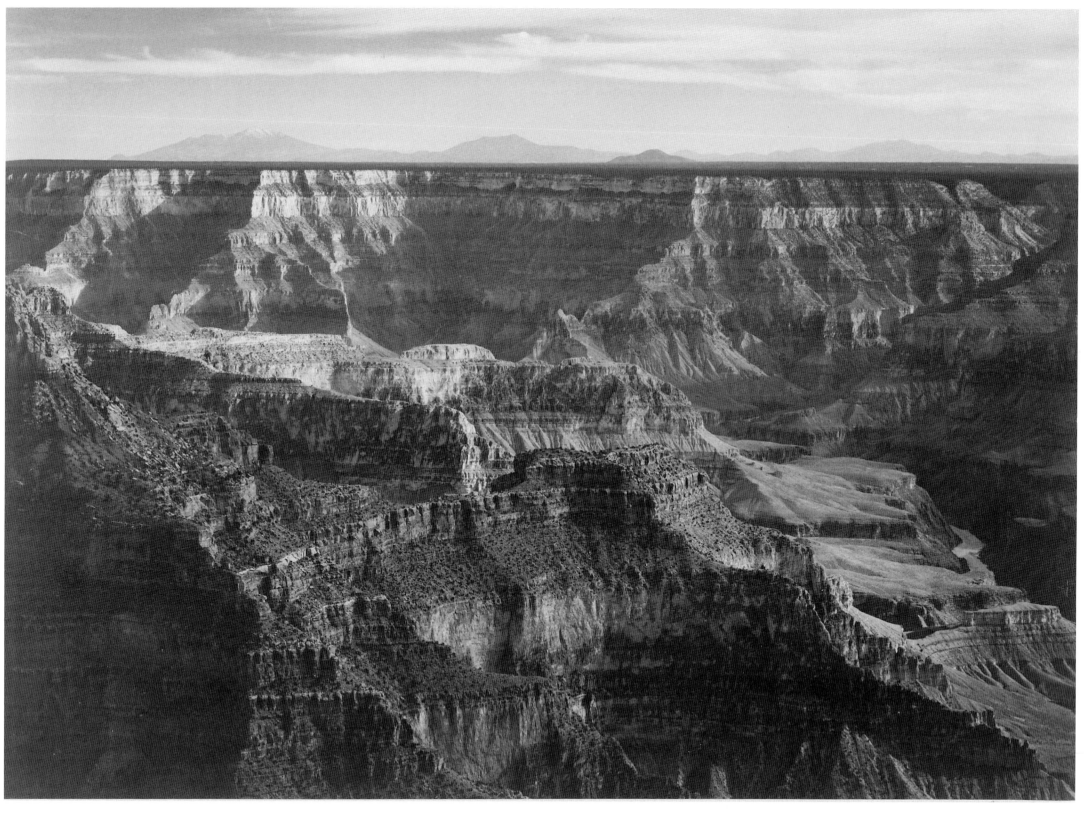

"Grand Canyon National Park."

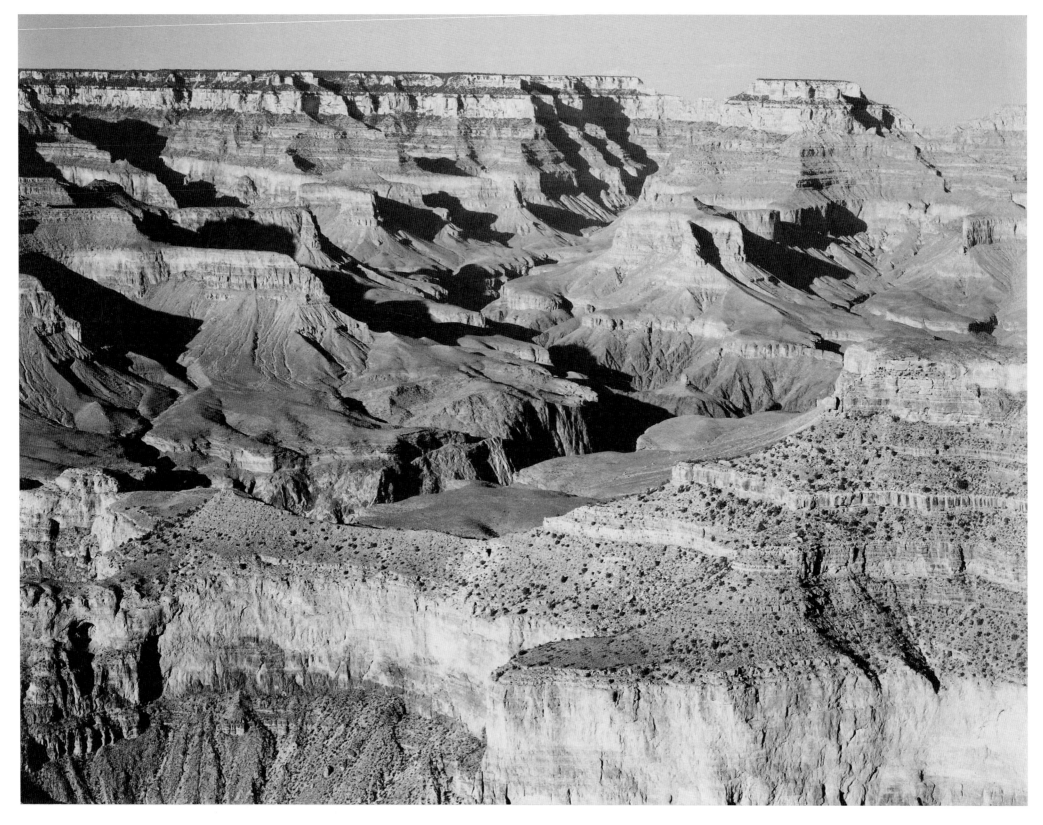

"Grand Canyon National Park."

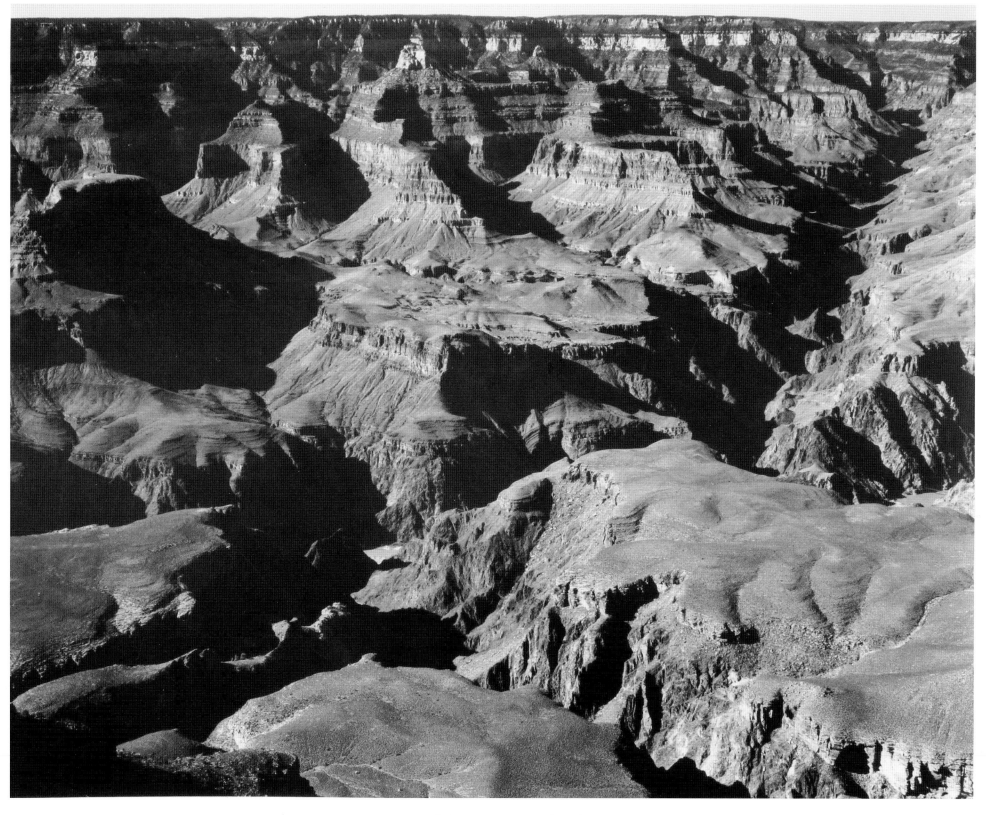

"Grand Canyon National Park."

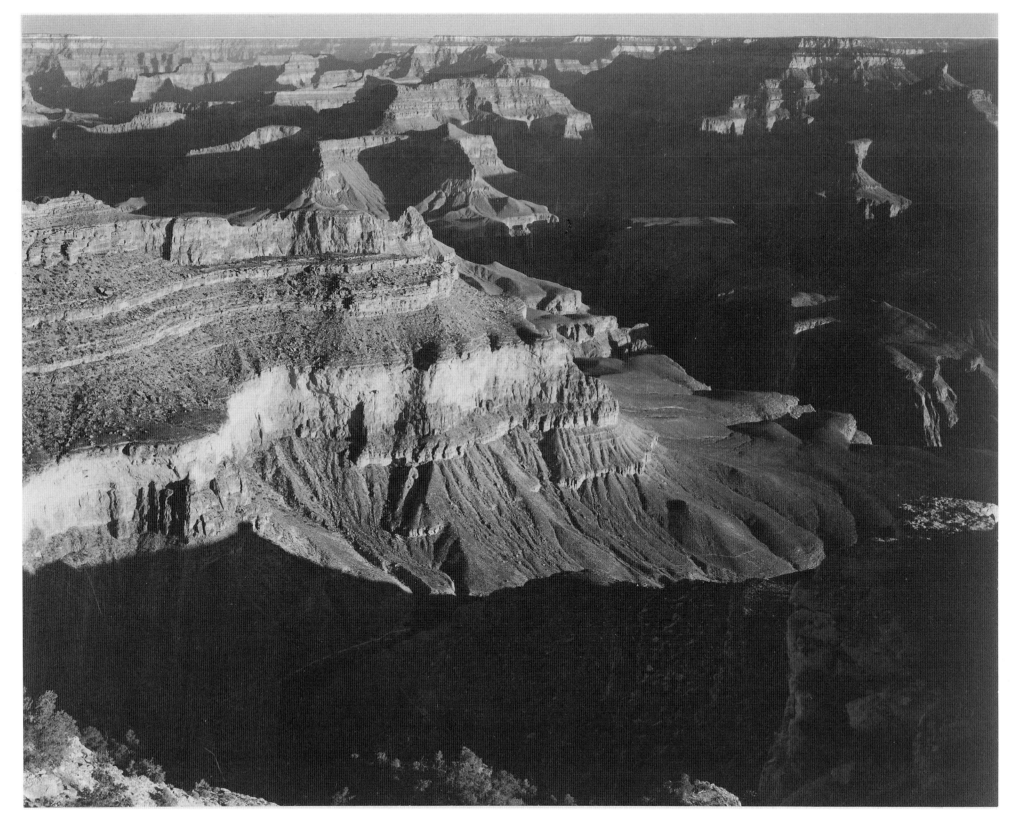

"Grand Canyon National Park."

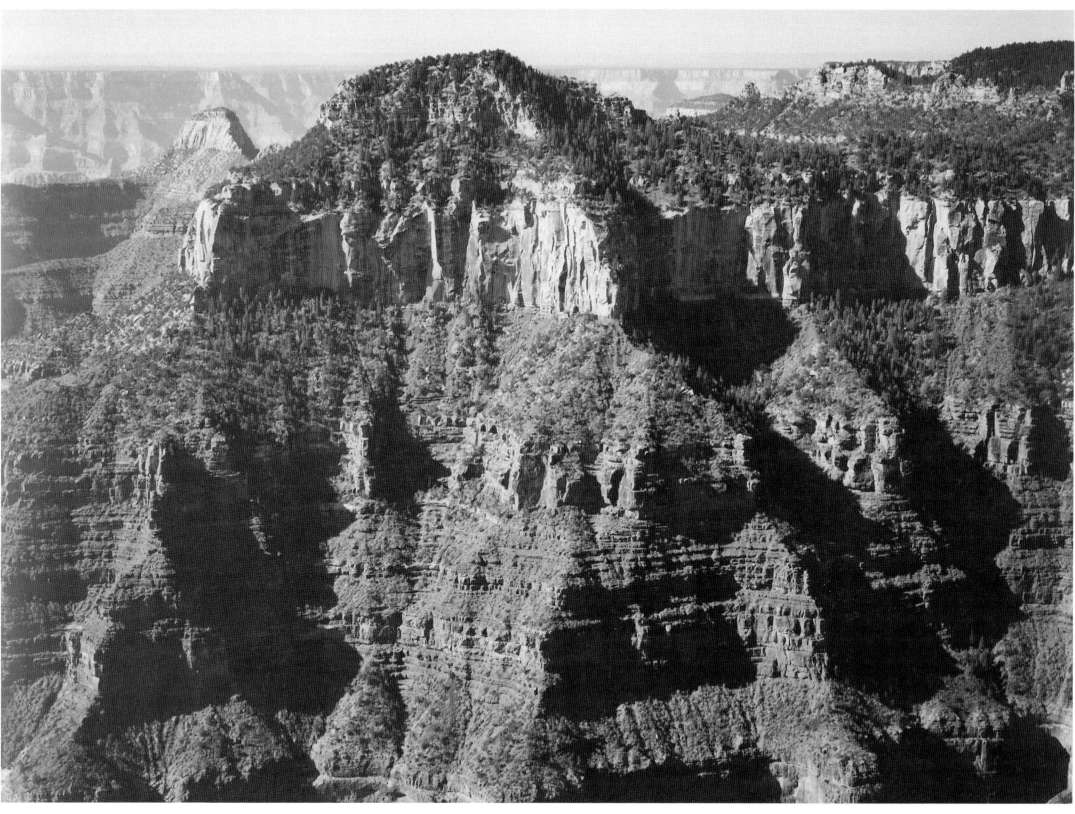

"Grand Canyon National Park."

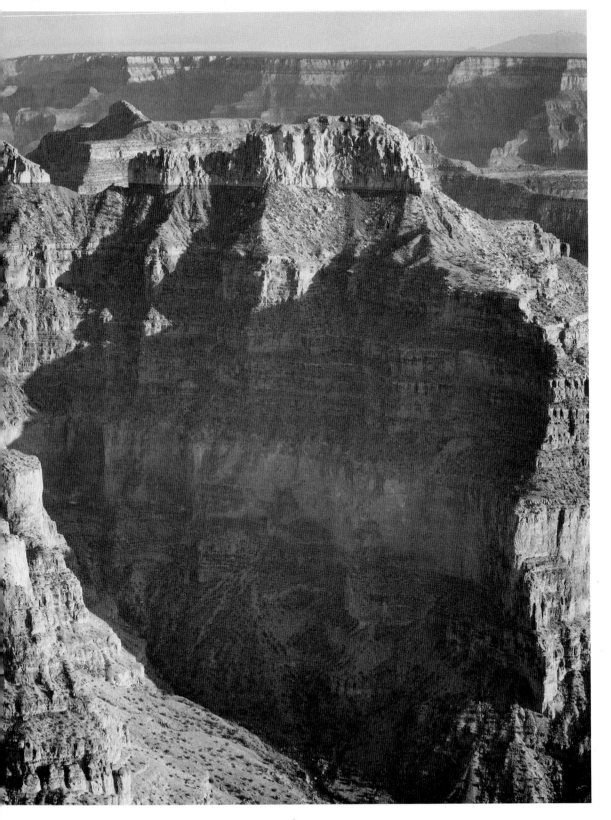

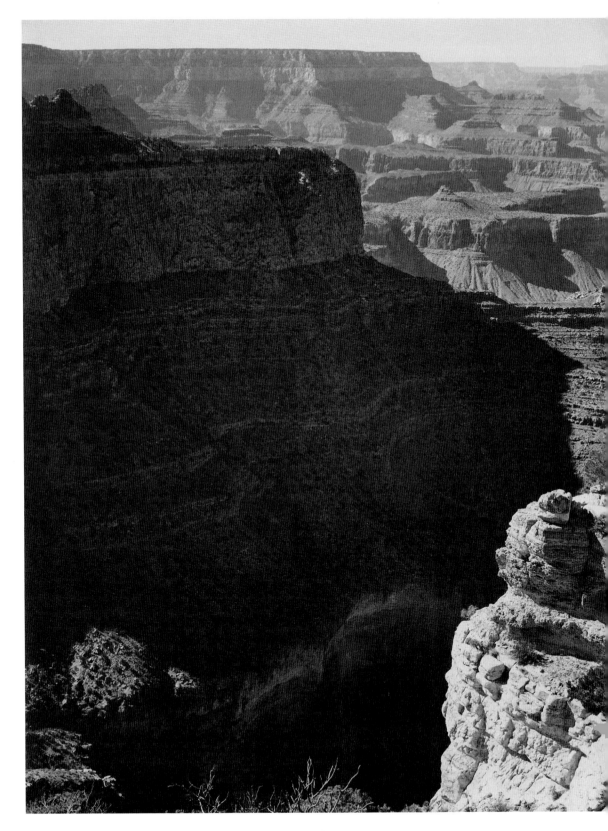

"Grand Canyon from N. Rim, 1941."

"Grand Canyon from S. Rim, 1941."

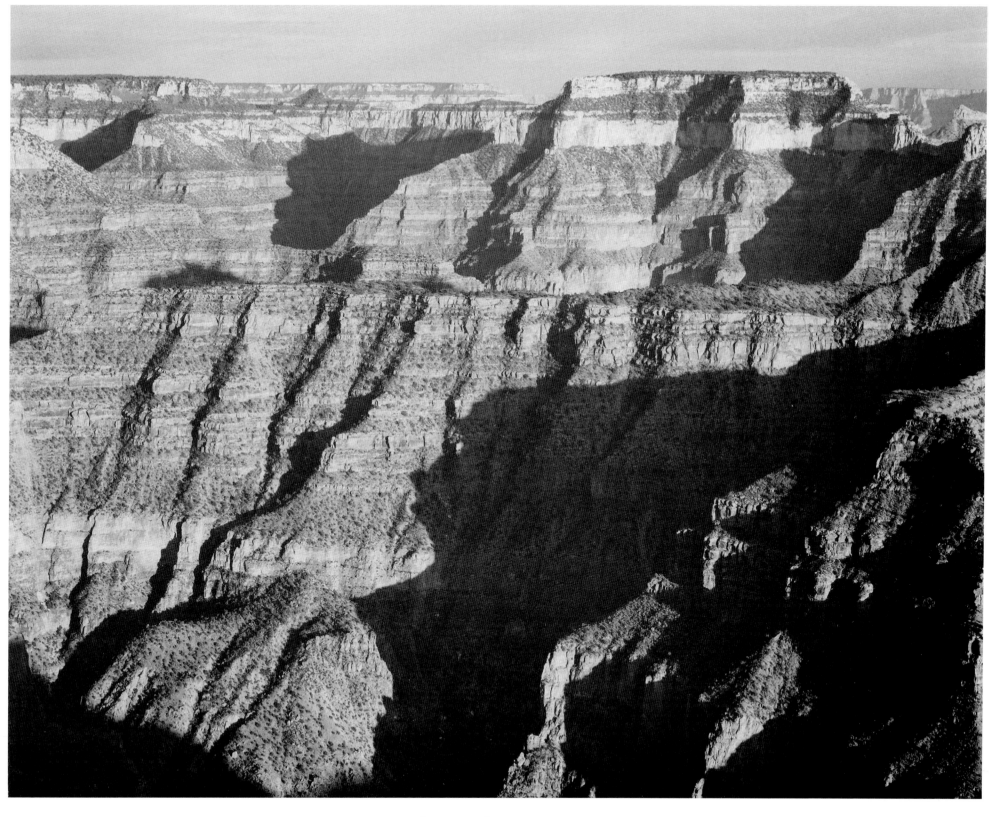

"Grand Canyon from N. Rim, 1941."

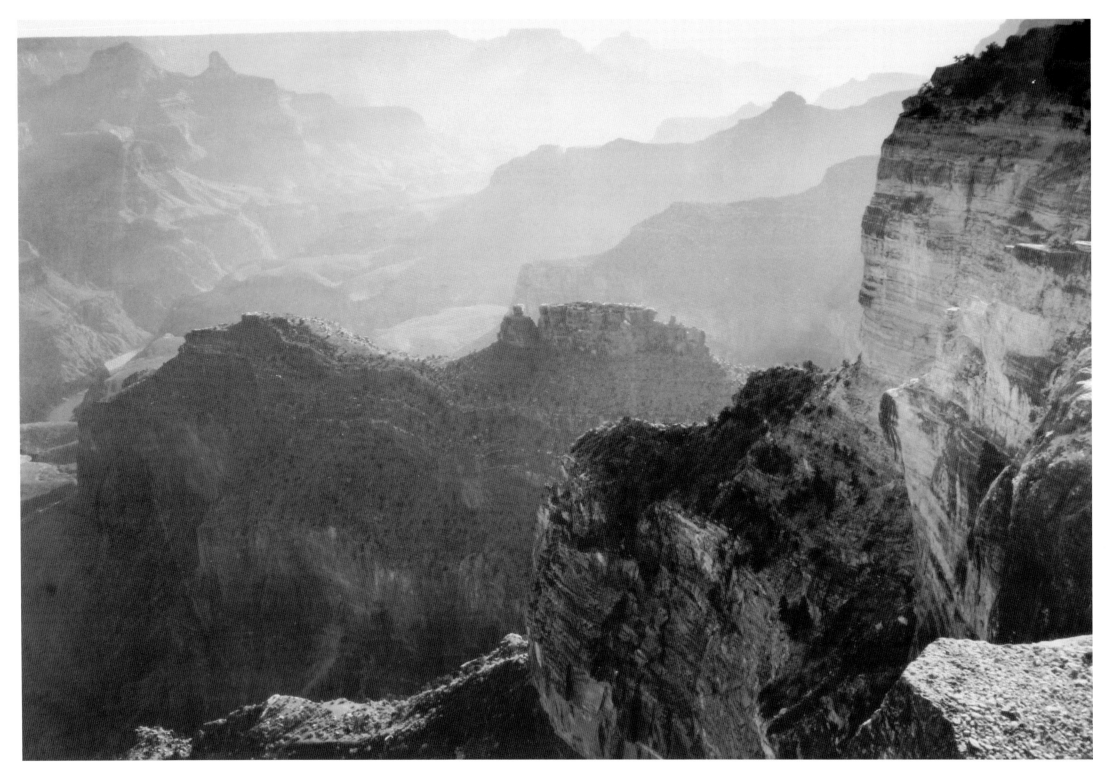

"Grand Canyon National Park."

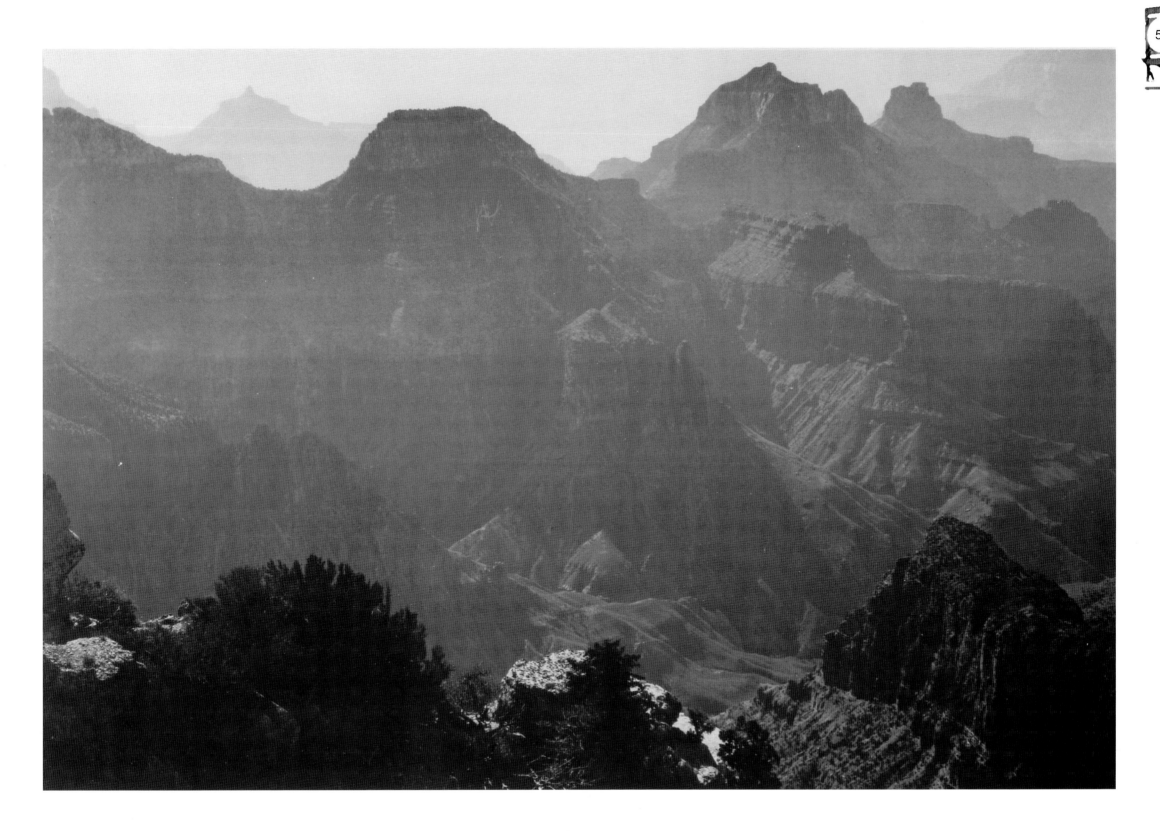

"Grand Canyon National Park."

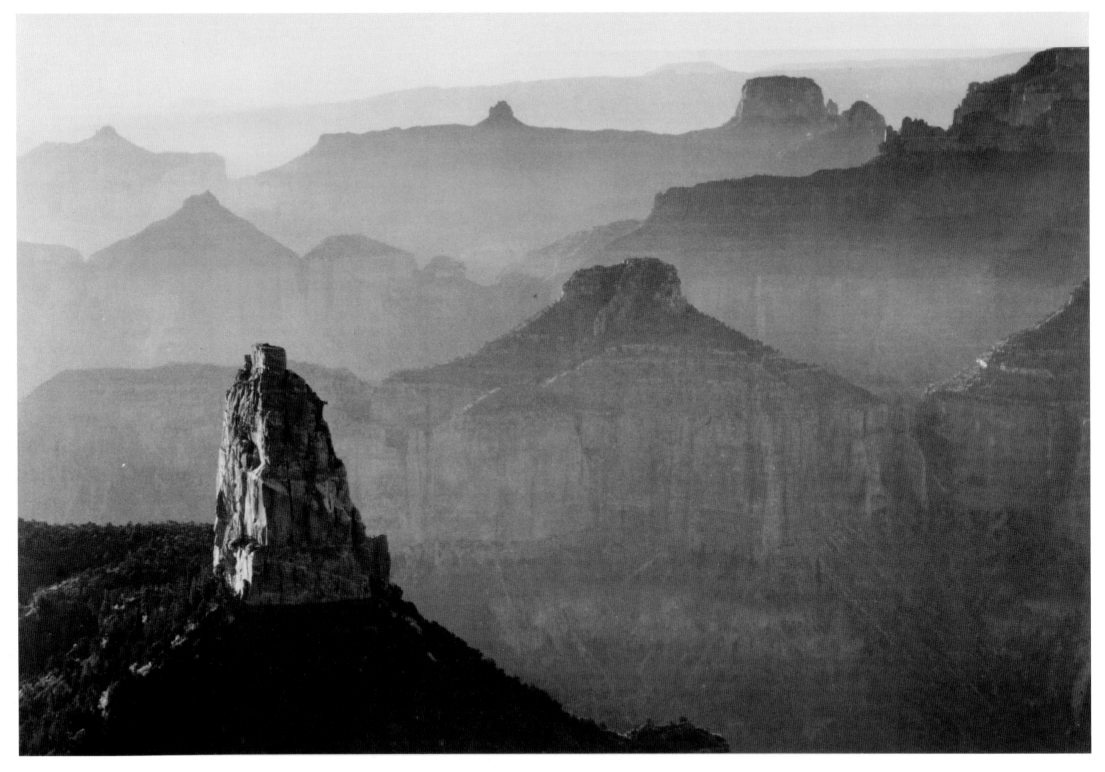

"Grand Canyon National Park."

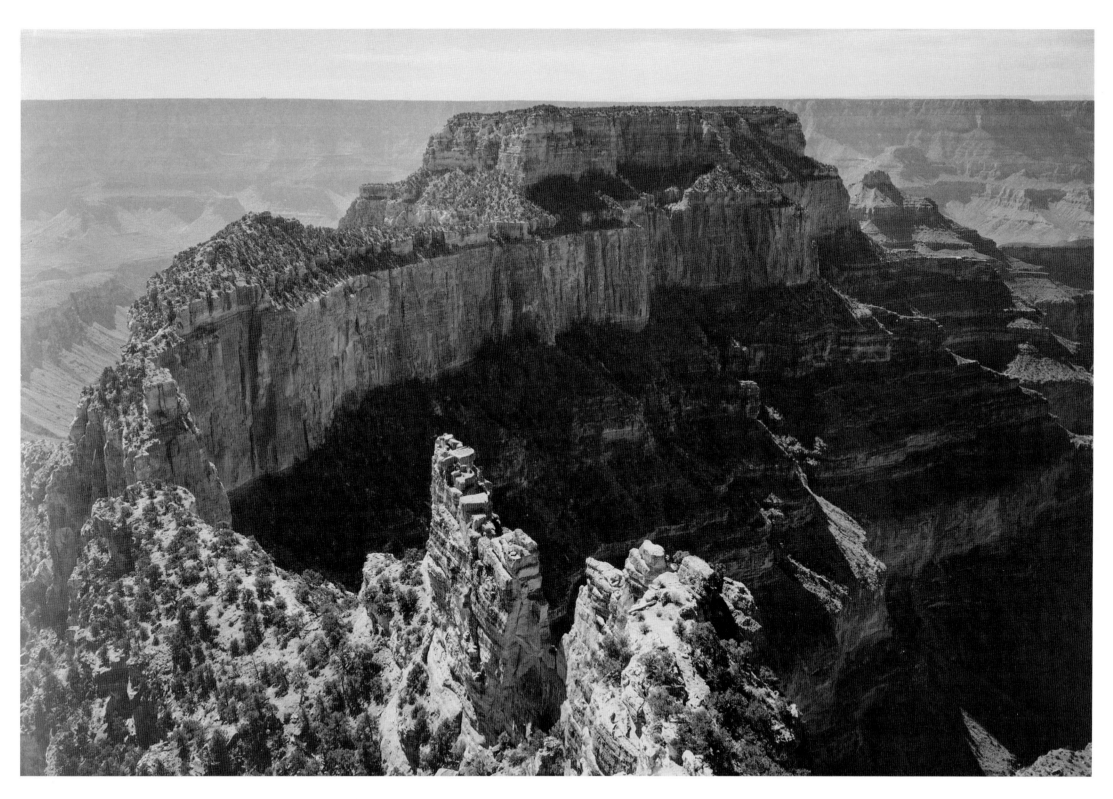

"Grand Canyon National Park."

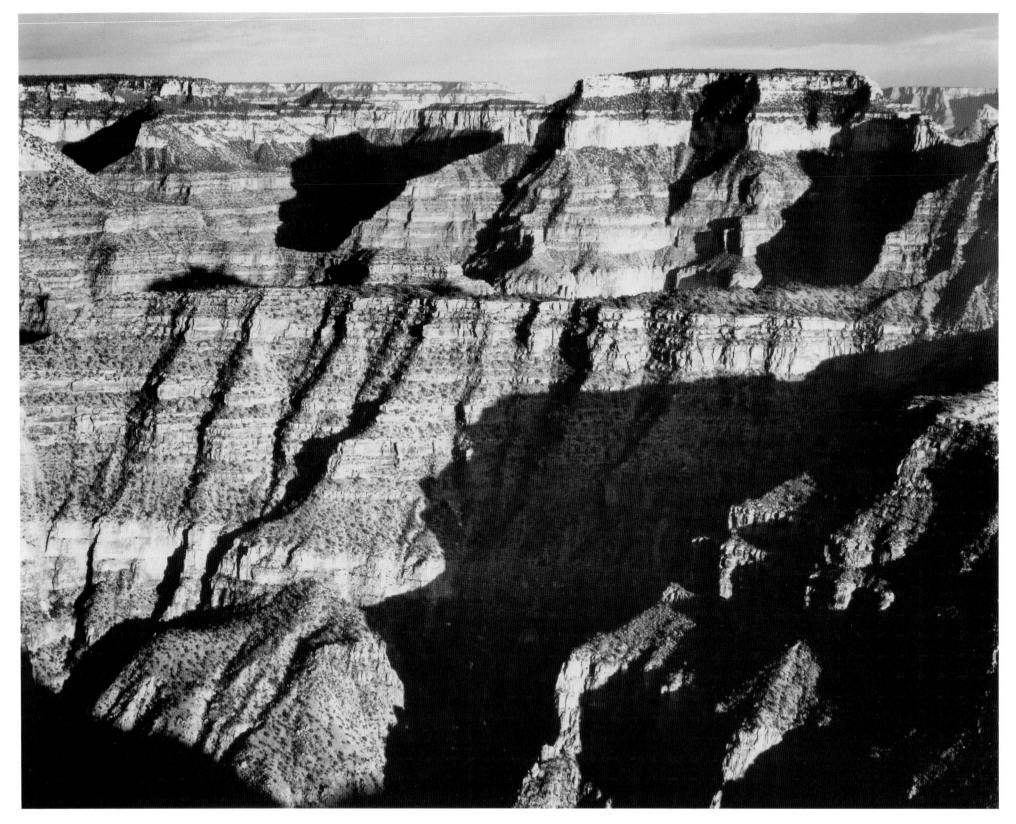

"Grand Canyon from N. Rim, 1941."

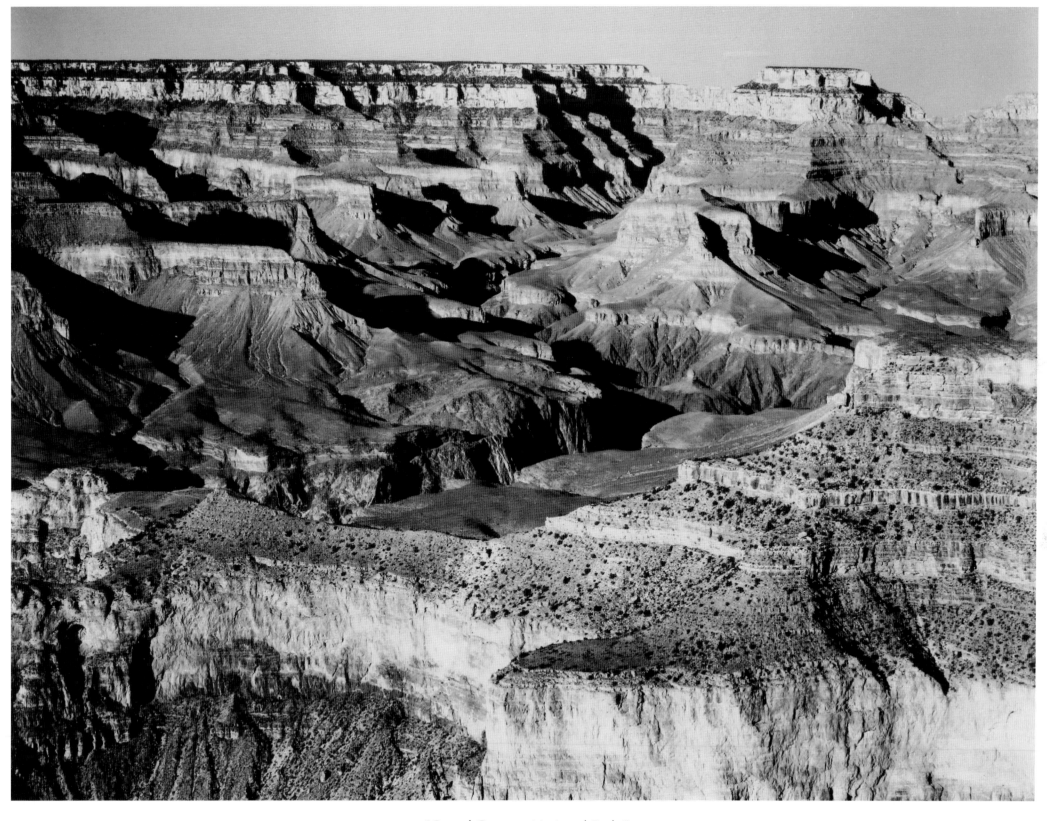

"Grand Canyon National Park."

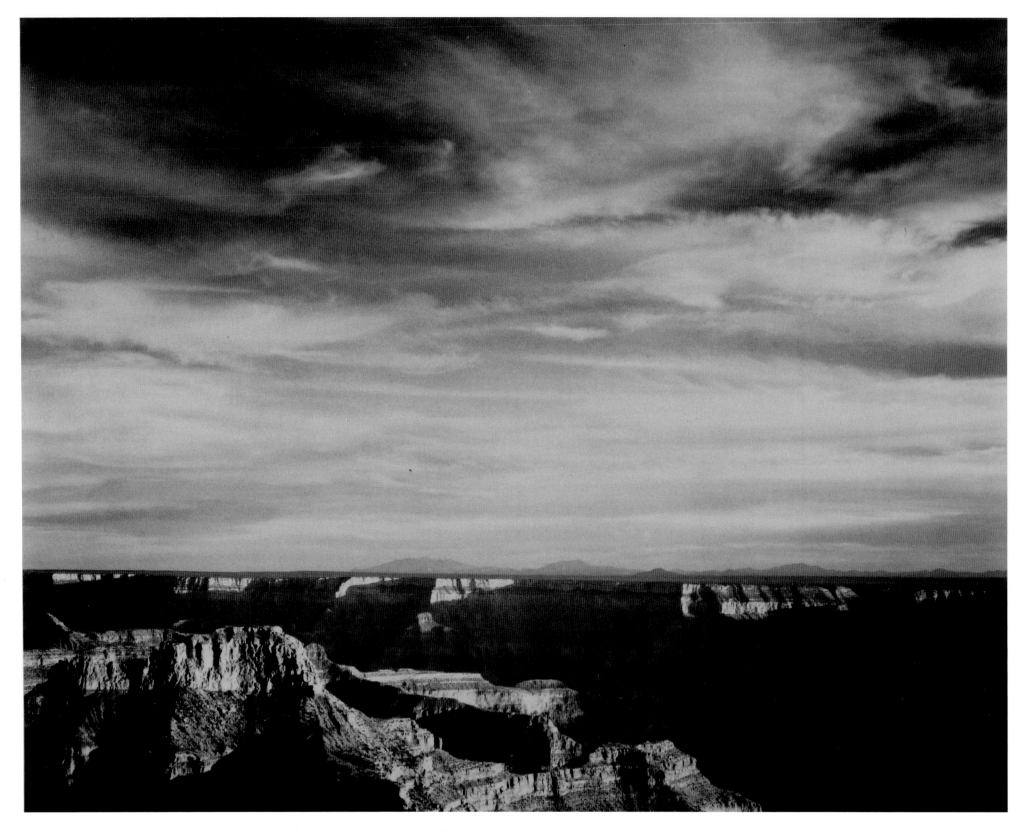

"Grand Canyon from N. Rim, 1941."

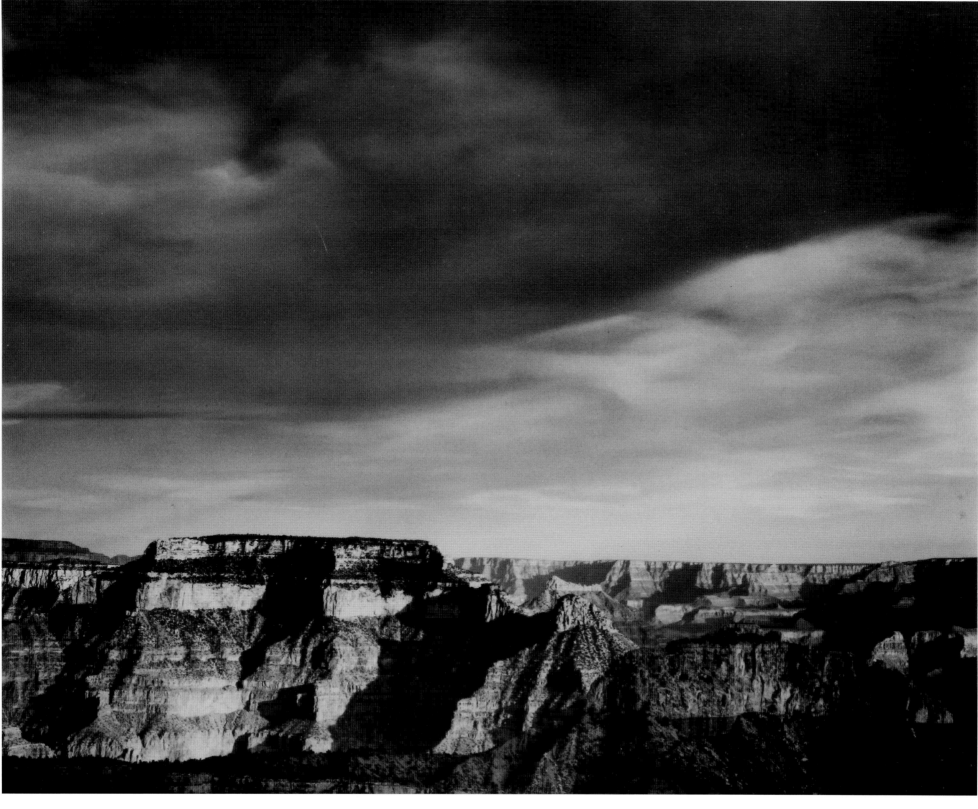

"Grand Canyon National Park."

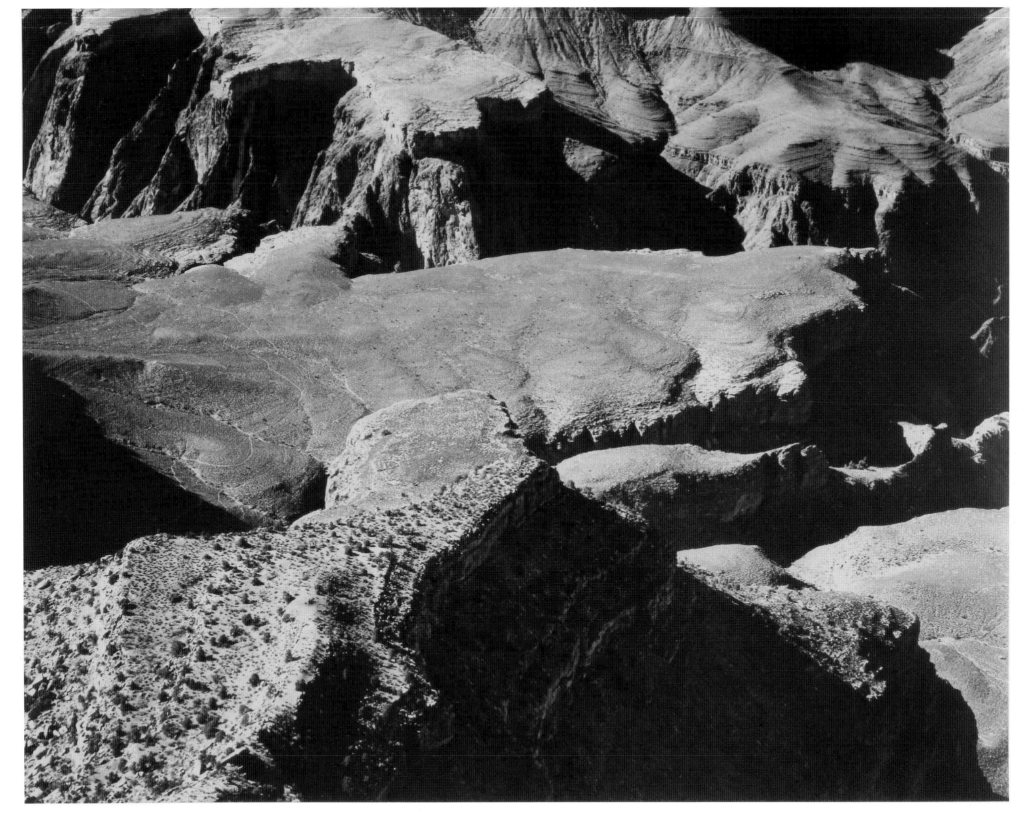

"Grand Canyon National Park."

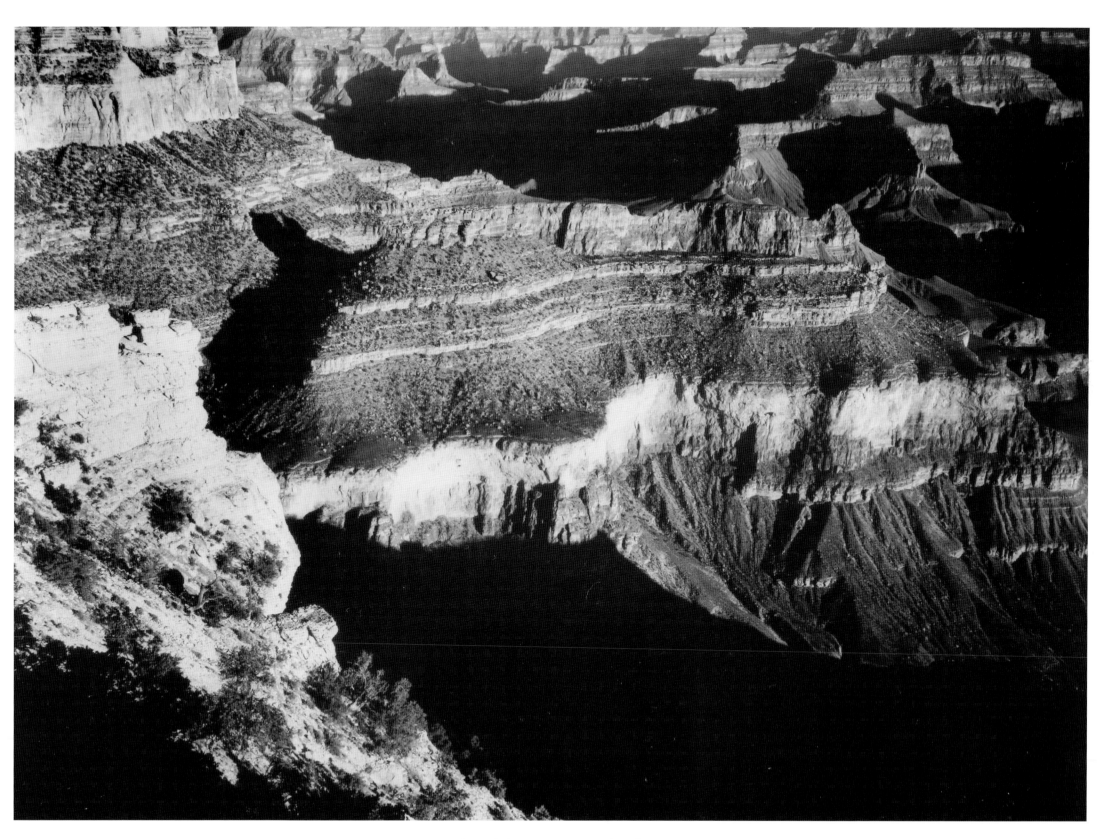

"Grand Canyon National Park."

INDIAN FARM NEAR TUBA CITY

Tuba City lies on Navajo land in Coconino County, Arizona. It lies within the Painted Desert on the western edge of the Navajo Nation. Ansel Adams photographed the area as part of his Mural Project for the National Park Service in the early 1940s. As part of the Mural Project Adams was also commissioned to photograph Native Americans and their lands. The Navajo still cultivate the arid land as they have for thousands of years and Adams captured their timeless quality.

Following the cancellation of the assignment, the photographs Adams had made for the Mural Project disappeared into the vaults of the Department of the Interior without being printed up as the intended murals. He did print up and sign smaller original prints and they were stored in Washington D.C. while the original negatives were sent for storage at Yosemite National Park. They were lost and largely forgotten for over forty years before being rediscovered and displayed for the first time.

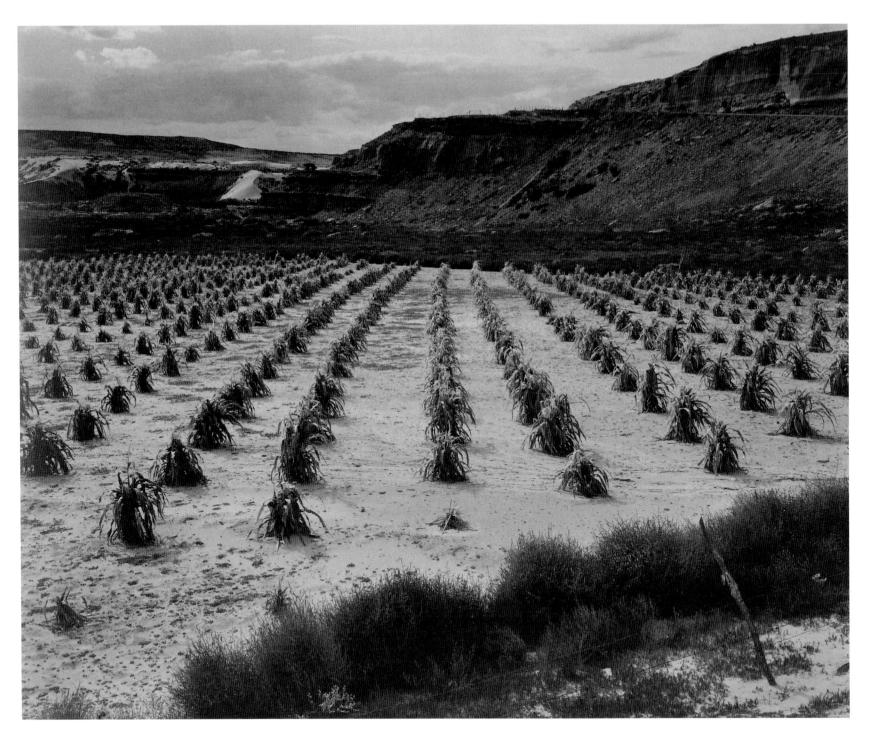

"Corn Field, Indian Farm near Tuba City, Arizona, in Rain, 1941."

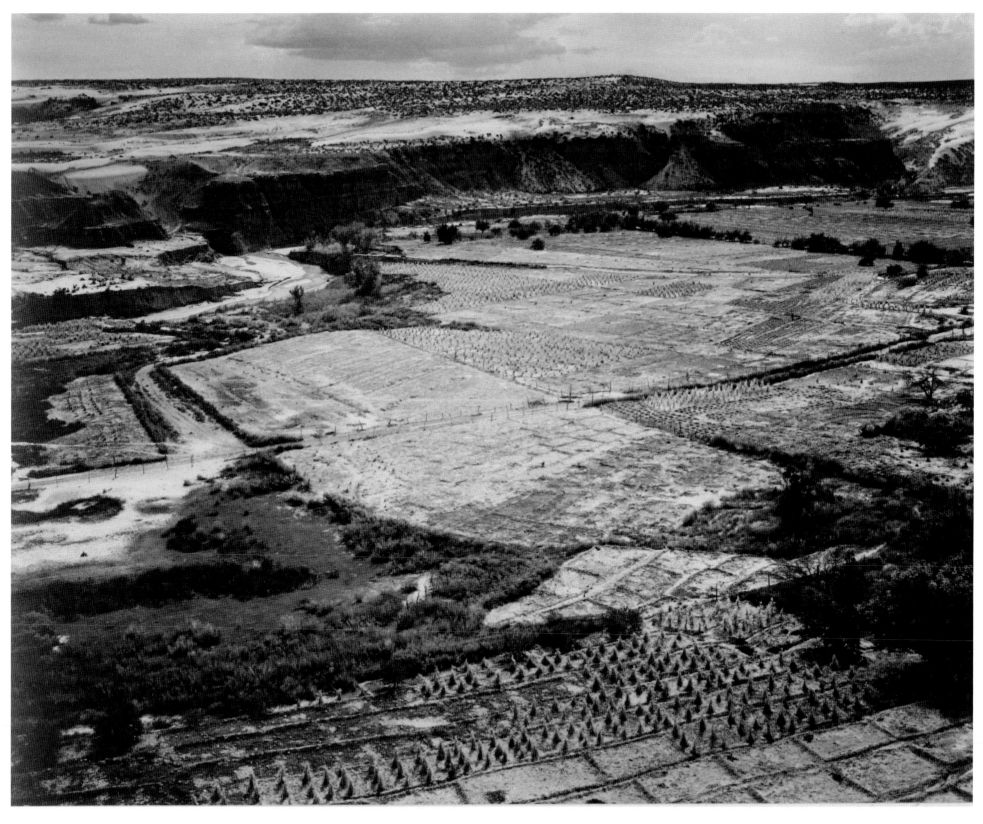

"Corn Field, Indian Farm near Tuba City, Arizona, in Rain, 1941."

SAGUARO NATIONAL MONUMENT

Saguaro National Monument near Tucson, in southern Arizona was established in March 1933 with a Presidential Proclamation by President Herbert Hoover. It was established to preserve and protect part of the Sonoran Desert, the Rincon Mountain area east of Tucson, and the Cactus Forest. In particular it was established to protect and preserve the unique Saguaro cactus, the first national park or monument designed specifically to protect a plant species from people who wanted to remove them and use the land for cattle instead. The monument was expanded in 1961, 1976, and finally in 1994, when President Bill Clinton established Saguaro National Park as the nation's fifty-second national park. The landscape and flora of Saguaro National Monument (as it used to be called) reflects the extreme nature of the environment: regular summer temperatures of over 100°F and under twelve inches of rain a year. The Saguaro cactus (*Carnegiea gigantea*) is the distinctive symbol of the area and only grows naturally in a small part of the Southwest. It can grow to about sixty feet tall with an eight-foot girth, and live for around 150 years; in fact, it is unlikely to grow an "arm" before the age of seventy-five. When it rains the plant visibly expands and then very gradually shrinks back as it utilizes the water. These extraordinary plants intrigued Adams and he made many studies of their extraordinary shapes and groupings. In many ways they epitomized the wilderness and environment he spent his life fighting to preserve—wild and wonderful examples of nature that serve no distinctive purpose for mankind other than to enrich our lives, but in themselves so fragile that they need legal protection from people who would rip them out and use the land for commercial purposes.

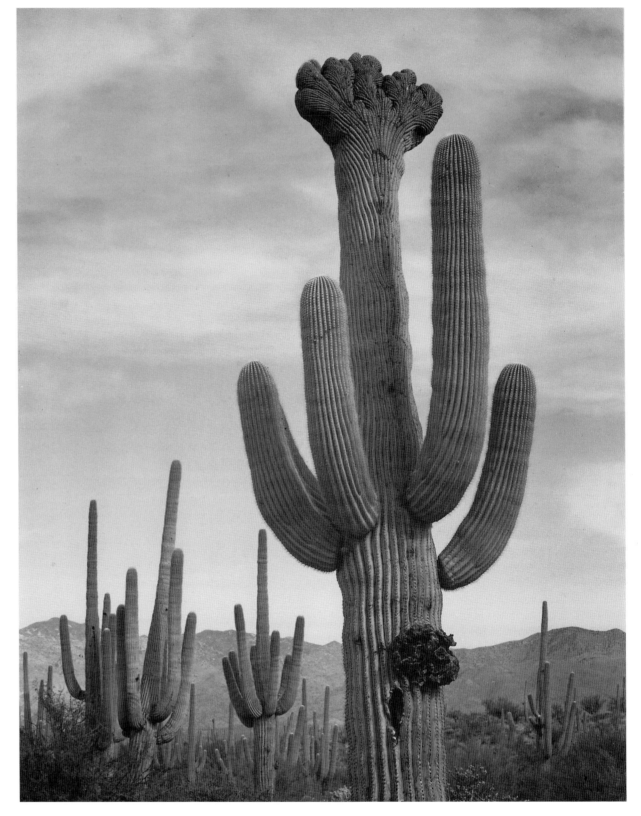

"Saguaros, Saguaro National Monument."

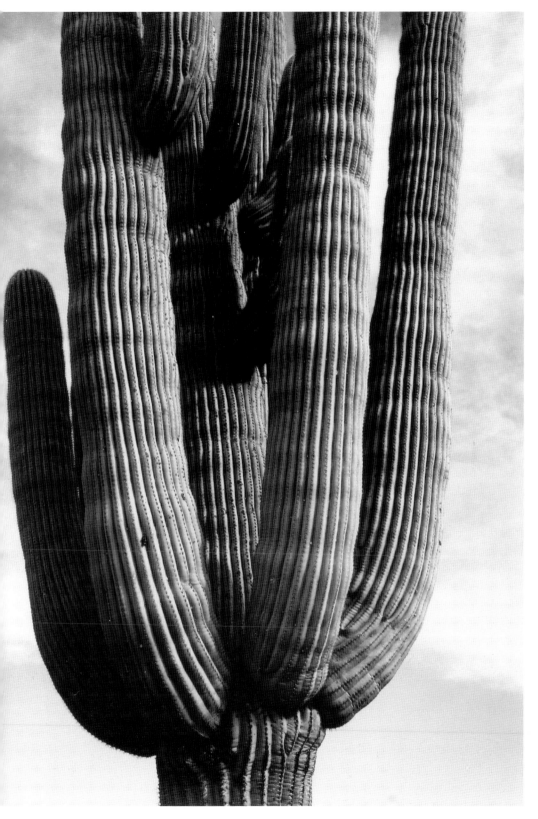

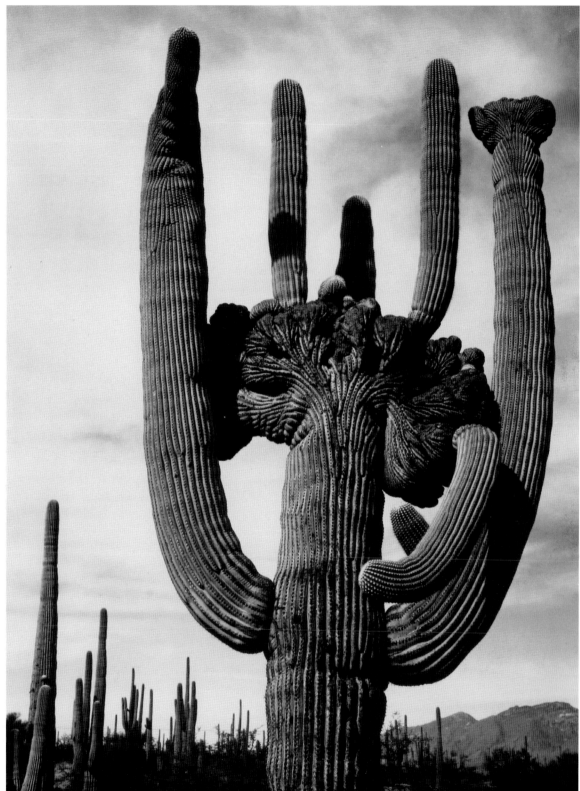

"Saguaros."

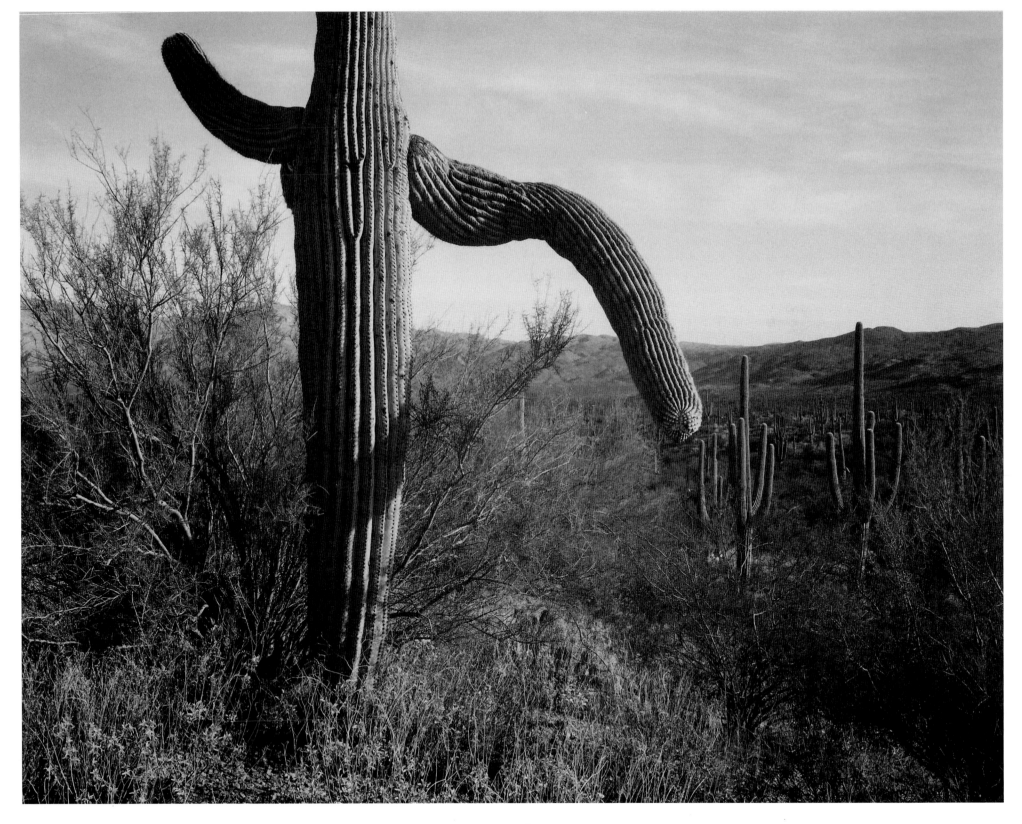

"Saguaro National Monument."

WALPI VILLAGE, FIRST MESA

The ancient sandstone and earth-built Hopi village of Walpi lies east of the Grand Canyon in Navajo Country in northwest Arizona. It was built in about 900 A.D. at the base of the mesa and centuries later relocated to a defensive position on a narrow finger 300 feet above the canyon floor on top of First Mesa in 1680 following the Pueblo Revolt against the Spanish. The pueblo has been lived in for over 1,100 years, making it one of the oldest continuously inhabited settlements in the United States. The homes are passed down through matrilineal clan lineage and the women hand plaster their own homes. The people here live as their ancestors did—without electricity or running water—making kachina dolls and fine polychrome pottery for tourists. Walpi is the mother village of eleven surrounding Hopi settlements.

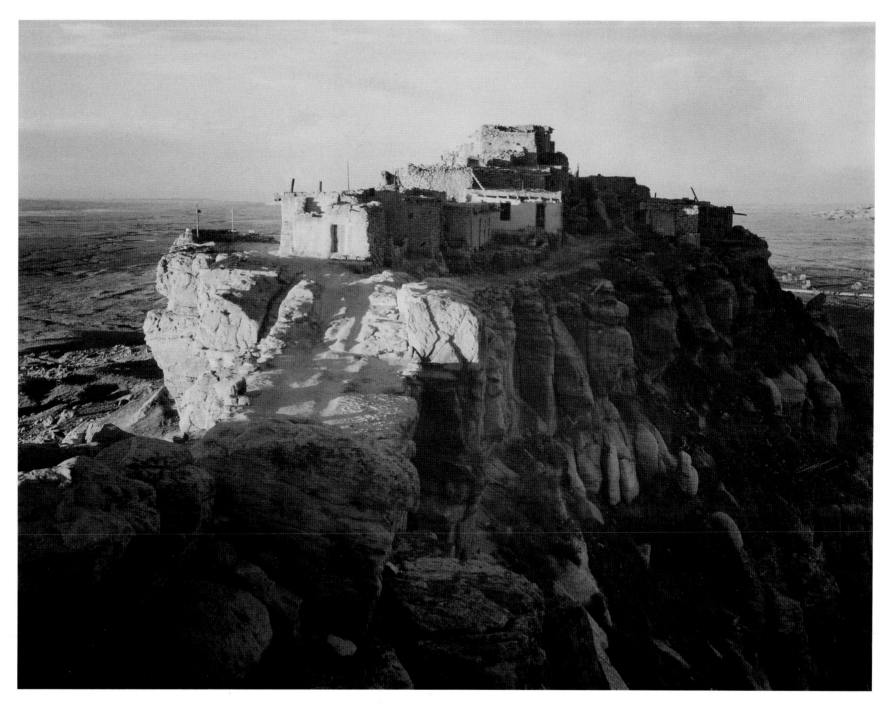

"Walpi, Arizona, 1941."

CALIFORNIA

DEATH VALLEY NATIONAL PARK

California was Ansel Adams home state and he loved it above all others. He was born and raised in San Francisco and spent the greater part of his life there, living among the sand dunes beside the Golden Gate Strait. In later life he sold the family home and moved with his wife Virginia to Carmel Heights where his purpose-built house overlooked the mighty Pacific Ocean. Adams loved the west coast of the United States with all his heart and battled fiercely all his life to preserve and conserve its natural wonders. He took his photographs to Washington D.C. as evidence to show politicians and businessmen of the beauties of the remote wildernesses that they would never otherwise have seen or begun to understand. That way he won over may skeptics who would otherwise have had no conception of what natural habitats they were consigning to the careless grasp of capitalism. Of all the great wildernesses Adams particularly loved Yosemite with its stupendous Half Dome, magnificent landscapes, and wonderous flora and fauna. To complete the magic he met and fell in love with Virginia there and together they spent many summers in the park at their family shop and gallery. It's interesting to note, that a photographer best-loved for black and white photography should say, "Yosemite Valley, to me, is always a sunrise, a glitter of green and golden wonder in a vast edifice of stone and space."

In February 1933 President Herbert Hoover declared Death Valley a National Monument—among other things this temporarily stopped prospecting and mining. This was Death Valley's status when Adams photographed it; indeed, it only became a national park in October 1994. In the early 1950s Adams collaborated with critic and writer Nancy Newhall to produce *Death Valley* (published 1954), the first of seven books together. He had first visited Death Valley in 1941 but it took him a while to truely appreciate and capture its unique grandeur and beauty, whose continually moving and shifting sand dunes change the shape of the landscape from one visit to another. Because of the brilliant quality of light and the sharply thrown shadows it presents considerable problems for the photographer—the shadows blank out into flat black areas with no subtle detail. Adams credited his friend and fellow photographer Edward Weston for opening his eyes to the vast wilderness with his subtle photographic studies of the desert. Weston had learned the hard way that the traditional yellow filter used for black and white photography in such conditions only produced a flat image. Removing the filter provided a much sharper photograph. Adams would typically spend the night in the desert sleeping on the 5 x 9-foot camera platform on top of his car, rise before dawn, drink a quick cup of coffee and finish last night's supper before taking his camera and tripod off across the dunes looking for the first beams of sunshine to pick out the details of the landscape. To deflect the extreme light levels and heat Adams painted his camera cases white.

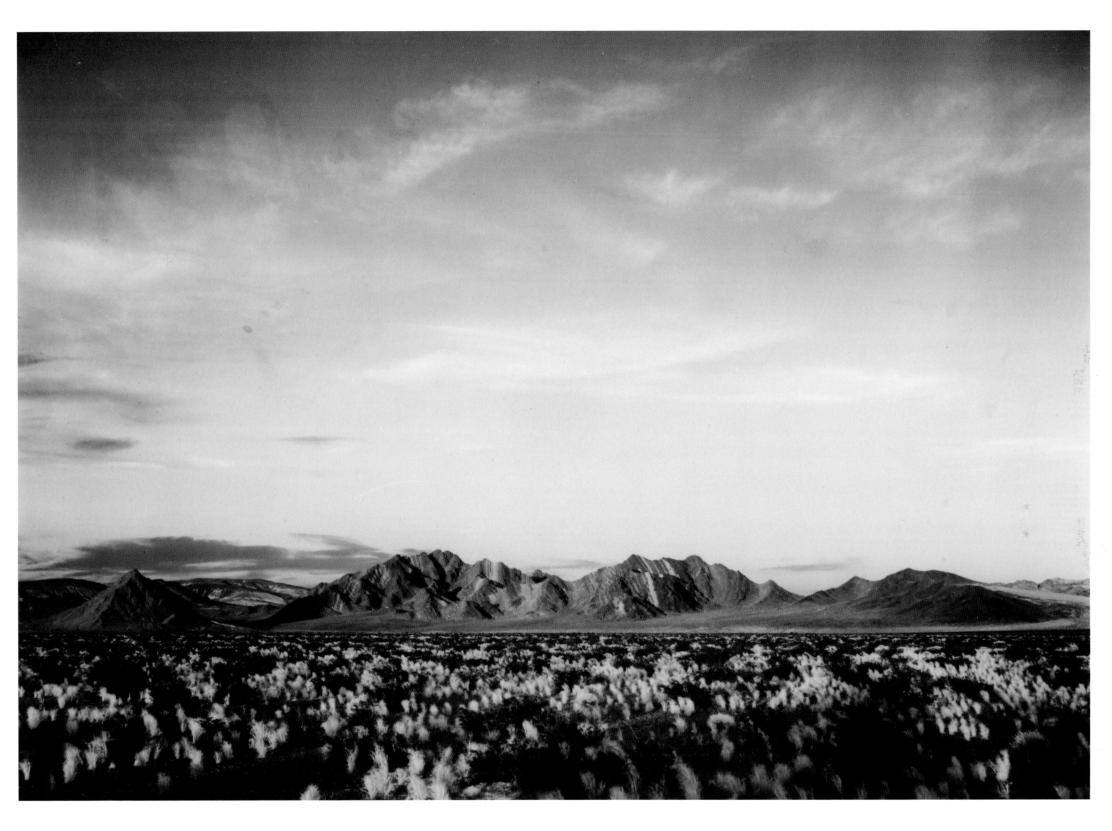

"Near Death Valley National Monument."

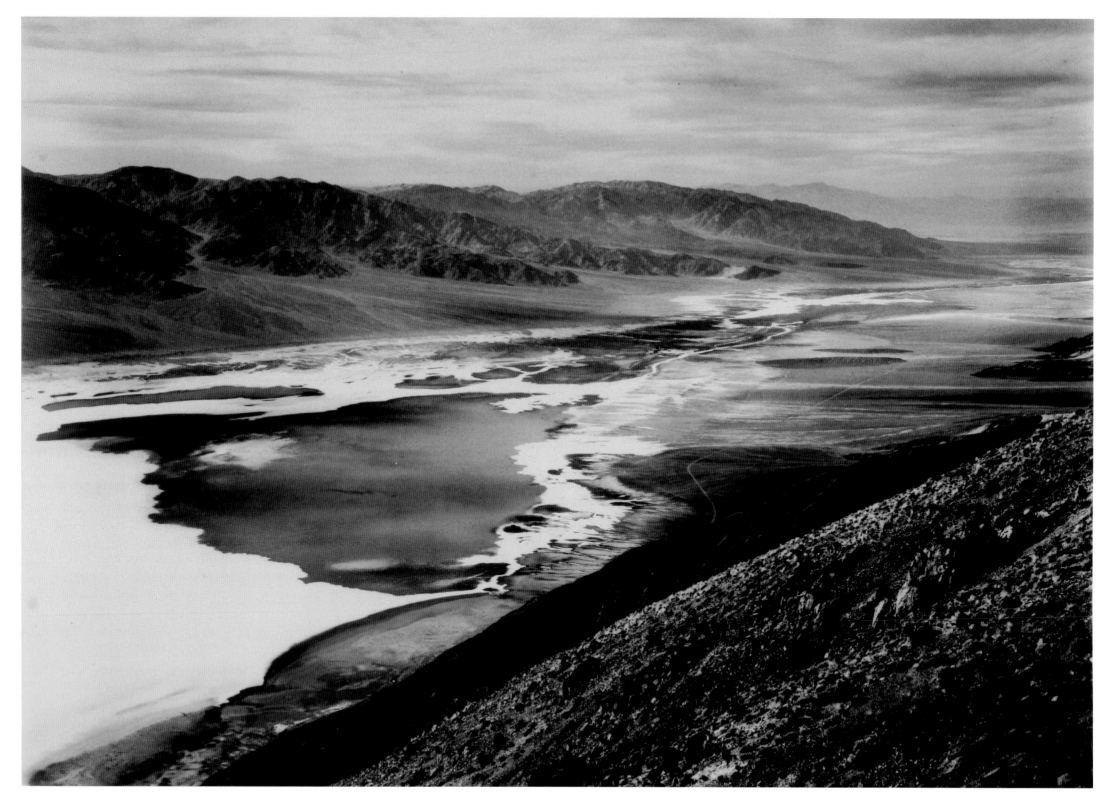

"Death Valley National Monument."

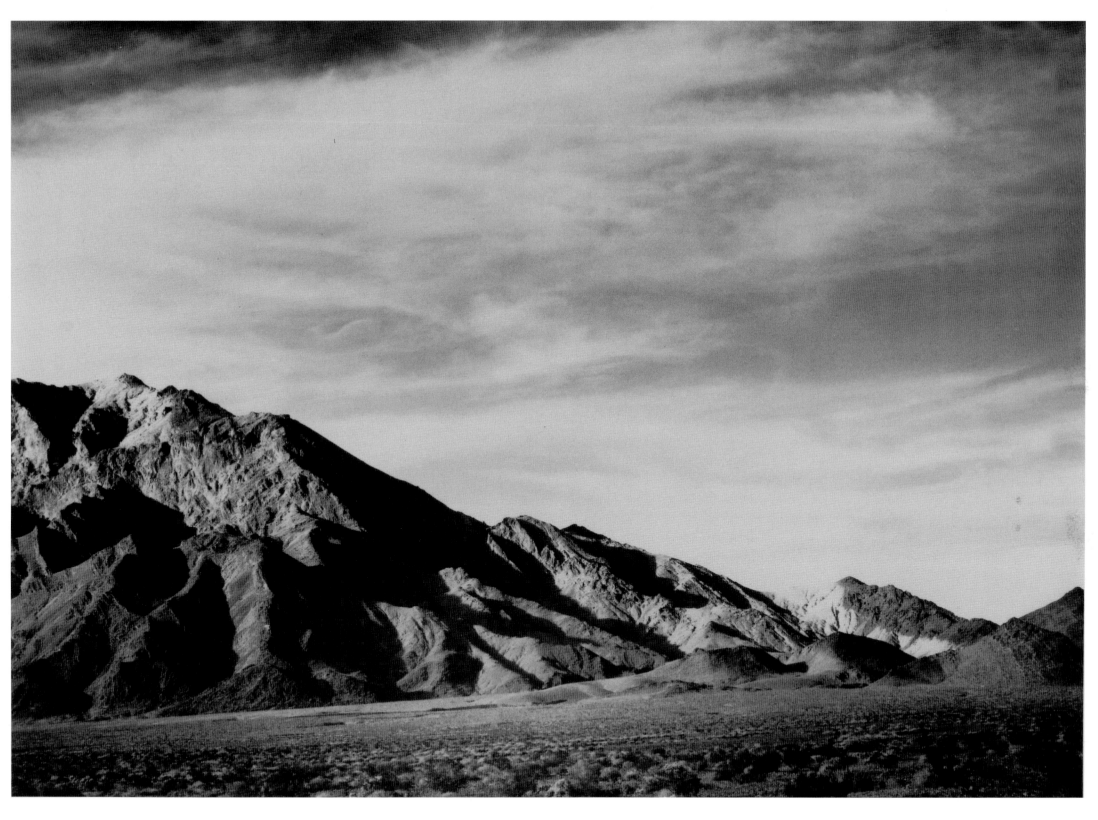

"Near Death Valley."

THE FIAT LUX COLLECTION

Fiat Lux means "Let there be Light" in Latin and is the motto of the University of California. In 1968 the university was set to celebrate its centennial, and as part of the events the president of the university, Clark Kerr, approached Adams to make a portrait of the life of the university. Adams was more than happy to accept, because the commission ensured his income for three years and meant he could turn down commercial work that he would otherwise have to take. The fee for the project was an impressive $75,000. The contract stated that he was "to capture and relate in photographs the appearance and spirit of the campuses and the activities of the University of California ... It is intended that your book will emphasize the prospective view for the university and that it will present a sense of the opportunities which lie ahead." Furthermore, that the university be presented as a "single entity that manifests itself in many ways and in many locations throughout the state." The project provided a stimulating artistic and intellectual challenge for Adams. He had to find the beauty in a range of subjects so he could express the university's diversity and its role in California's ever-expanding economy. In 1966, the university comprised nine campuses and numerous research stations scattered across the state—as well as around 88,000 enrolled students plus hundreds of academic staff and researchers. He didn't let the enormity of the project daunt him; instead, he said, "To look at the University of California is to look at California itself—its land, its people, and their problems—into the civilization rushing towards us from the future." He also agreed to oversee all aspects of the book's production, prepare an accompanying narrative (from his long-time collaborator Nancy Newhall), and lay out and design the book. During World War II the economy of the United States expanded enormously with huge resources poured into research and new technologies—such as aerodynamics, computing, atomic energy, and polymer sciences. The University of California was at the epicenter of this and as a result attracted some of the brightest minds and leading thinkers in their fields. This was what Adams set out to celebrate in *Fiat Lux*.

"Tower of Masks, UCLA, 1966."

"Class Change from the Top of the Old Physics Building, Royce Hall in Background, October 1966."

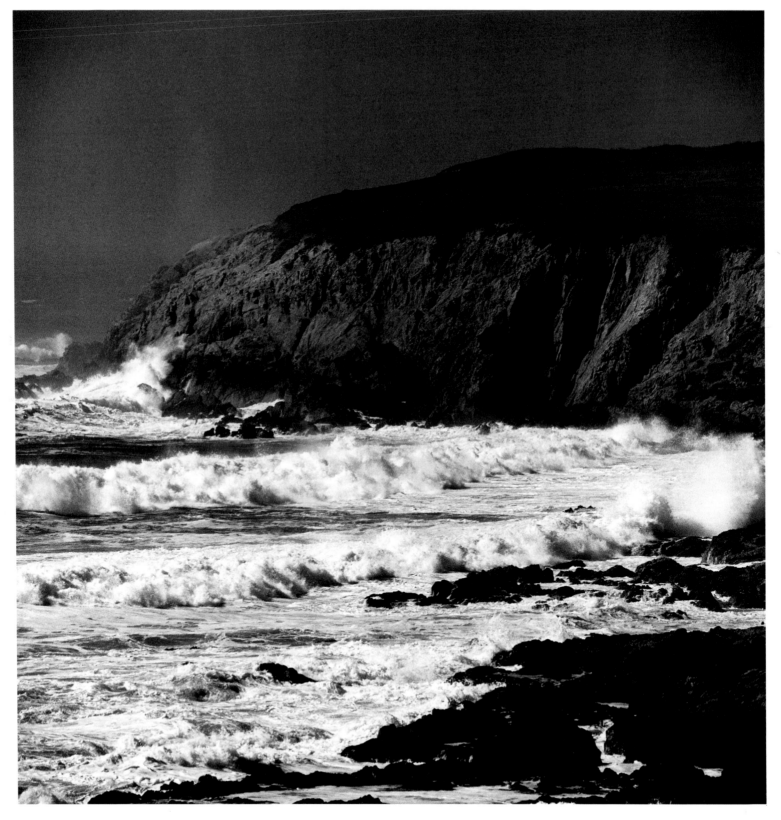

"Surf and Rocks, near Bodega Station, September 1966."

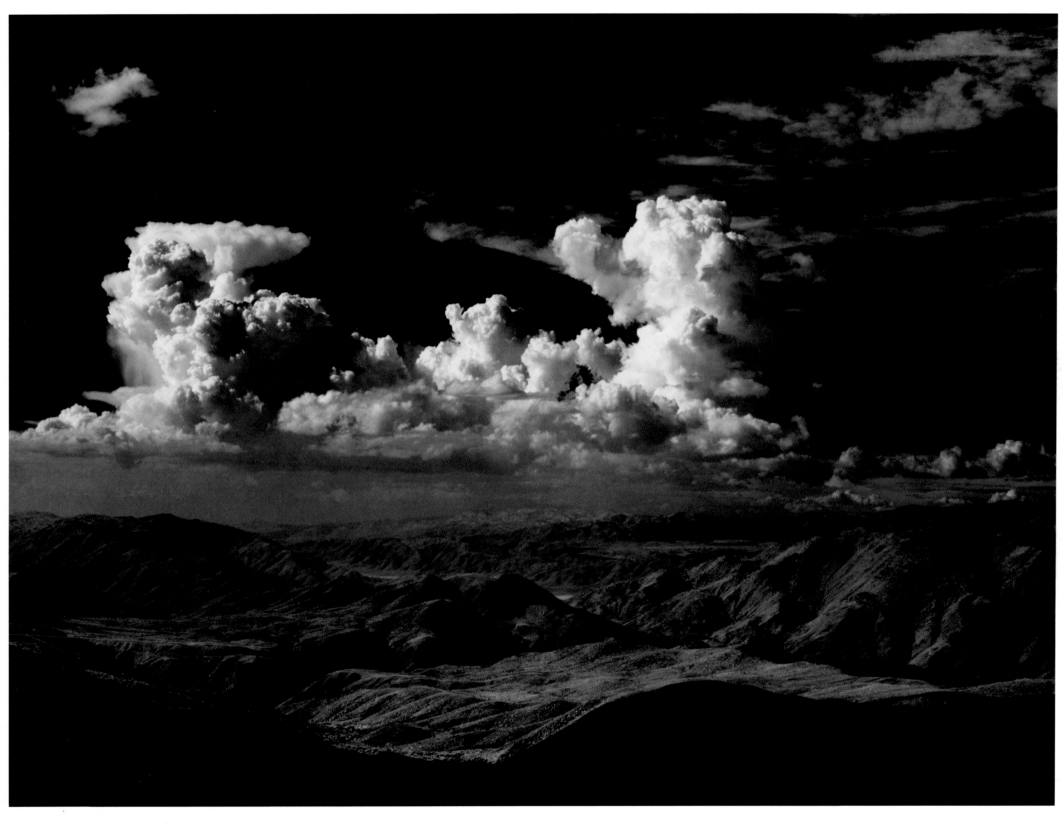

"Clouds over the Anza-Borrego Desert, c. 1966."

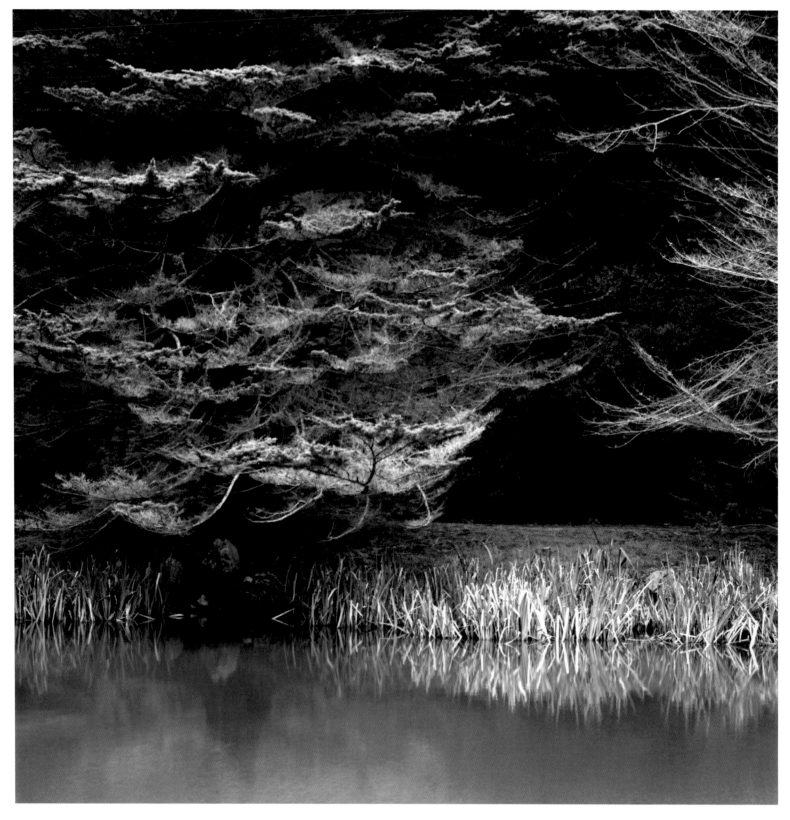

"Water and Trees near UC San Francisco, April 1966."

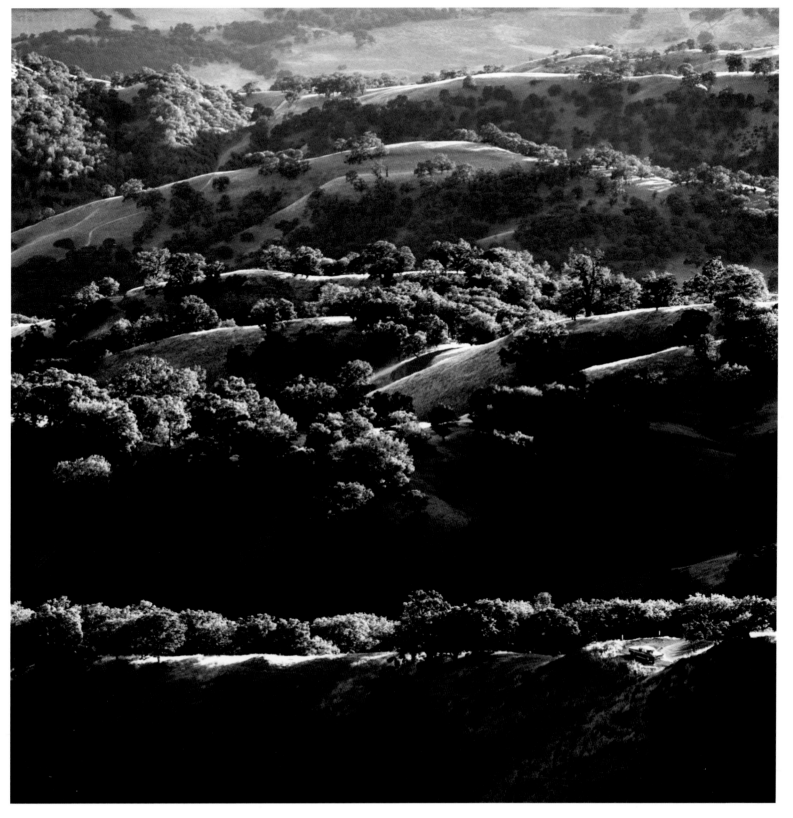

"Untitled, 1960–70."

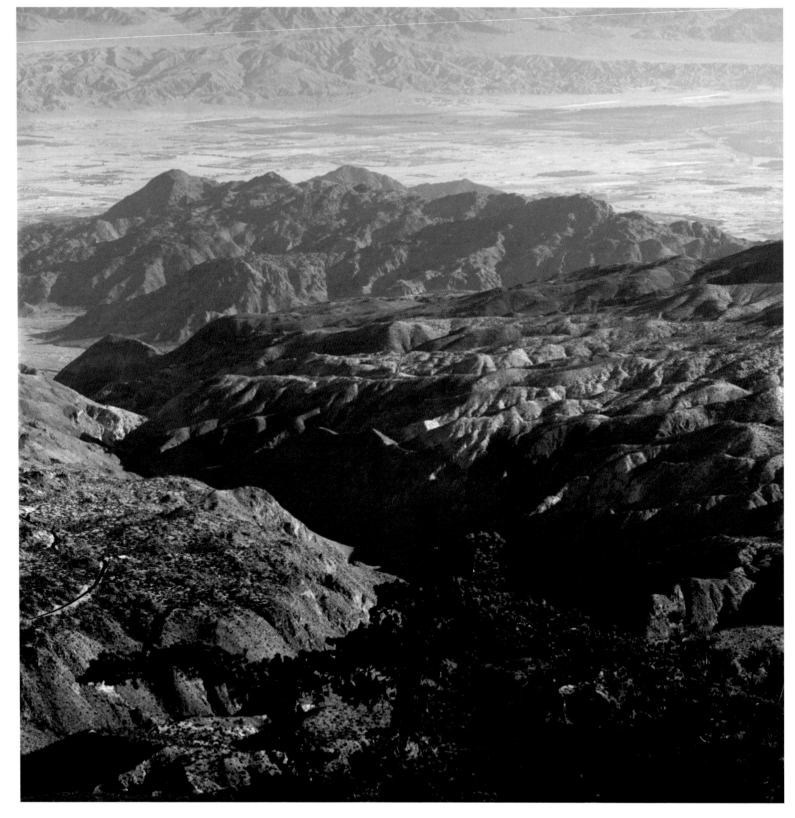

"Deep Canyon Desert Research Station (UCR) from Santa Rosa Mountains Road, November 1965."

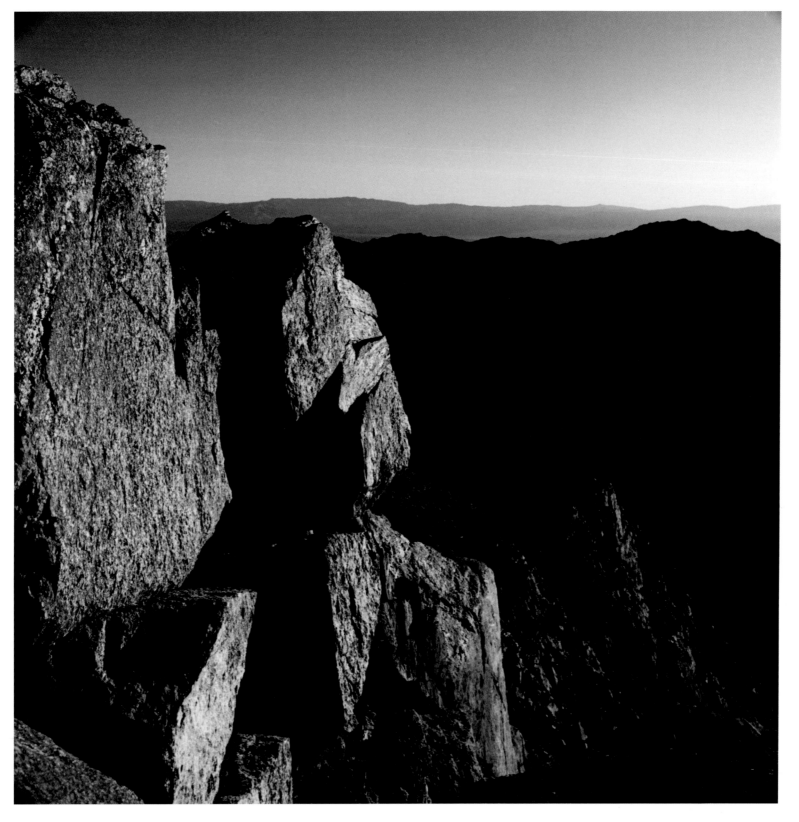

"Deep Canyon Desert Research Station, Rock Configurations from Second Rim Point, November 1965."

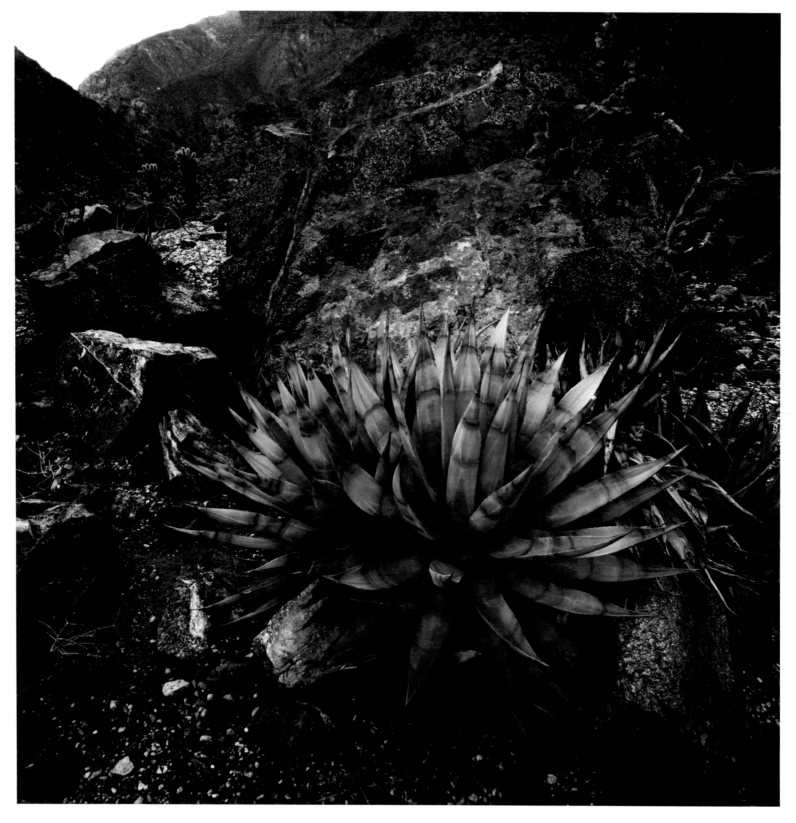

"Agave in Canyon, Deep Canyon Desert Research Station, November 1965."

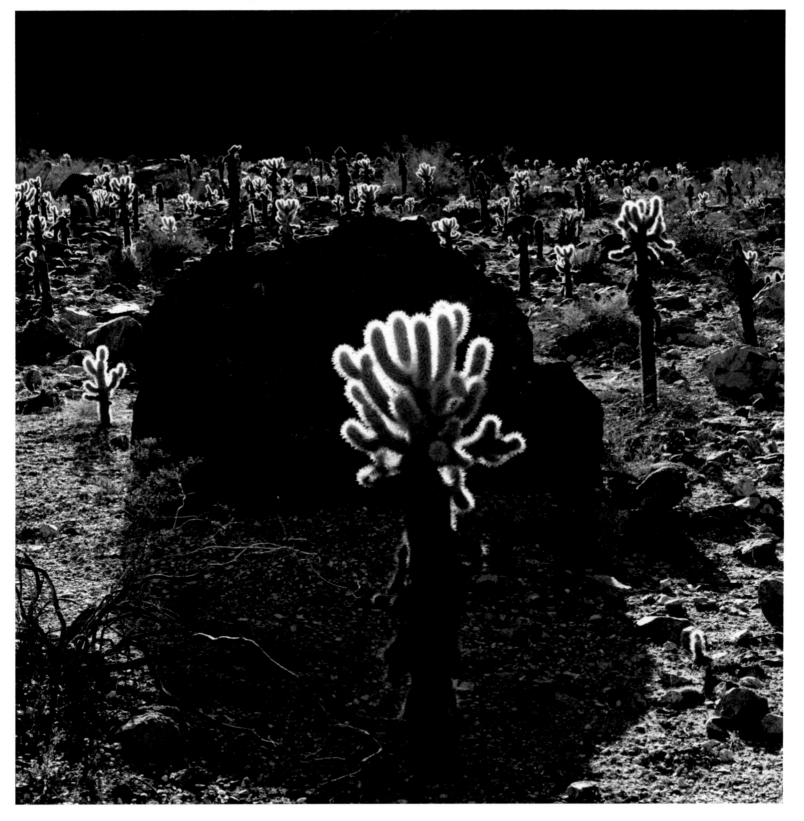

"Deep Canyon Desert Research Station, Chollas, November 1965."

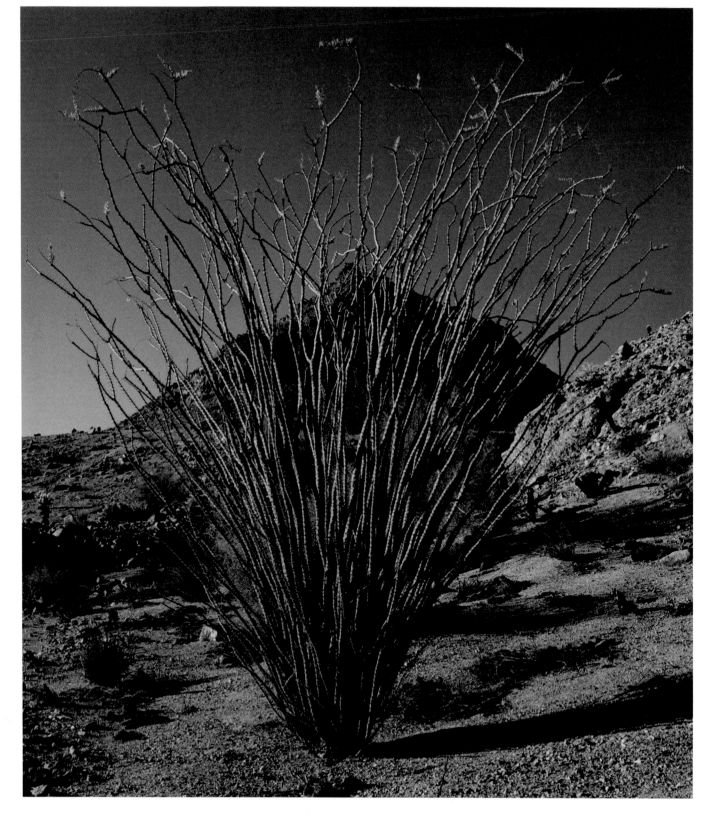

"Deep Canyon Desert Research Station (UCR) from 2nd Lookout on Rim, Detail of Desert Bush, November 1965."

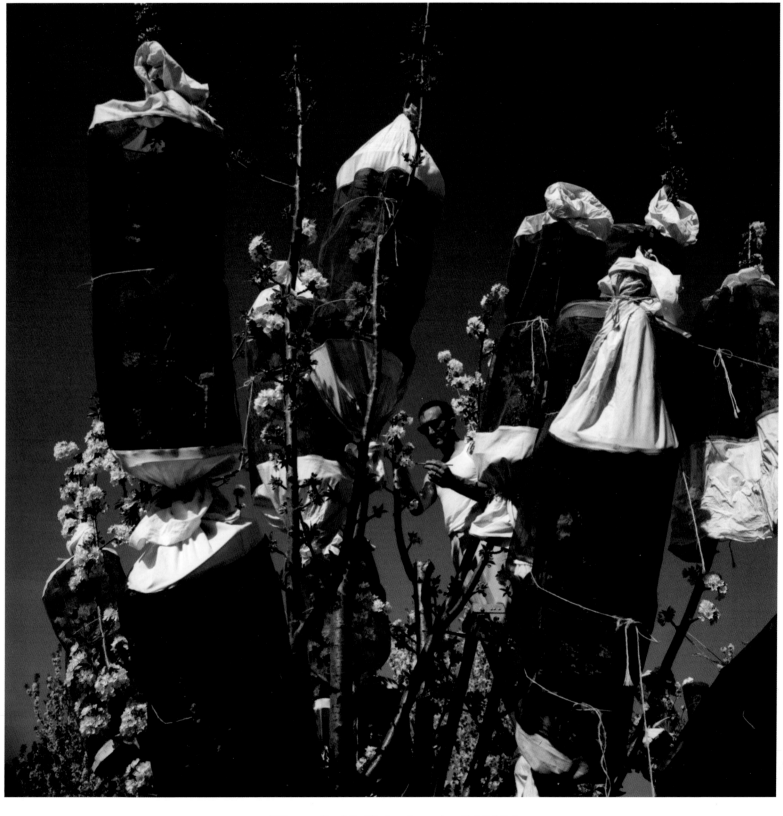

"Controlled Pollinization, April 1966."

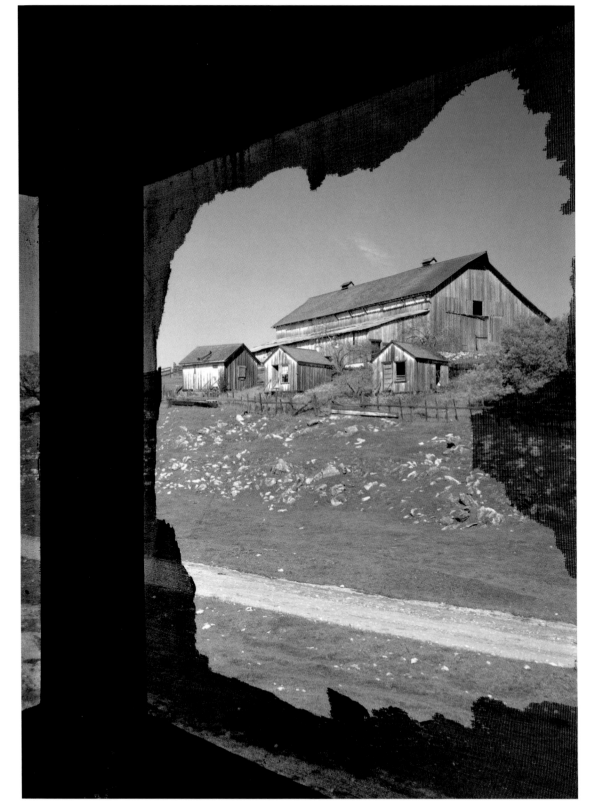

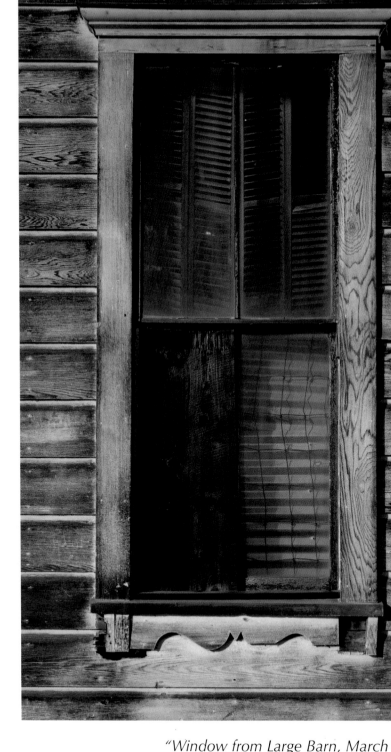

"Barn through Broken Screen of Old Cookhouse, March 1962."

"Window from Large Barn, March 1962."

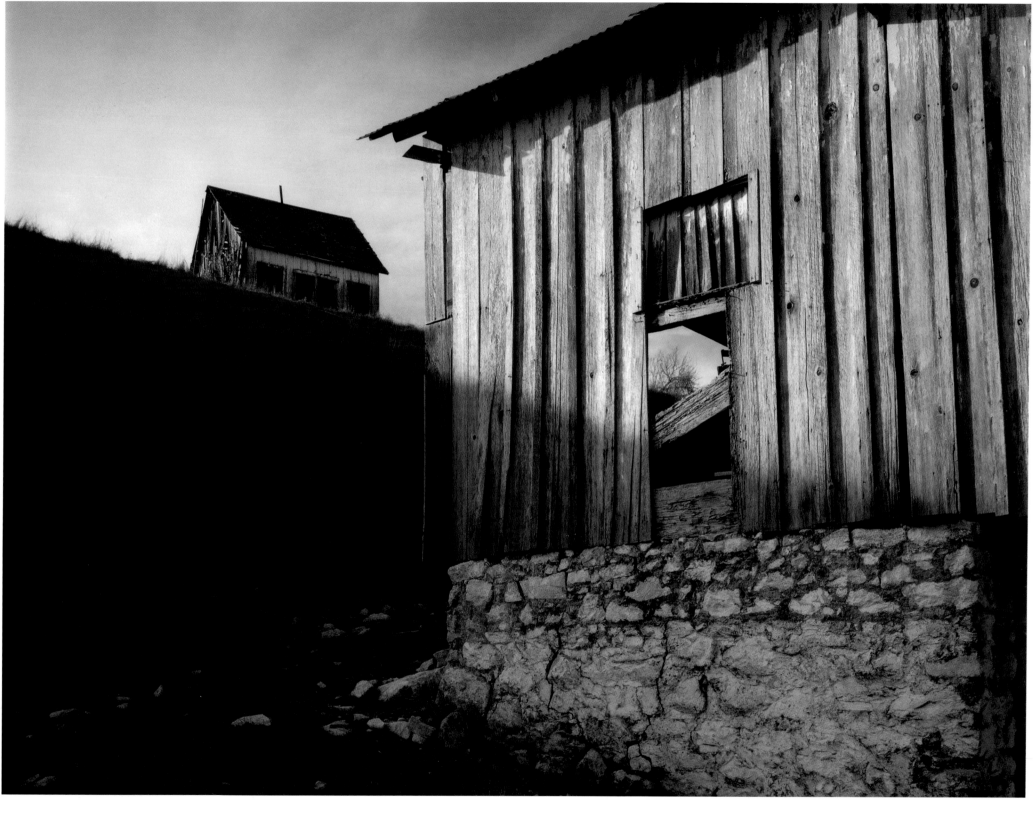

"Barn and Stonework, March 1962."

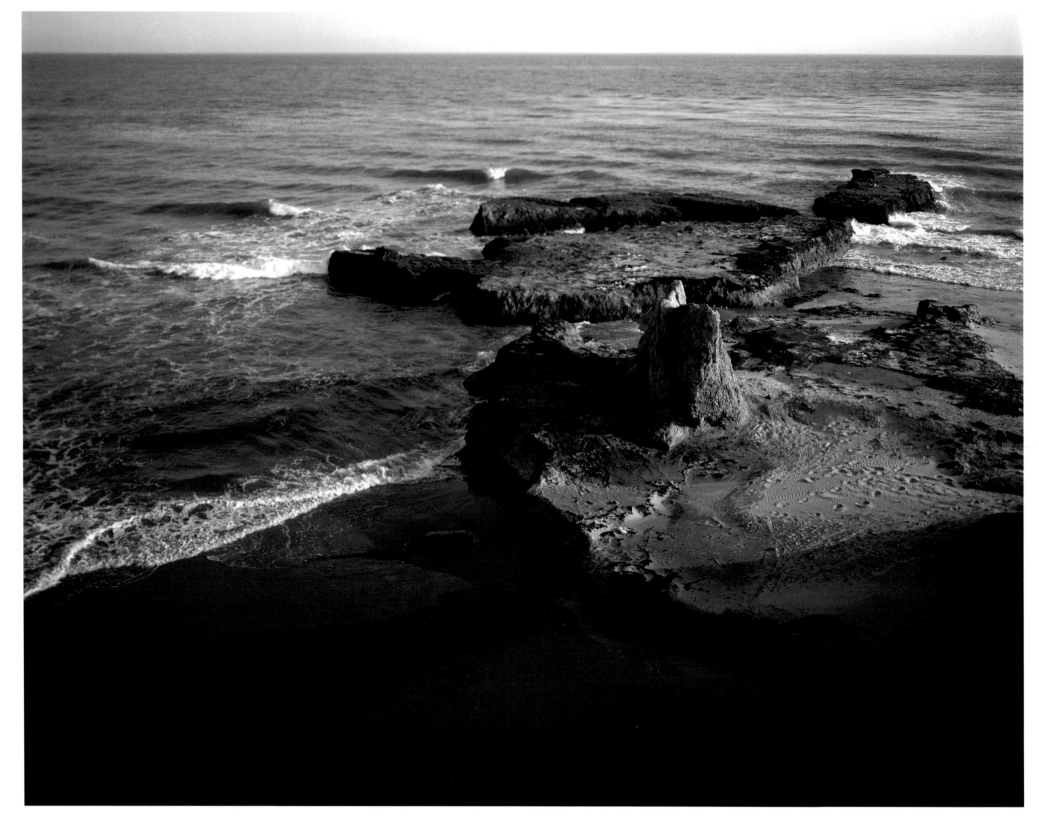

"Untitled, February 1966."

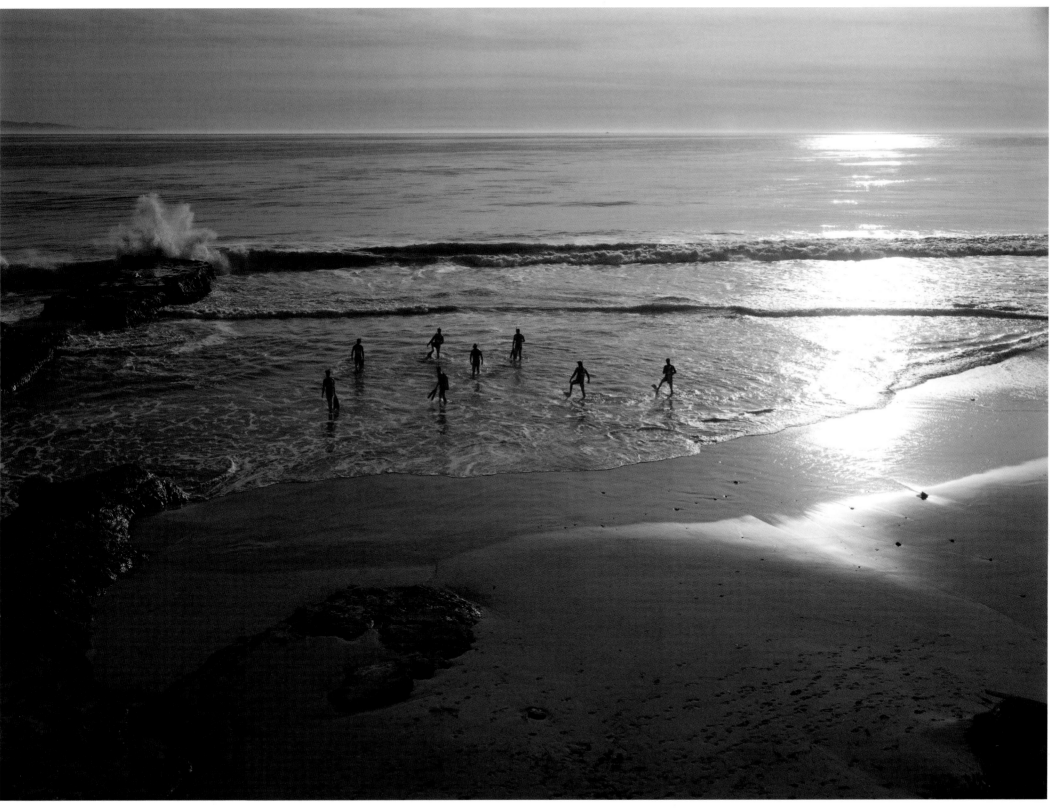

"Scuba Diver Class, U.C. Coast, December 1966."

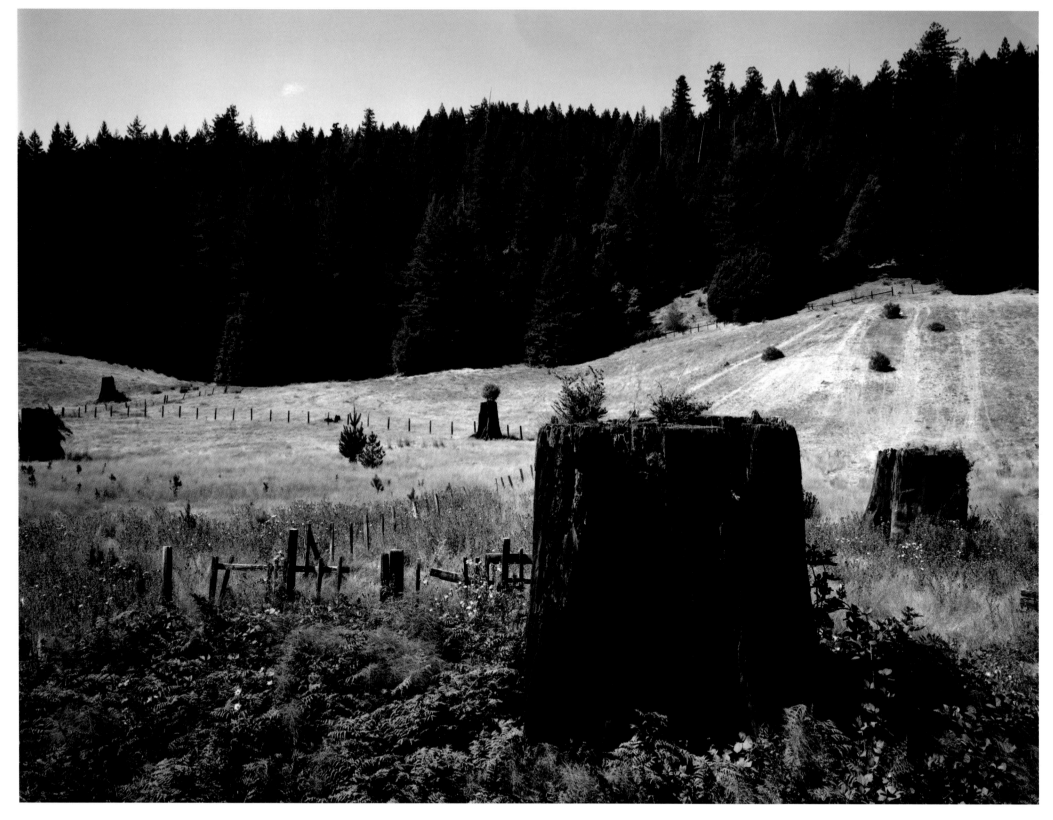

"Redwood Stumps, Reclaimed Land, Northern California, August 1966."

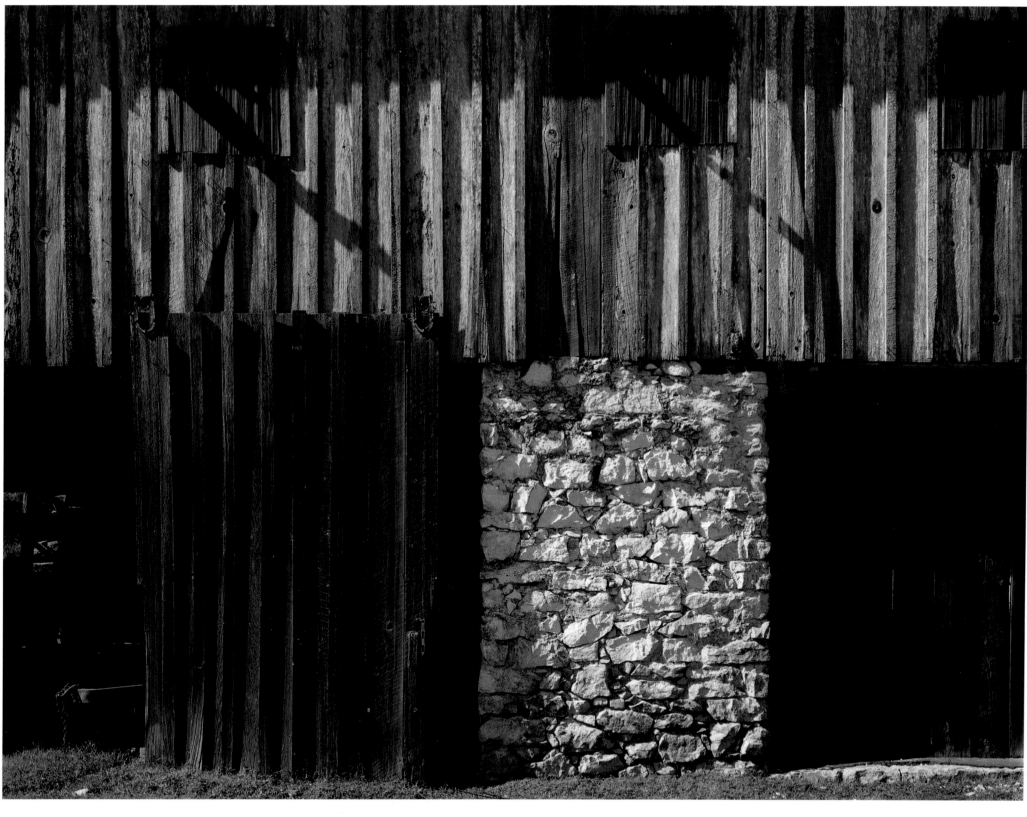

"Barn and Stone Work, March 1962."

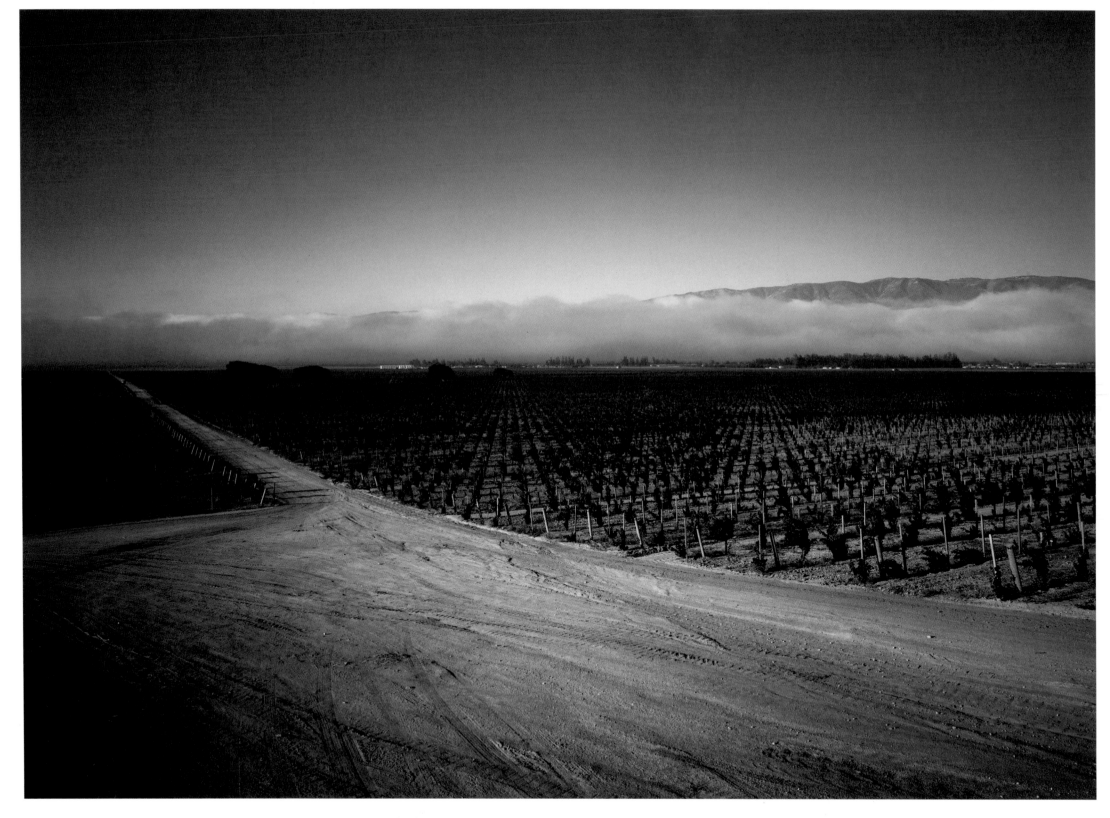

"Paul Masson Vineyard at Soledad from Hill to North, Fog before Distant Santa Lucia Mountains, August 1966."

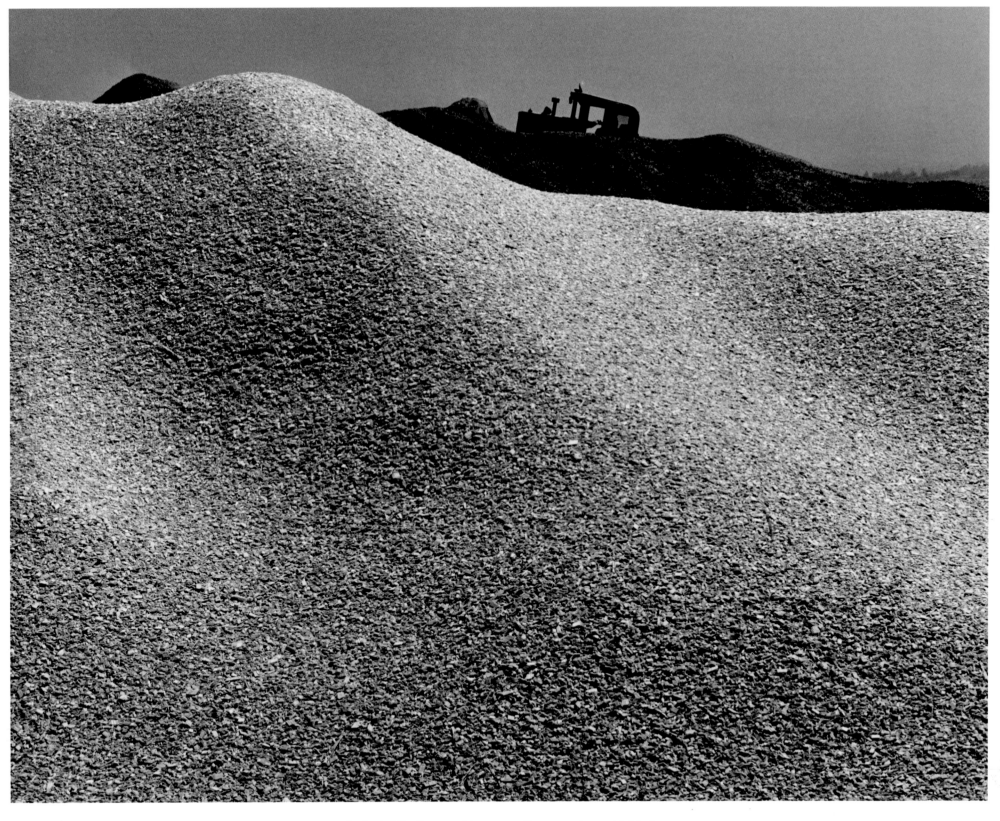

"Pulp Mill, Crown-Simpson Corporation, 1963."

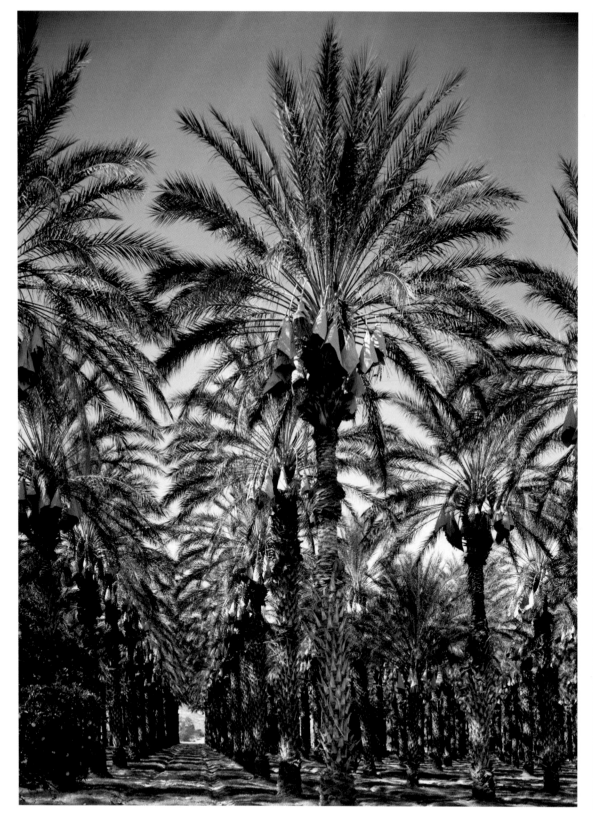

"Palm Trees, Vertical near Cathedral City, January 1966."

"Bell Tower, Trees, December 1966."

"Bell Tower, Pampas Grass, December 1966."

"Sather Tower Trees from Plaza, 1964."

"Geology Class with Dr. Eaton at Joshua Tree National Monument, December 1966."

"Moonrise from near Residence Halls, November 1966."

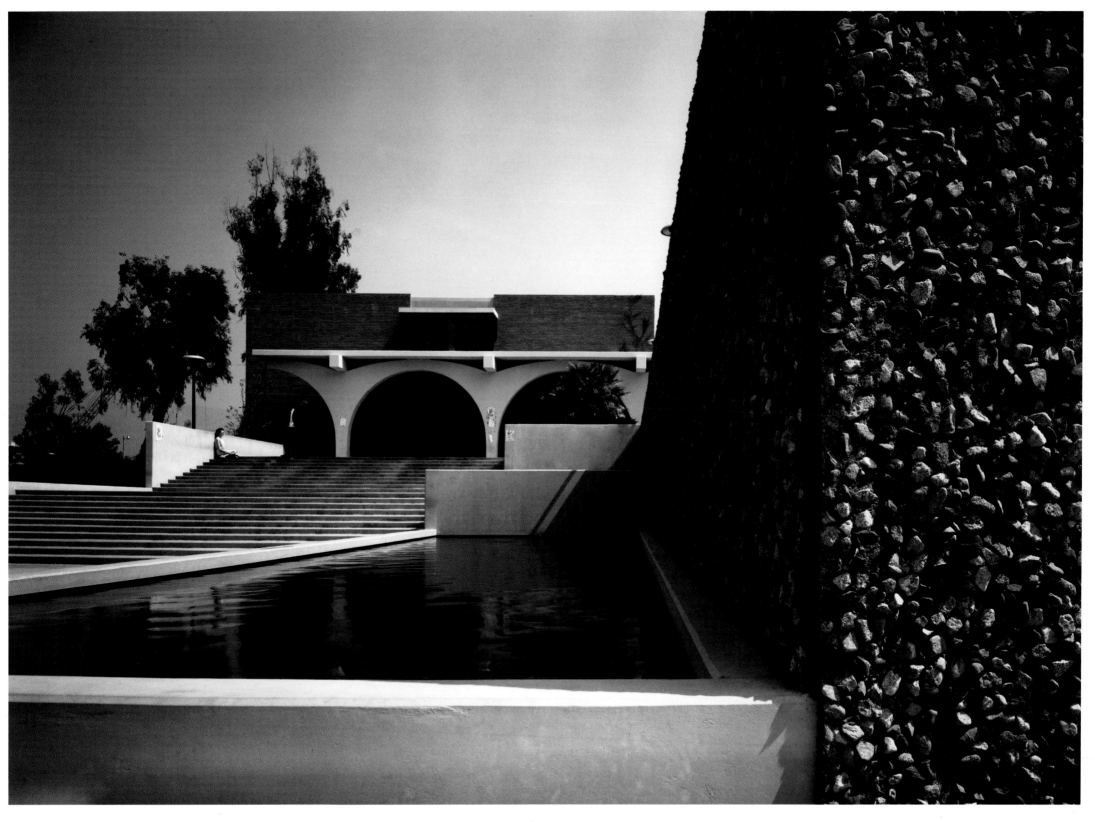

"Humanities Building, Pool, Figures, March 1966."

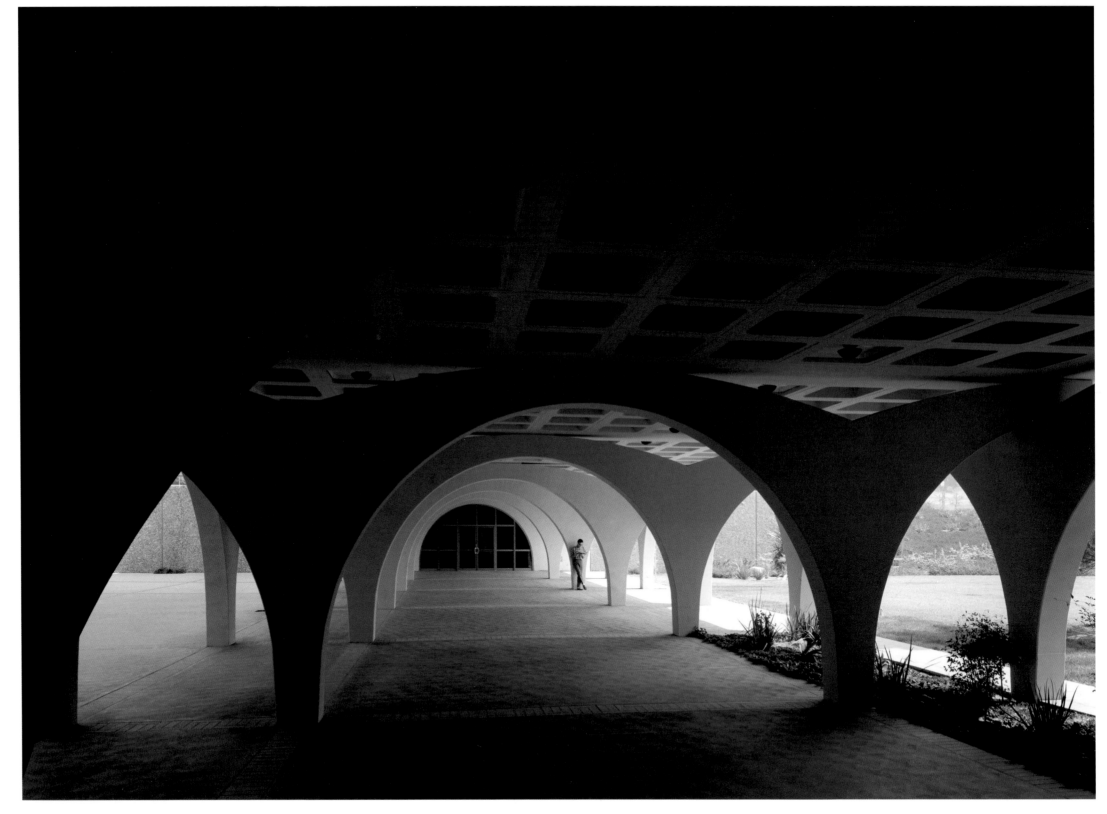

"Humanities Building, Arches (Small Figure), March 1966."

"Detail, Physics Lecture Hall Building, January 1966."

"Breezeway, Theatre Arts Building, No Figures, February 1967."

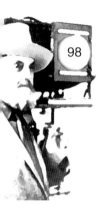

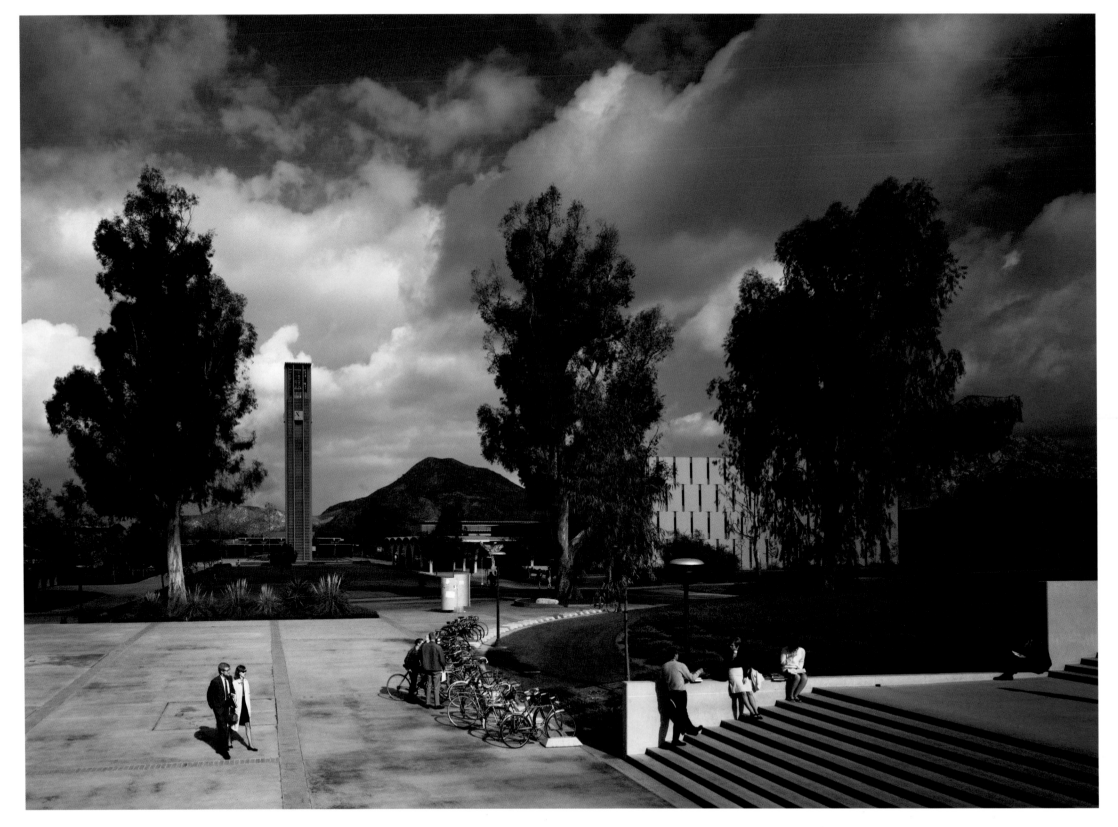

"From Humanities Building, View North, December 1966."

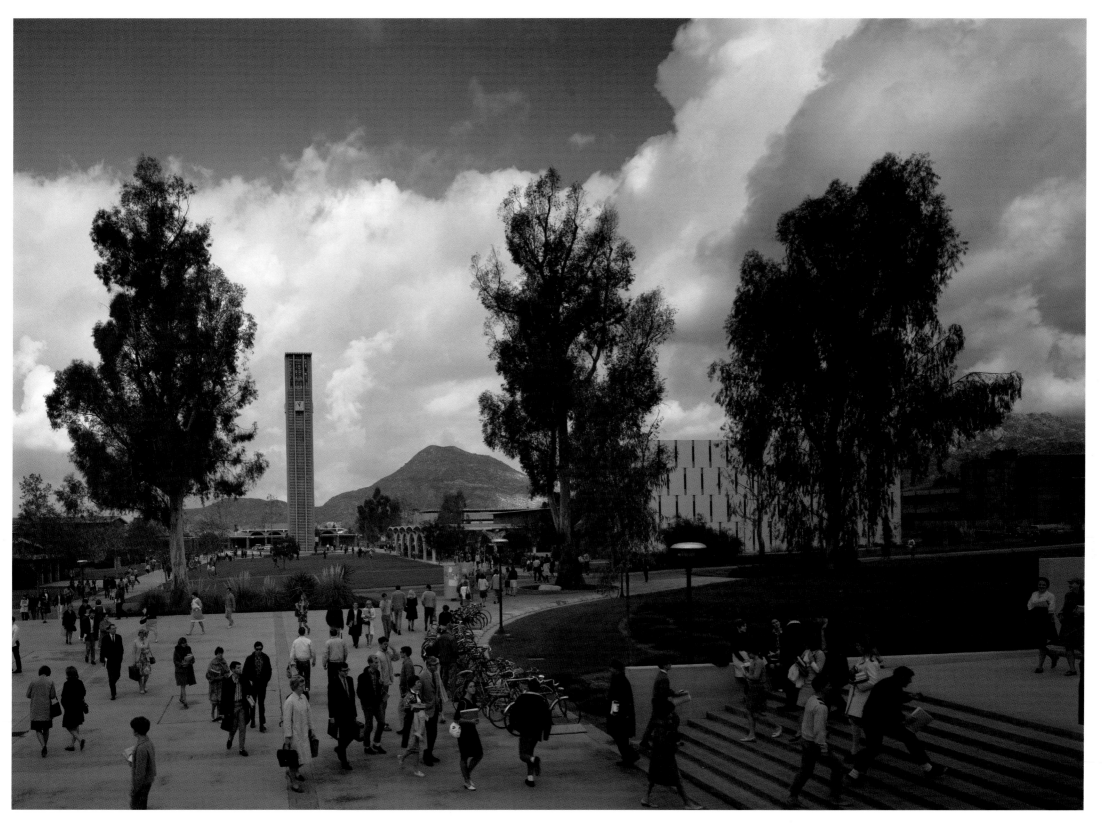

"Class Change, December 1966."

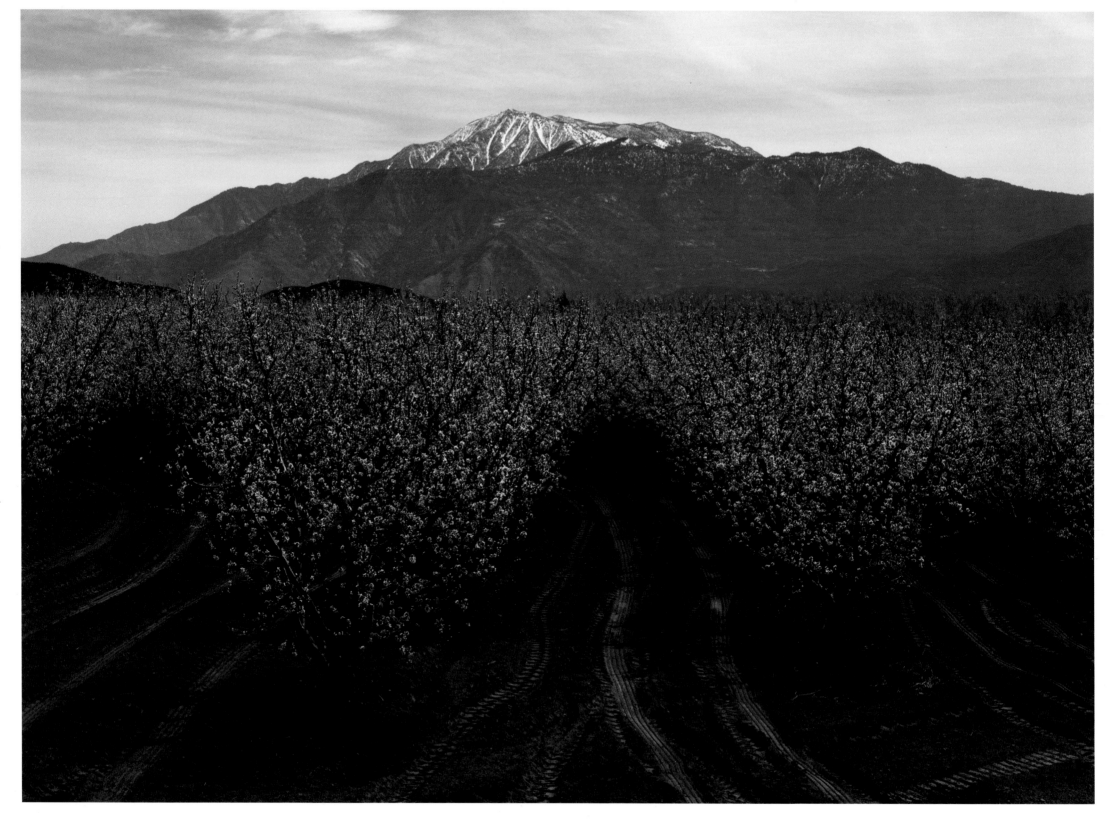

"Orchards, Banning Heights (Mount San Jacinto), March 1966."

"Lick Observatory, 1960–70."

"Honor Student Miss Pamela Jane Nielsen on the Stair of Student Union, April 1966."

"Benjamin Foster, January 1966."

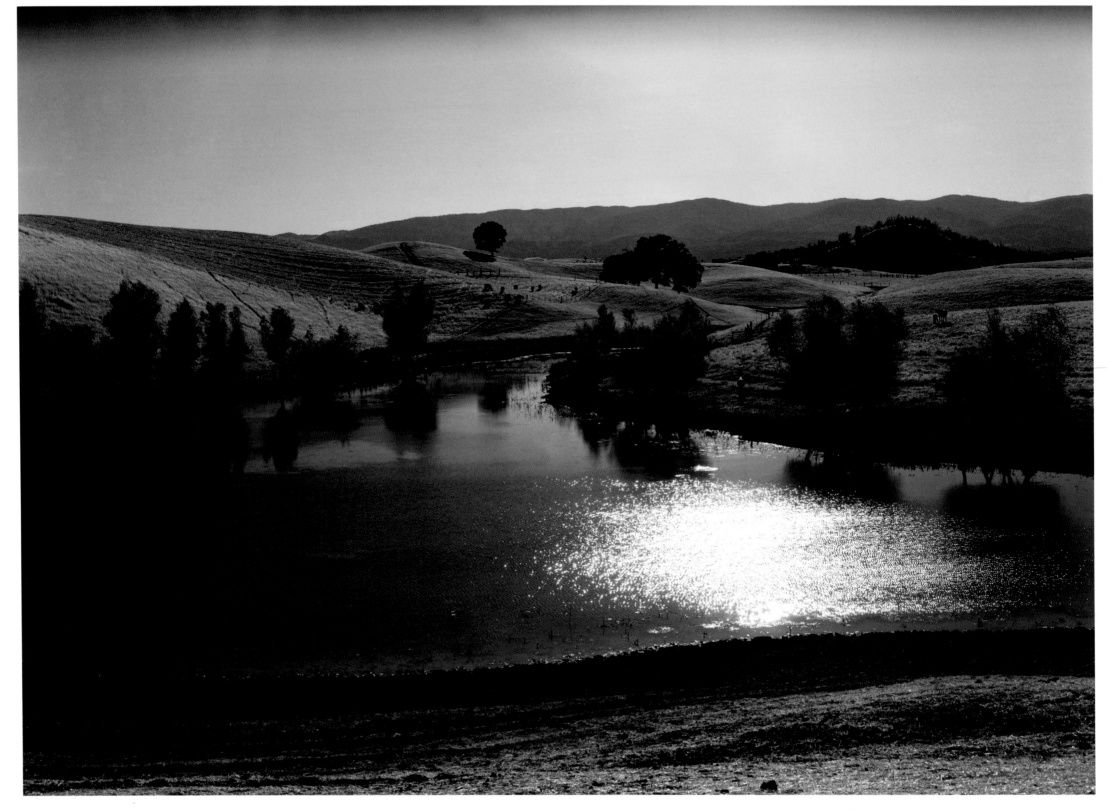

"Pond, Cattle, Sun-glint Near Red Bluff, October 1966."

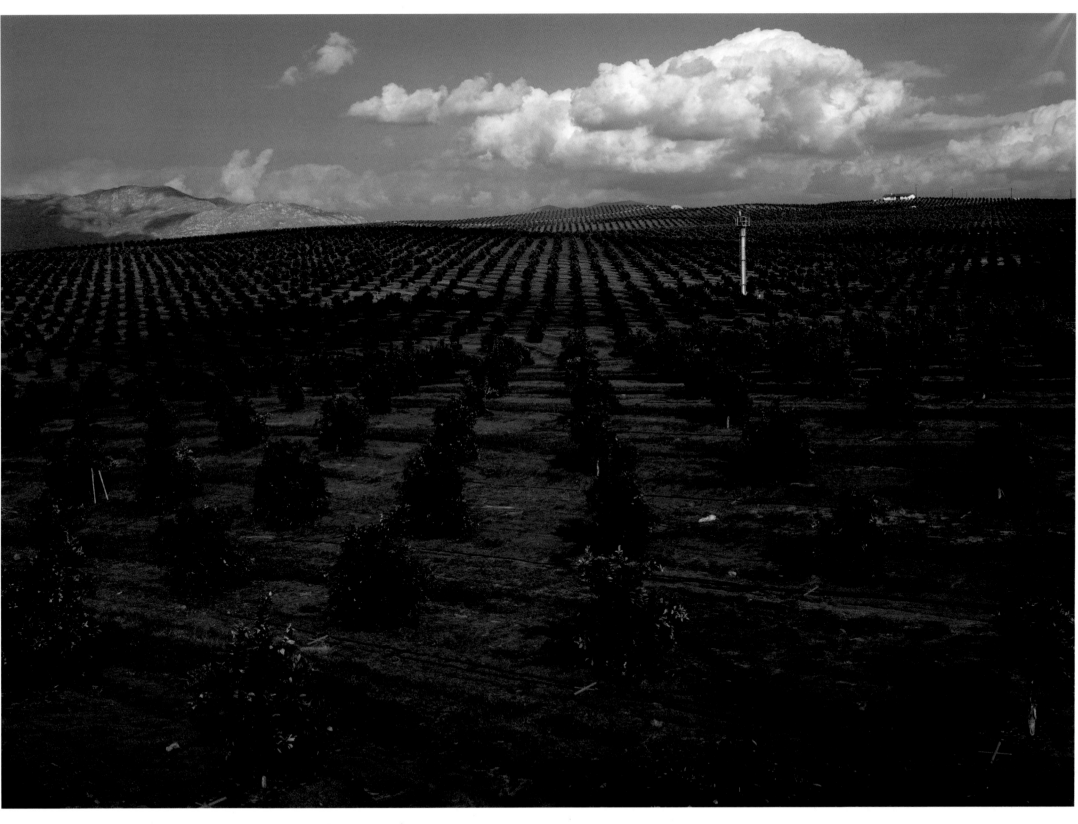

"Latter Day [sic] Saints Citrus Orchard near Riverside, December 1966."

"Los Angeles from the Air (Freeway), October 1966."

"Aerials, Sacramento Valley Rice Fields, May 1966."

KINGS CANYON NATIONAL PARK

The Kings River in south-central California runs down 125 miles in three forks from the High Sierra through mountains and steep canyons into California's Central Valley where it supplies water to numerous cities. The South Fork runs through King's Canyon, a steep glacial valley at an altitude of 8,000 feet. This area was the subject of the Sierra Club's campaign to establish a national park at the time when Adams first joined. It was an area Adams knew well: he had trekked there in 1924 and 1925 and then went with Sierra Club expeditions several times in the 1930s. At the time of the campaign he already possessed an extensive collection of negatives of the area, a number of which had already been published in the club's bulletin. In 1936 a big conference in Washington D.C was held to discuss the future of national and state parks. The Sierra Club sent Adams, armed with his portfolio, to lobby for the establishment of Kings Canyon National Park. He tracked down various congressmen and senators in their offices and displayed his photographs of the High Sierra and the canyons, showing many of them for the first time the remarkable geology and beauty of the area. As a result he was asked to address the conference itself and in the process was introduced to Secretary of the Interior, Harold Ickes. Adams' lobbying of the politicians raised awareness of the region but initially failed to produce any concrete promises of protection. Back in San Francisco, Adams sent Secretary Ickes a copy of his *The Sierra Nevada and the John Muir Trail* that included many photos of Kings Canyon. Ickes showed the book to President Roosevelt, who promptly commandeered it for the White House. A few years later in 1940 Ickes and Roosevelt drove a reluctant Congress to pass the Kings Canyon National Park bill, preserving the wilderness there forever.

Note: All prints in this section are labeled: "Kings River Canyon (Proposed as a national park). Photos donated by Ansel Adams, February 1936"

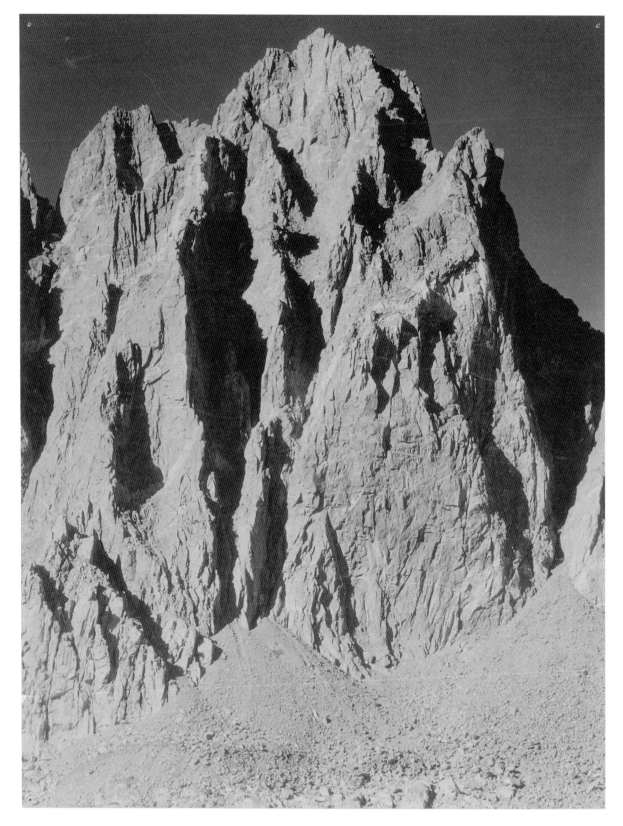

"Mt. Winchell."

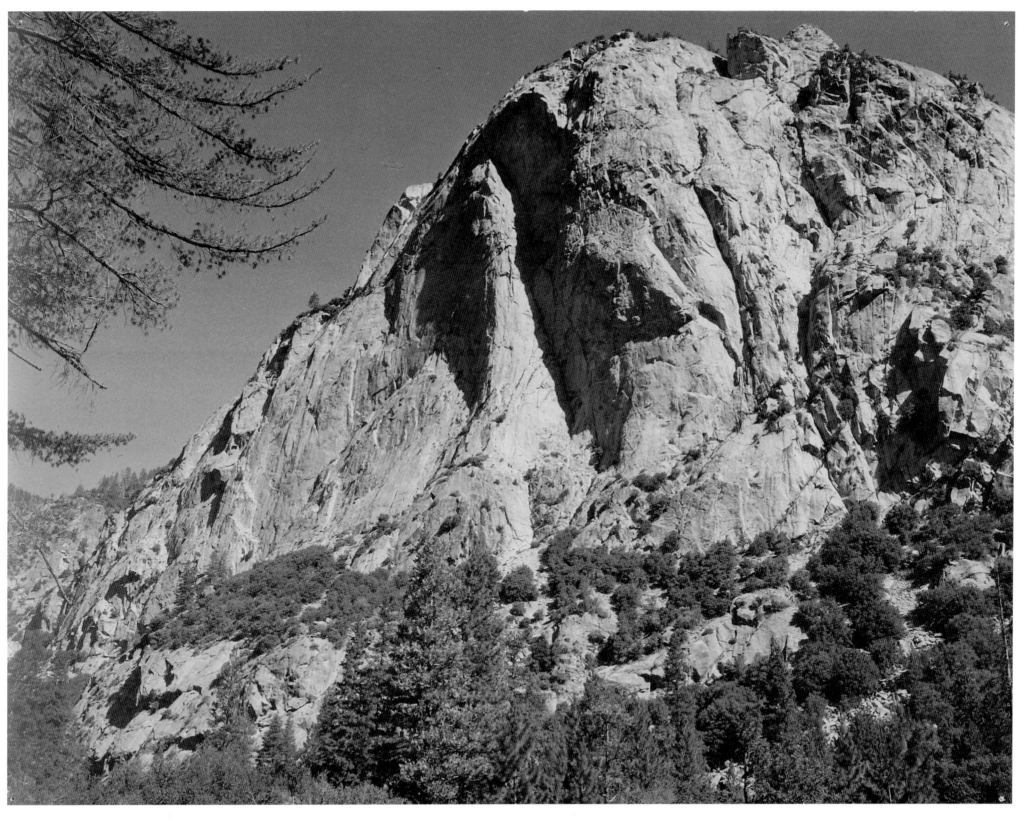

"North Dome, Kings River Canyon."

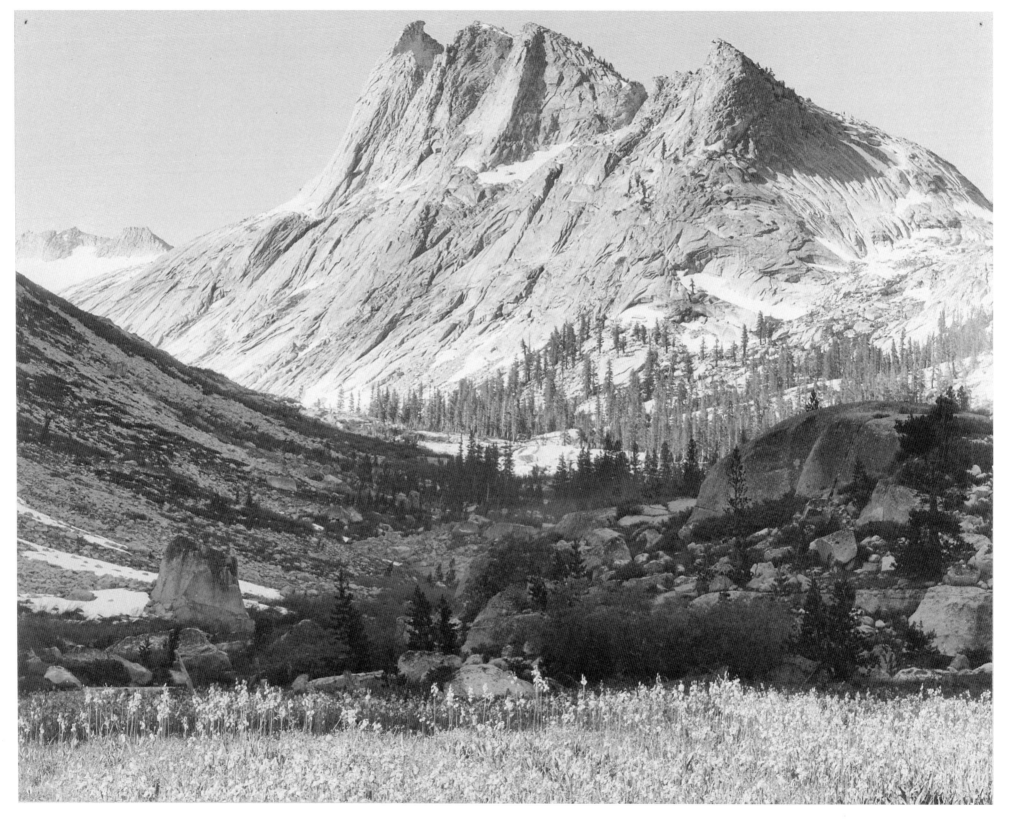

"Boaring River, Kings Region."

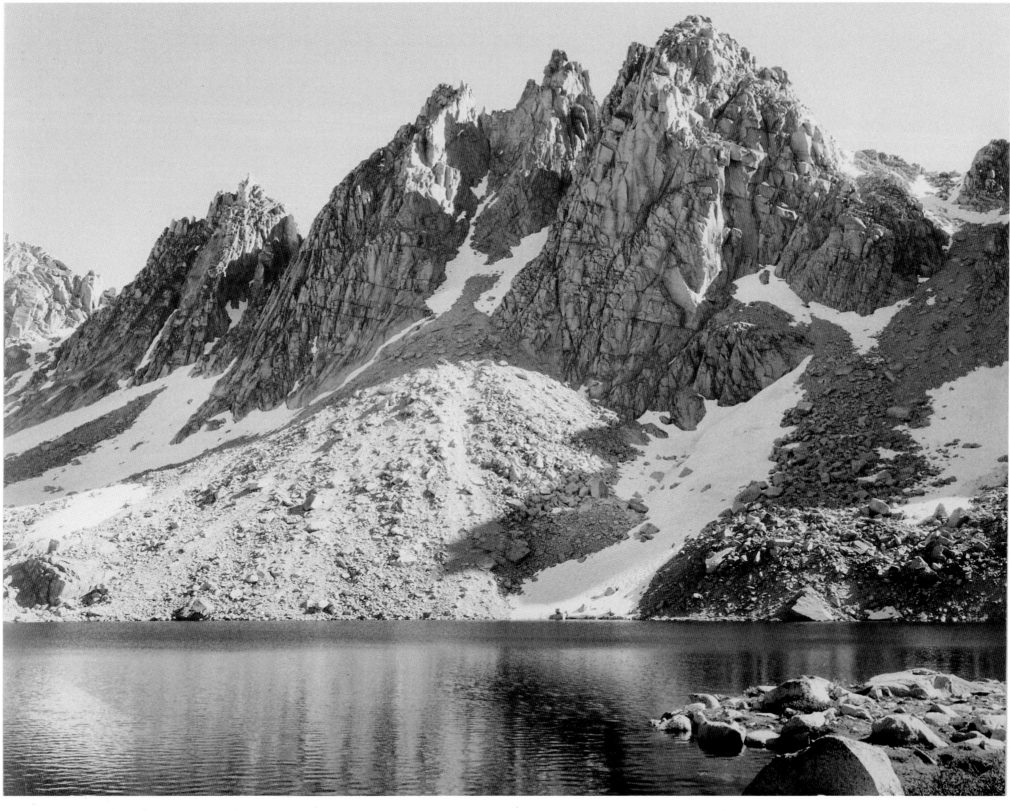

"Kearsage Pinnacles."

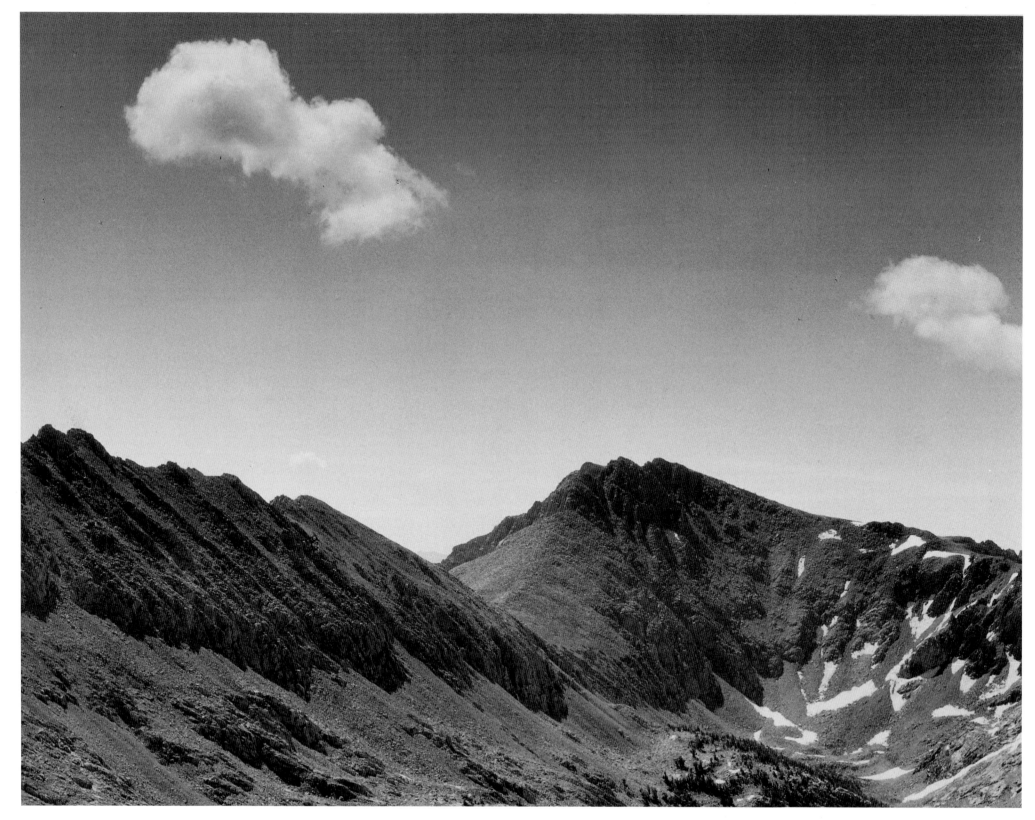

"Coloseum Mountain."

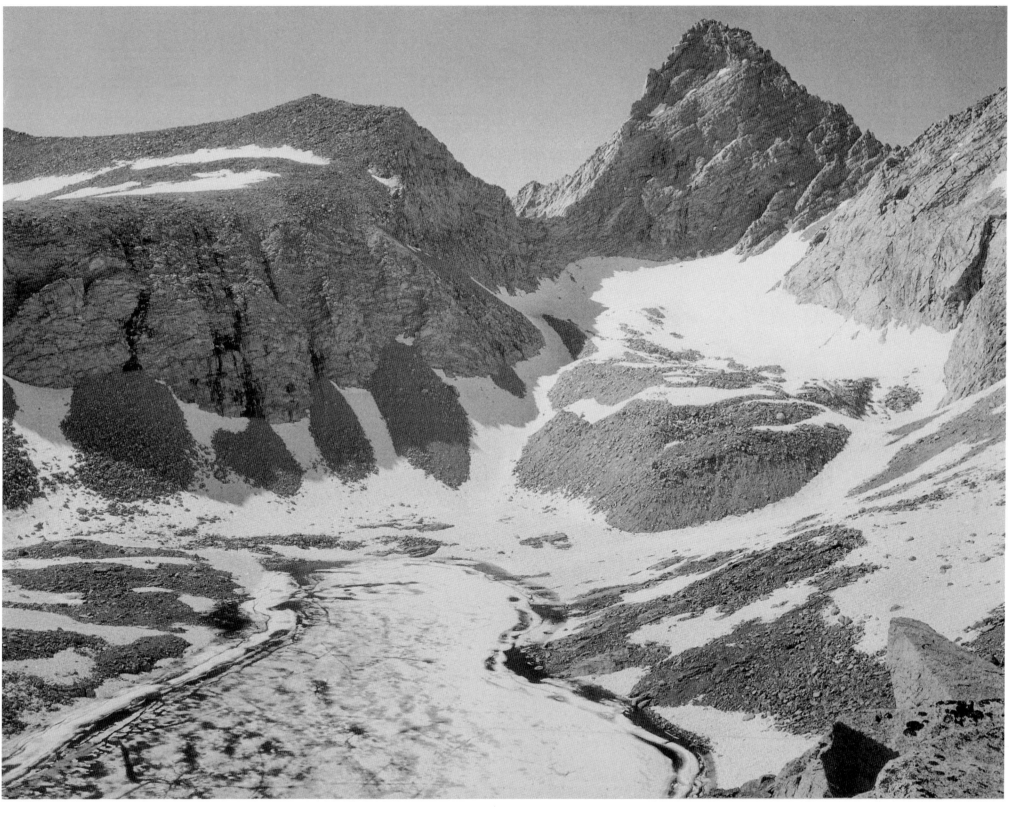

"Junction Peak."

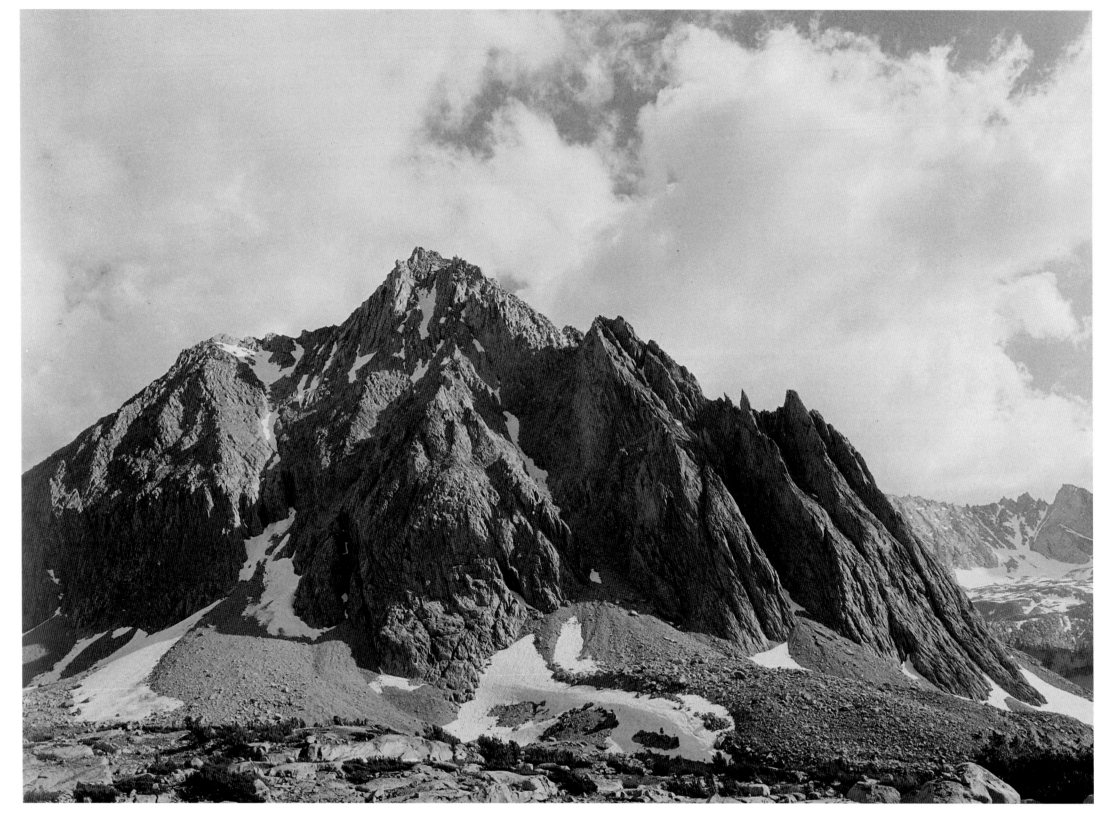

"Center Peak, Center Basin."

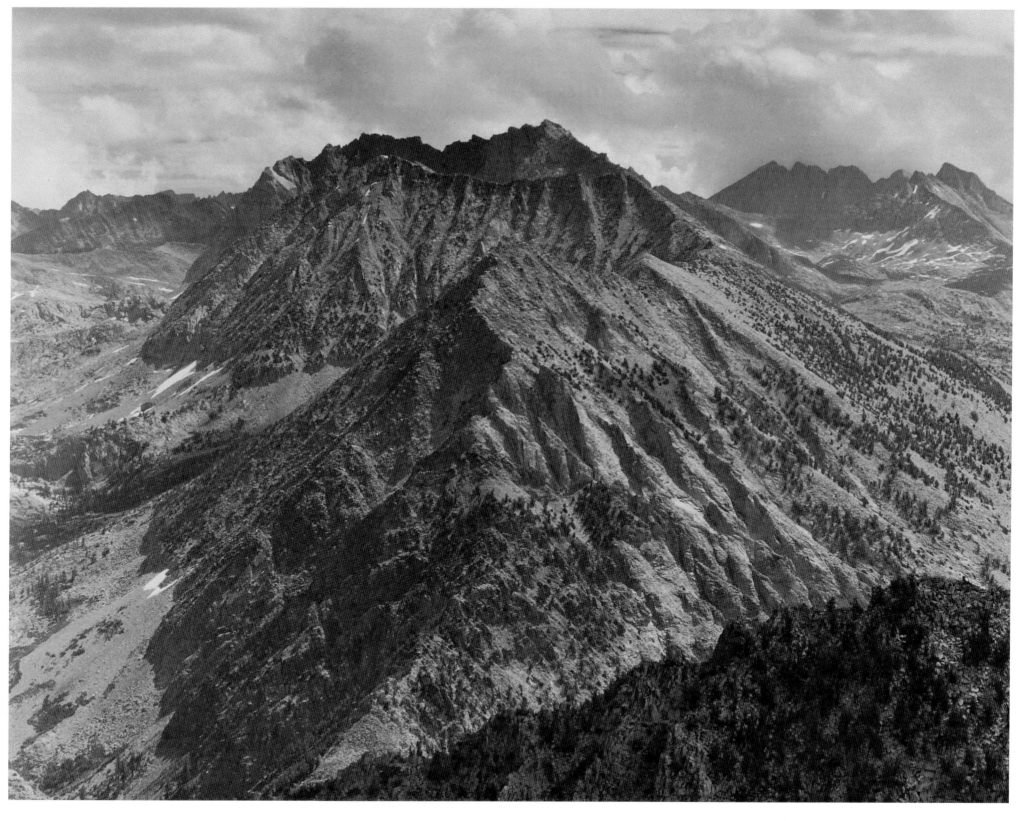

"From Windy Point, Middle Fork, Kings River."

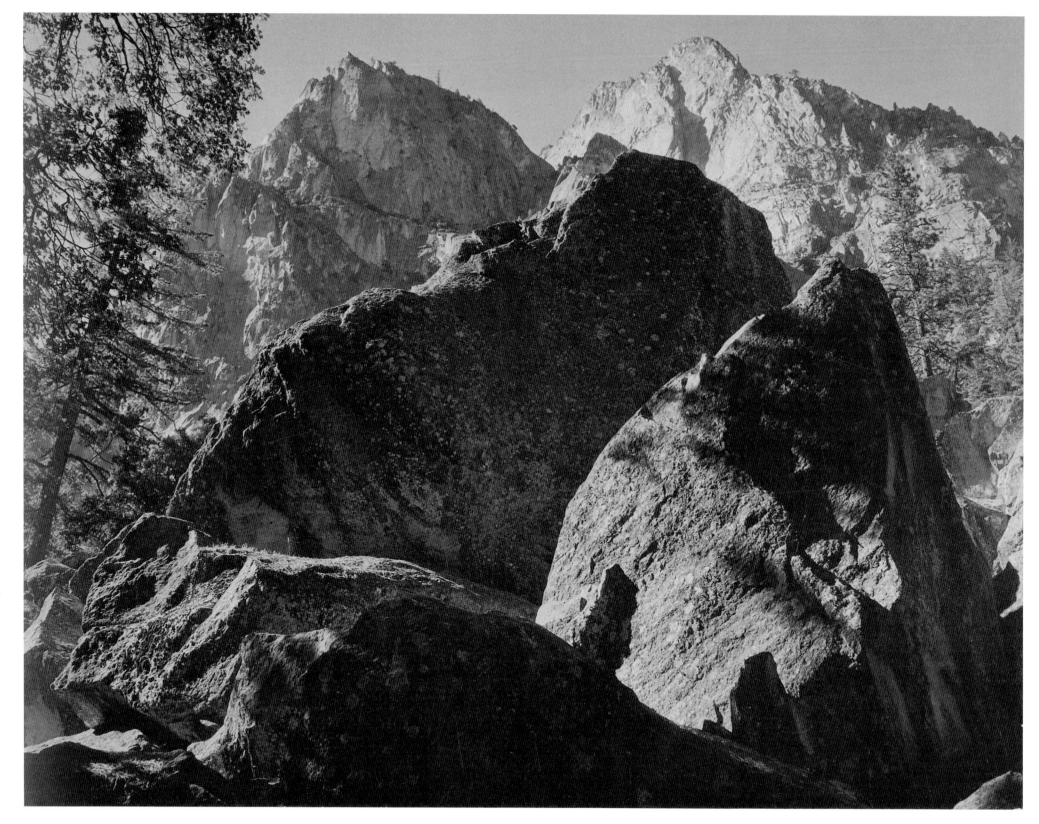

"Grand Sentinel."

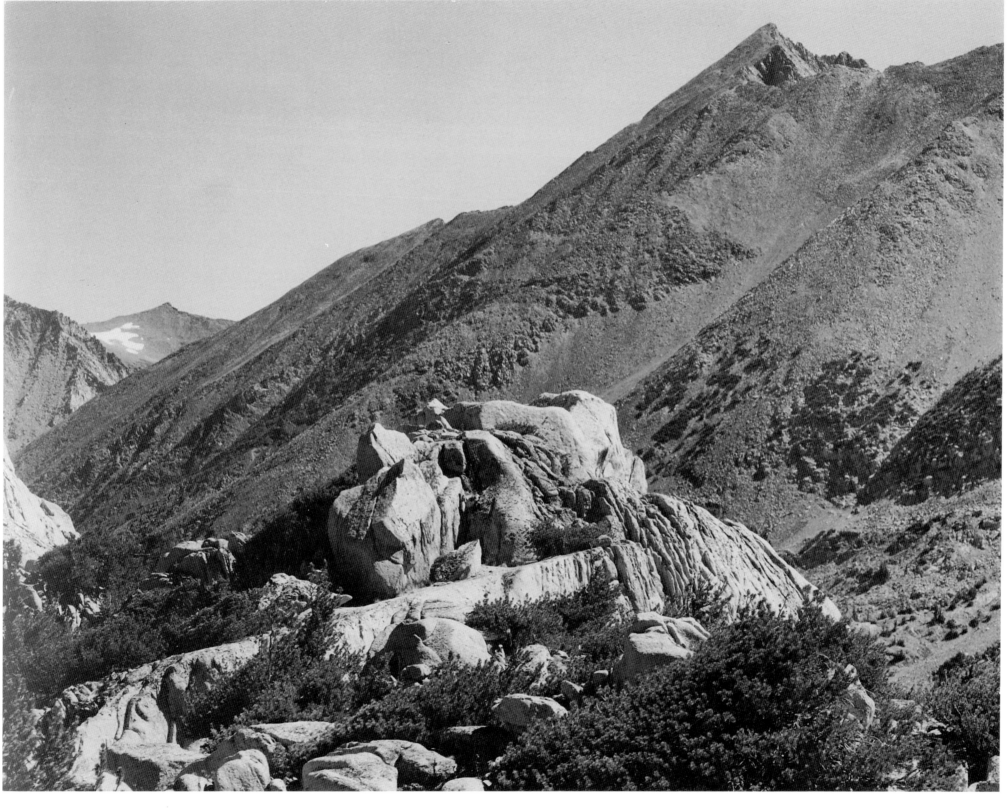

"Peak near Rae Lake."

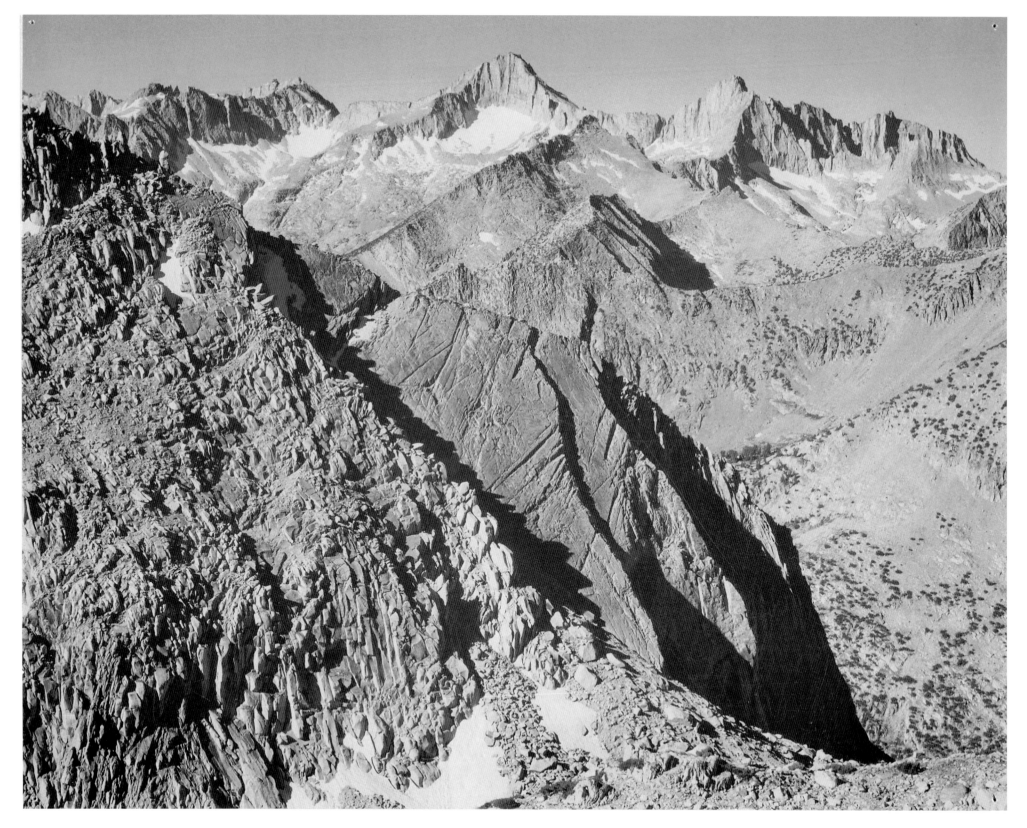

"Mount Brewer."

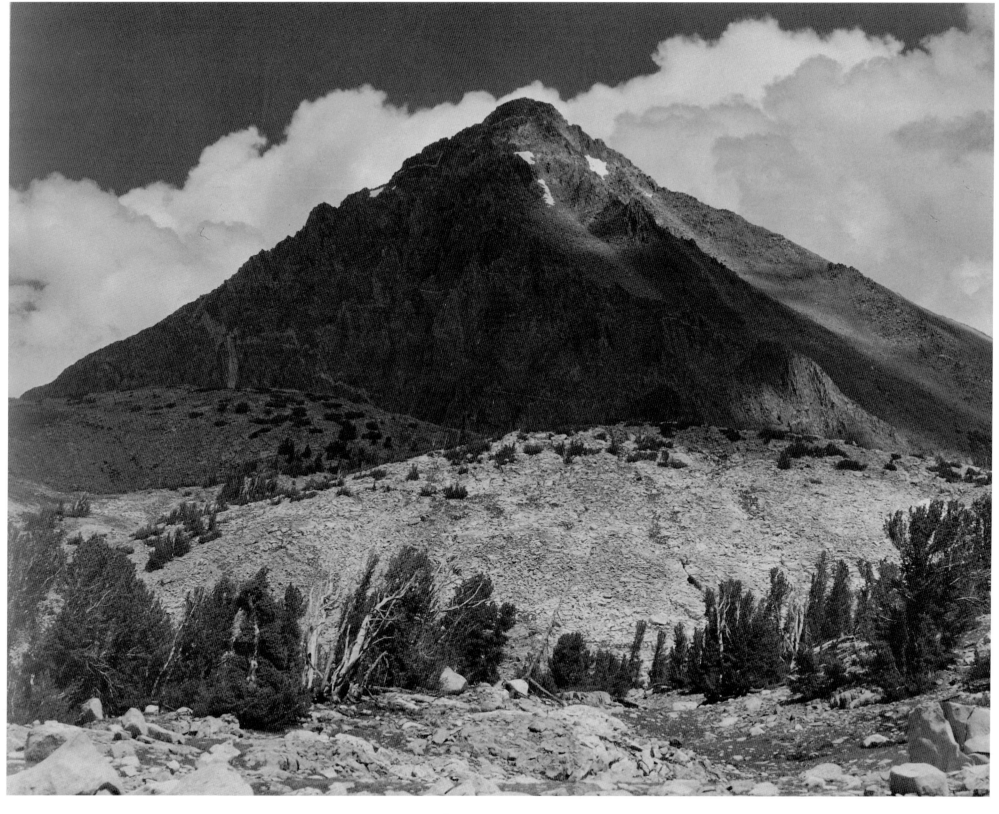

"Pinchot Pass, Mt. Wynne."

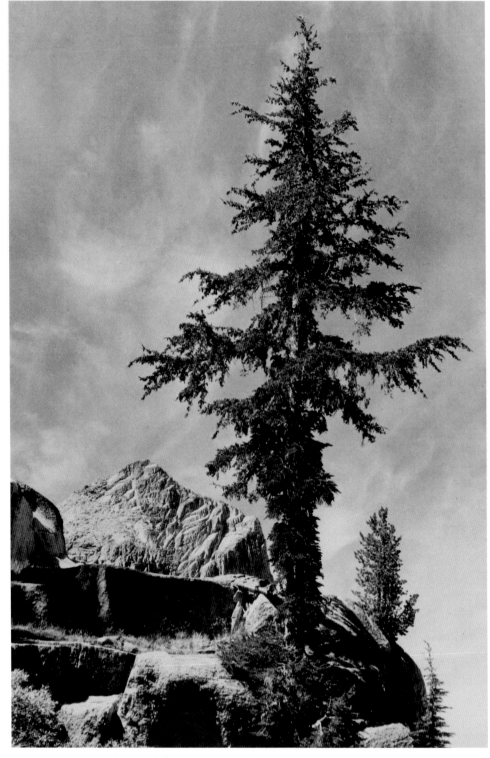

"An Unnamed Peak."

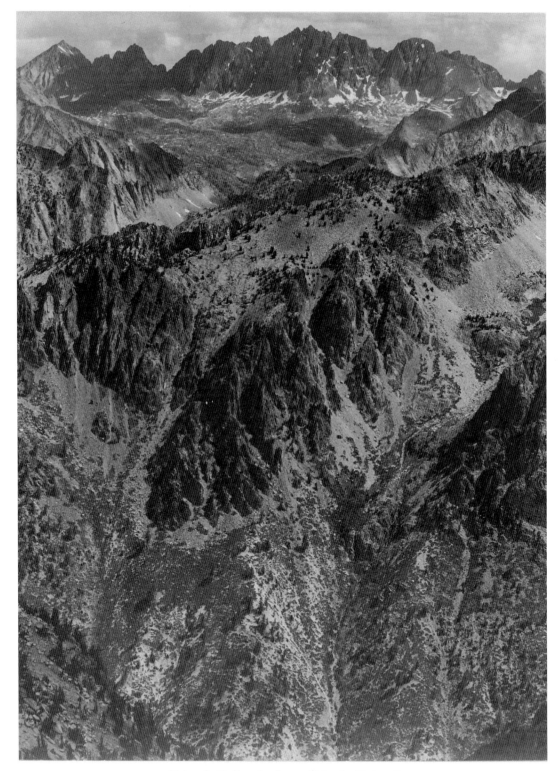

"North Palisade from Windy Point."

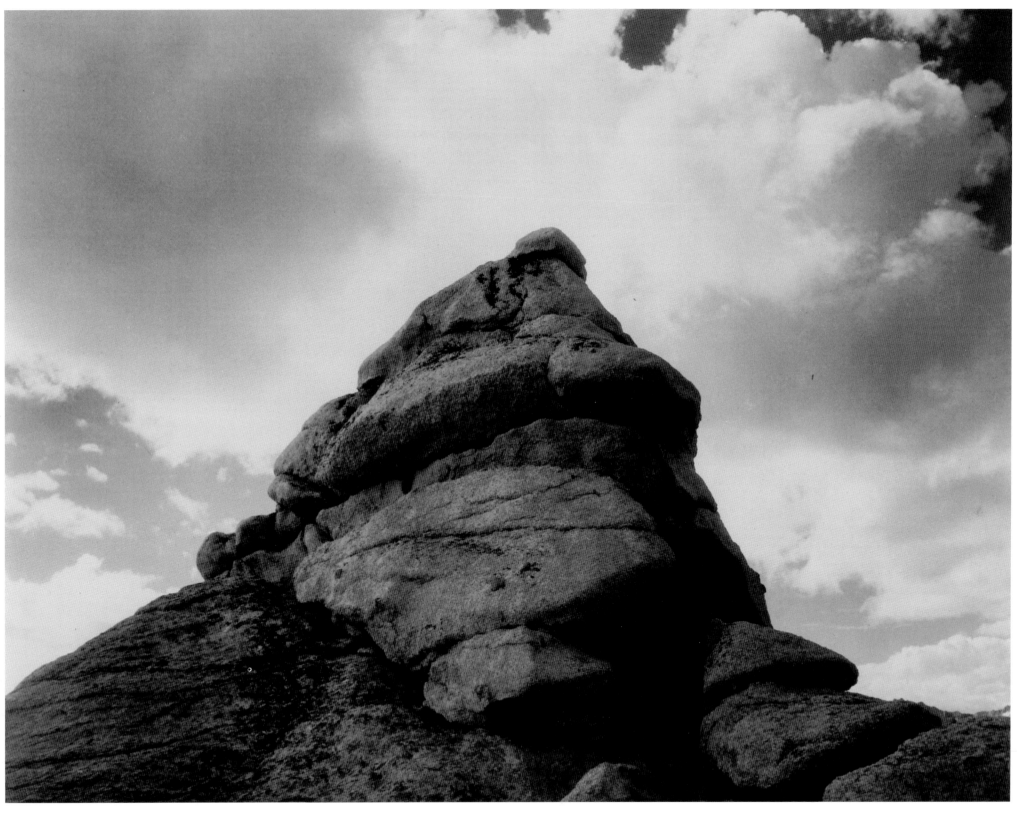

"Rock and Cloud."

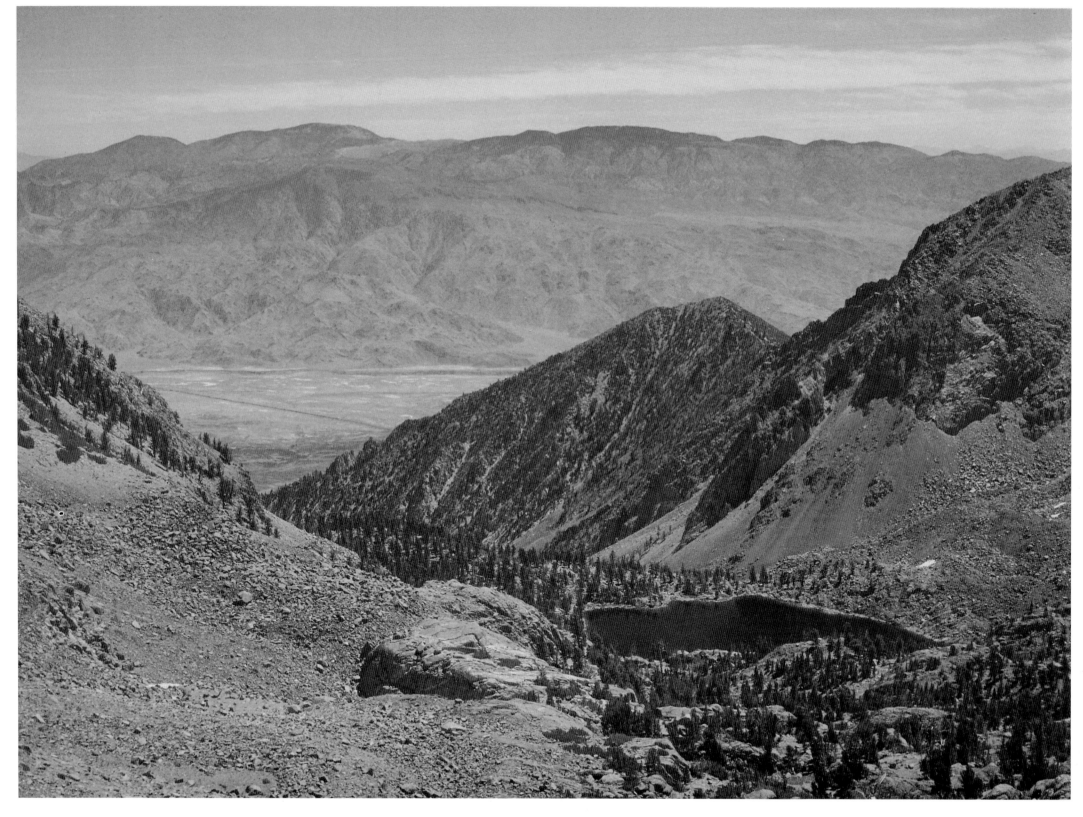

"Owens Valley from Sawmill Pass."

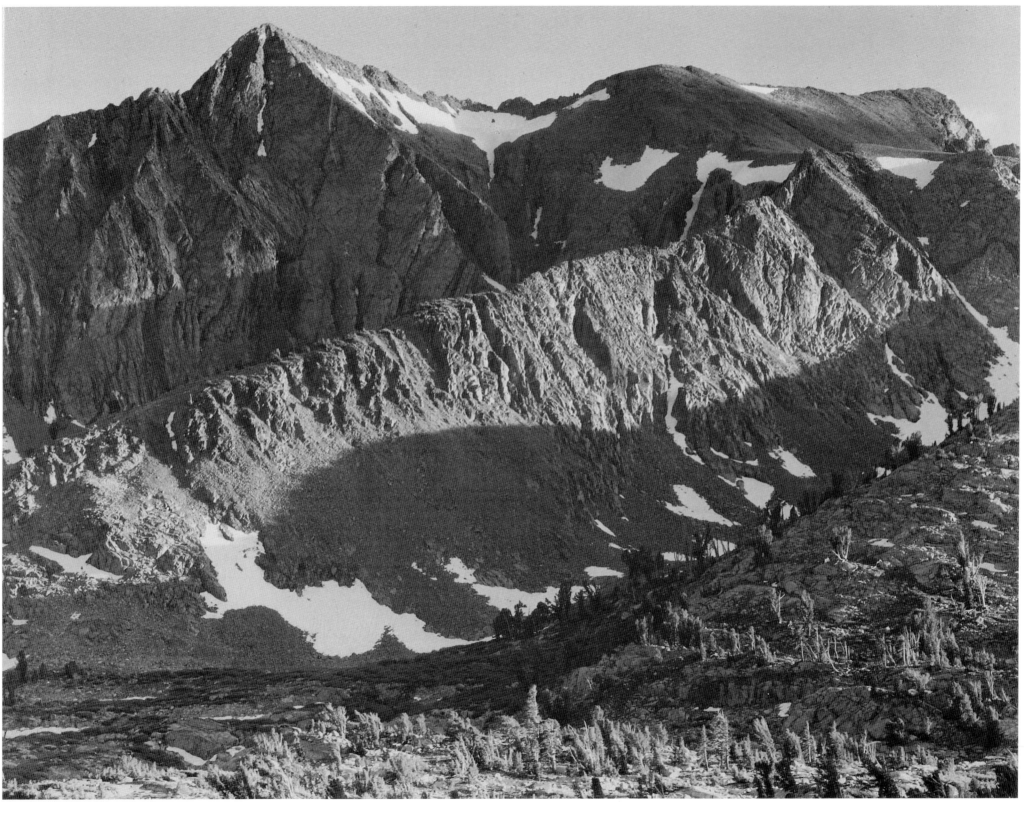

"Peak above Woody Lake."

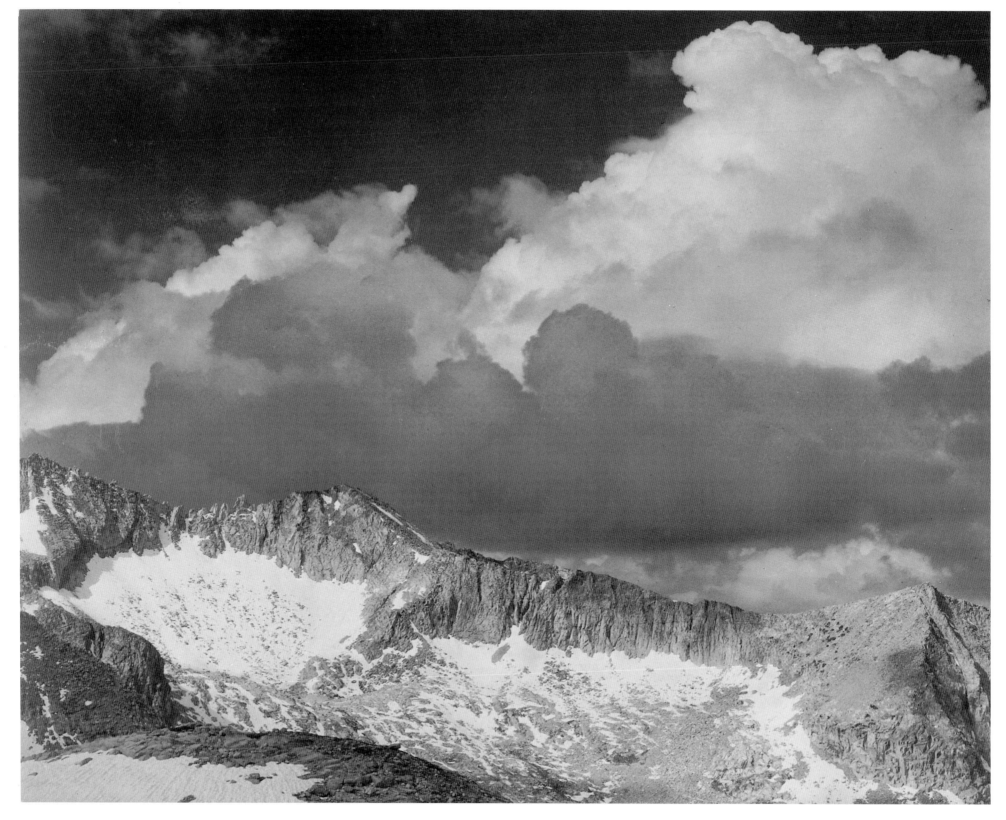

"Clouds—White Pass."

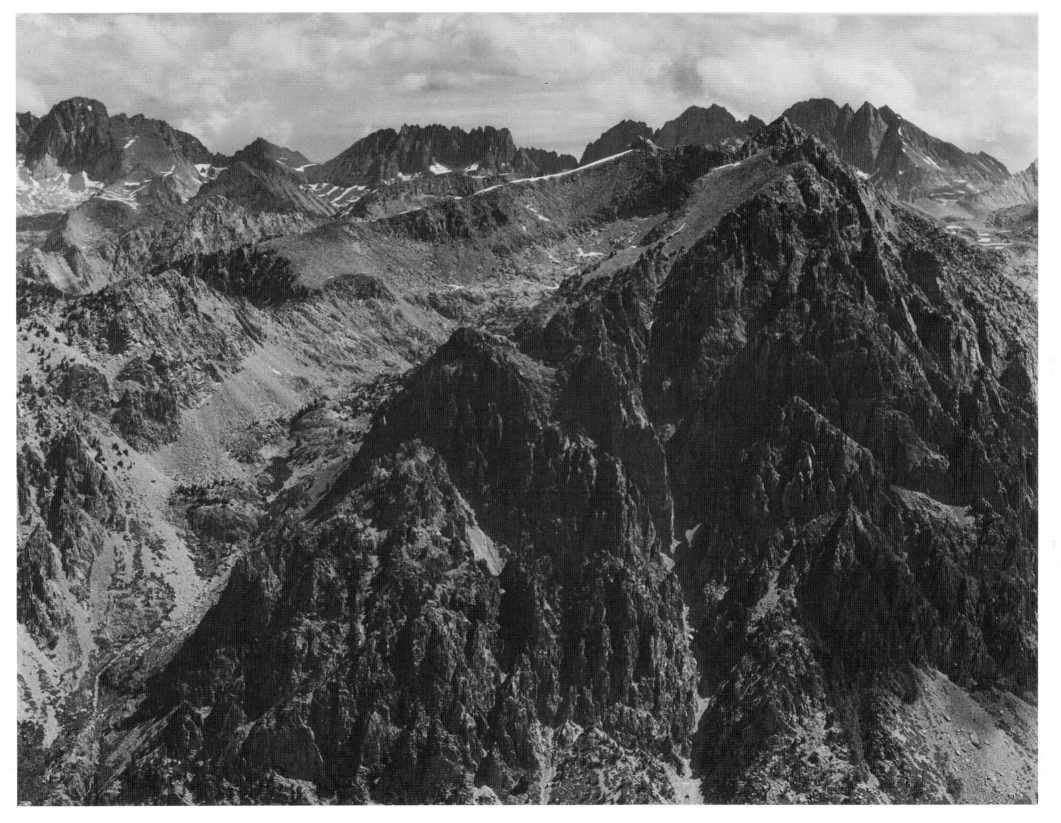

"From Windy Point."

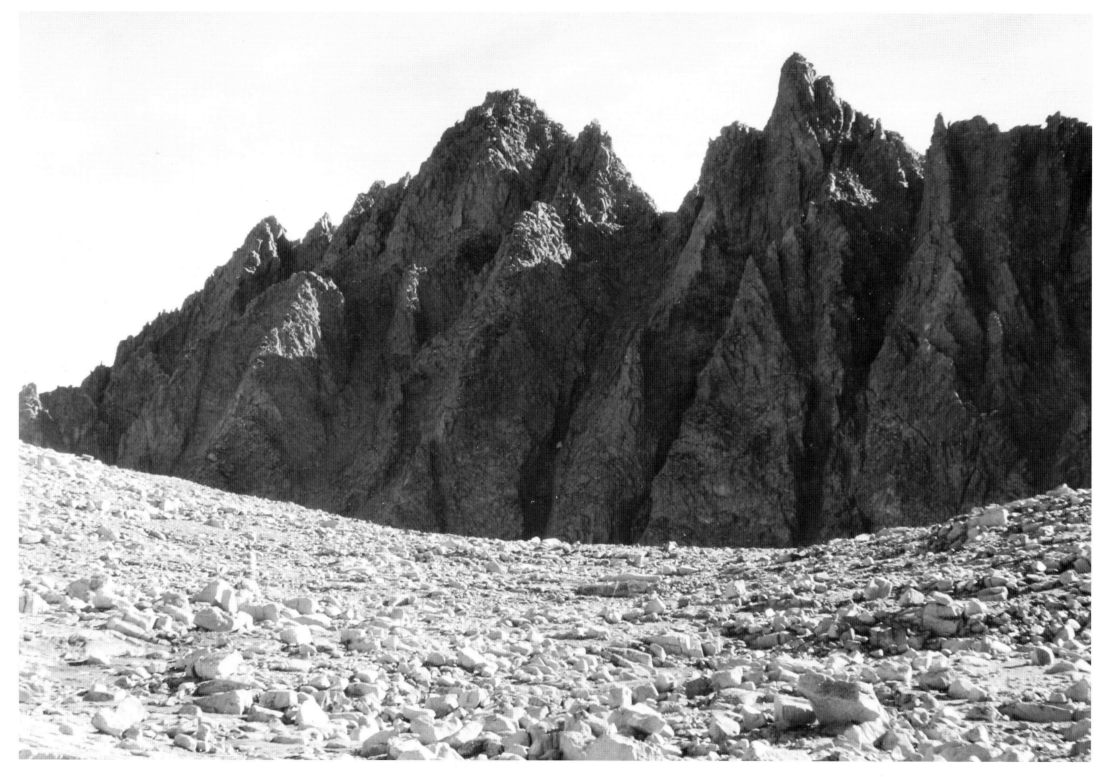

"Bishop Pass."

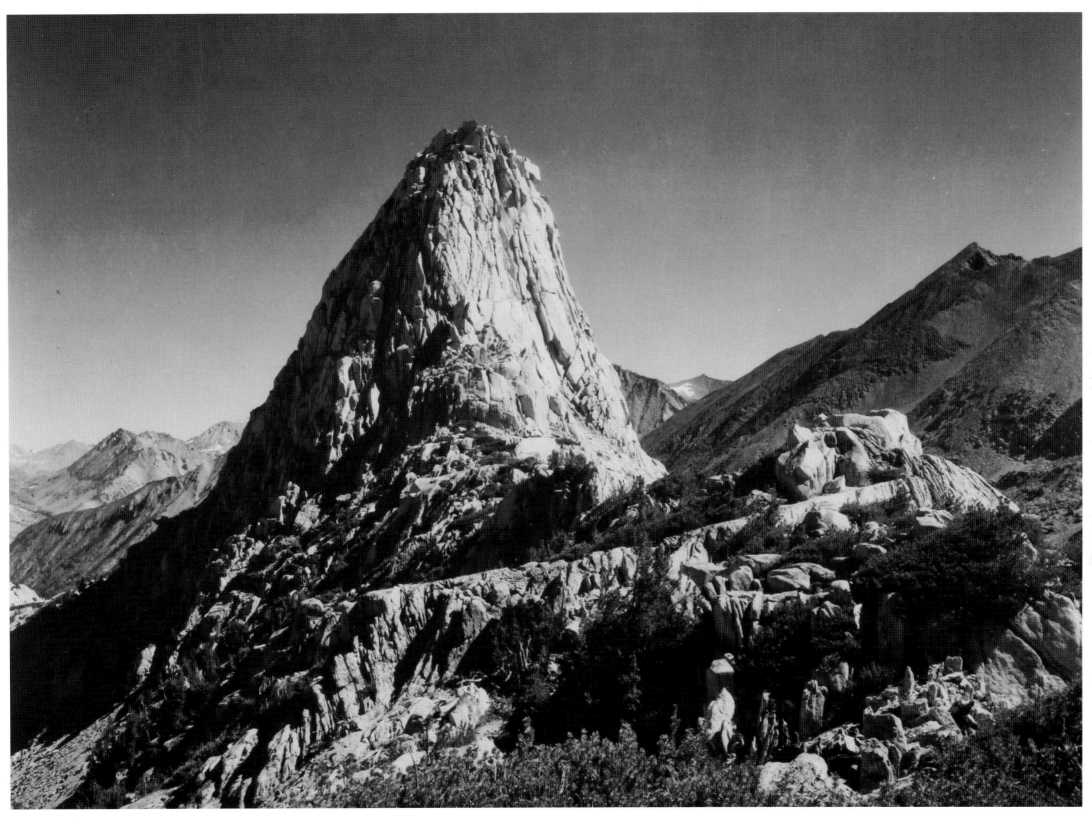

"Fin Dome."

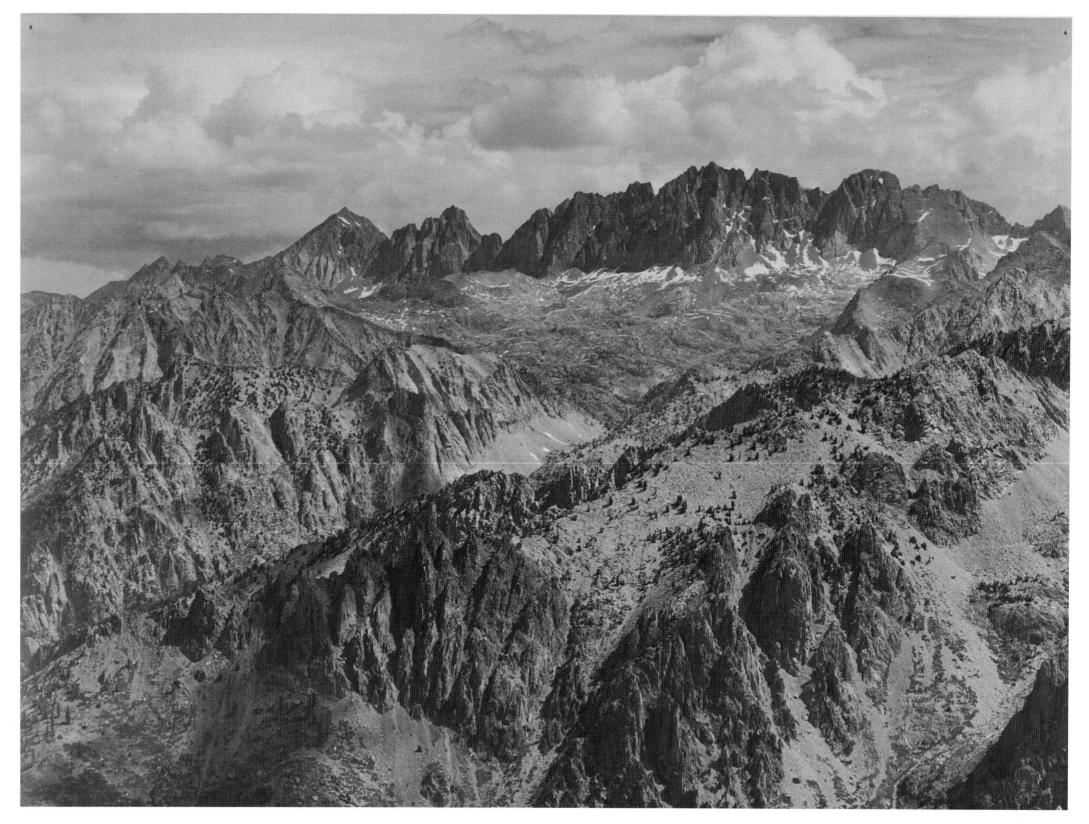

"North Palisade from Windy Point."

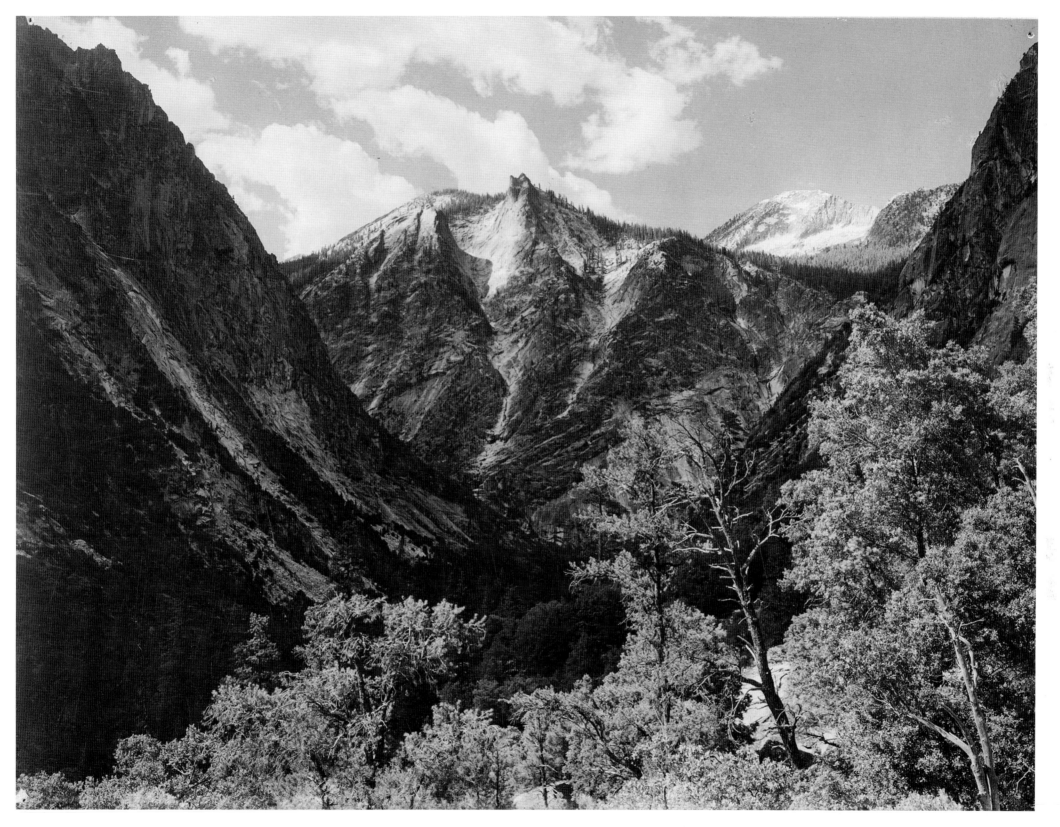

"Paradise Valley."

Manzanar National Historic Site

Owens Valley Paiute established settlements in Owens Valley, California about 1,500 year ago. Much later miners, ranchers, and settlers moved in and the Native Americans forcibly moved out. In 1910 the small settlement of Manzanar (meaning "apple orchard" in Spanish) was established, and the rich lands proved bountiful for crops. That all ended when the city of Los Angeles acquired all the rights to Manzanar's lands and diverted the water for their own needs. Manzanar became unsustainable and was abandoned in the 1930s. During World War II, however, following the Japanese attack on Pearl Harbor in 1942, the U.S. Army leased 6,200 acres from Los Angeles to turn Manzanar into a holding camp for all Japanese-Americans living on the West Coast. Unlike other native immigrant communities (Germans and Italians in particular), the Japanese-Americans were thought—on the unsubstantiated prospect of a West Coast invasion—to be a threat to national security. So all West Coast *Nisei* (first generation American citizens of Japanese descent) were rounded up and resettled for the duration of the war at ten internment camps, of which Manzanar War Relocation Camp was the best known. The inmates of Manzanar were fortunate in as much as their director was Sierra Club member and friend of Ansel Adams, Ralph Merritt. He was a compassionate man who did the best he could to alleviate their plight, by among other things encouraging their community spirit and civilization. He suggested that Adams come and photograph the efforts the *Nisei* were making in their daily lives to create a habitable existence despite the circumstances. No money changed hands but Adams was given full access. He first visited the camp in fall 1943 and made many subsequent visits. Gradually he got to know the people and warmed to their charm and generous spirit. As he later said, he was profoundly affected by Manzanar and the unfairness of their position. The resulting book, *Born Free and Equal: The Story of Loyal Japanese-Americans*, was published in 1944.

BORN FREE
and EQUAL

☆

Text and Photographs
by
ANSEL ADAMS

THE STORY OF LOYAL JAPANESE-AMERICANS

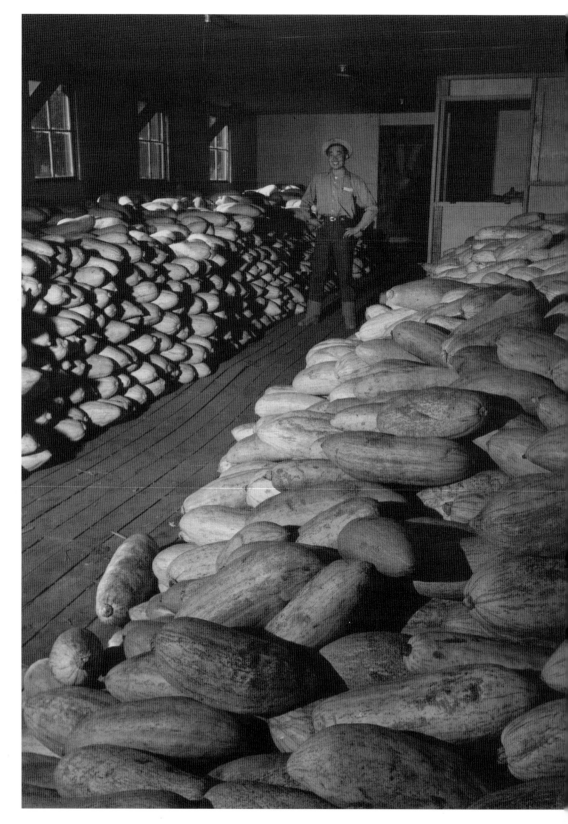

"Benji Iguchi with squash."

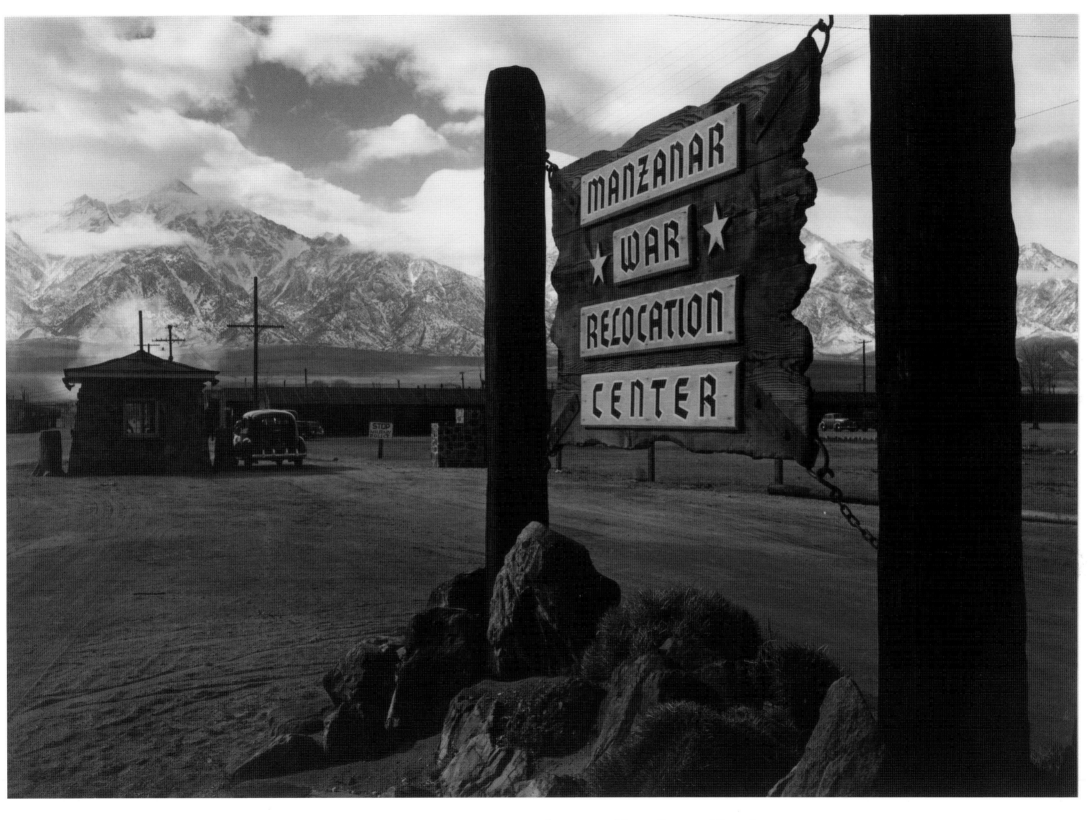

"Entrance to Manzanar." As used on p. 4 of Born Free and Equal.

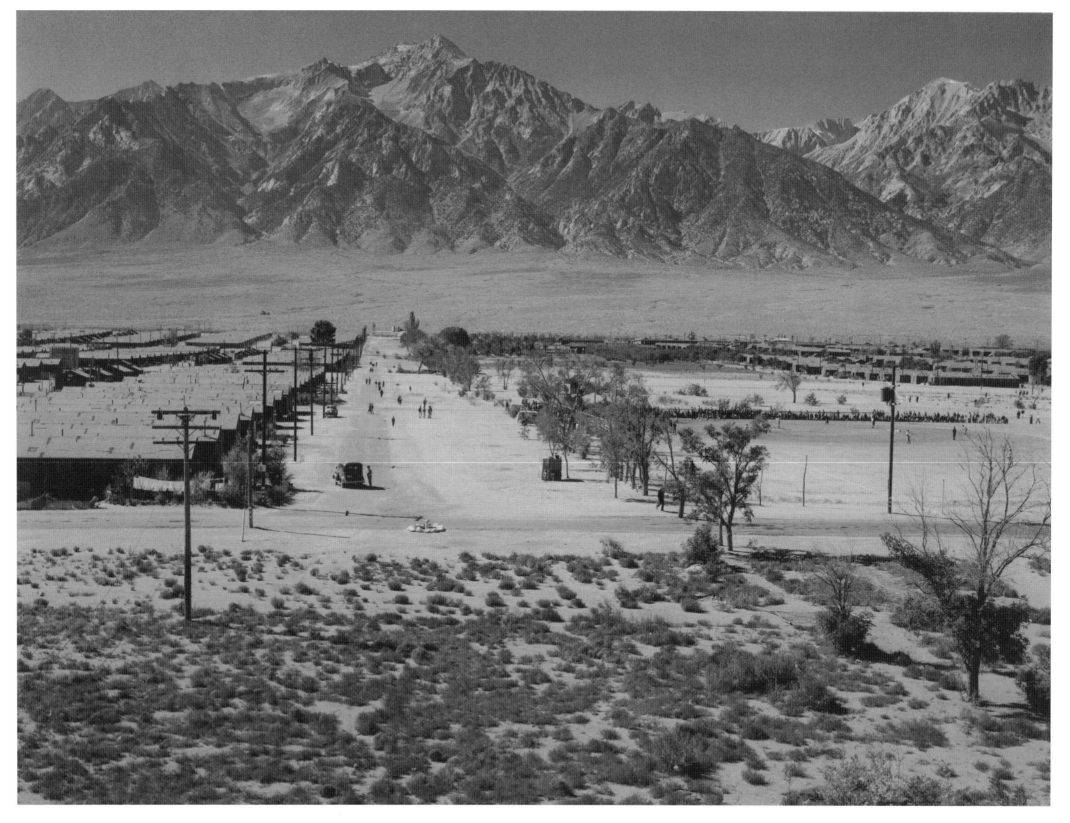

"Manzanar Relocation Center from tower." As used on pp. 26–27 of Born Free and Equal.

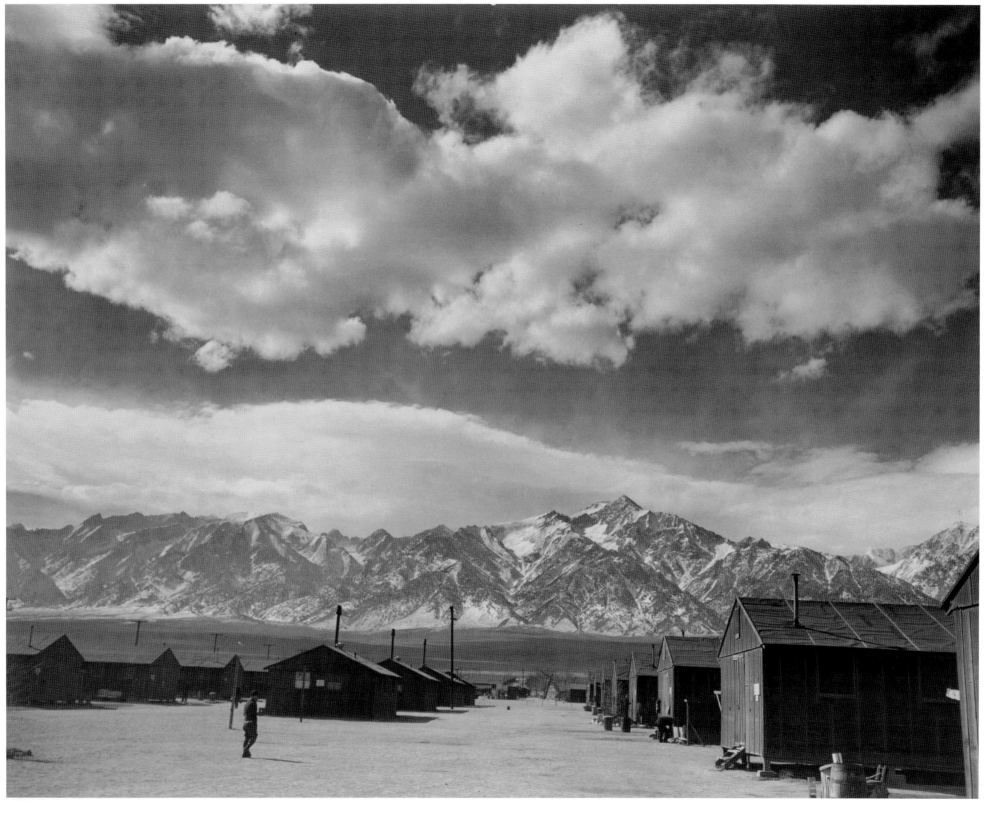

"Manzanar street scene, clouds."

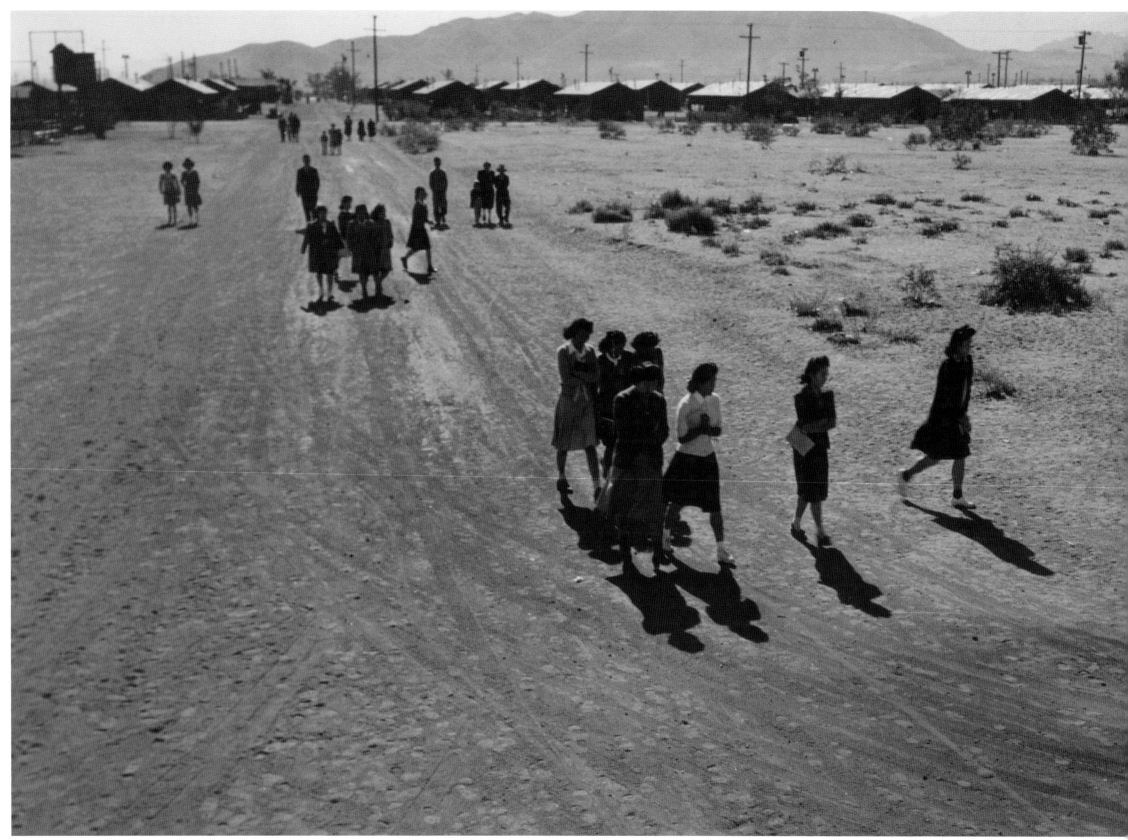

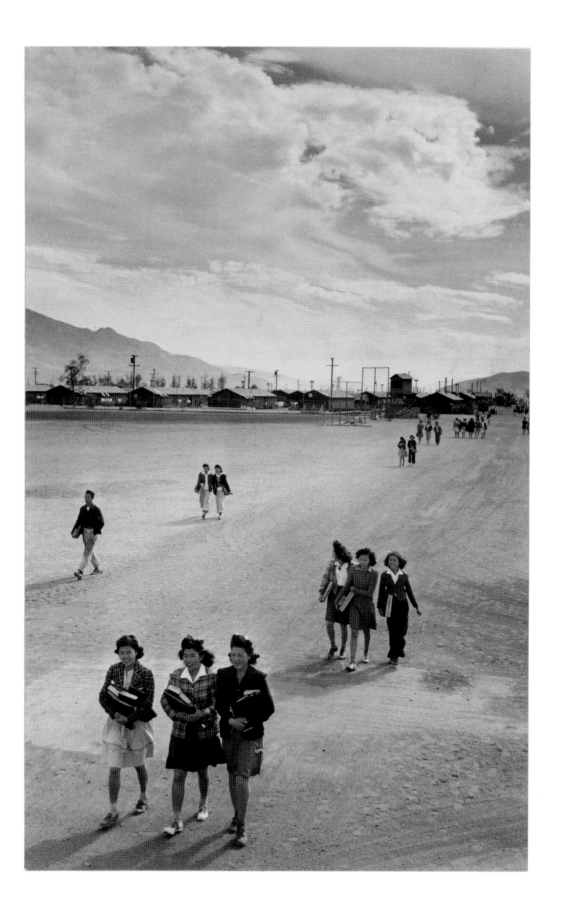

Opposite: *"People walking."*

Left: *"School children."* As used on p. 24 of Born Free and Equal.

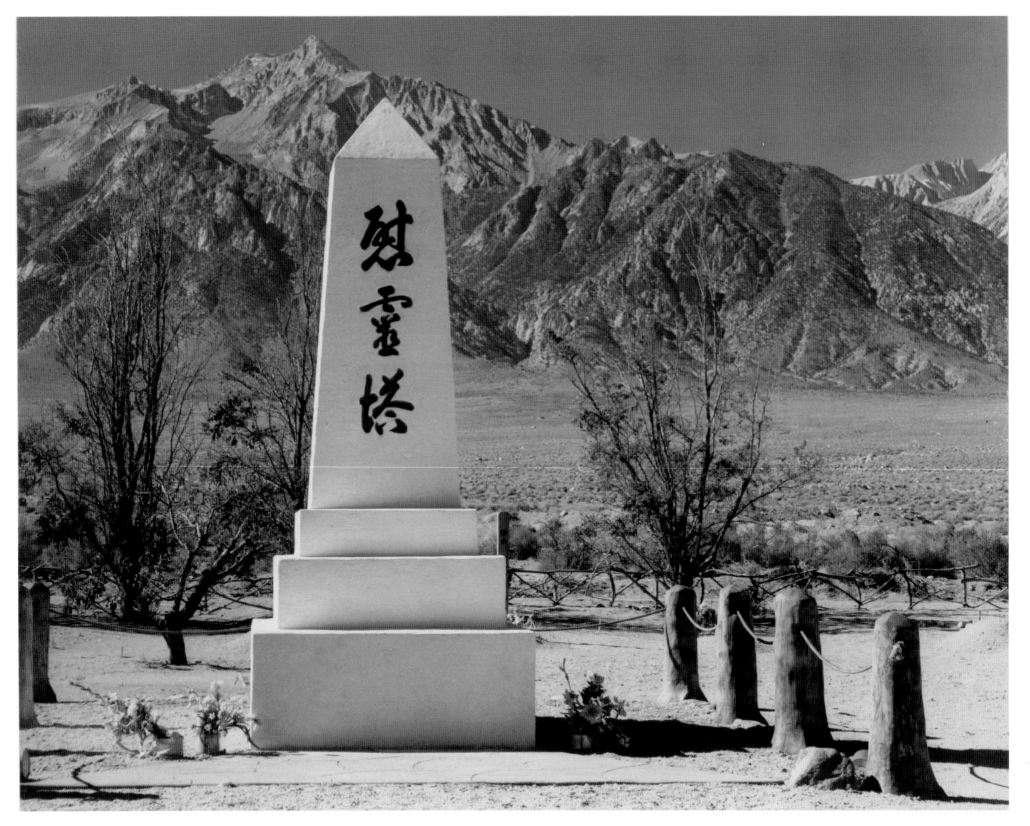

"Monument in cemetery." As used on p. 28 of Born Free and Equal.

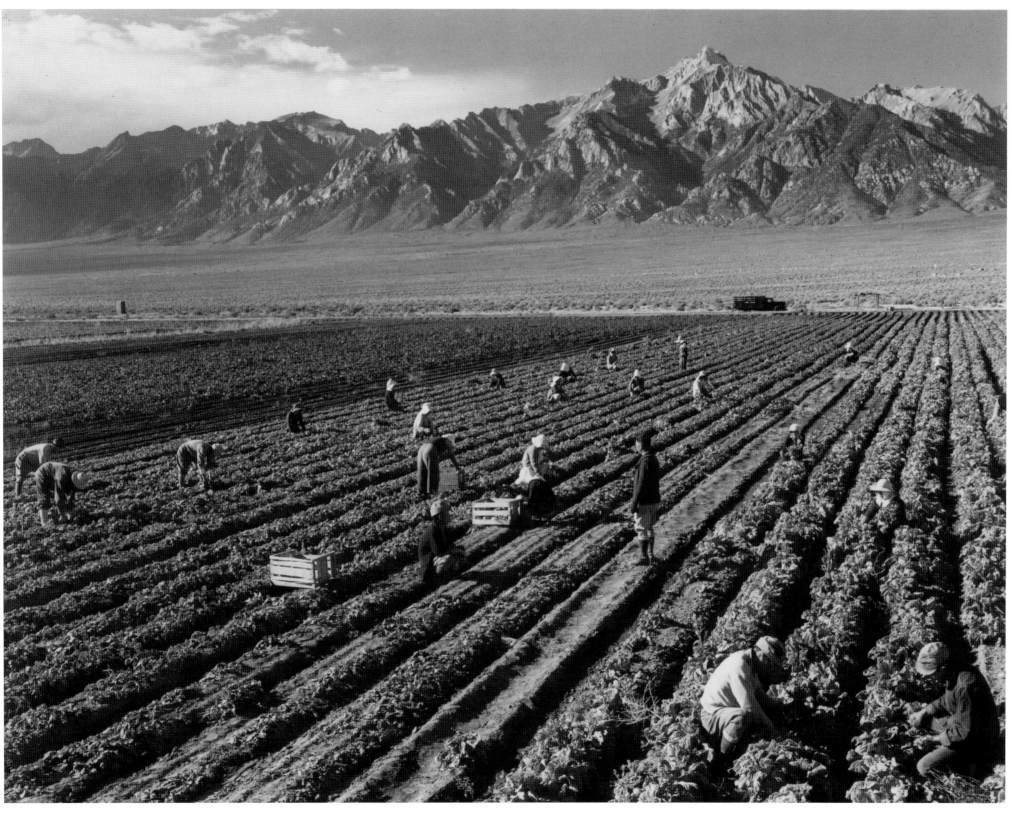

"Farm, farm workers, Mt. Williamson in background." As used on pp. 82–83 of Born Free and Equal.

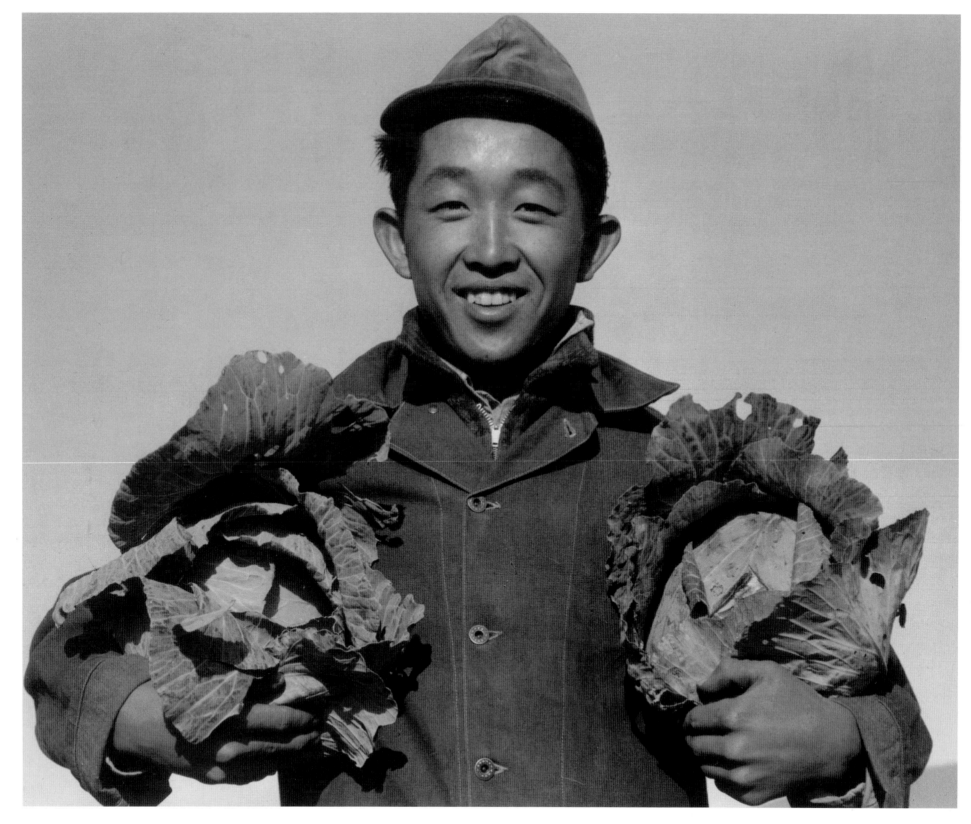

"Richard Kobayashi, farmer with cabbages." As used on p. 84 of Born Free and Equal.

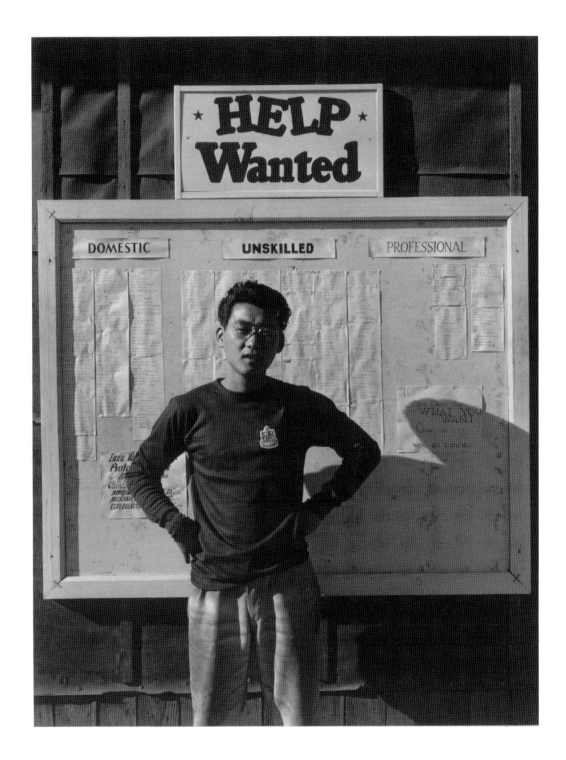

"Phil Hara relocation: in charge of work-offer signs."

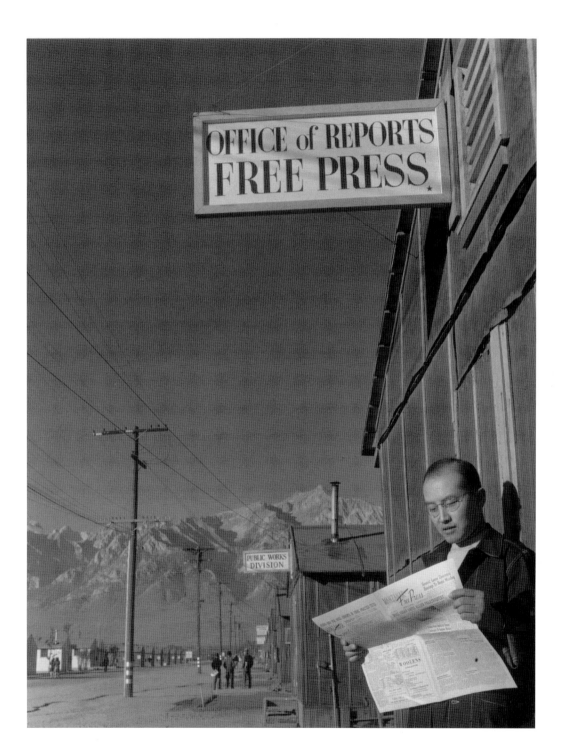

"Roy Takeno, editor reading paper in front of office."

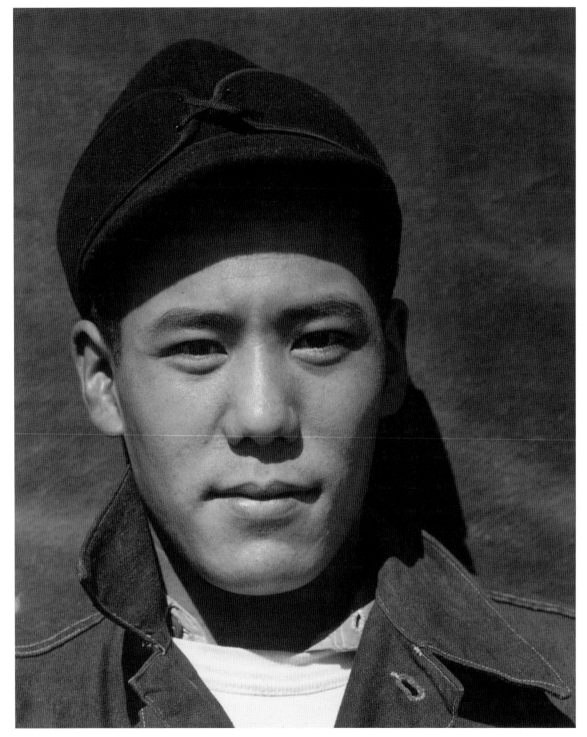

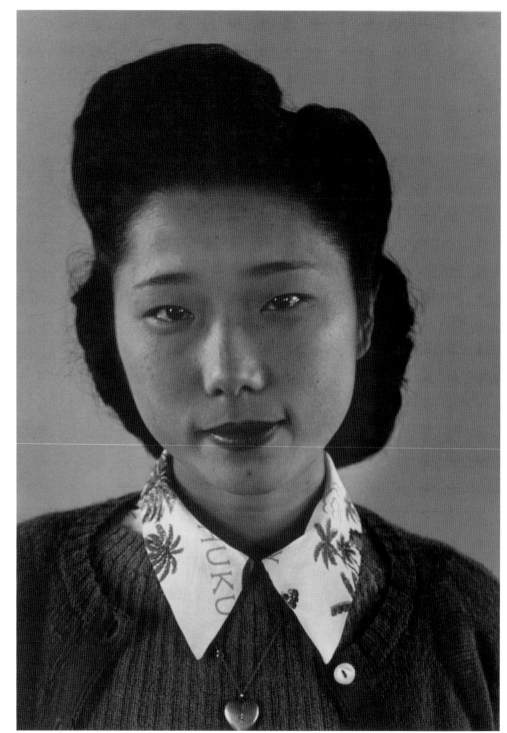

"Hidemi Tayenaka."

"Teruko Kiyomura (Bookkeeper)."

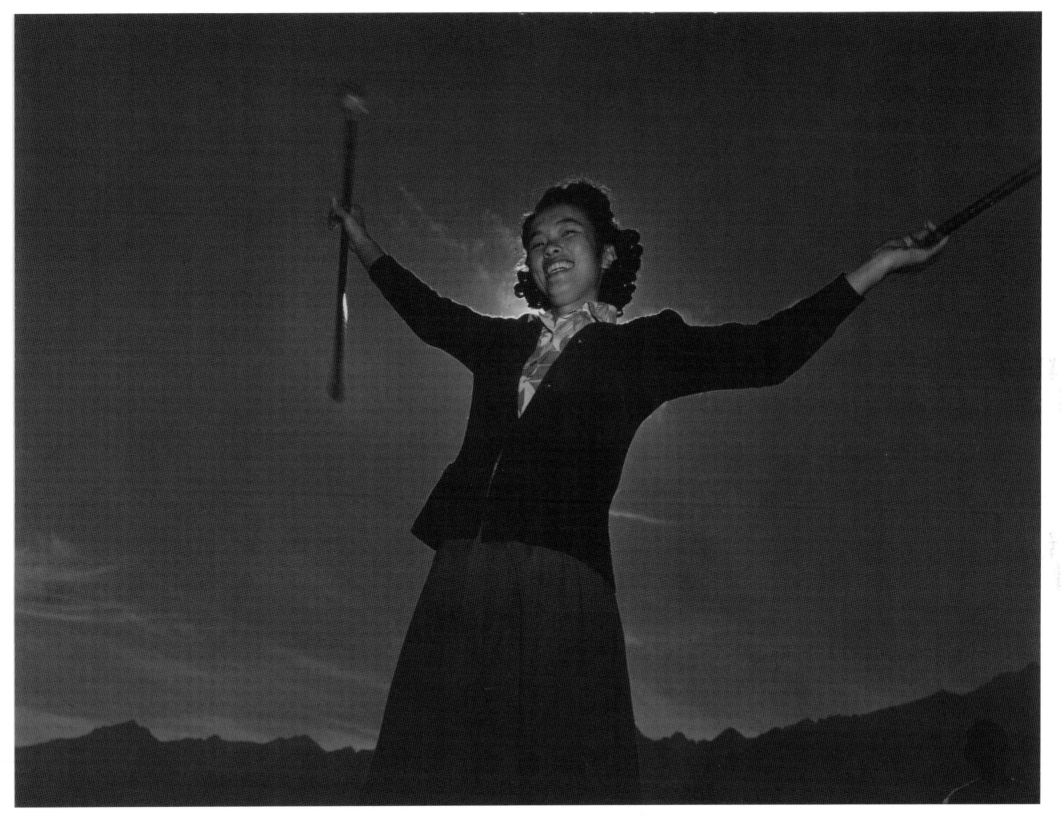

"Baton practice, Florence Kuwata."

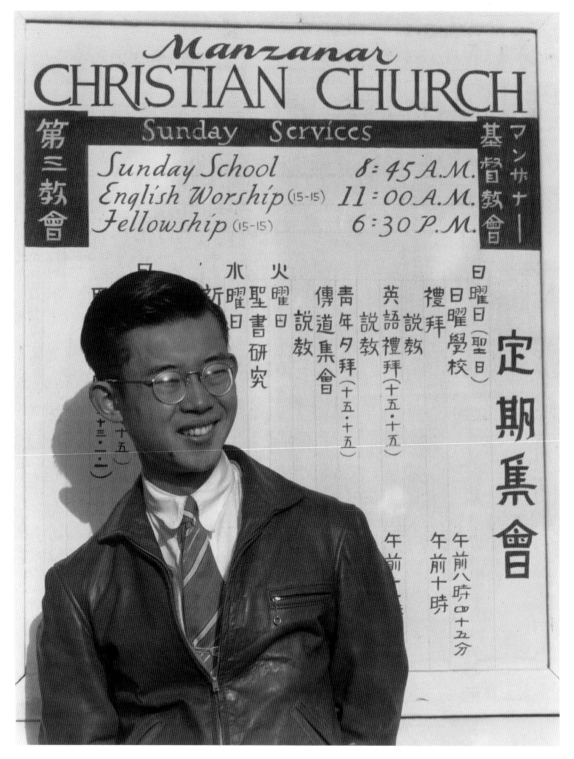

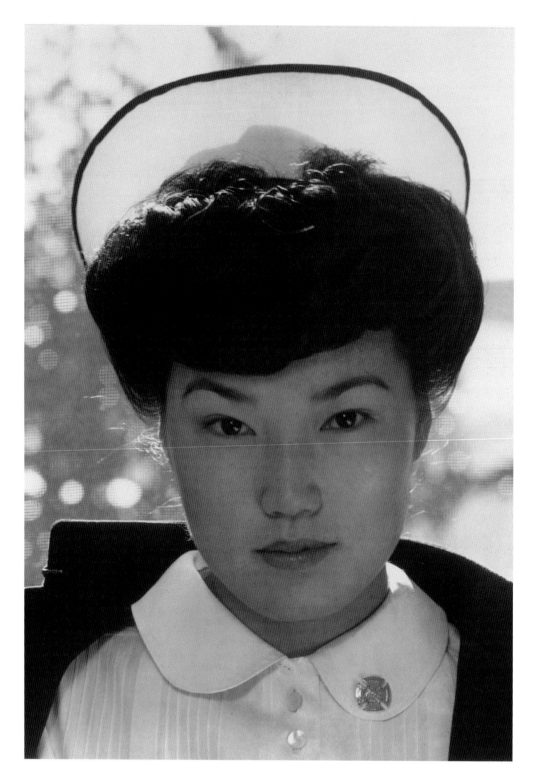

"Tatsuo Miyake (student of divinity)." As used on p. 69 of
Born Free and Equal.

"Nurse Aiko Hamaguchi." As used on p. 60 of Born Free and Equal.

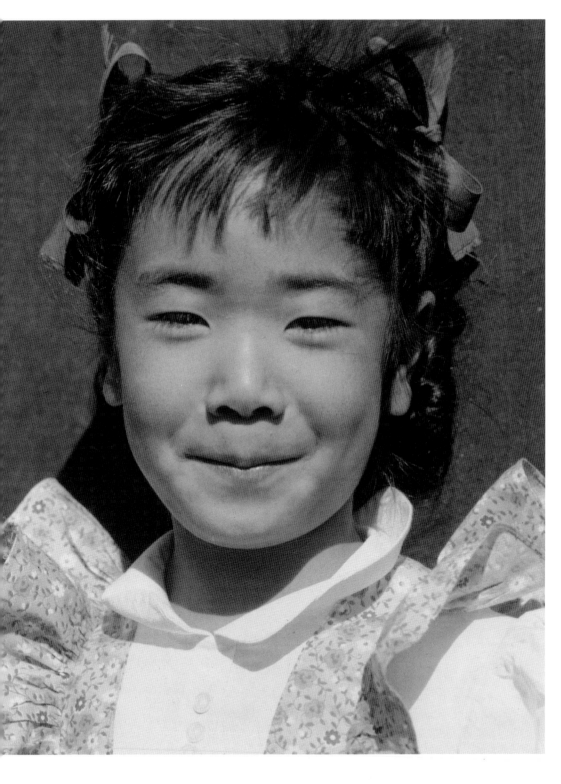

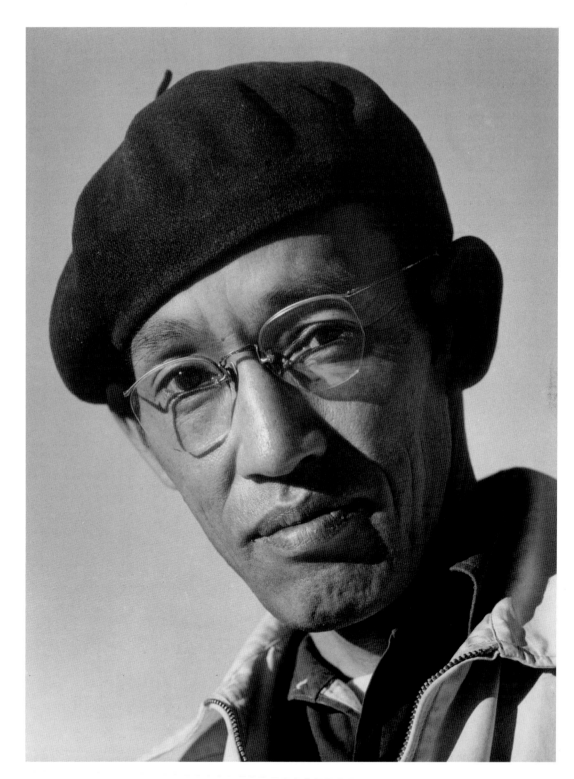

"Louise Tamiko Nakamura." As used on p. 47 of Born Free and Equal.

"Toyo Miyatake, (Photographer)."

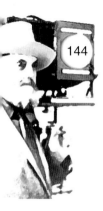

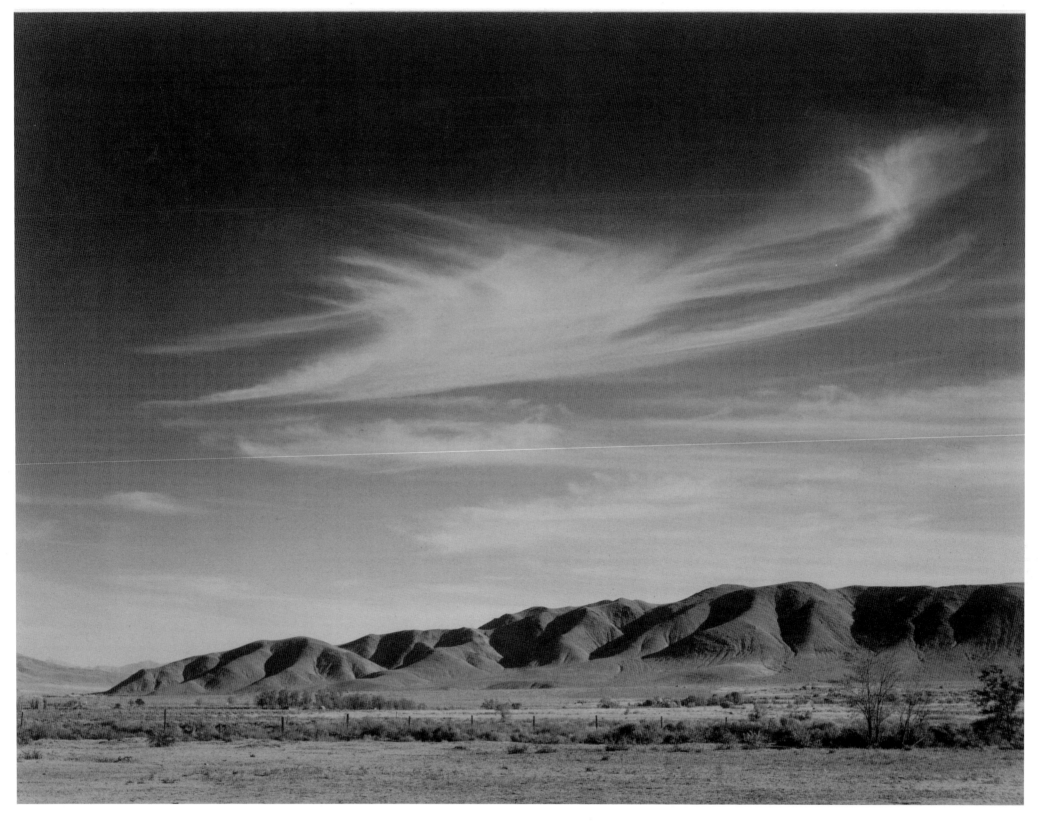

"View south from Manzanar to Alabama Hills."

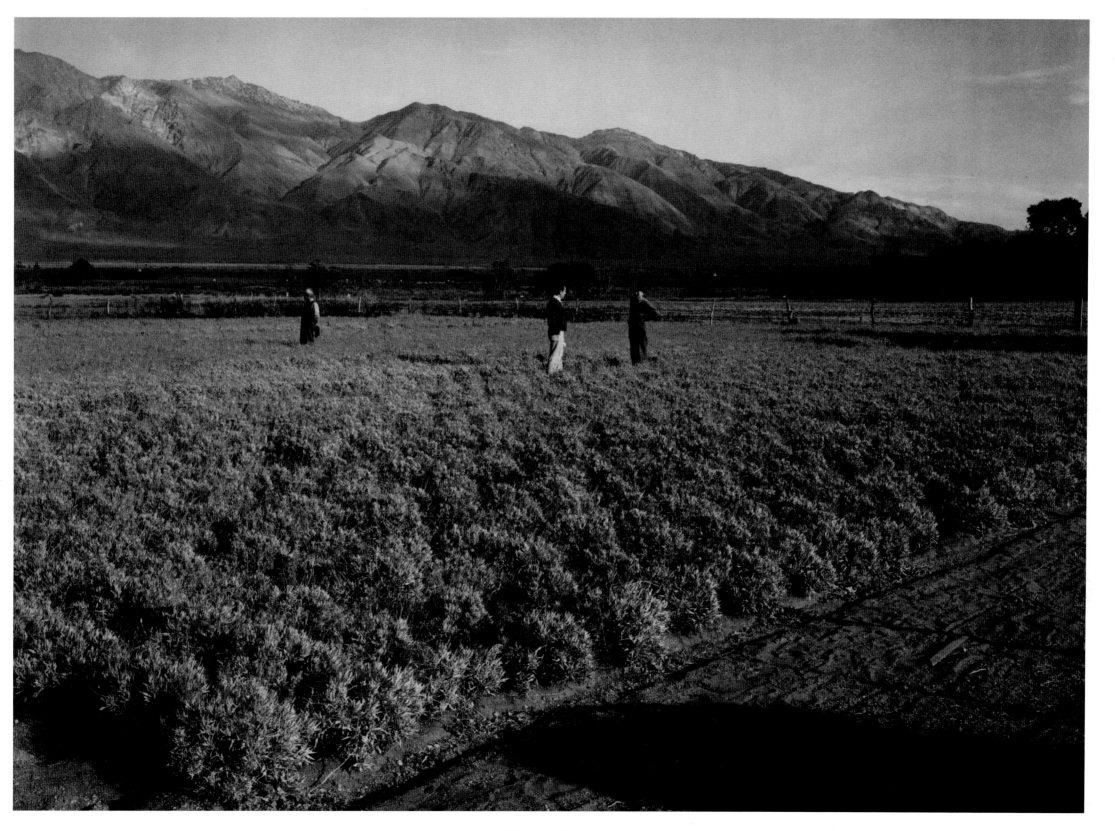

"Guayle Field."

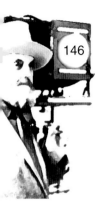

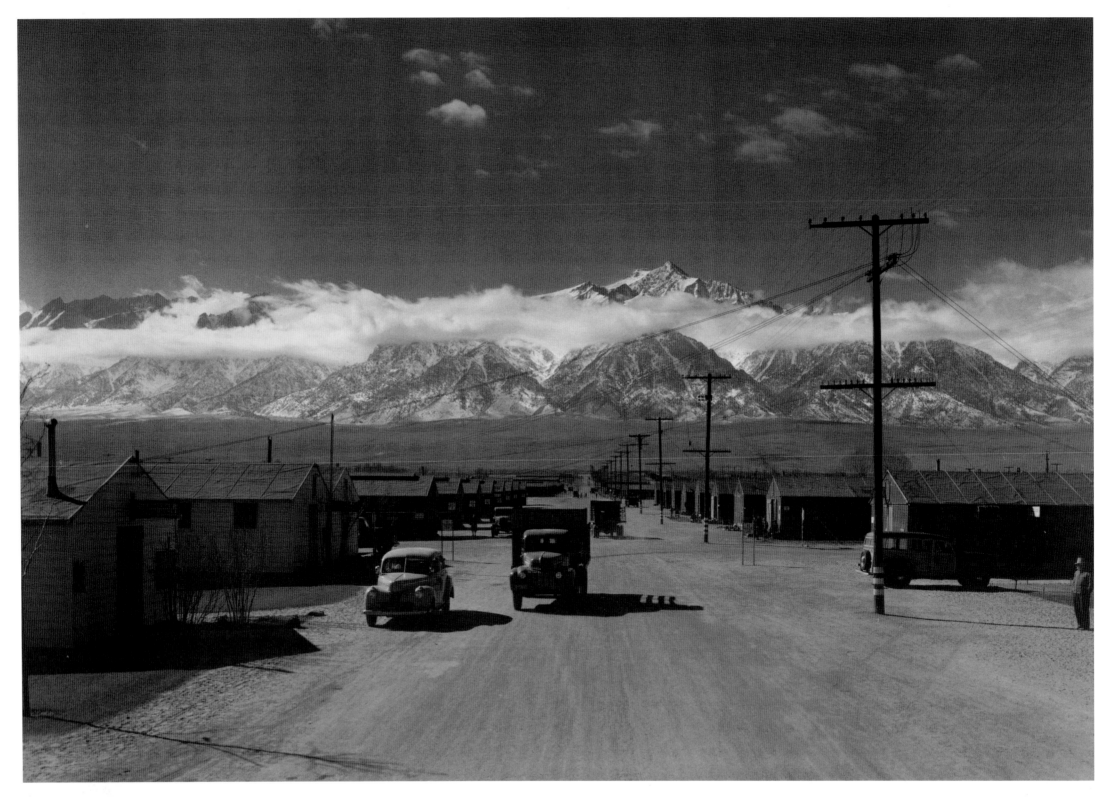

"Manzanar street scene, spring."

"Birds on wire, evening." As used on pp. 32–33 of Born Free and Equal.

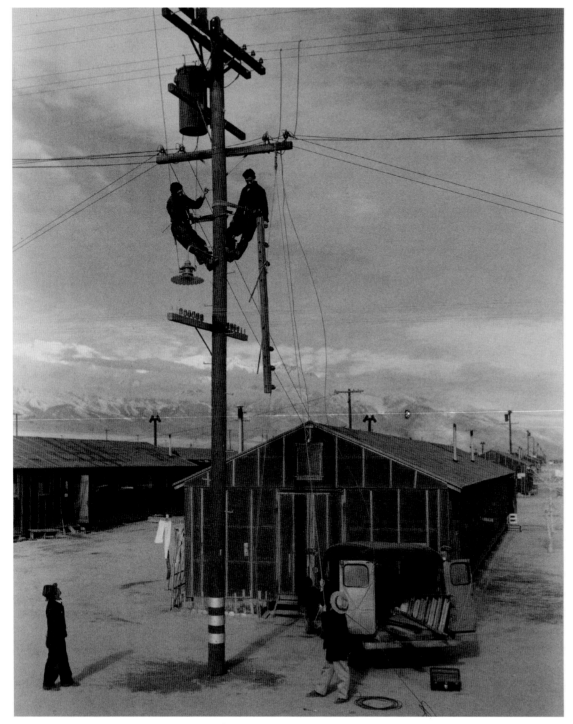

"Line crew at work in Manzanar."

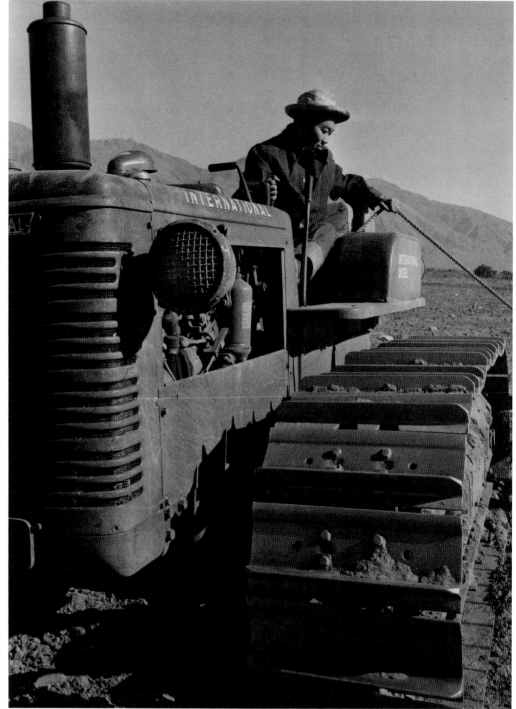

"Benji Iguchi on tractor."

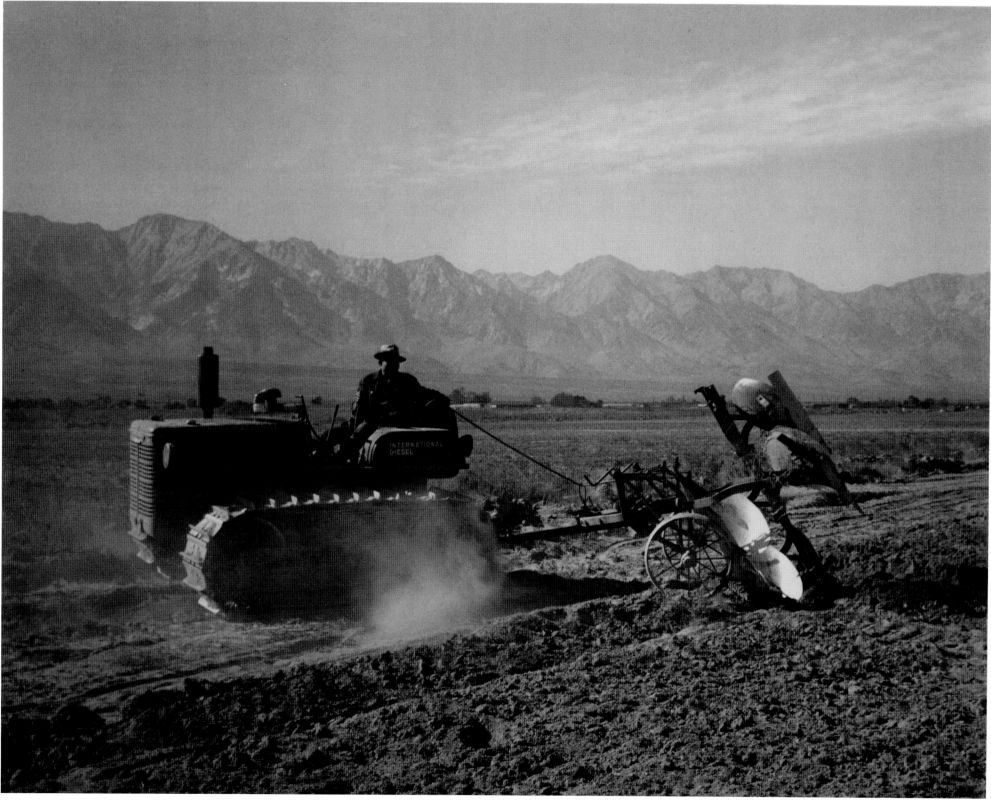

"Benji Iguchi driving tractor."

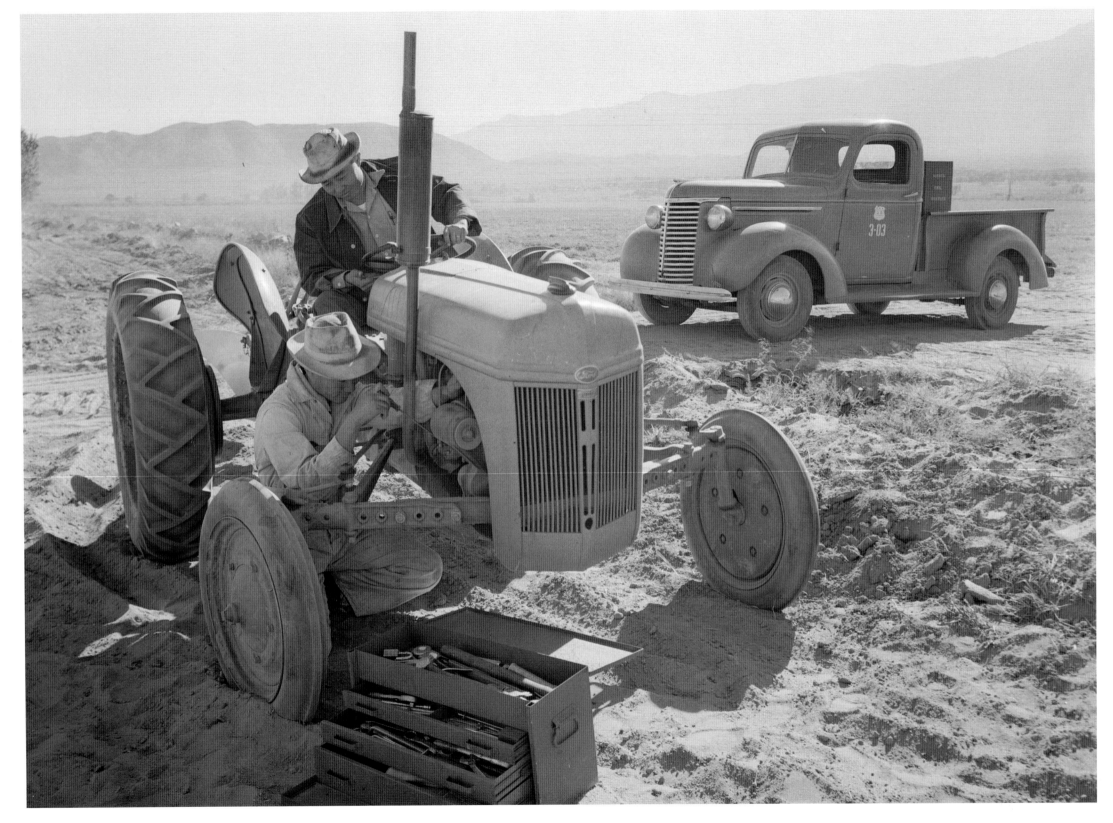

"Benji Iguchi and Harry [i.e., Henry] Hanawa, tractor repair."

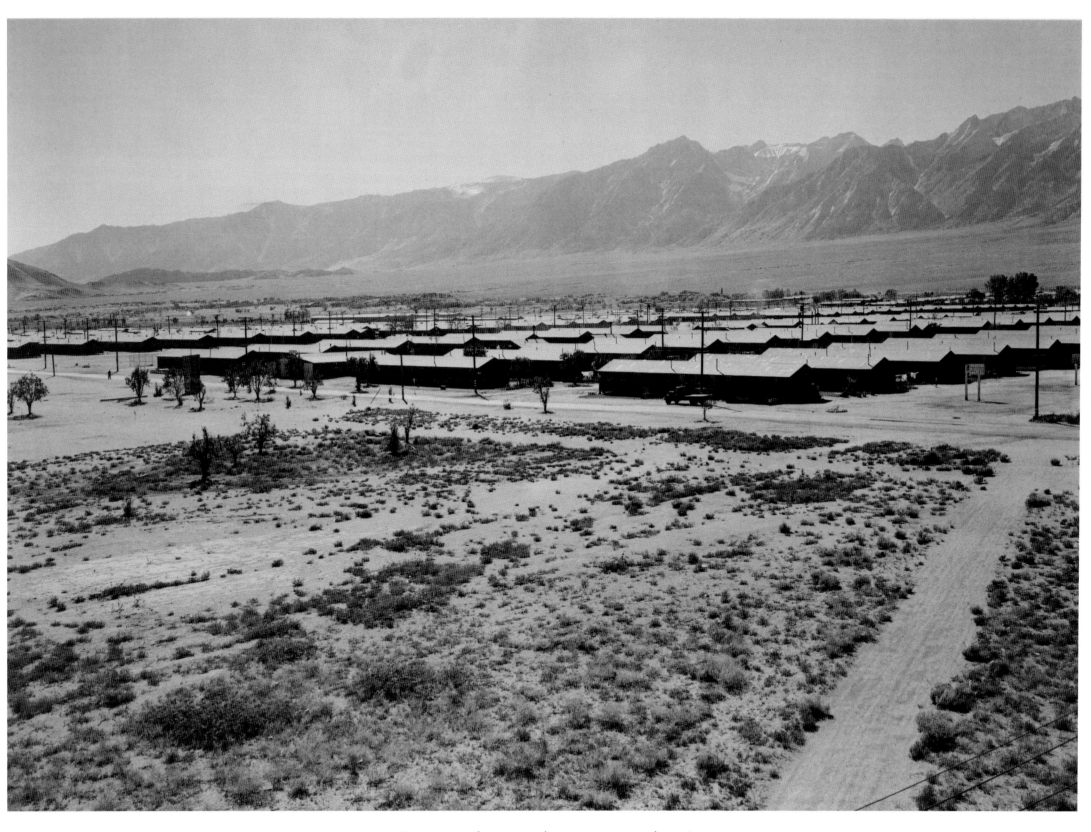

"Manzanar from guard tower, summer heat."

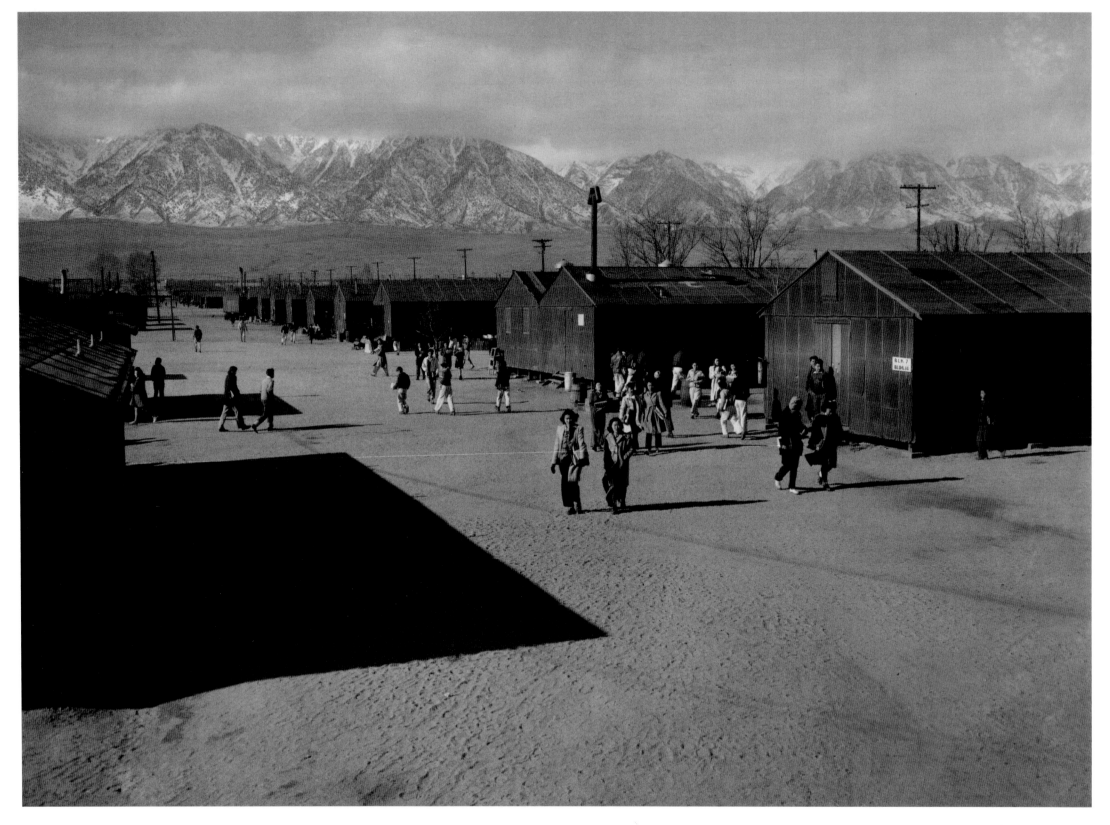

"High school recess period."

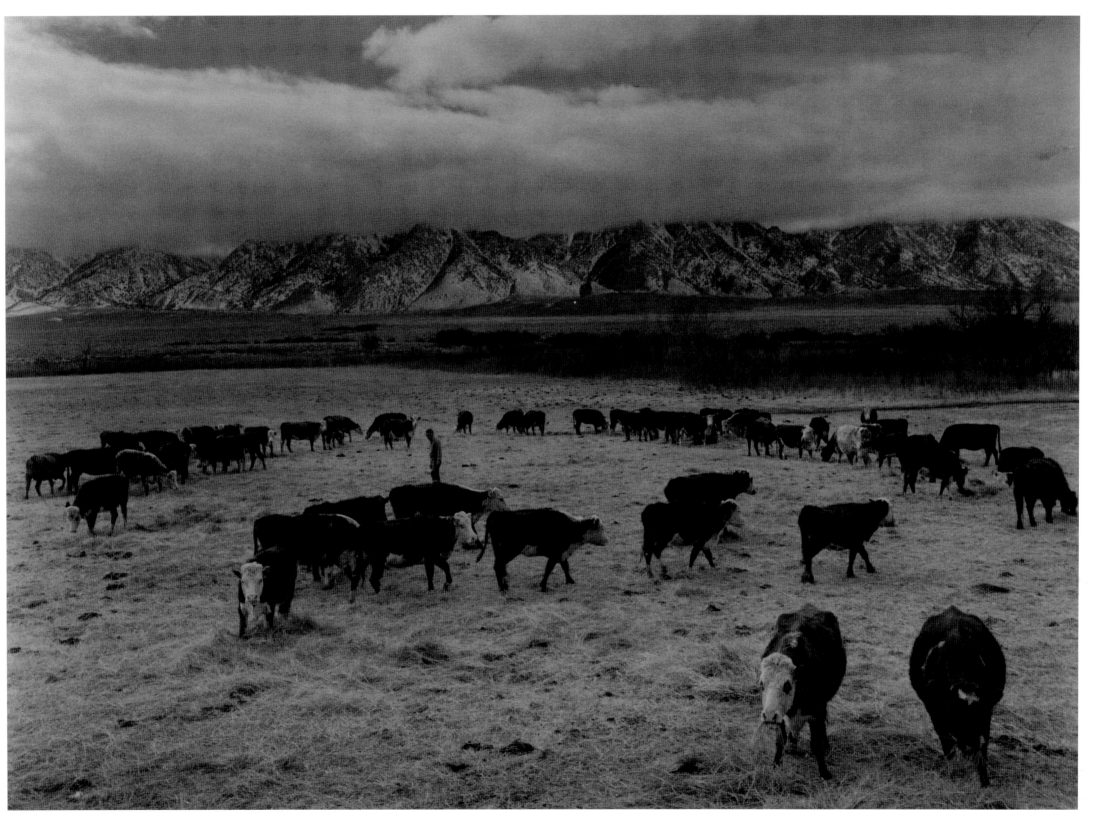

"Cattle in south farm."

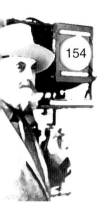

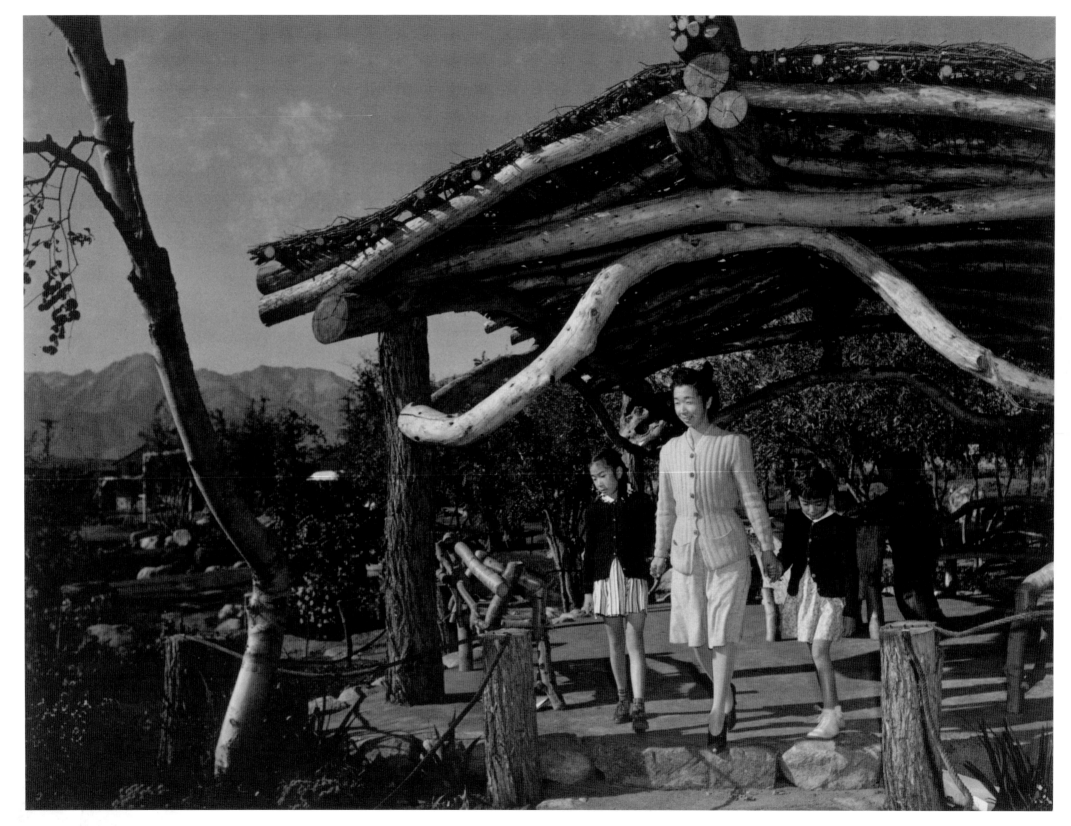

"Mrs. Nakamura and family in park."

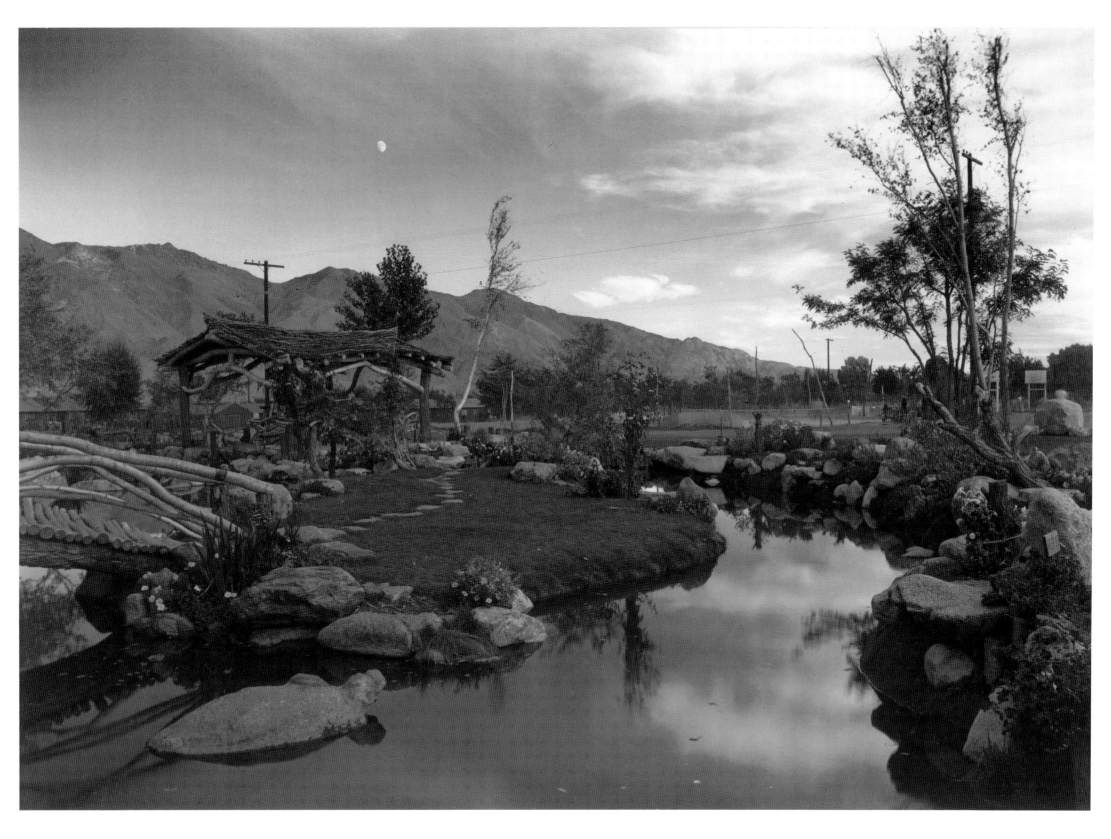

"Pool in pleasure park." As used on pp. 20–21 of Born Free and Equal.

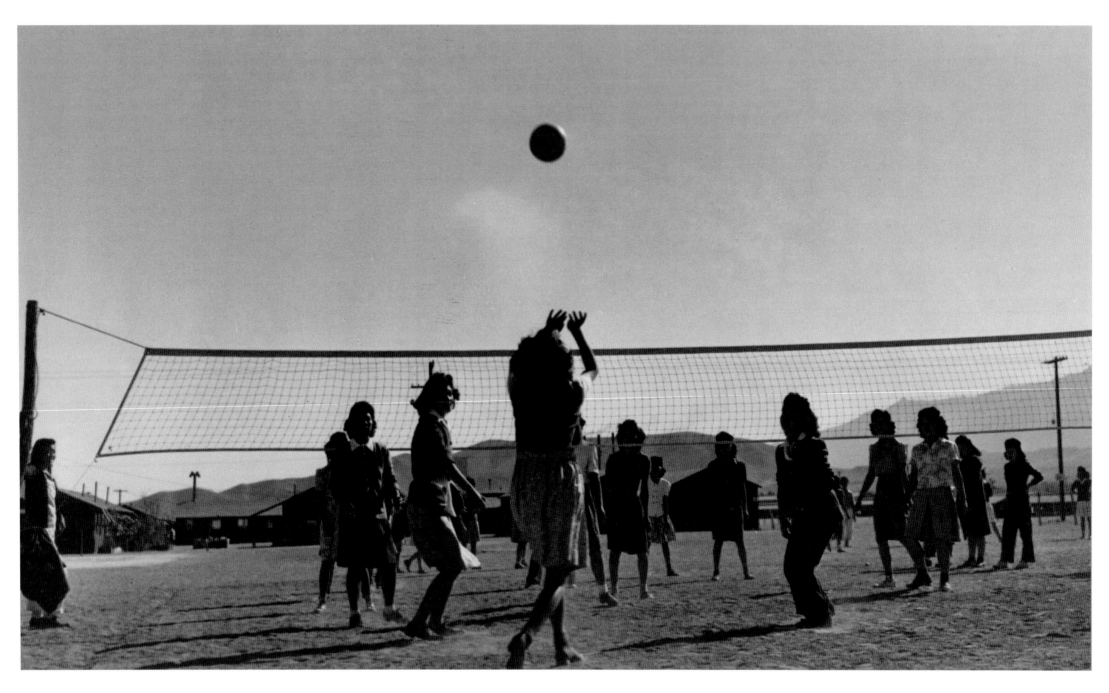

"Volley Ball game."

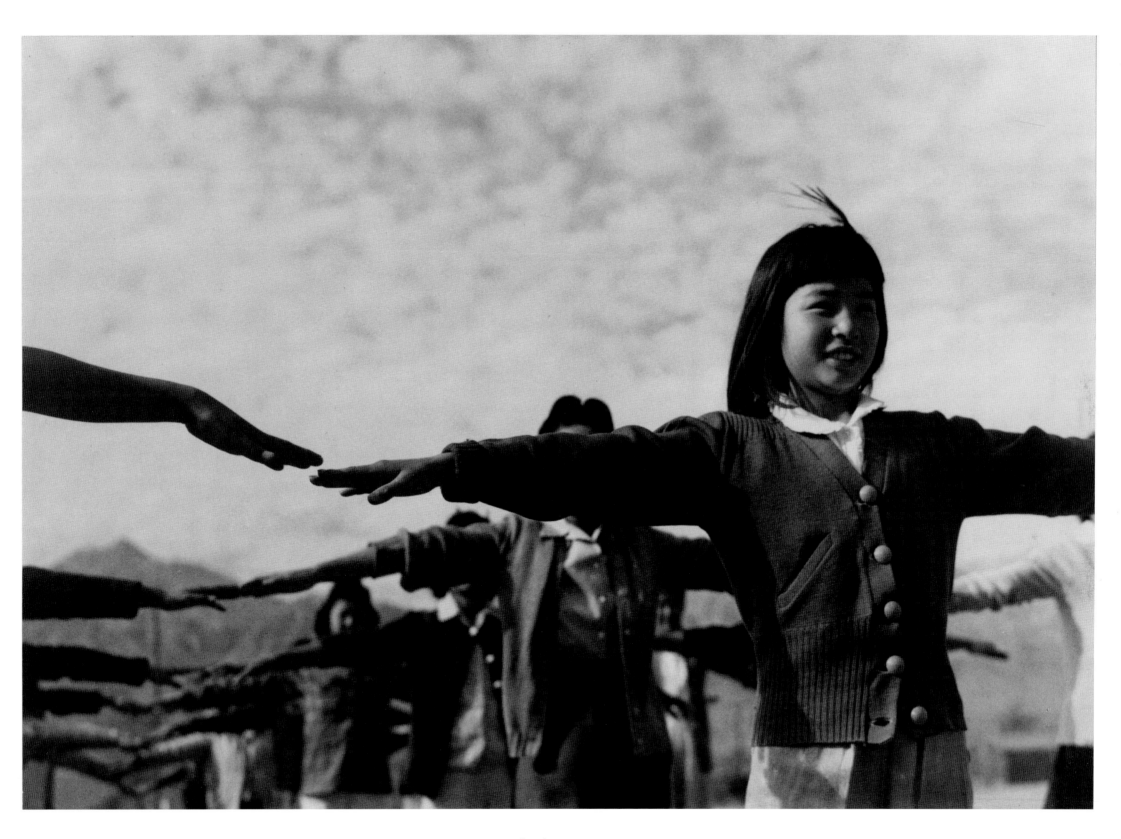

"Calesthenics [sic]."

OWENS VALLEY

This valley in eastern California is surrounded by mountain ranges—the Sierra Nevada, Inyo Mountains, and White Mountains—but the valley itself is one of the deepest in the U.S. and was formed by seismic action when the land dropped down between two vertical faults. It is blisteringly hot and dry in summer but very cold in winter. The Sierra Nevada on the western side throw a rain shadow across the valley giving it the label of "the Land of Little Rain"—a phrase used by Mary Austin to title her account of the life and land of the Mojave Desert. The Owens Valley was a prolific agricultural area before the Los Angeles Aqueduct corralled all the water. Adams was impressed by both the beauty and desolation of Owens Valley, which he visited frequently in the 1940s as the Manzanar Relocation Camp (see previous section) was also located there.

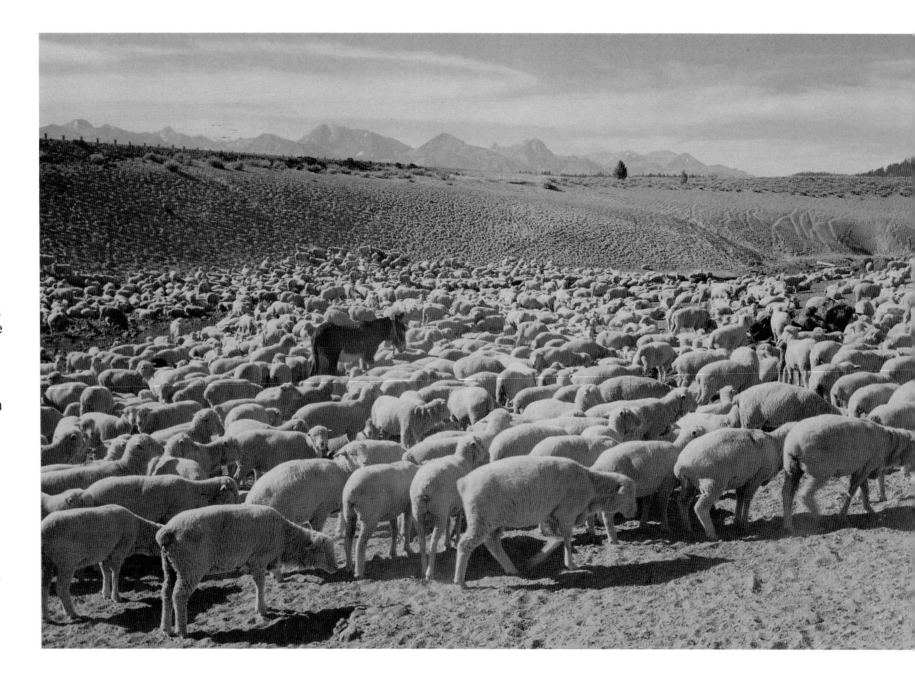

"Flock in Owens Valley, 1941."

"Flock in Owens Valley, 1941."

COLORADO

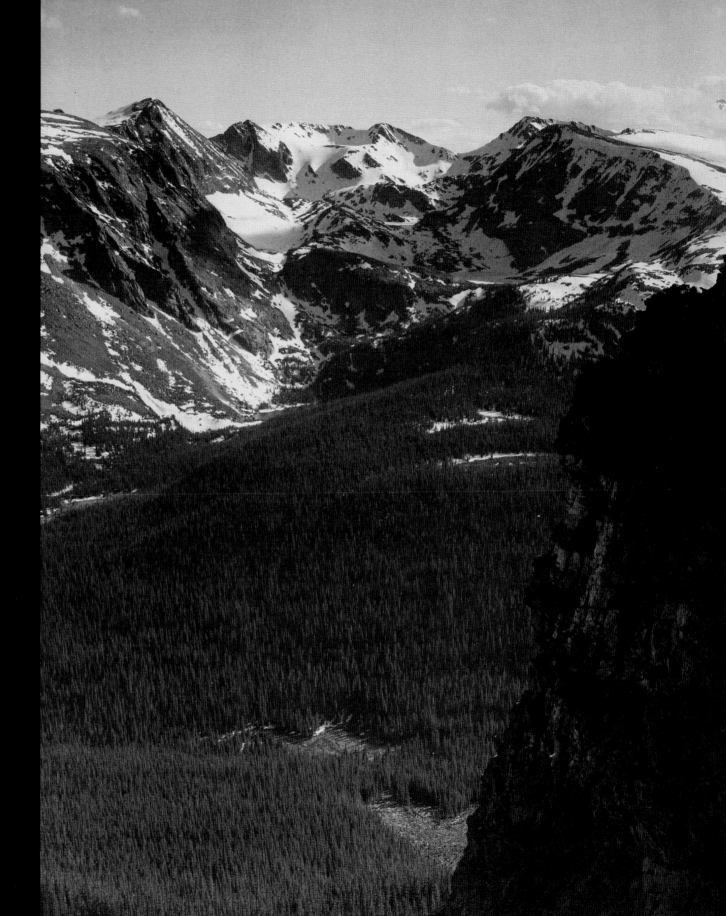

Colorado, with its magnificent arid landscape and Rocky Mountains, was one of Ansel Adams favorite states. The area was named by Spanish travelers who saw the muddy red Colorado River and called it *colorado*— red colored. It joined the Union as the 38th state when President Ulysses S. Grant signed the proclamation on August 1, 1876. The Continental Divide runs through the state along the crest of the Rocky Mountains. Water on the western side of the mountains drains into the Colorado River and Green River, and into the Pacific Ocean; waters to the east eventually reach the Gulf of Mexico and the Atlantic. Colorado has thirteen national parks or monuments of which Mesa Verde is probably the best known: it is also a World Heritage Site. Adams had already visited Colorado before the National Park Service commissioned him to make his Mural Project photographs. The state offered all the pristine beauty of unspoilt wilderness that Adams loved and fought so hard to preserve for future generations. His enjoyment of the state bubbles through a letter he wrote Nancy Newhall in June 1942 and quoted in his autobiography: "Got a superb picture of the Never Summer Range west of the Rocky Mountain National Park—great snow-covered mountains with shaded, snow-covered hills in the foreground ..."

"In Rocky Mountain National Park."

MESA VERDE NATIONAL PARK

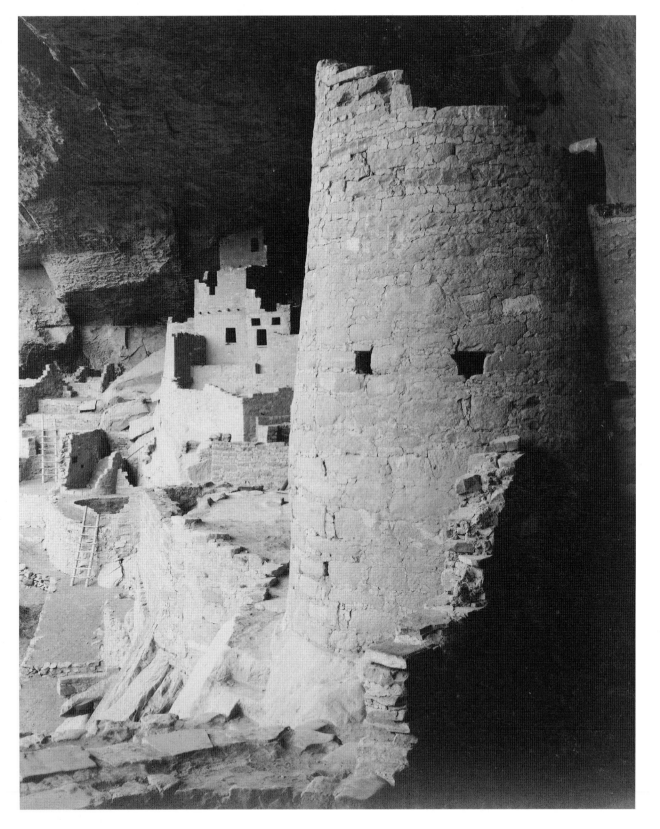

"Untitled."

Mesa Verde means "green table" in Spanish and is located at an elevation of 7,000 feet in Montezuma County, Colorado. It was inhabited by ancient pueblo peoples between AD 600–1300, after which they mysteriously abandoned it and apparently completely disappeared, although it is now thought they migrated south into Arizona and New Mexico following a severe drought. In the area are some 600 sandstone and adobe cliff dwellings long since abandoned by their builders and over four thousand other archaeological sites. Mesa Verde was established by President Theodore Roosevelt as one of the first national parks in June 1906, "to preserve the works of man" and was the first such to do so. It is also the only cultural national park set aside by the National Park Service. Ansel Adams photographed the remarkable cliff dwellings as part of his commission from the U.S. National Park Service for his Mural Project. His photographs show how the cliff dwellings looked before tourism and casual looting degraded the structures. Adams enjoyed his trip across Colorado to Mesa Verde through the huge gorges which filled into roaring torrents with the heavy rains. He described the experience as a "spectacular and dangerous trip."

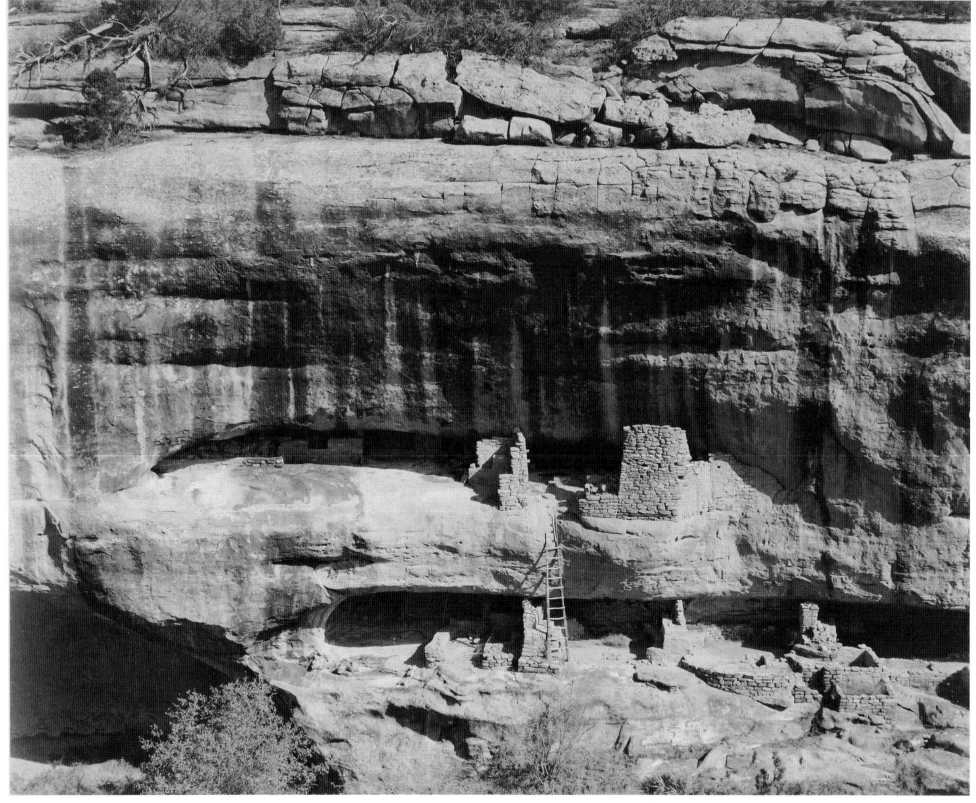

"Mesa Verde National Park, 1941."

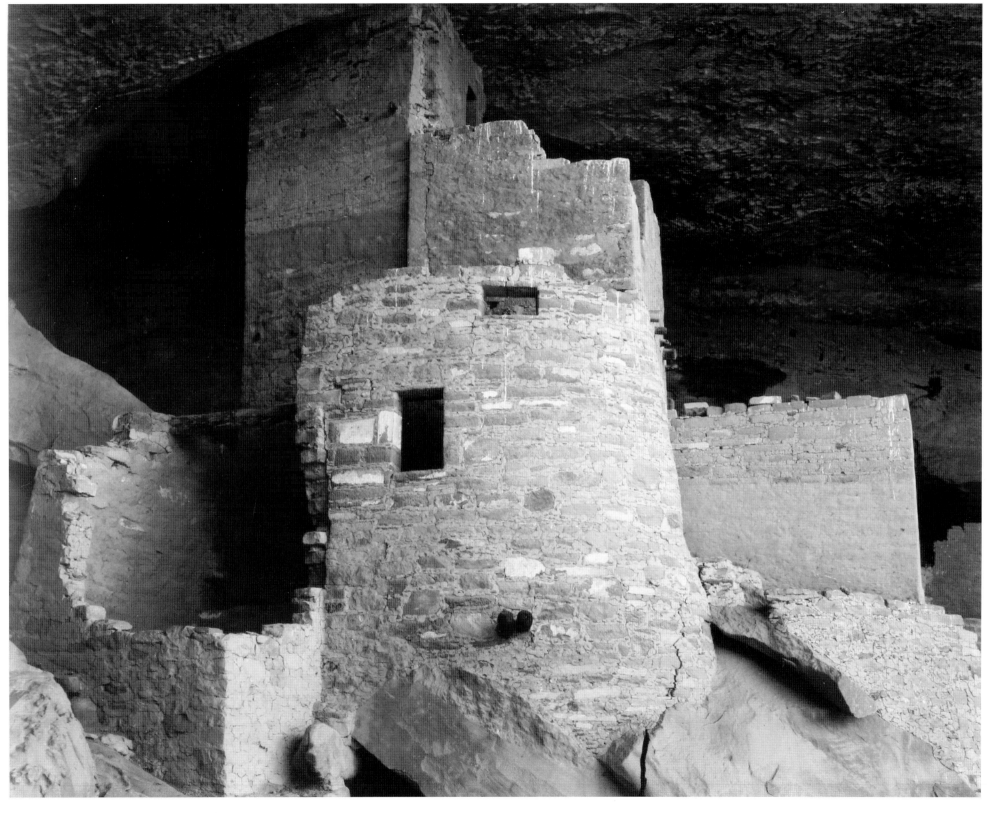

"Cliff Palace, Mesa Verde National Park."

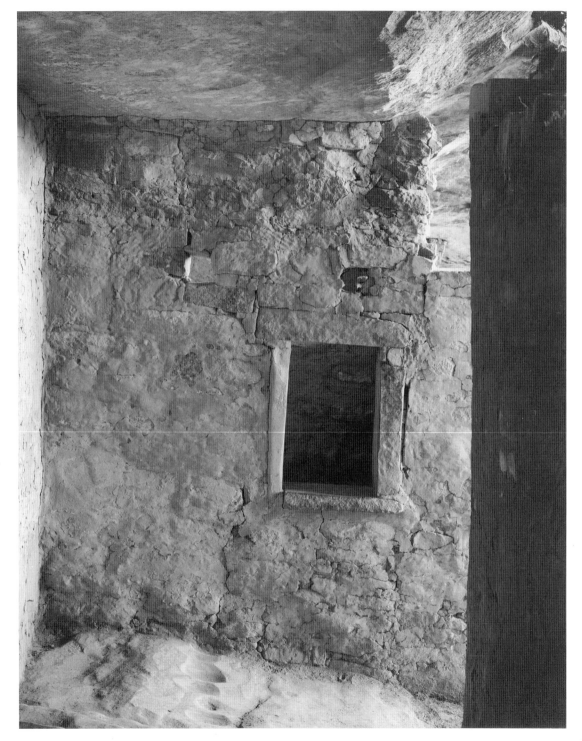

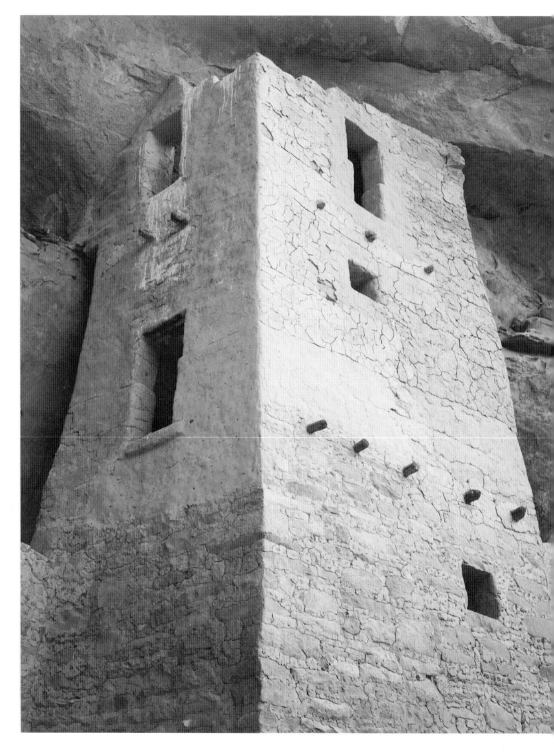

"Interior at Ruin Cliff Palace, Mesa Verde National Park, 1941."

"Cliff Palace, Mesa Verde National Park."

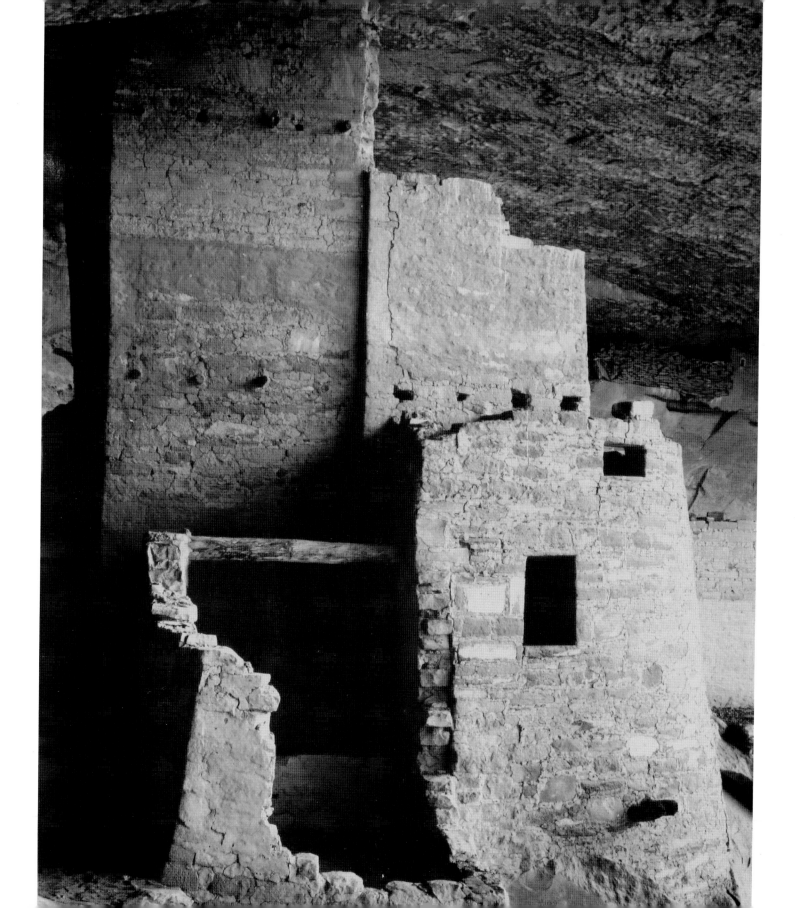

"Cliff Palace, Mesa Verde National Park."

ROCKY MOUNTAIN NATIONAL PARK

Rocky Mountain National Park lies in north-central Colorado in the Front Range of the Rocky Mountains. The Continental Divide straddles the region marking where waters headed for the Pacific Ocean drain westwards and waters eventually destined for the Atlantic and Gulf of Mexico drain eastwards. The headwaters of the Colorado River rise here. Despite vocal lobbying from miners, loggers and other interested parties, the area became a national park in January 1915 when President Woodrow Wilson signed the bill passed by Congress. Camps, lodges, and roads were built in the 1920s, culminating in the construction of the scenic Trail Ridge Road (built 1929–1933) linking the town of Estes Park to Grand Lake. The road climbs to a maximum elevation of 12,183 feet and at Milner Pass it crosses the Continental Divide. Ansel Adams came here to photograph for his National Park Service mural commission and those images played a significant role in the recent centennial celebrations.

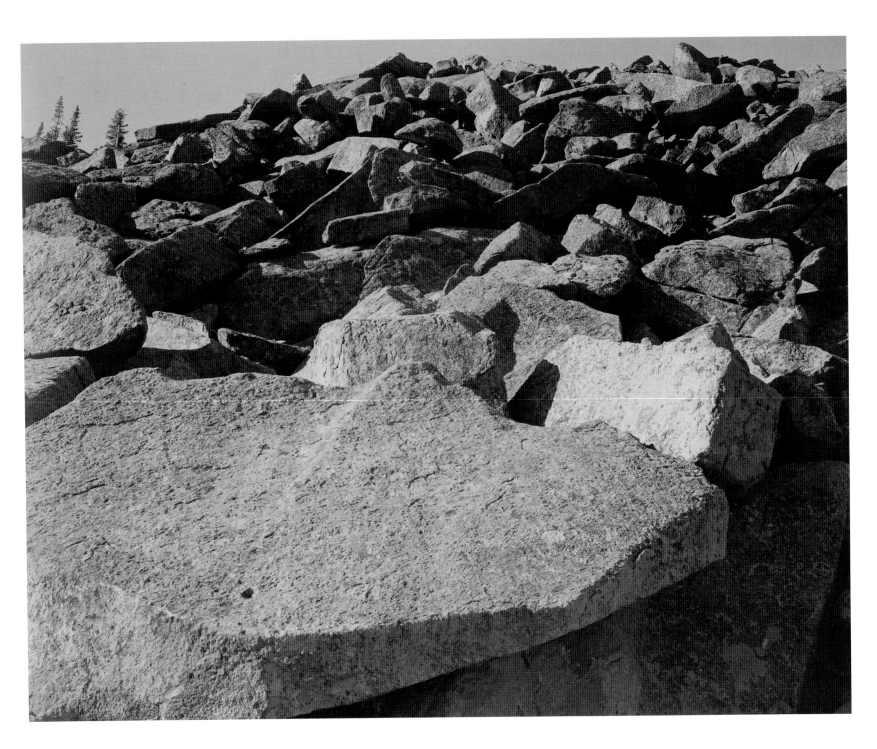

"Moraine, Rocky Mountain National Park."

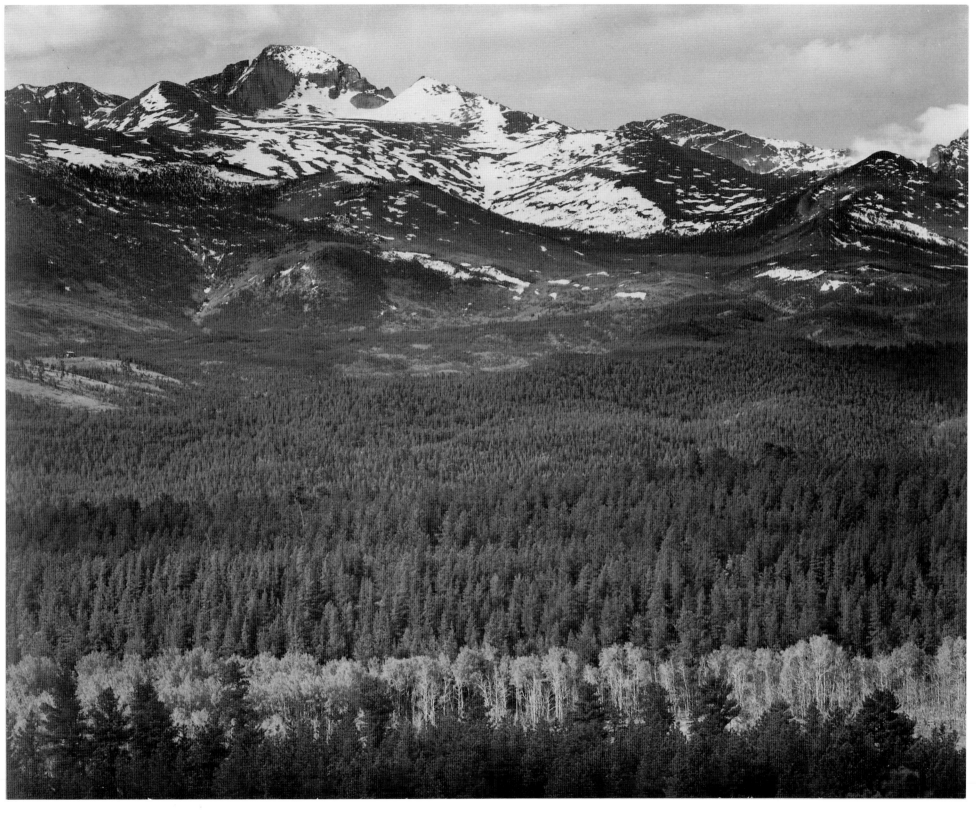

"Long's Peak from Road. Rocky Mountain National Park."

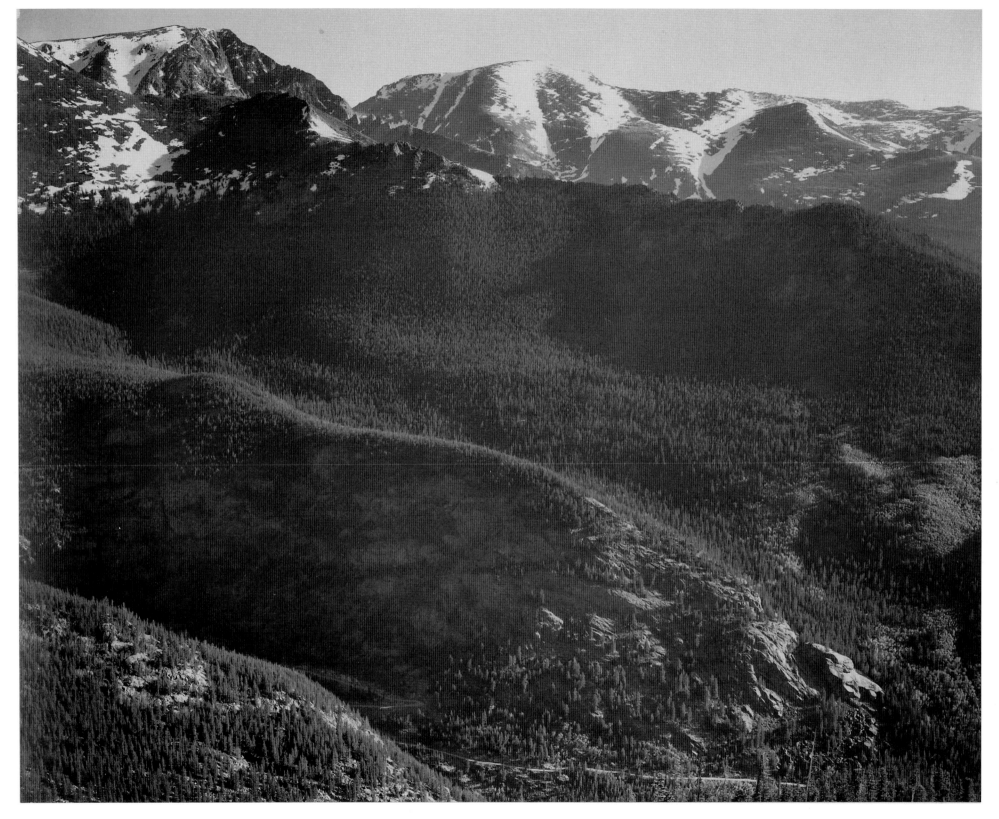

"In Rocky Mountain National Park."

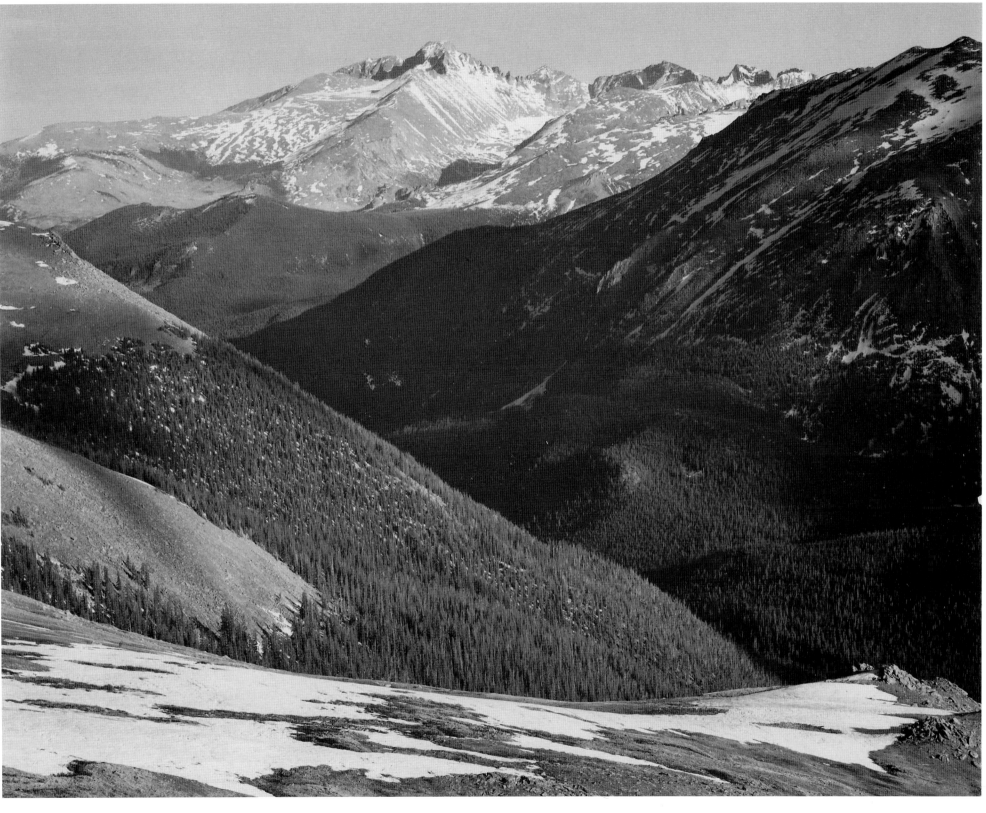

"Long's Peak, Rocky Mountain National Park."

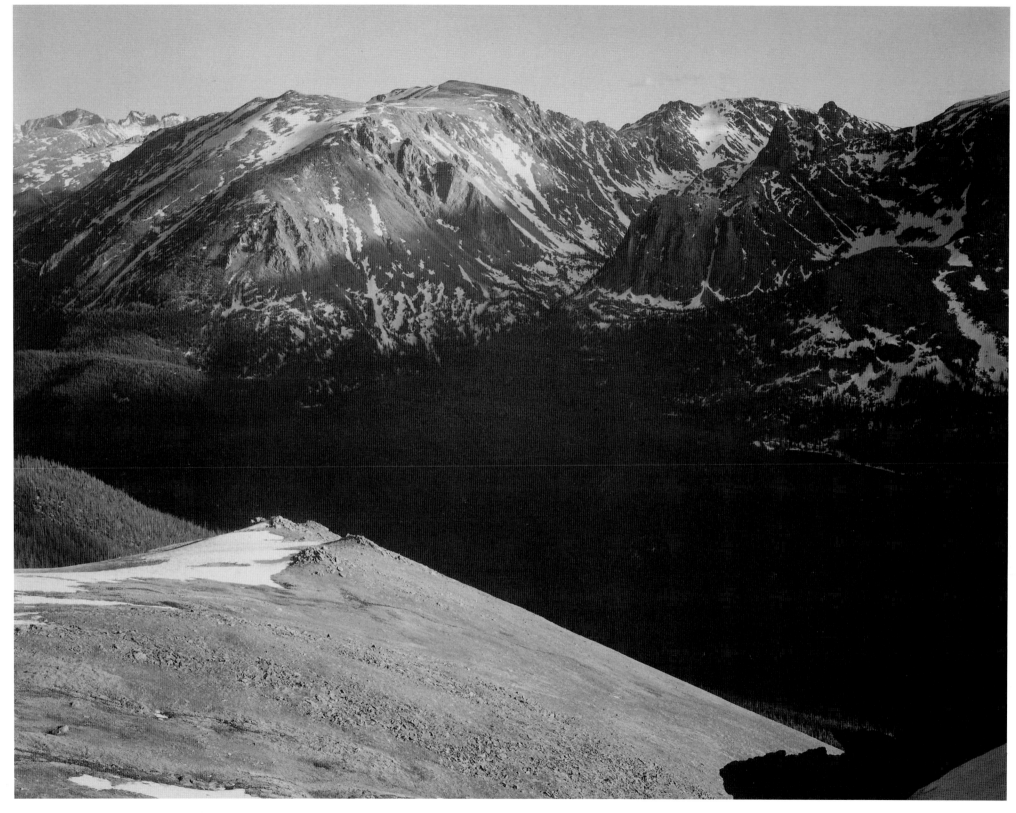

"In Rocky Mountain National Park."

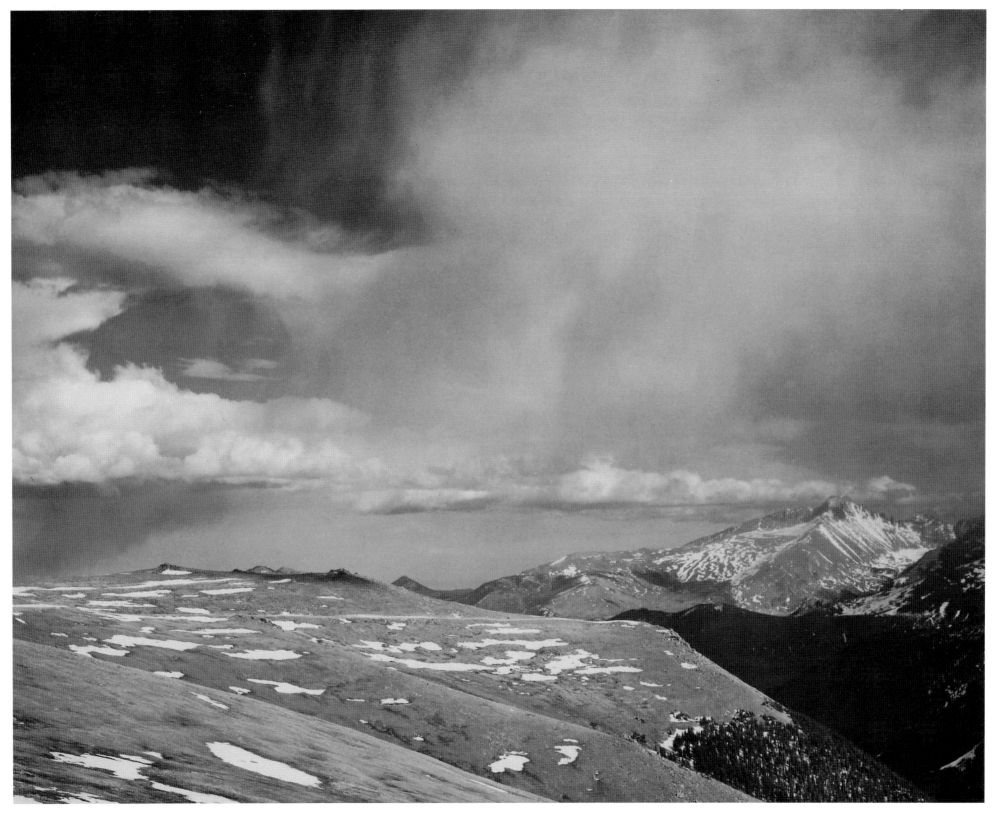

"In Rocky Mountain National Park."

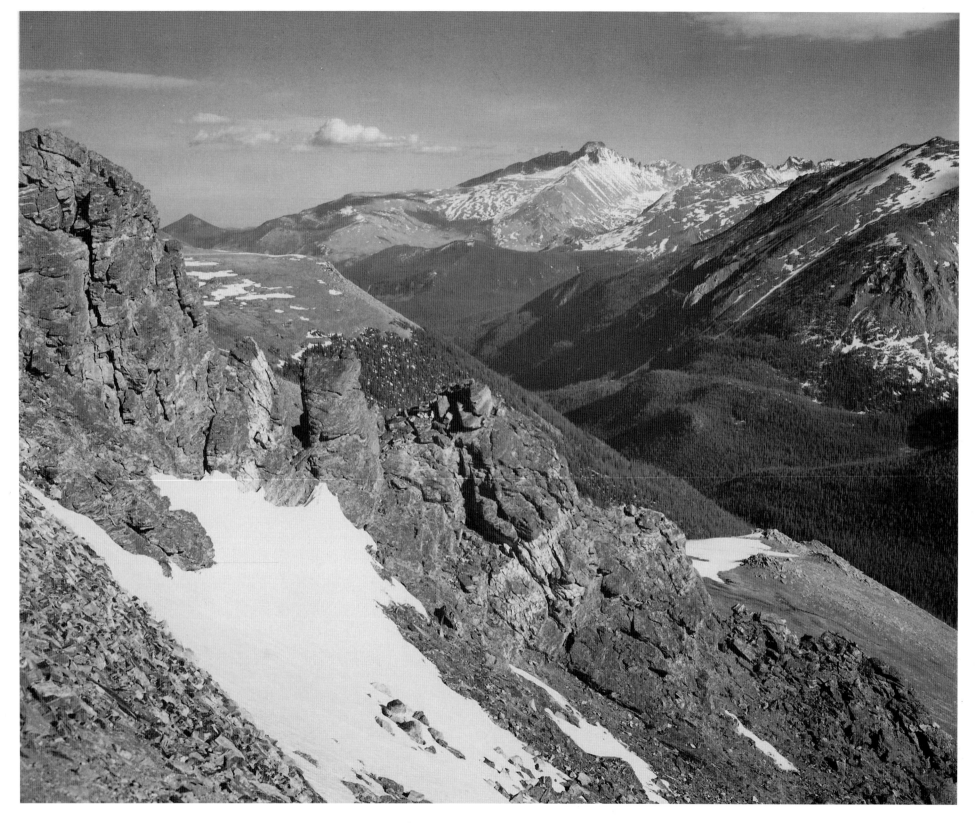

"Long's Peak, Rocky Mountain National Park."

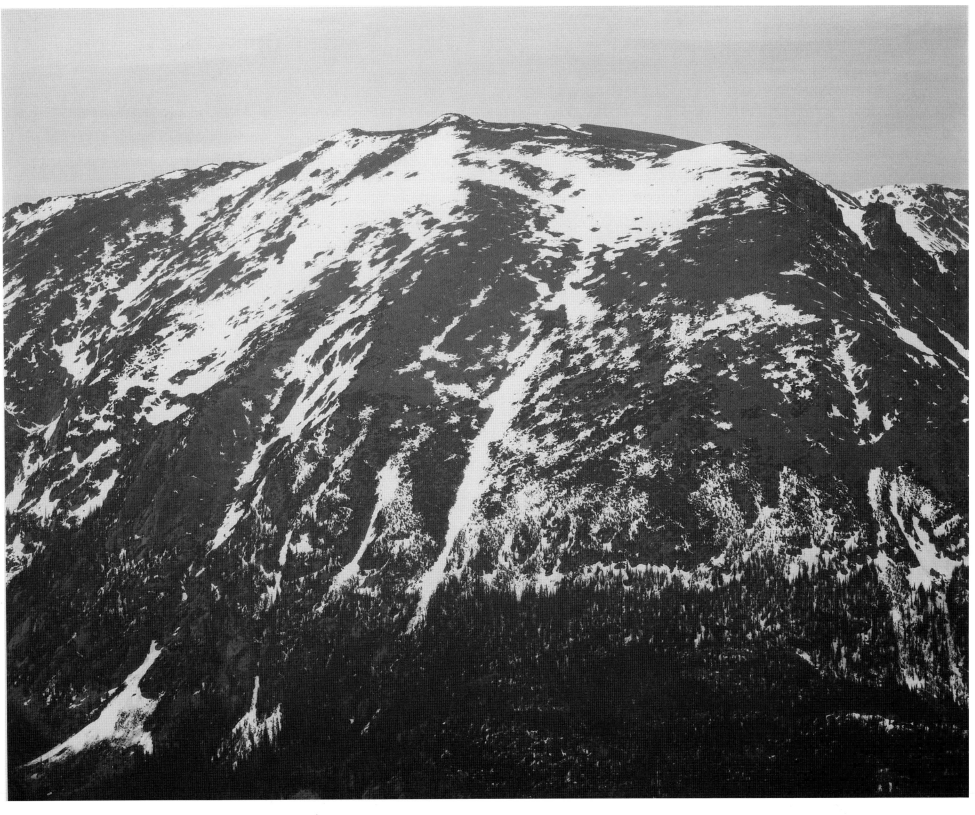

"In Rocky Mountain National Park."

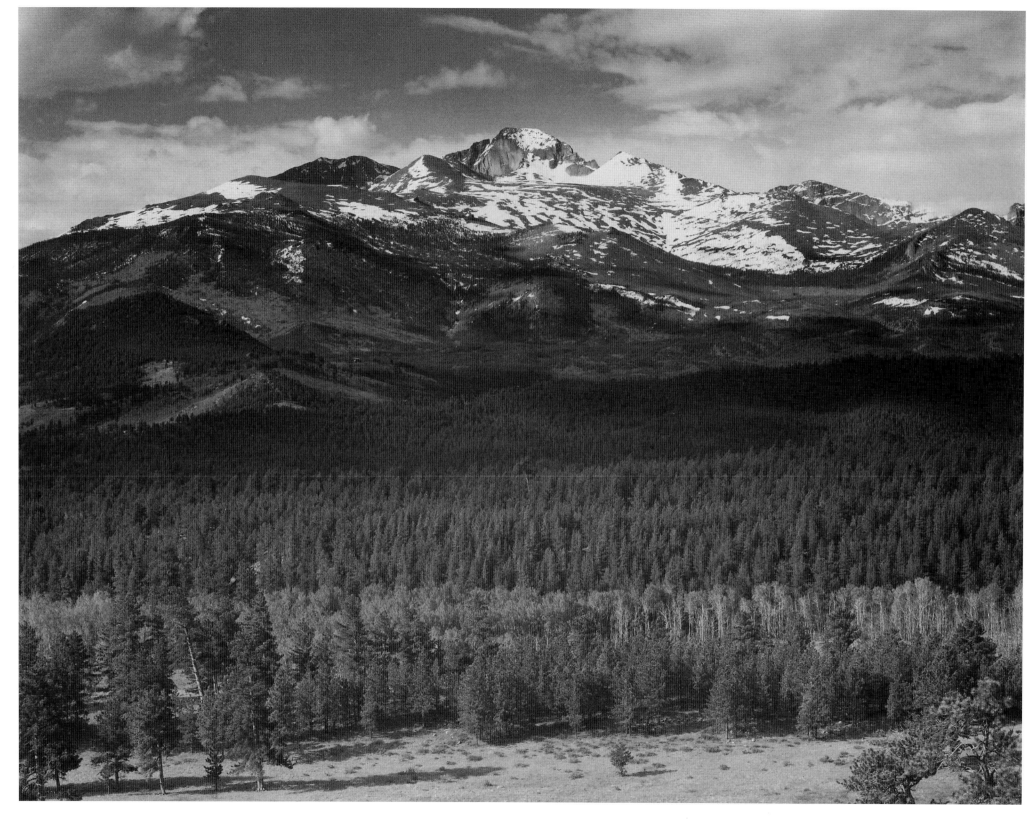

"Long's Peak from North, Rocky Mountain National Park."

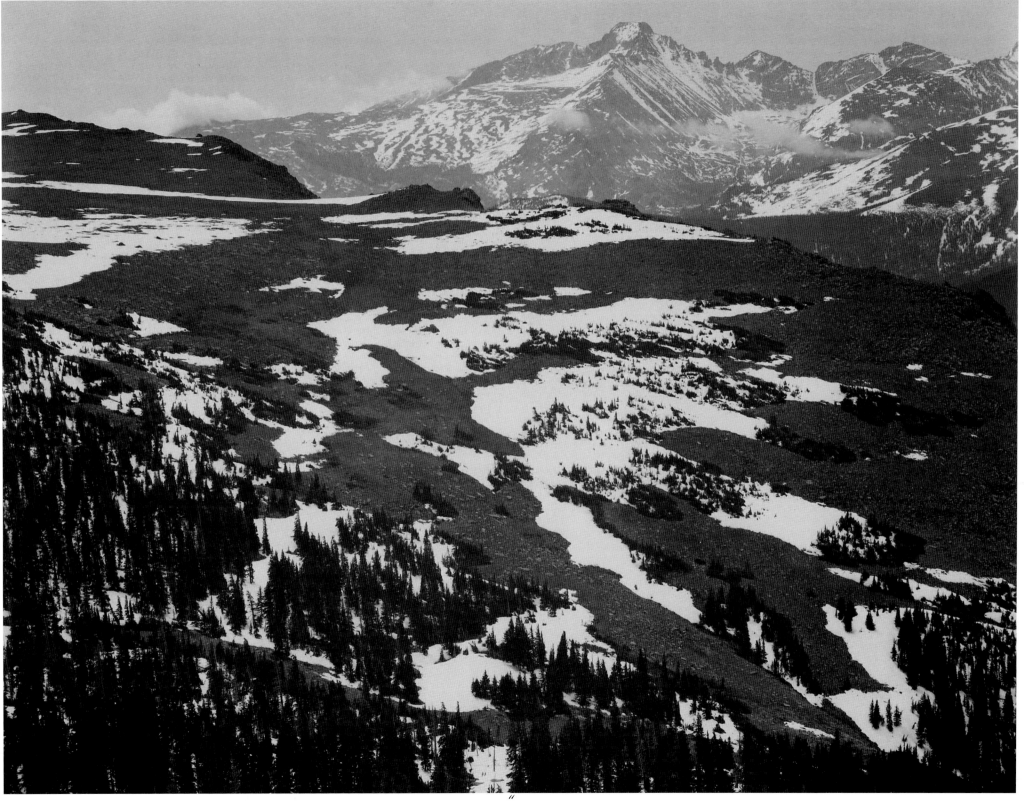

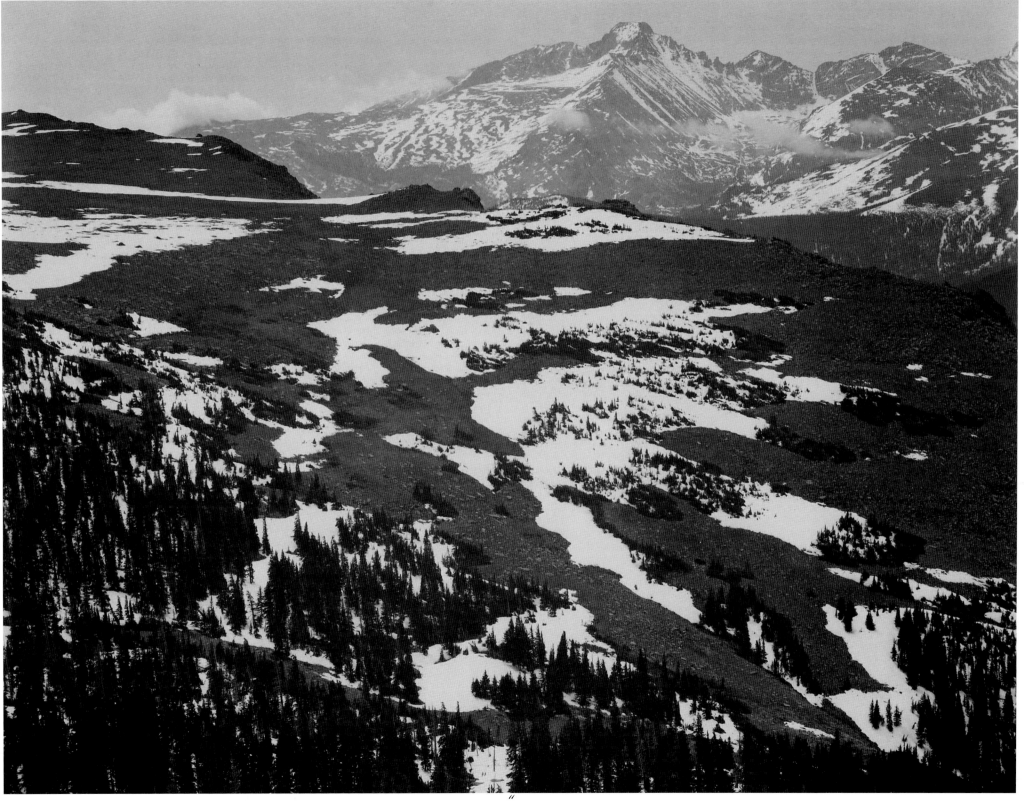

"Long's Peak, Rocky Mountain National Park."

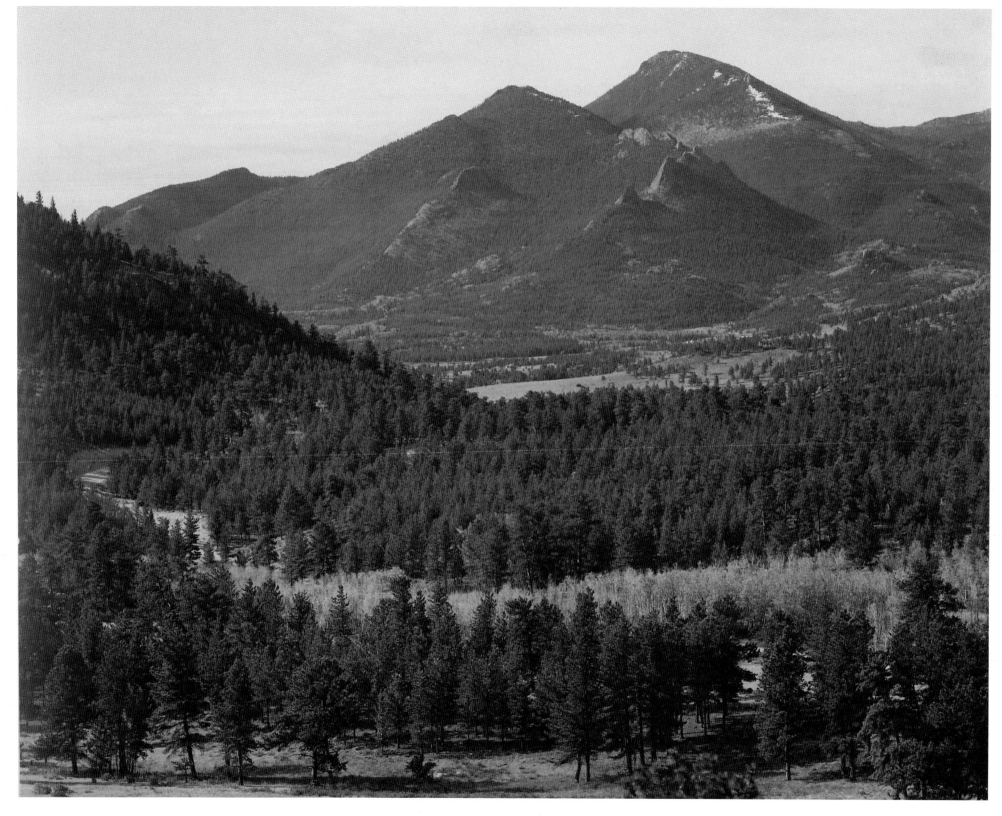

"In Rocky Mountain National Park."

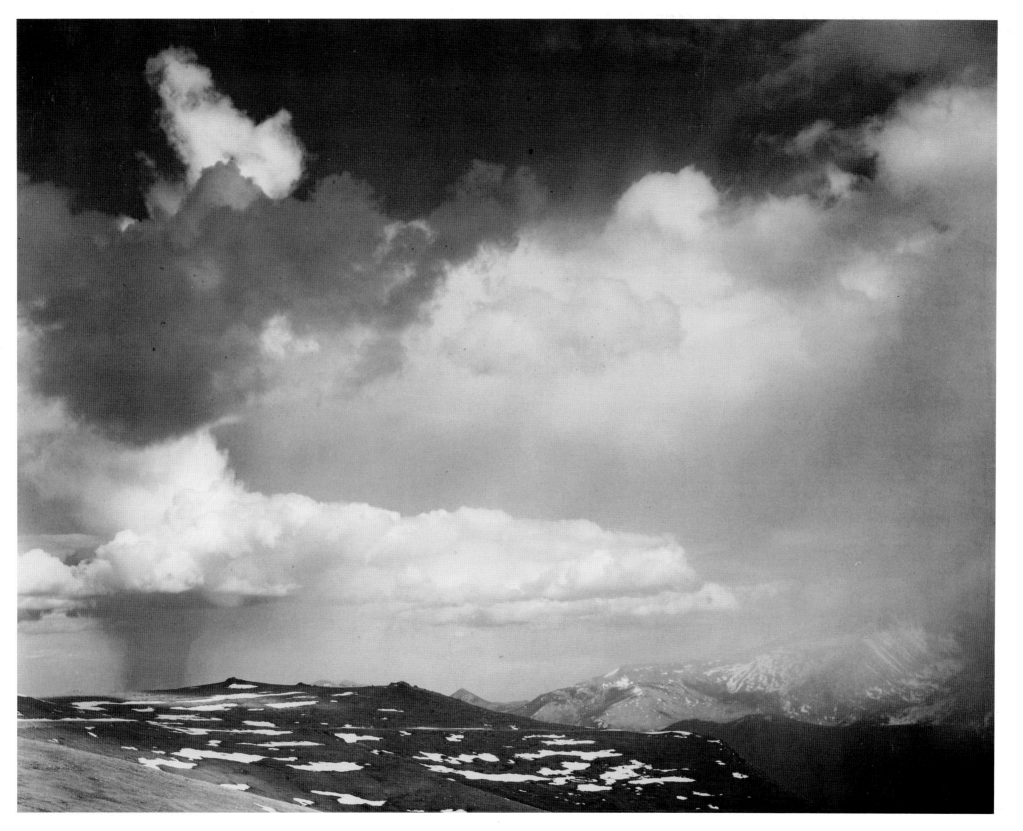

"In Rocky Mountain National Park."

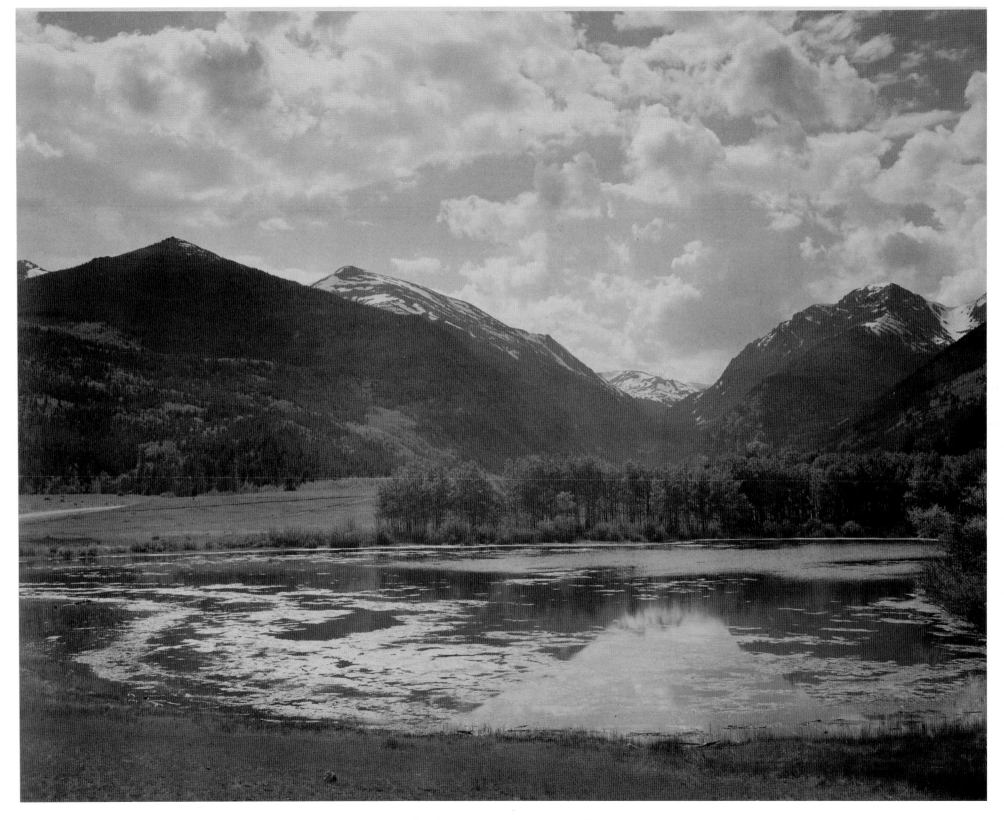

"In Rocky Mountain National Park."

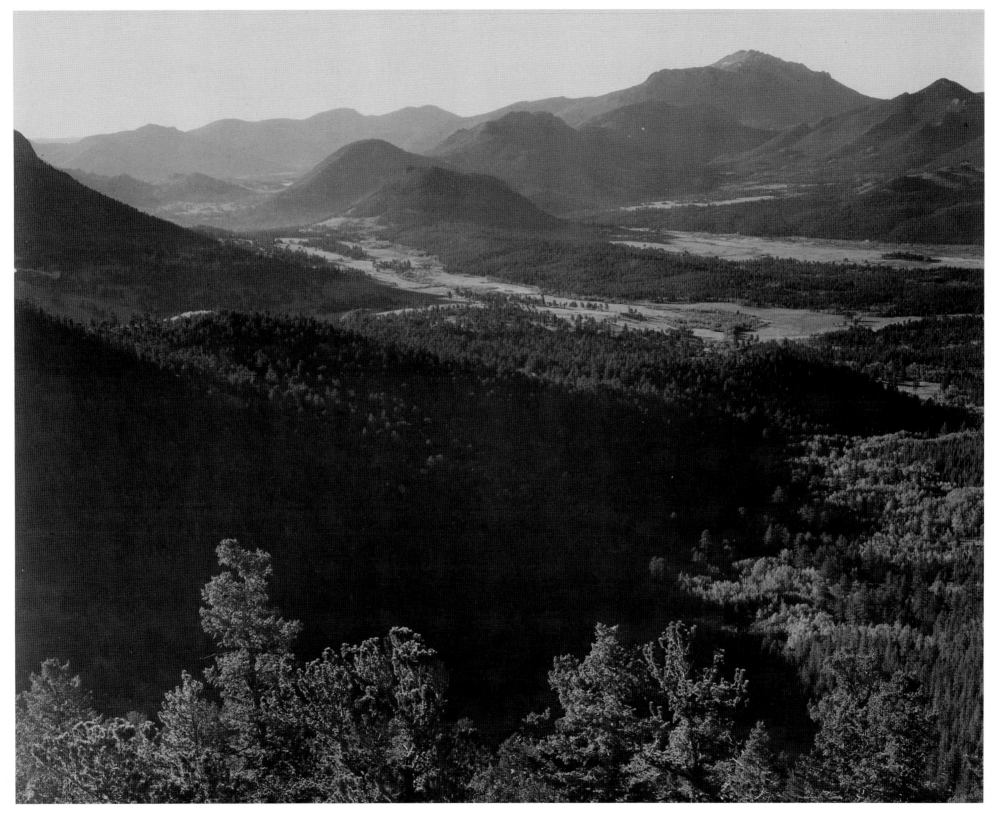

"In Rocky Mountain National Park."

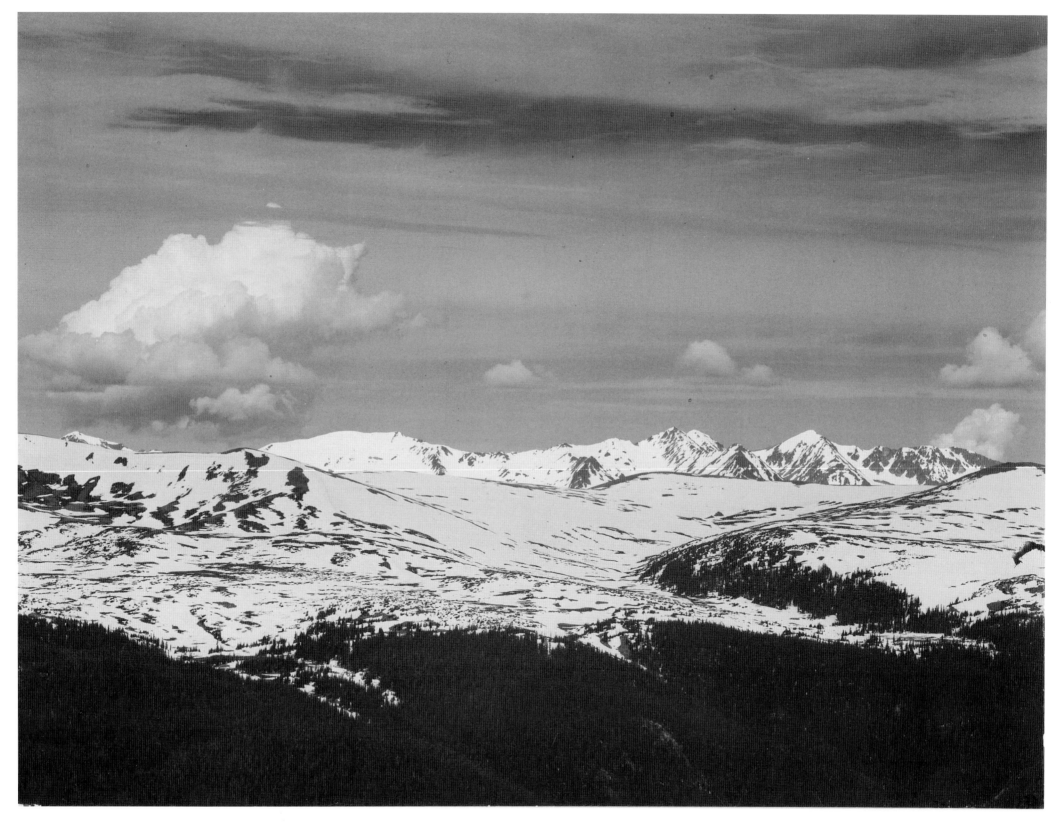

"Rocky Mountain National Park. Never Summer Range."

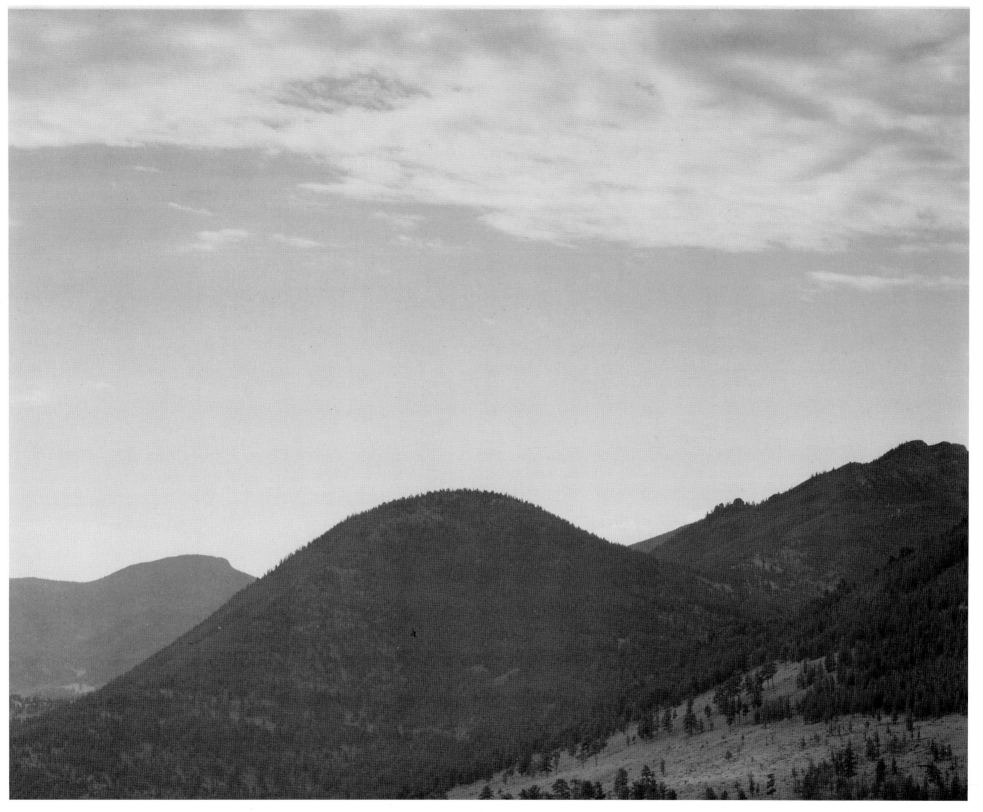

"In Rocky Mountain National Park."

NEW MEXICO

As he traveled through the national parks, Adams would often make photographs (he is famously quoted as saying "You don't take a photograph, you make it.) of the same prospect in color and black-and-white, the color pictures to satisfy his clients. Many of these were of New Mexico, one of his favorite states, particularly the north, where he and his wife frequently ventured. They seriously considered moving to Santa Fe before they moved to Carmel Highlands. They didn't because it was a long way from most of their friends, their family, and also from business opportunities. It was in New Mexico, of course, that Adams made what many think his finest work—"Moonrise, Hernandez, New Mexico"—that sold for over $600,000 in 2006. In 1976 Adams wrote, "... wherever one goes in the Southwest one encounters magic, strength, and beauty. Myriad miracles in time and place occur; there is no end to the grandeurs and intimacies, no end to the revival of the spirit which they offer to all." Over his life Adams visited New Mexico many times, often to visit with his and Virginia's long-term friend, the artist Georgia O'Keeffe, at her home on Ghost Ranch. Adams' son Michael recalled that he was seven in 1941 when he traveled with his father for the first time: "He'd wait if there were clouds, he'd wait for the conditions that he liked the best. We sat around for a number of hours sometimes waiting for the light that he wanted. We would talk, but I would usually have a book or be looking at a magazine—or just looking at the view, as some of the places we went were pretty exciting."

"Formations along the wall of the Big Room, near Crystal Spring Home."

CARLSBAD CAVERNS NATIONAL PARK

During World War II the U.S. government opened rest camps in Carlsbad Caverns National Park for returning servicemen. Adams photographed the park for the Mural Project. Even though the commission had to be cancelled because of the war, and the photos never (in his lifetime) blown up to mural size (about four-feet square), his work for the National Park Service was not unappreciated. The Department of the Interior gave him its highest honor, the Conservation Service Award. Carlsbad was one of the earliest national parks that Adams visited to photograph for the project. In fact, he was already in Carlsbad to do some commercial work for the U.S. Potash Company in their potash mines. When he entered the dark caverns at Carlsbad, he realized that the illumination there was entirely theatrical for effect and was in no way suitable for his photographs. The caverns were huge and would need serious amounts of illumination, so he resolved to return at a later date with plenty of lights to capture the grandeur of the caves. He was already traveling with 280 pounds of baggage and cameras, tripods, and typewriters and would need to return with a much larger baggage train. He wrote of the caverns, "they are so strange and deep in the earth that I can never feel about them as I do with things in the sun ... The photographic problems are terrific; I start with a basic exposure of about 10 minutes ... I then boost up the image and 'drama' with photoflash. Some of the forms are beyond description for sheer beauty ... Twice a day I ride down in the elevator (just like an office building) for 750 feet, and then walk a mile through the caverns to the selected spot ..."

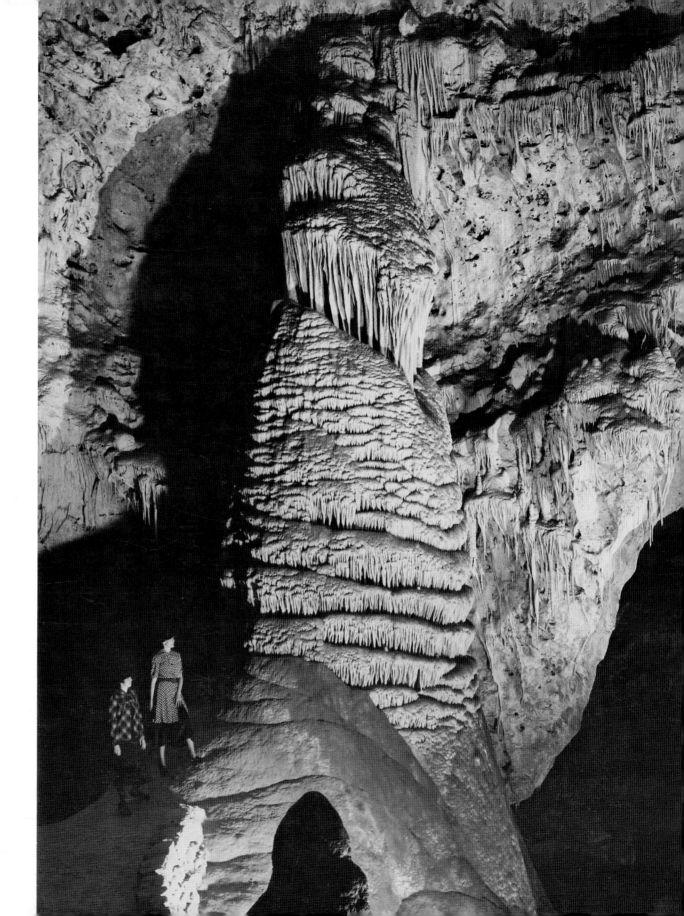

"The Rock of Ages, Big Room."

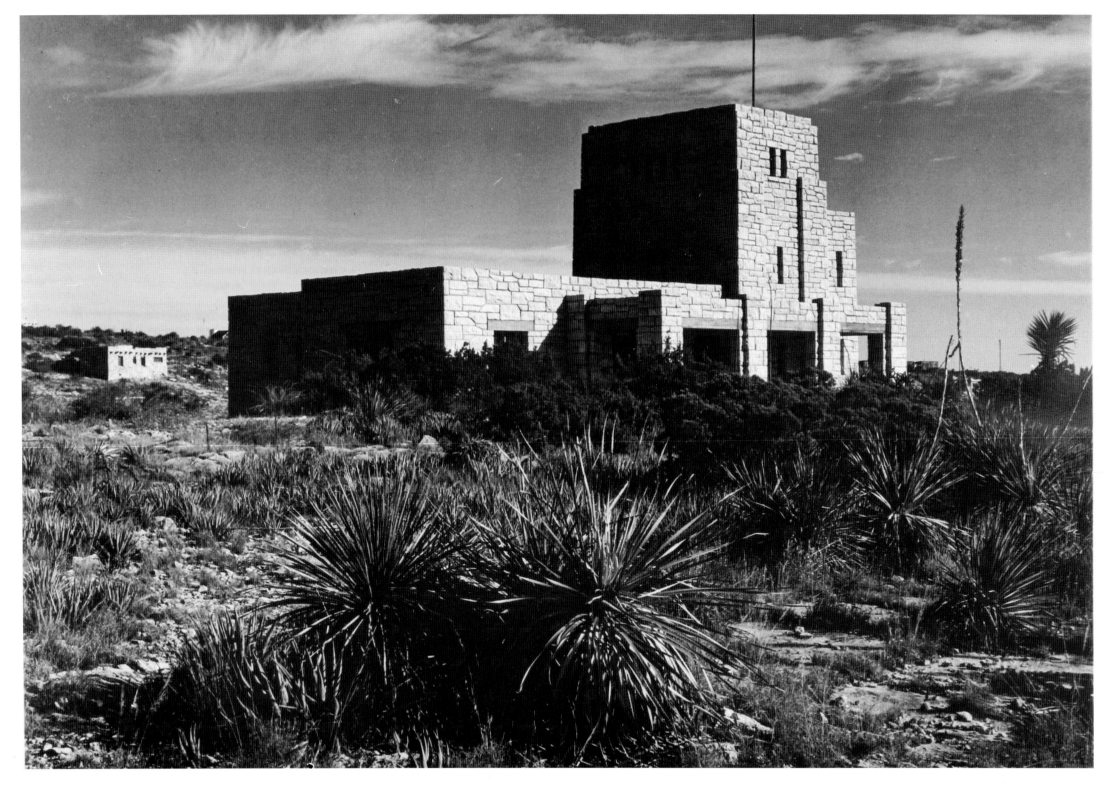

"Elevator House."

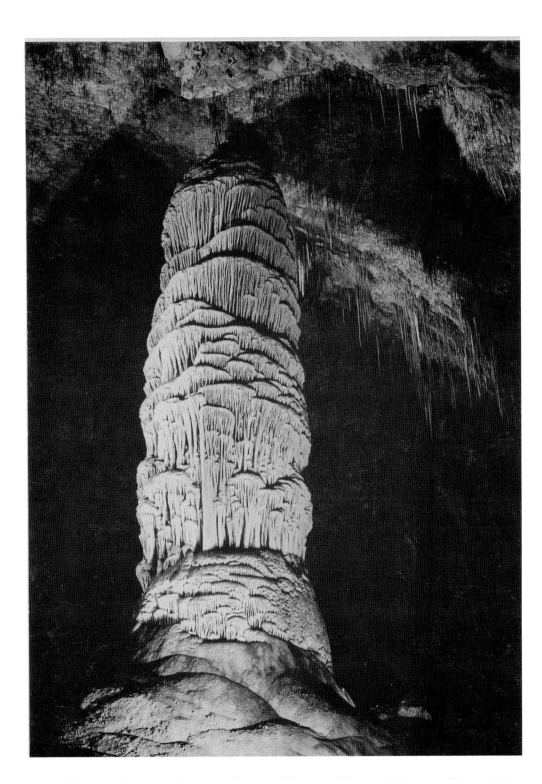

"Large formations or dome in the "Hall of the Giants" or "Big Room"."

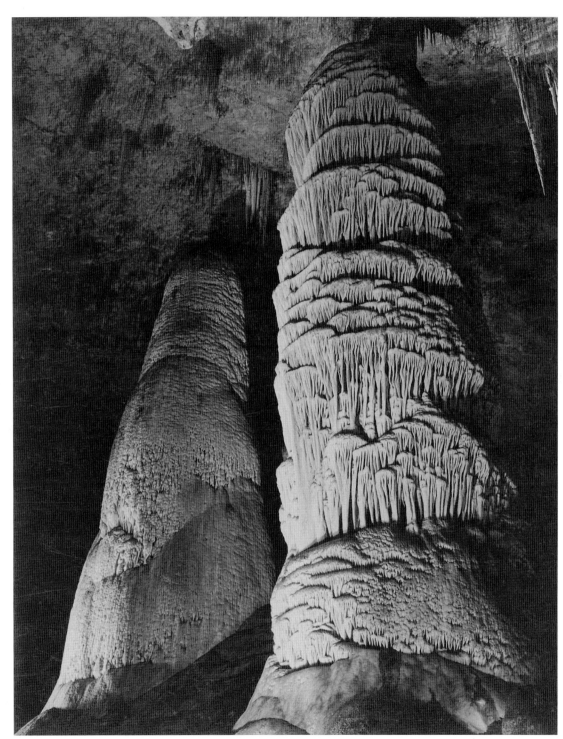

"The Giant Dome, largest stalagmite thus far discovered. It is 16 feet in diameter and estimated to be 60 million years old. Hall of Giants, Big Room"

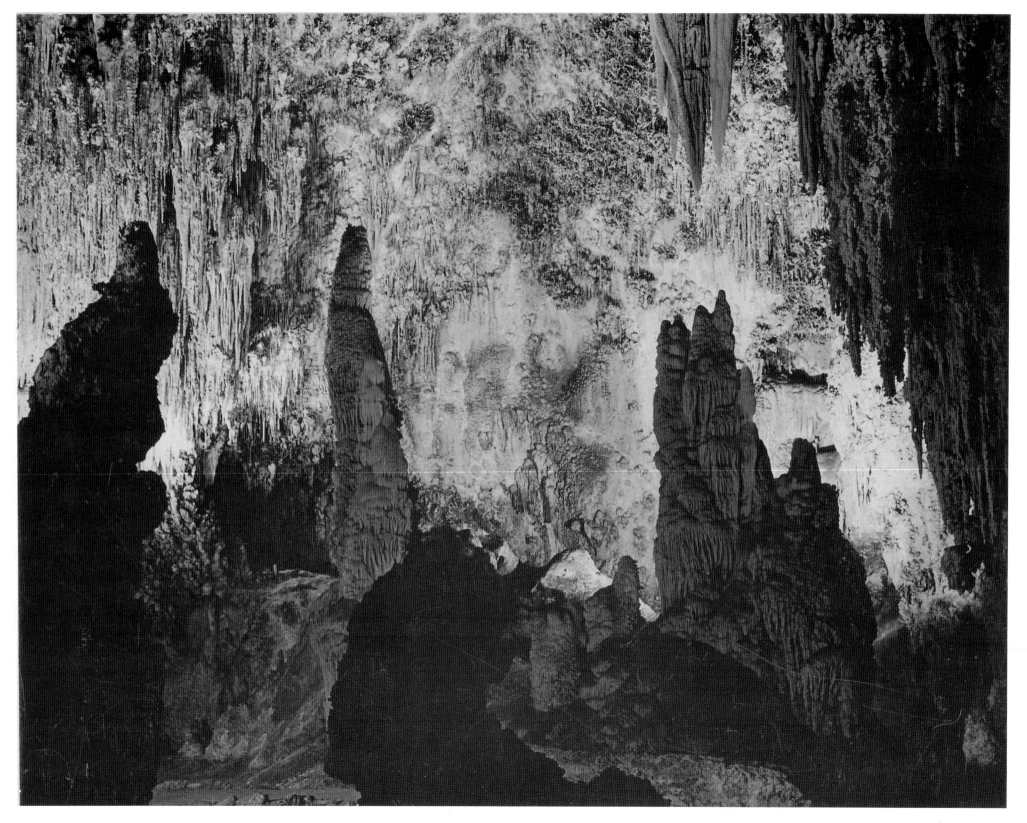

"In the Queen's Chamber."

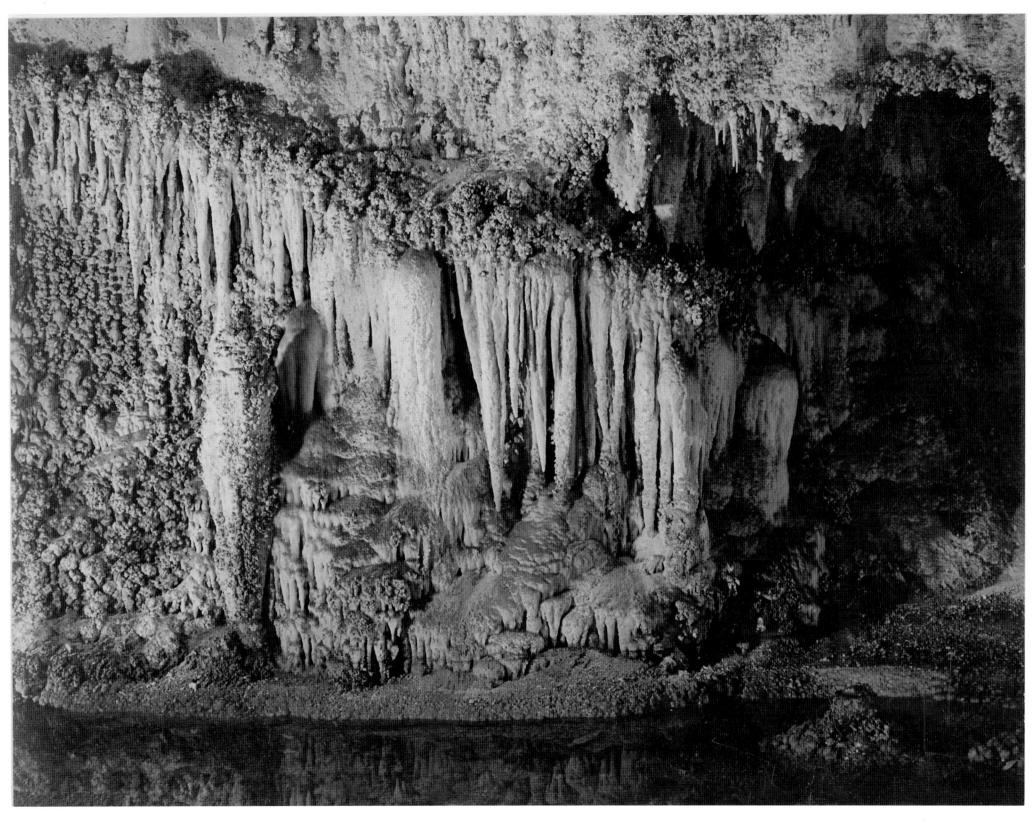

"Formations and Pool, large drapery formation known as the Guillatine, and the pool in the King's Palace.."

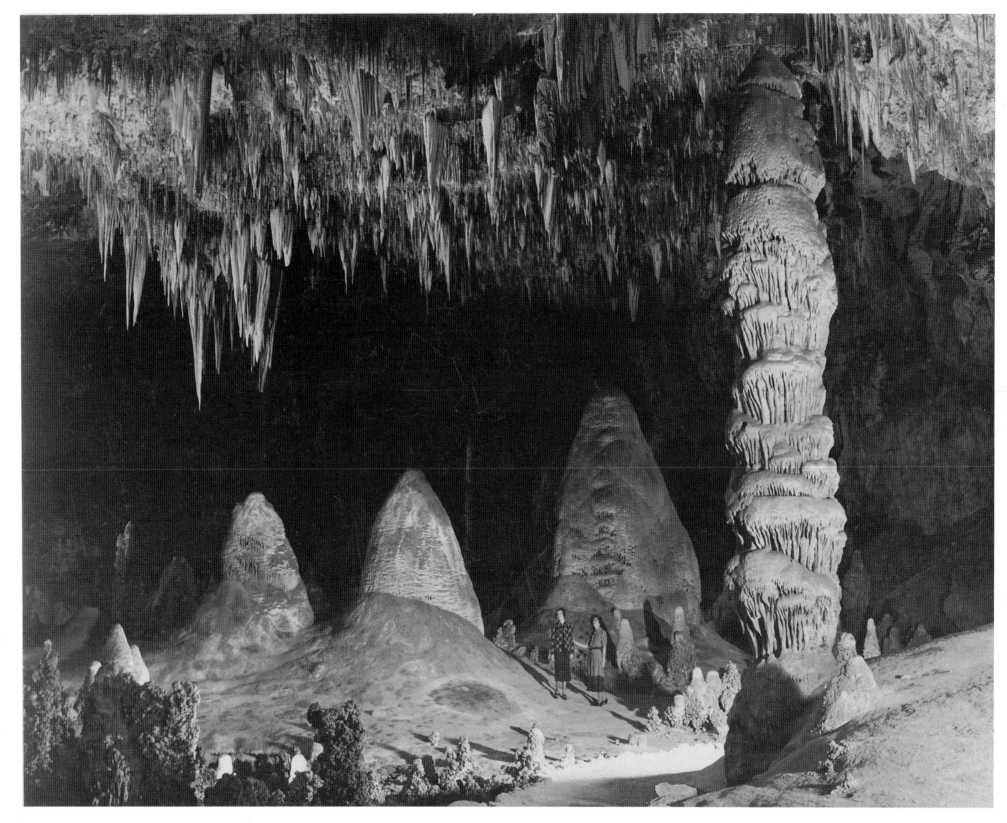

"The Rock of Ages in the Big Room."

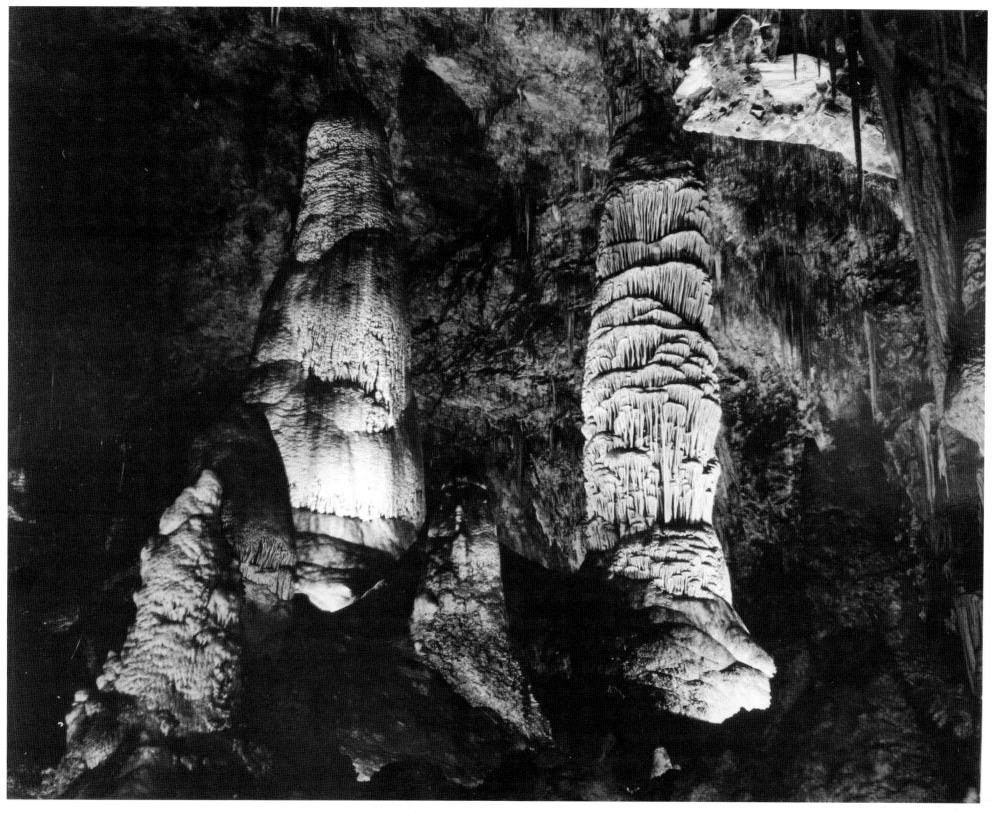

"Giant Domes."

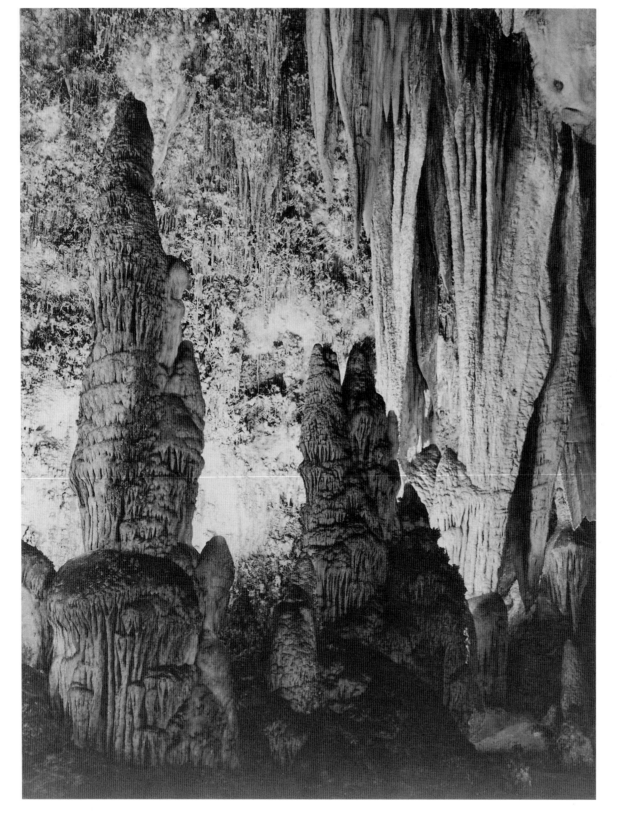

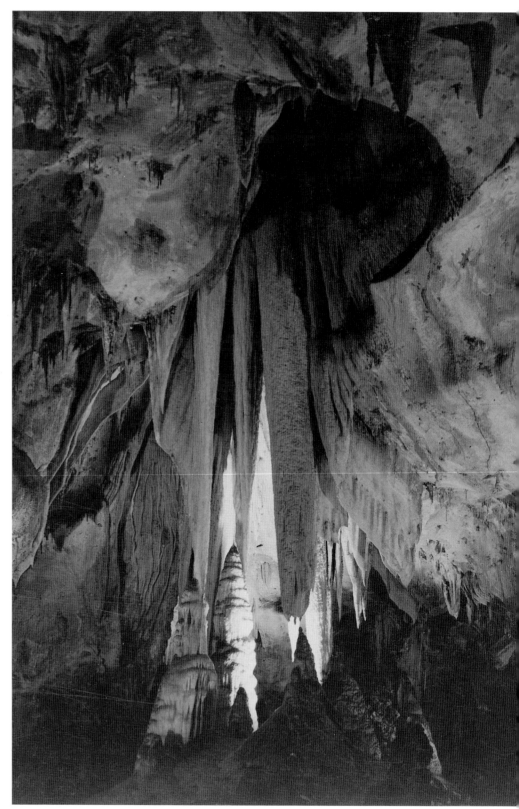

"The large stalagmite formations and the onyx drapes above it, in the Kings Palace.."

"Onyx drapes in the Papoose Room."

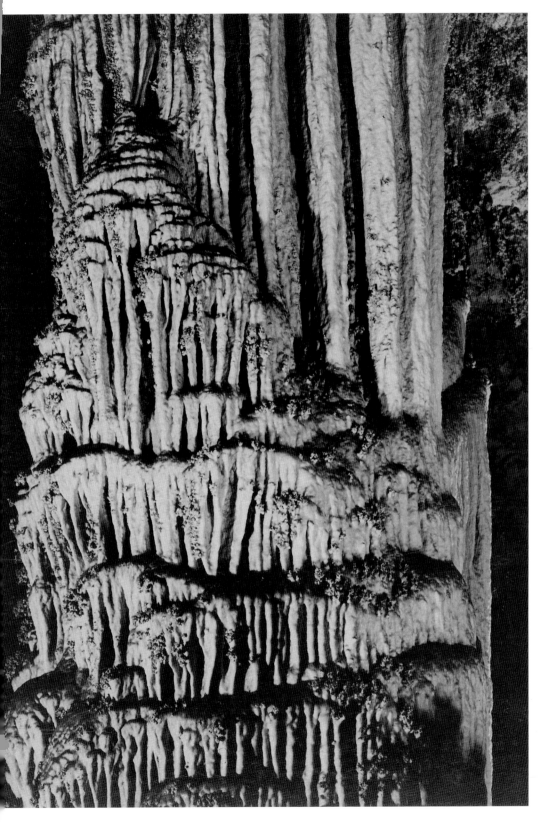

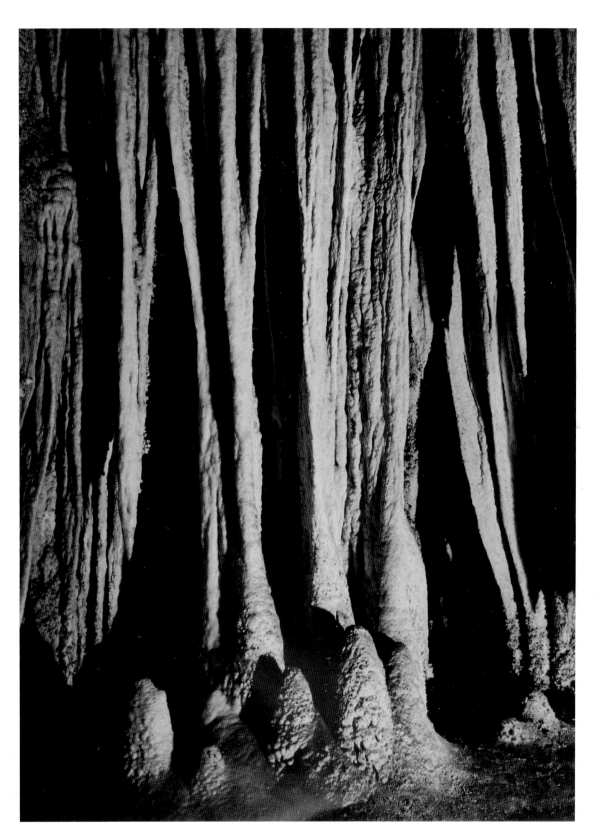

"The Chinese Pagoda, Big Room, detail."

"Formation along trail in the Big Room, near the Temple of the Sun."

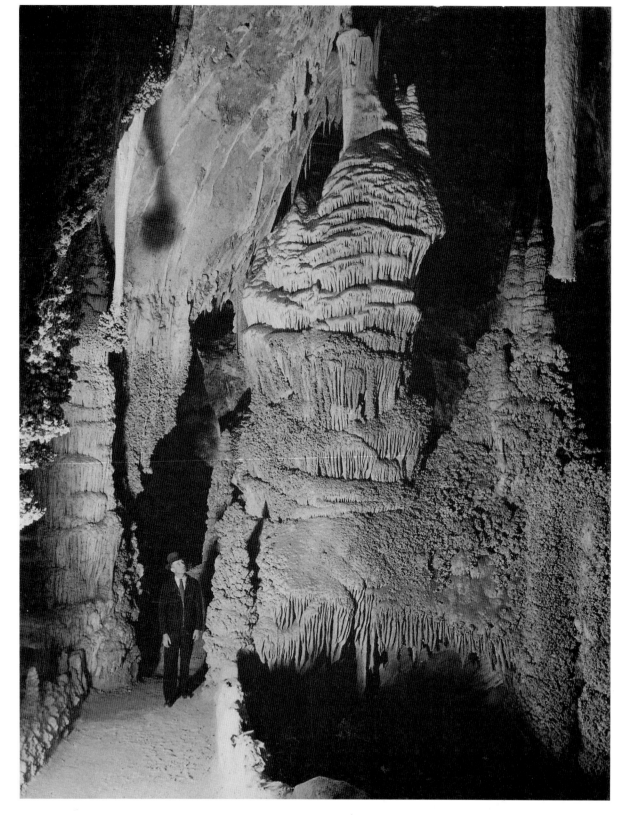

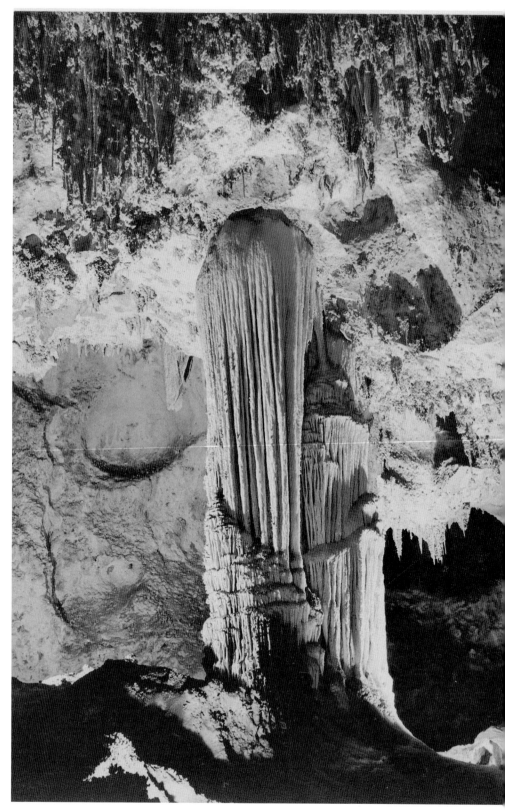

"Large Formation at the "Hall of Giants" in Carlsbad Cavern."

"Formations above Green Lake, Large stalagmite with draped stalactite ab
it. One of the principal features in the King's Palace."

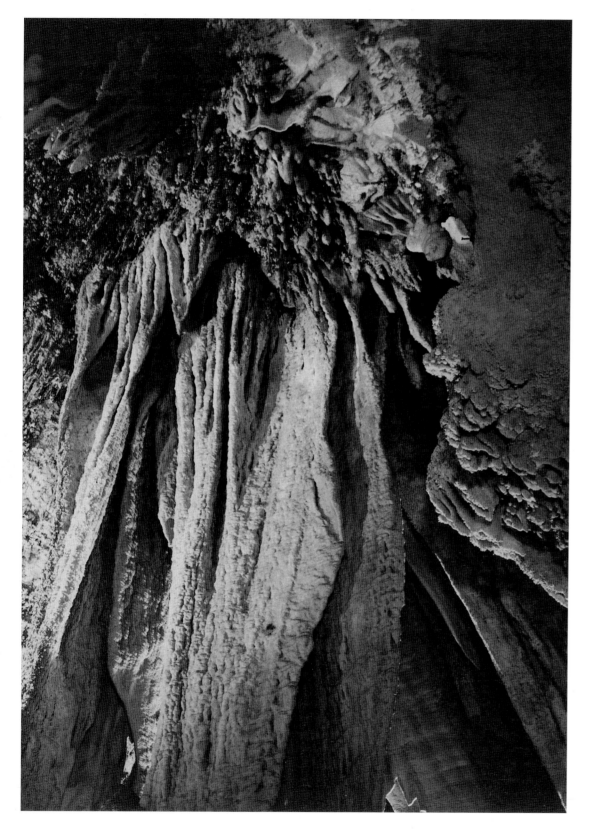

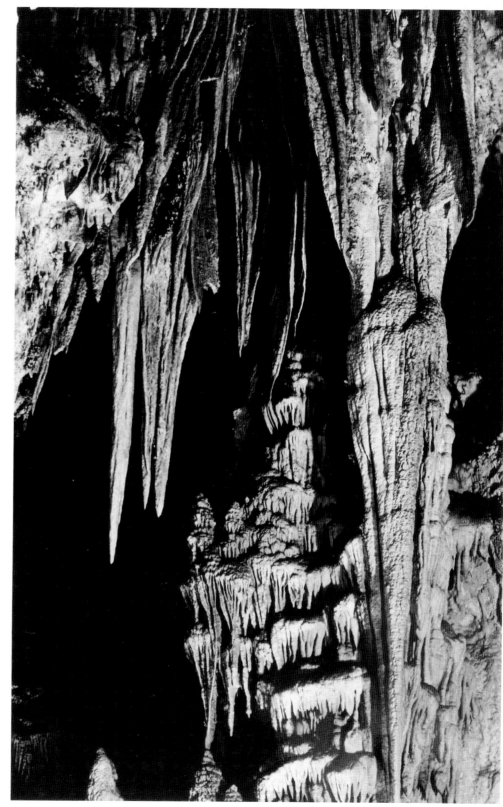

"Formations in the Big Room near the Temple of the Sun, detail."

"Formations, along trail in the Big Room, beyond the Temple of the Sun."

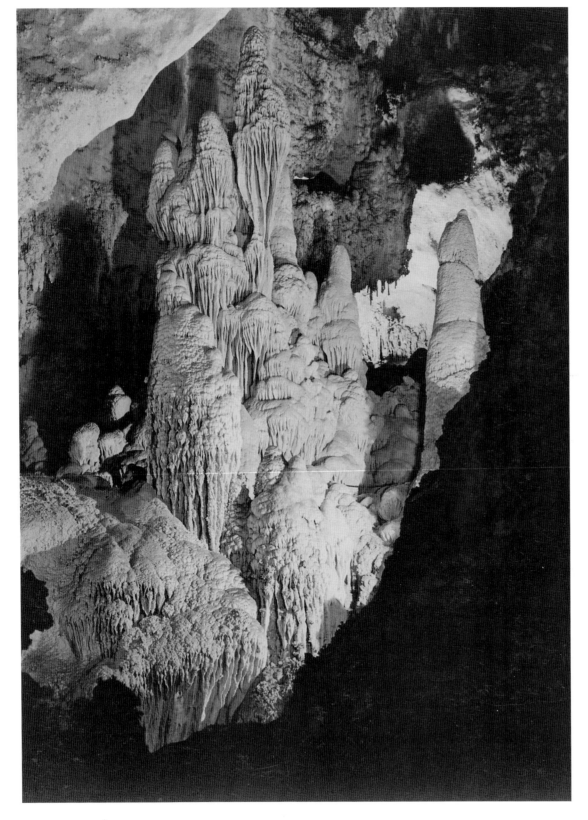

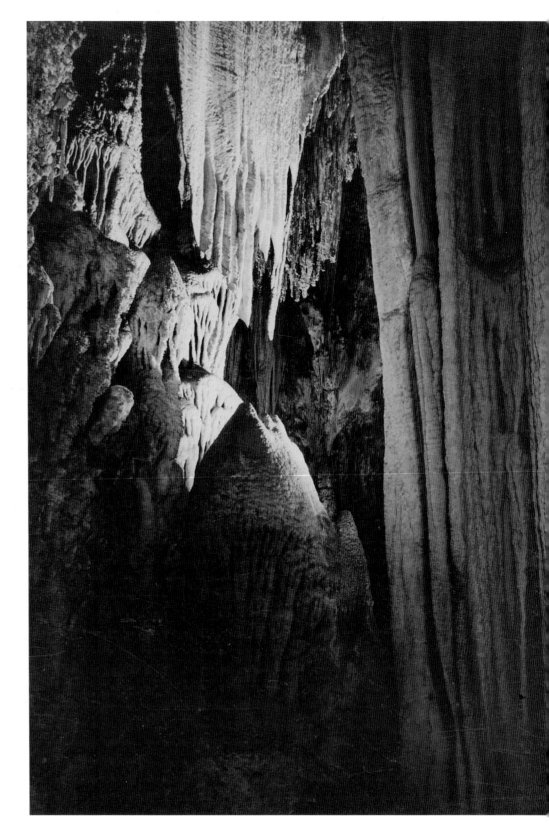

"Formations, a few of many natural formations at Carlsbad Caverns."

"Formations - detail, formations in the Queen's Chambers, at the entrance

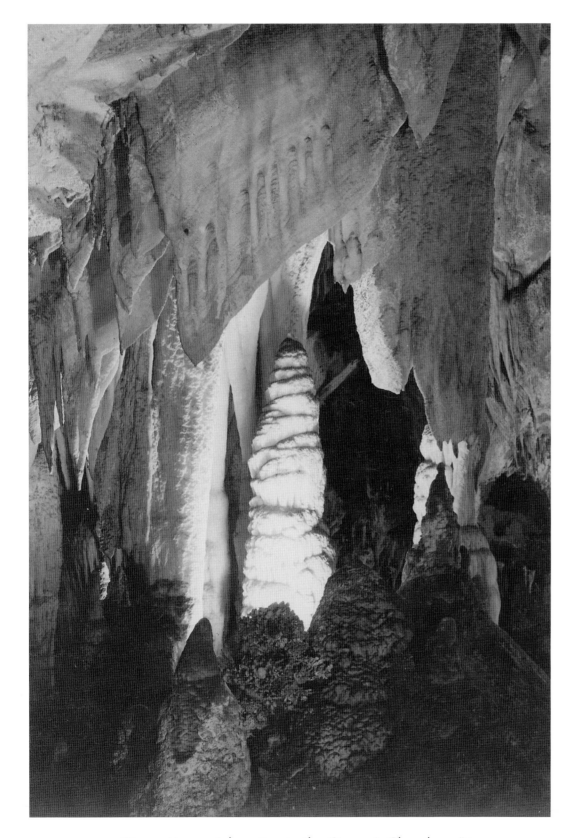

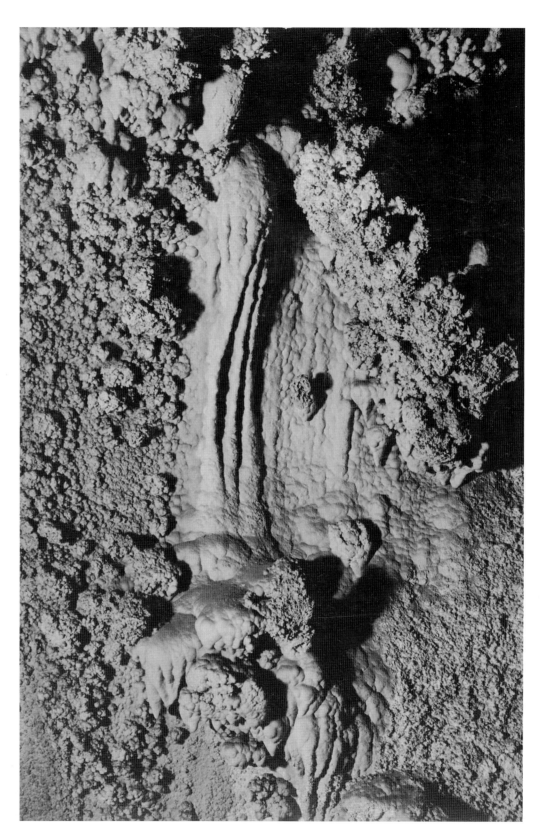

"Formations, stalagmites in the Queen's Chambers."

"Formations, a few of many natural formations at Carlsbad Caverns."

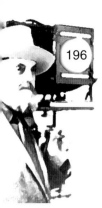
ACOMA PUEBLO

Acoma means "People of the White Rock." Acoma Pueblo is made up a scattering of villages—Old Acoma or Sky City, Anzac, Sky Line, and McCartys—on top of a 357-foot sandstone mesa about 60 miles west of Albuquerque, New Mexico. They are among the oldest continually inhabited communities in the United States having been occupied for more than 800 years. Adams visited Acoma Pueblo in 1942 after a rare storm, as the large puddle of water testifies. He is not as well known for his architectural photographs as his landscapes, but he found the starkness of these ancient adobe brick buildings and the built environment they created completely intriguing. The traditional buildings have no doors or windows and each level is reached by ladders—a unique defensive tradition. The spiritual center of the pueblo is the village plaza. As was his habit Adams did not include people in his photographs of the village: when he made studies of people he made portraits, otherwise figures were usually excluded from his work.

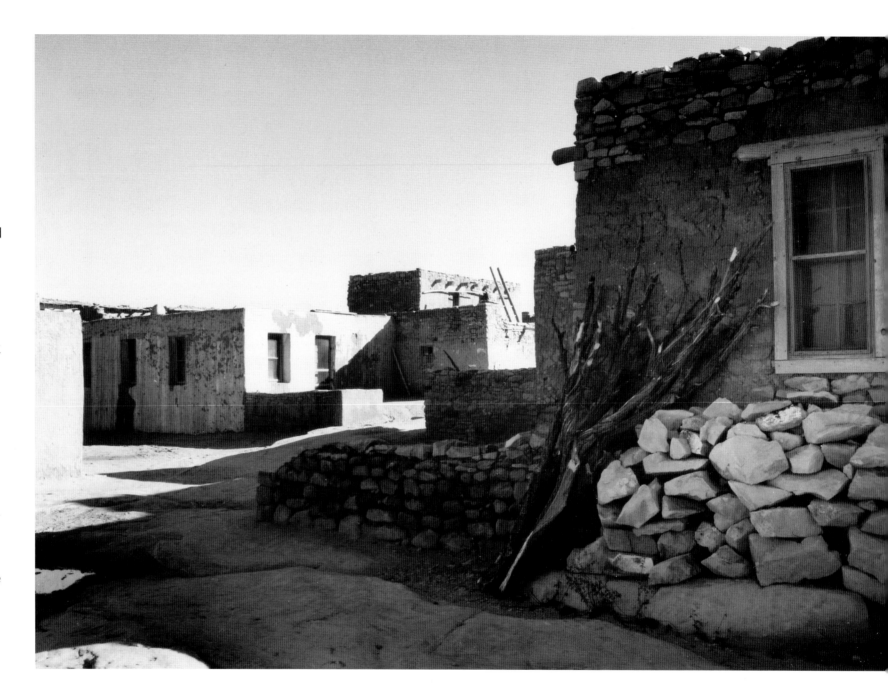

"Acoma Pueblo, looking across street toward houses."

"Acoma Pueblo, New Mexico."

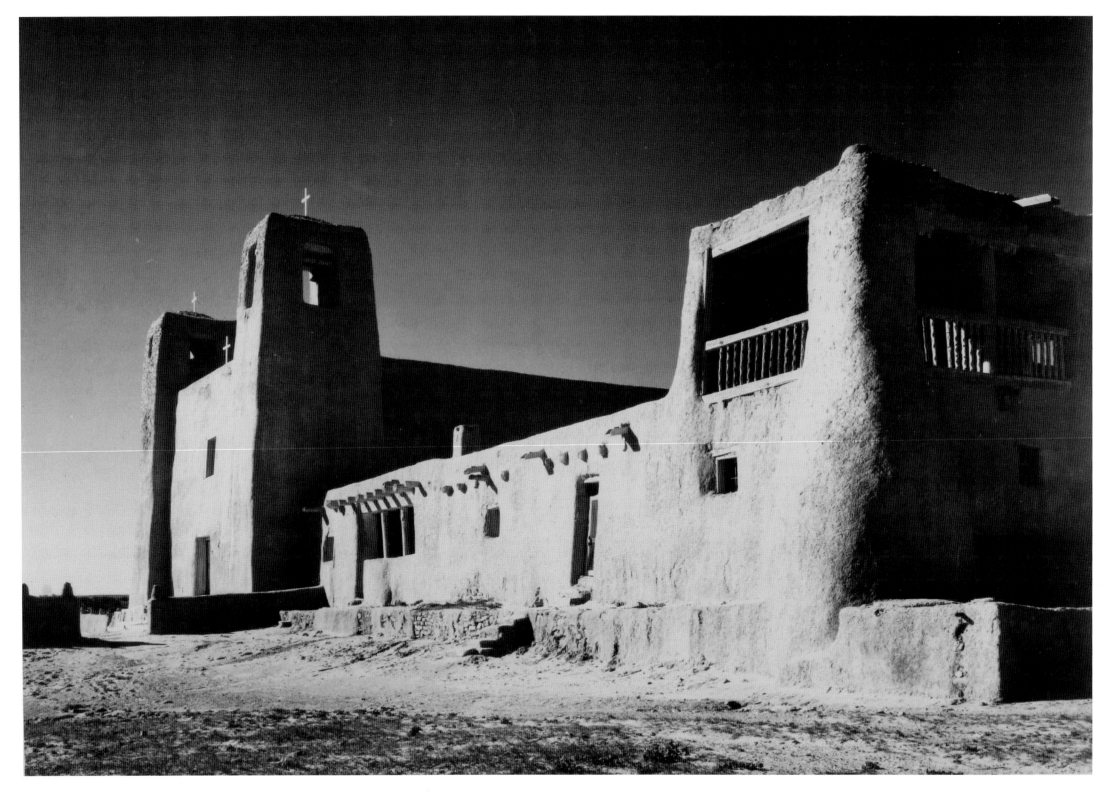

"Church, Acoma Pueblo."

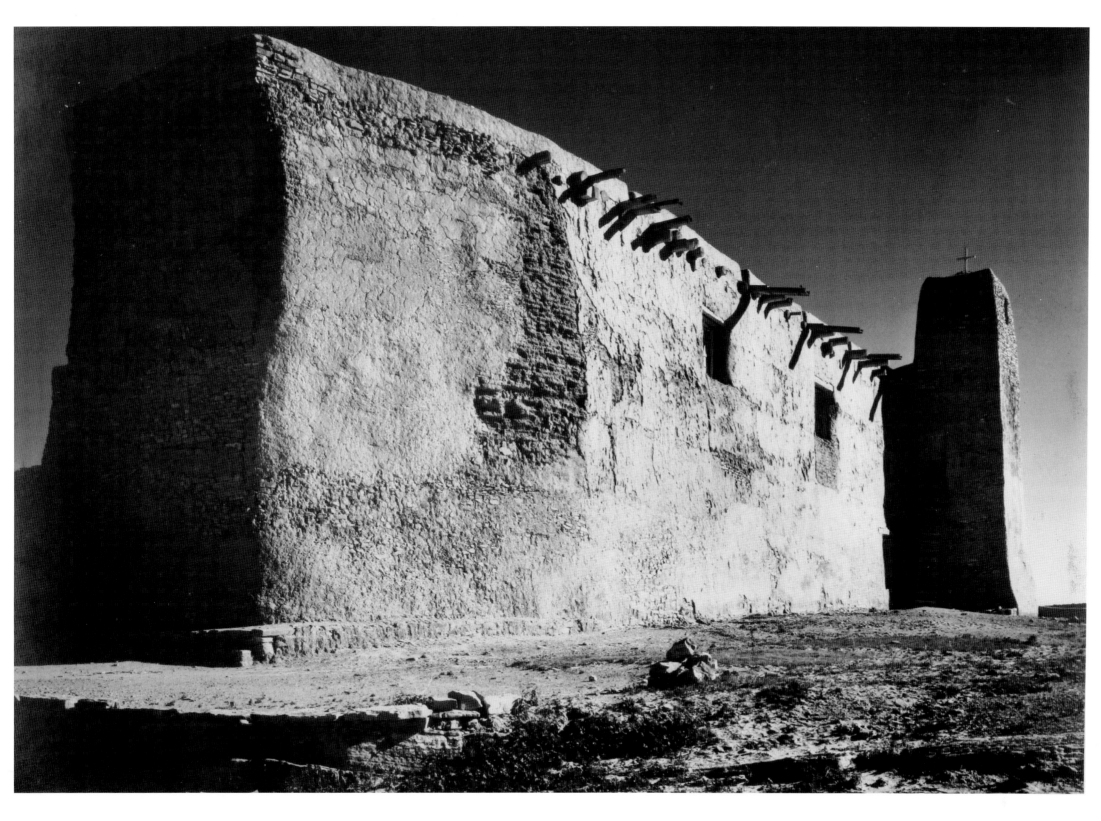

"Church, Acoma Pueblo."

SAN ILDEFONSO PUEBLO

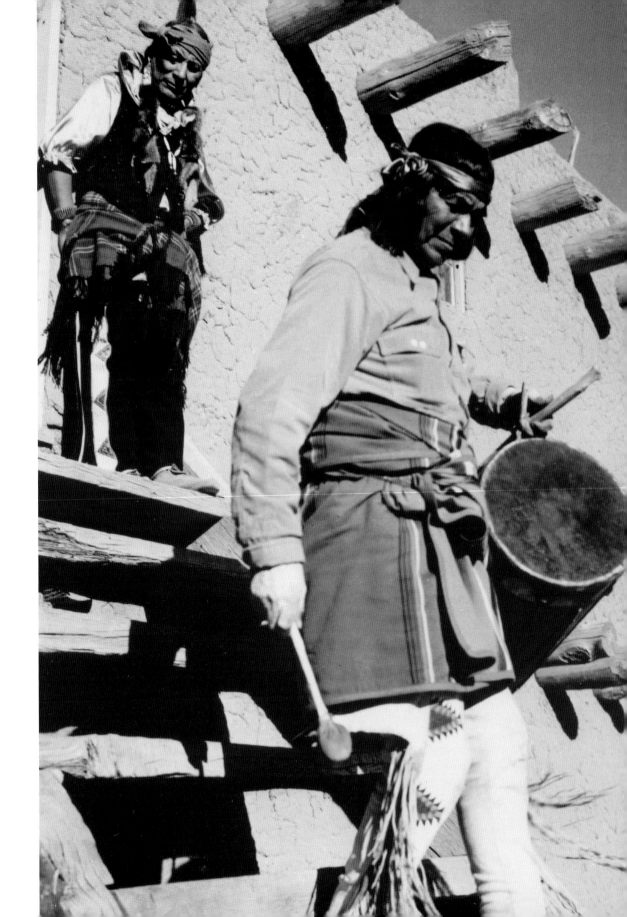

The Pueblo was established in about 1300 by Tewa-speaking Native Americans, who are probably descendants from the people who lived and then disappeared from Mesa Verde in southern Colorado. Their name for the pueblo is *Po-who-ge-oweenge* which means "where the water cuts through" and refers to the valleys and arroyos around the Rio Grande. The Pueblo is now a member of the Eight Northern Pueblos. In the early twentieth century the pueblo was in the grip of a severe economic depression due to loss of tribal lands to squatters, internal conflicts, and illegal logging, but then an interest in traditional Native American crafts prompted the revival of their traditional Black-on-Black pottery. Tourists started to come in such numbers that many inhabitants abandoned their previous agricultural lifestyle to concentrate on pottery. The people live a rich life of ritual, dance, and ceremonywhich helps them to retain their strong sense of community, history, and Native American identity. Many of these rituals remain private and the public are excluded. The dances are public at Easter and in early September the Corn Dance is celebrated. Adams photographed the people in their splendid traditional costumes, a rare occasion when he turned his lens on people rather than landscape. Adams' first visit to the American Southwest took place in 1927 when he accompanied his friend Albert Bender to Santa Fe, New Mexico. There he met nature writer and Indian activist Mary Austin, with whom he later collaborated; she as writer, he as photographer. He was fascinated by the dances of the Native Americans, and the early 1929 photos included "Eagle Dance, San Ildefonso, Pueblo, New Mexico" and "Buffalo Dance, San Ildefonso Pueblo, New Mexico." He returned to them in this group of
images taken in 1942.

"Dance, San Ildefonso Pueblo, New Mexico, 1942."

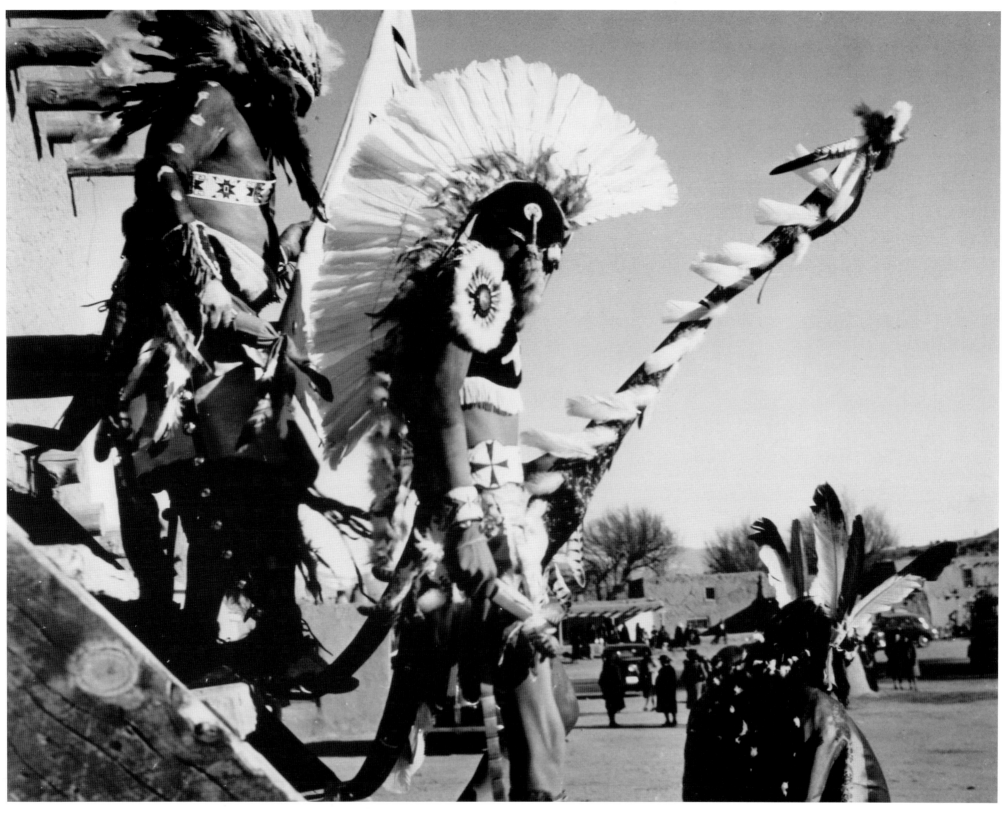

"Dance, San Ildefonso Pueblo, New Mexico, 1942."

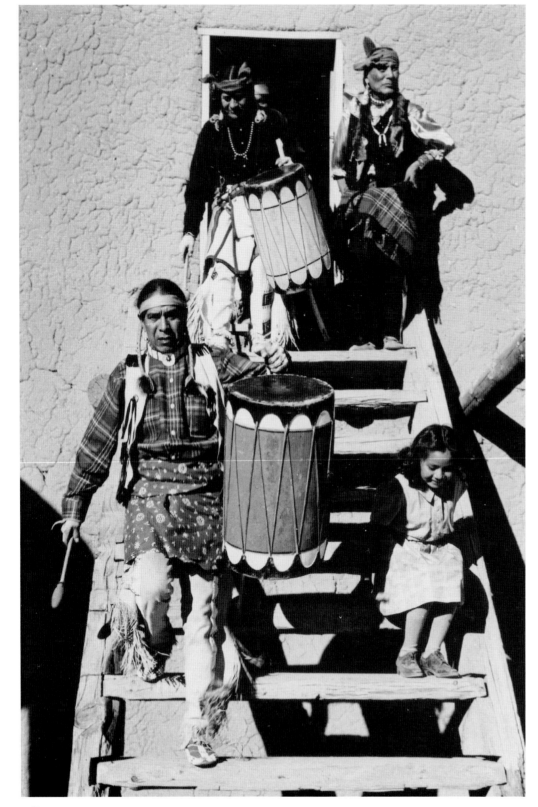

"Dance, San Ildefonso Pueblo, New Mexico, 1942."

"At San Ildefonso Pueblo, New Mexico, 1942."

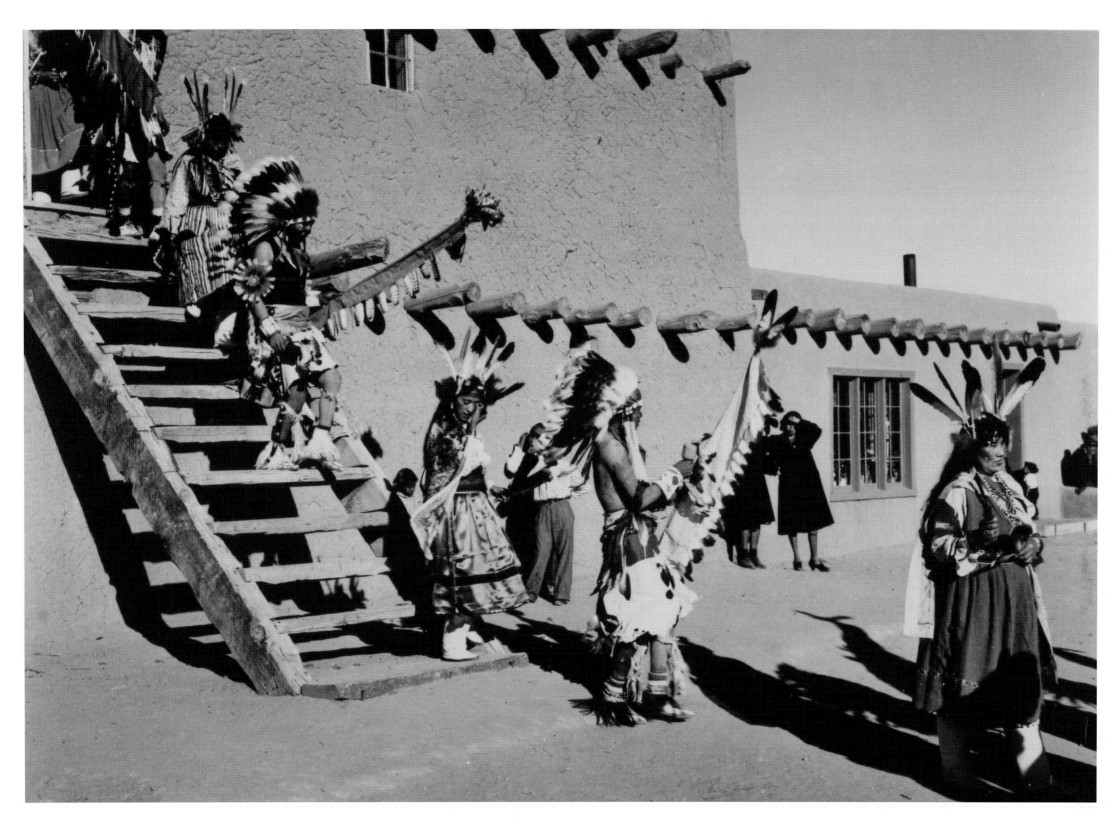

"Dance, San Ildefonso Pueblo, New Mexico."

TAOS PUEBLO

Taos Pueblo lies near the Taos Mountains and has the Rio Pueblo running through it. The ancient pueblo lies about a mile north of Taos, and is inhabited by Tiwa speaking Pueblo peoples. Comprising numerous reddish brown adobe buildings it is one of the oldest continuously inhabited communities in North America. The north side Pueblo is made of adobe walls at least 2 feet thick and is the largest multistoried Pueblo building in the world. Until 1900 the only way into the building was via ladders. Adams first photographed Taos Pueblo in 1927 on a general photographing expedition to New Mexico. The result was *Taos Pueblo* a limited edition of 100 books (plus eight artist's copies) of 12 original prints, with words by his friend Mary Austin, all for the then quite princely sum of $75. Adams had to get special clearance and permission from the pueblo council to gain access to the pueblo, plus pay a fee of $25 and give them copy of the finished book. The second time Adams visited Taos he stayed with friends at Los Gallos where Georgia O'Keeffe and Paul Strand, a well respected photographer, were also guests. It was Strand who unwittingly convinced Adams to concentrate his energies on photography rather than pursue a musical career after showing him some of his 4 x 5in negatives. Adams said in his autobiography, "My understanding of photography was crystallized that afternoon as I realized the great potential of the medium as an expressive art. I returned to San Francisco resolved that the camera, not the piano, would shape my destiny."

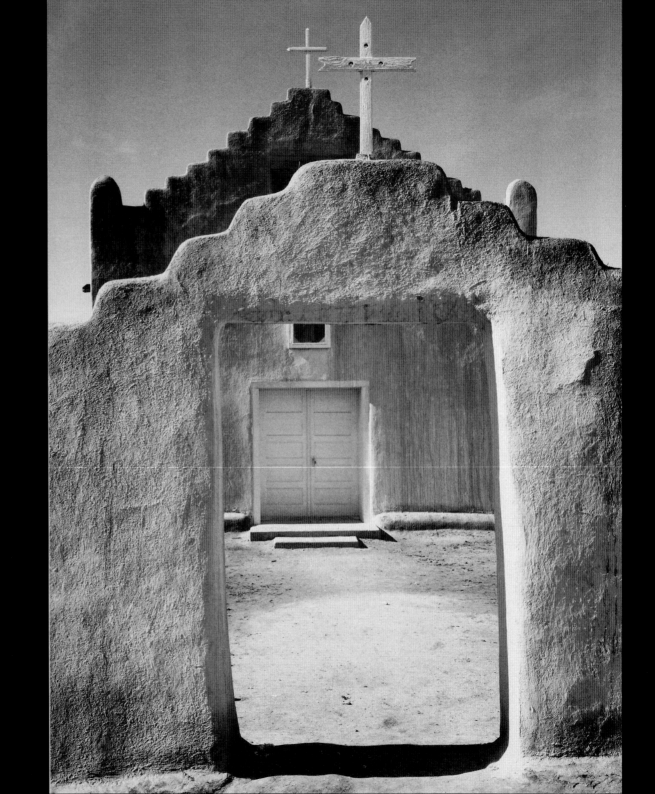

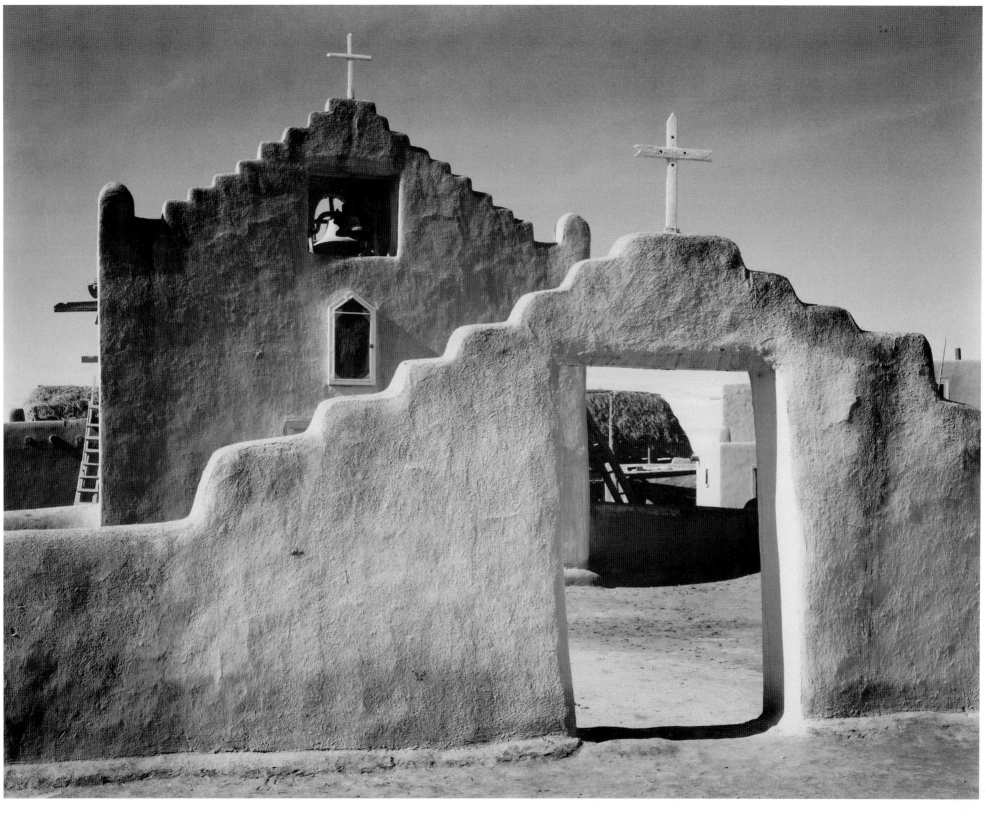

"Church, Taos Pueblo, New Mexico, 1941."

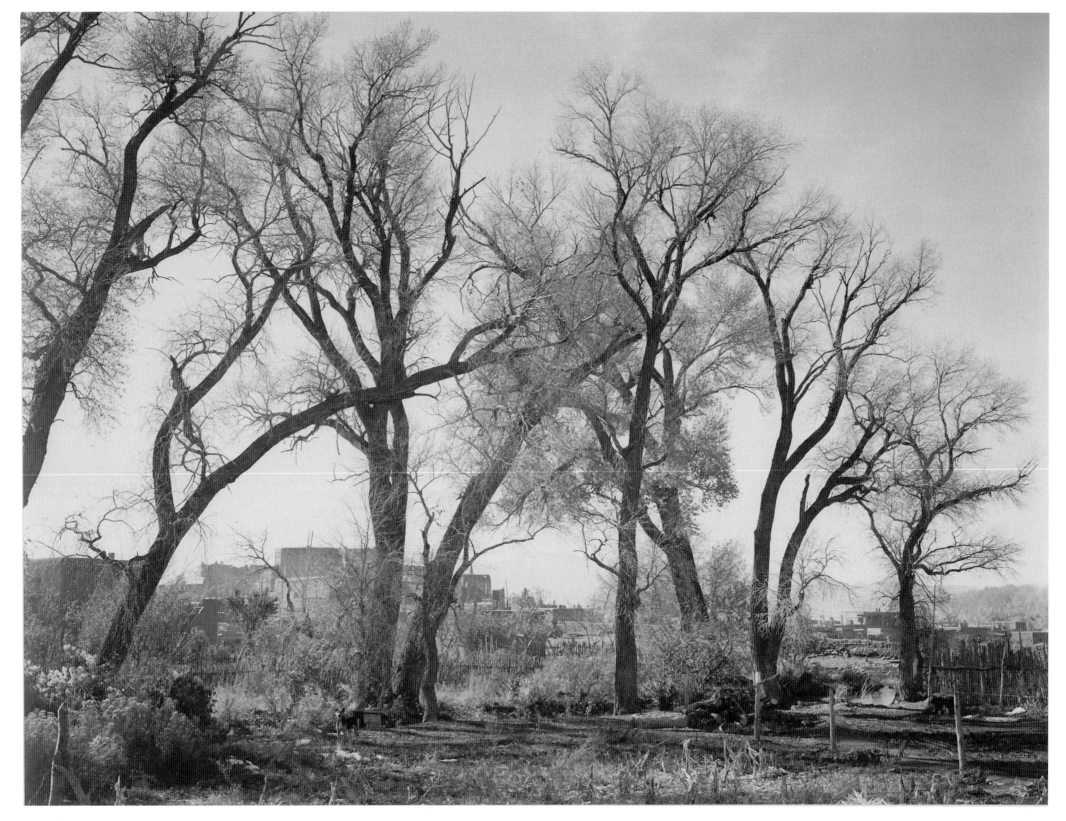

"At Taos Pueblo."

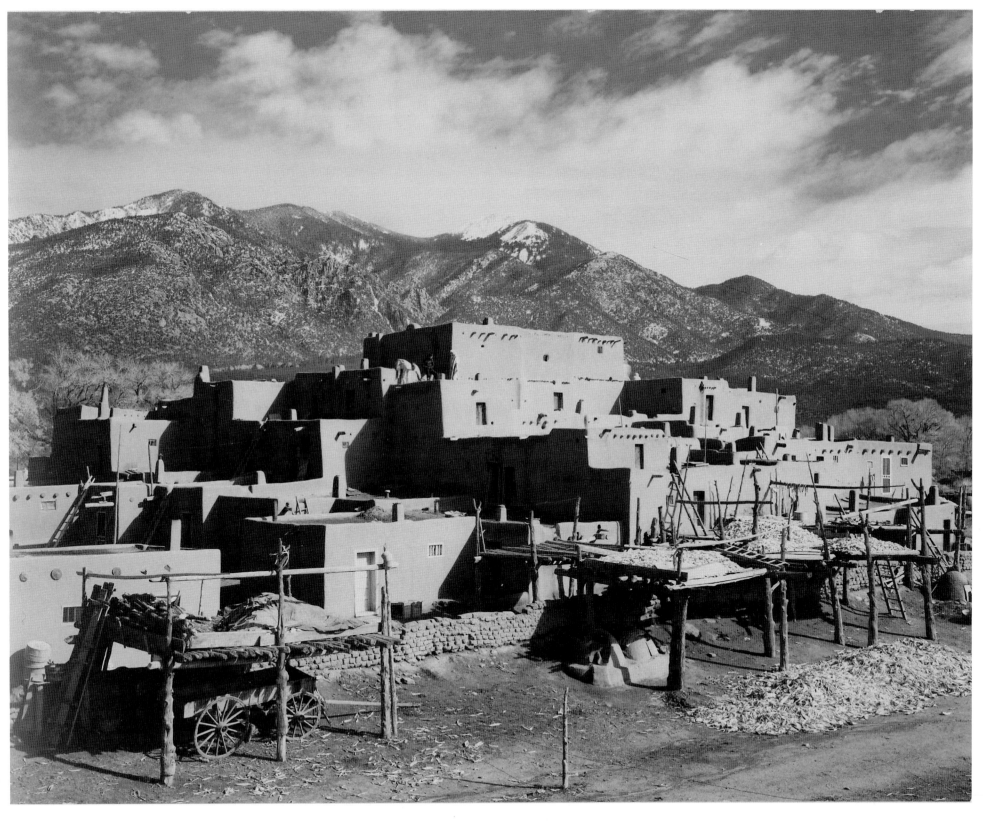

"Taos Pueblo, New Mexico, 1941."

MONTANA

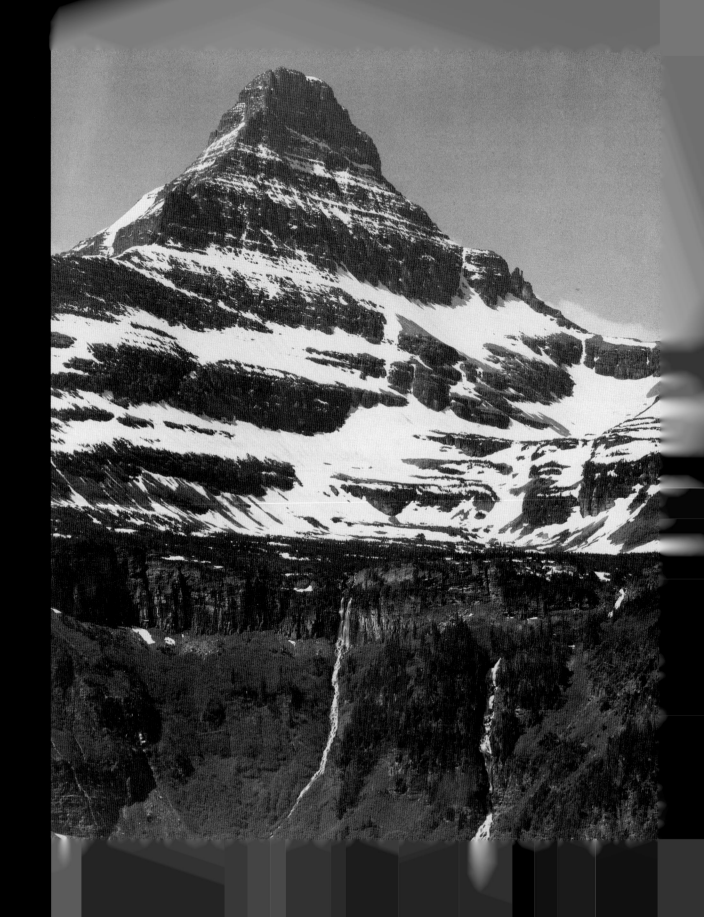

Early Spanish explorers named this area *Montaña del Norte* meaning mountainous country, and over time this was shortened to Montana. It is one of the biggest but least populous states in the country (only Alaska, Texas, and California are bigger) with much of its economy based on agriculture. The state is split east and west by the Continental Divide with most of the mountains located on the western side. To the west lie the Northern Rocky Mountains while to the south central lie the Central Rocky Mountains and in between lie numerous isolated island mountain ranges. Between these mountains prairie lands roll eastwards to become part of the northern Great Plains. Perhaps contrary to many peoples' expectations, over 50 percent of the state is prairie. The National Park Service is responsible for eight important sites in Montana including Glacier National Park, part of Yellowstone National Park (Wyoming and Idaho share the rest, although three of the five entrances are in Montana), Bighorn Canyon National Recreation Area, Little Bighorn Battlefield National Monument, Nez Perce National Historical Park, and the Lewis and Clark National Historic Trail.

One of Adams' most famous quotes, "Sometimes I do get to places just when God's ready to have somebody click the shutter" could not be more true when one looks at the sublime perfection of limpid Macdonald Lake, or the granduer of Going-to-the-Sun Mountain.

GLACIER NATIONAL PARK

Labeled "The Crown of the Continent," Glacier National Park was established in May 1910, one of the first protected areas to be made following the establishment of the National Park Service. High up in Montana on the border with Canada, it covers over 16,000 square miles, includes two mountain ranges, over 130 named lakes, over a thousand species of plants, and hundreds of different animals. Early inhabitants were Blackfeet Native Americans in the east and Flathead to the west. For the Blackfeet in particular, the mountains, especially Chief Mountain, were sacred sites and thought of as the "Backbone of the World." The Lewis Range sits in northern Montana in part of Glacier National Park. It was formed 170 million years ago by the Lewis Overthrust when three-mile thick Precambrian rocks slid over younger Cretaceous rocks, providing the rare geological occurrence of older rocks lying over newer rocks. The mountain ranges, the U-shaped valleys, and lakes all show evidence of enormous glacial action during the last ice age. Most of the glaciers have long since disappeared. In the mid-nineteenth century there were an estimated 150 glaciers in the area; this has now diminished to twenty-five active glaciers and even these are rapidly melting. Ansel Adams' photographs may one day be one of the few early records of the beauty and magnificence of this wilderness before rampant global warming. The lack of glaciers will alter the habitat in as yet unknown ways which may lead to the disappearance of cold water-dependant flora and fauna.

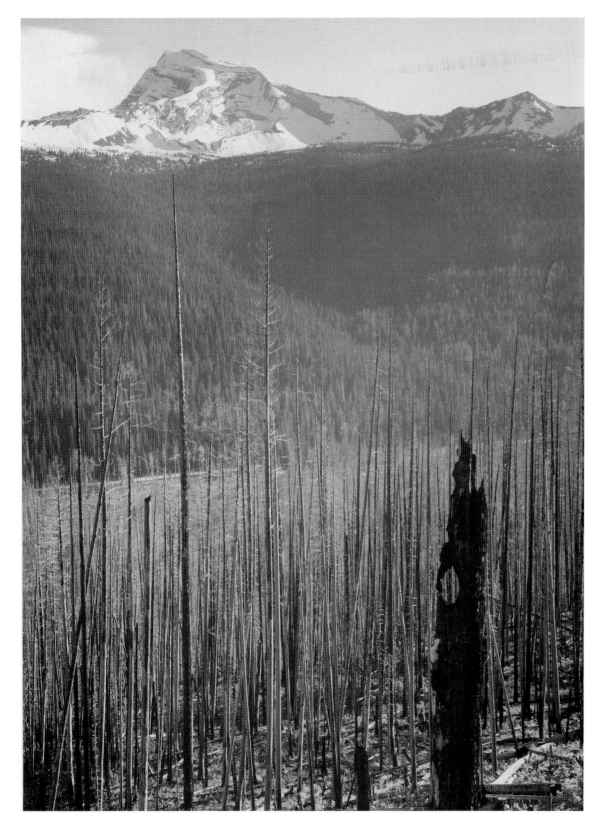

"In Glacier National Park."

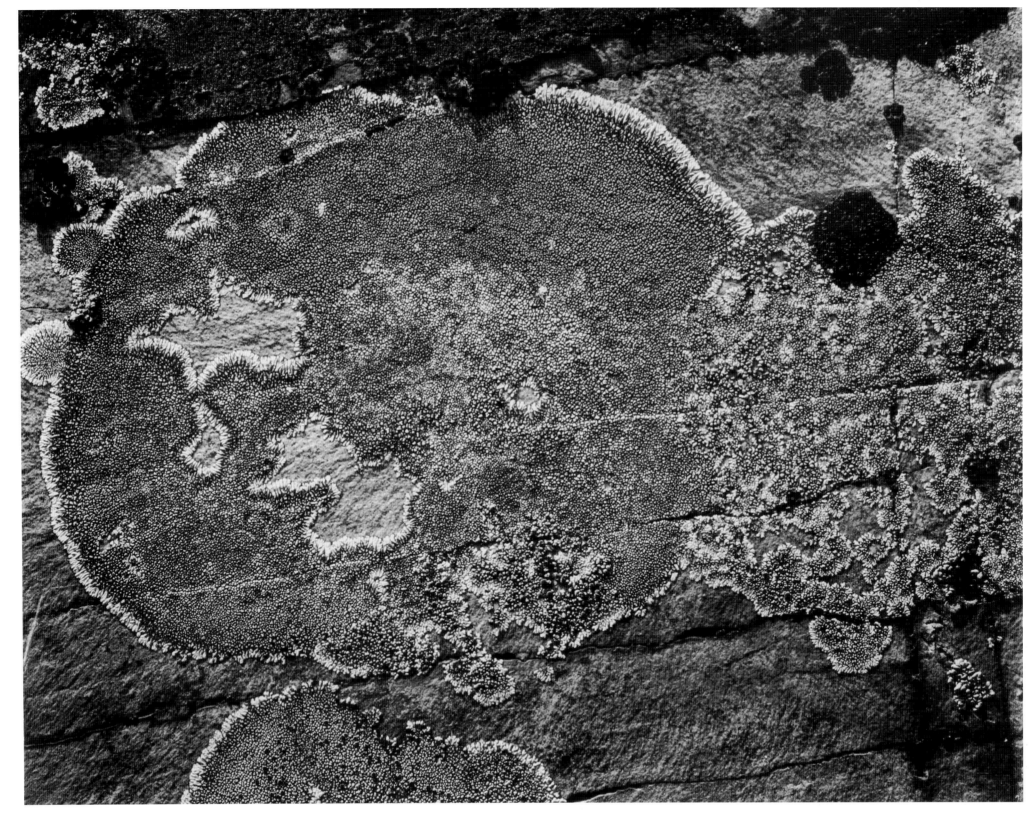

"Linchons, Glacier National Park."

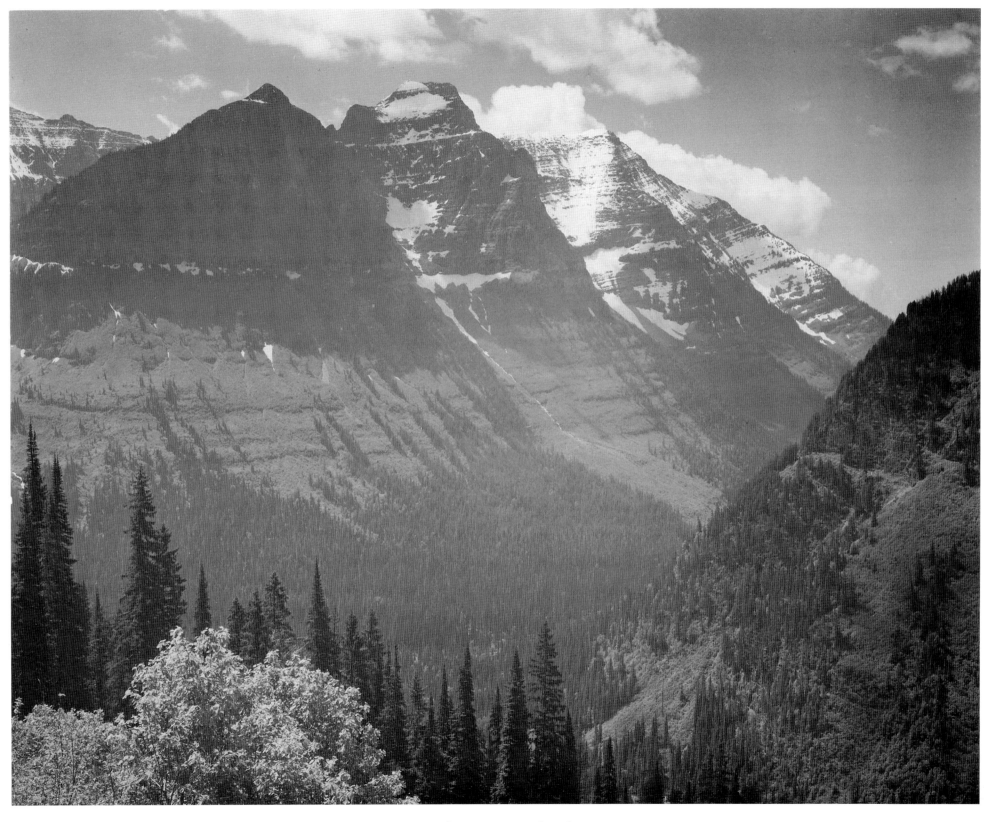

"In Glacier National Park."

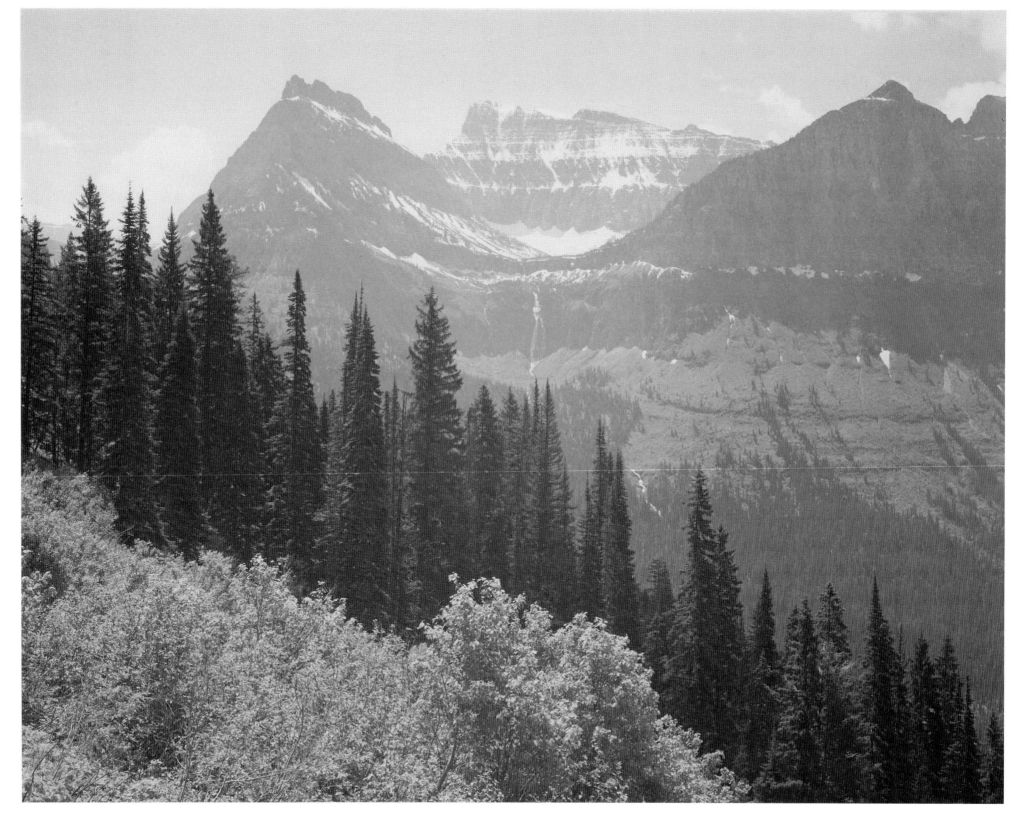

"In Glacier National Park."

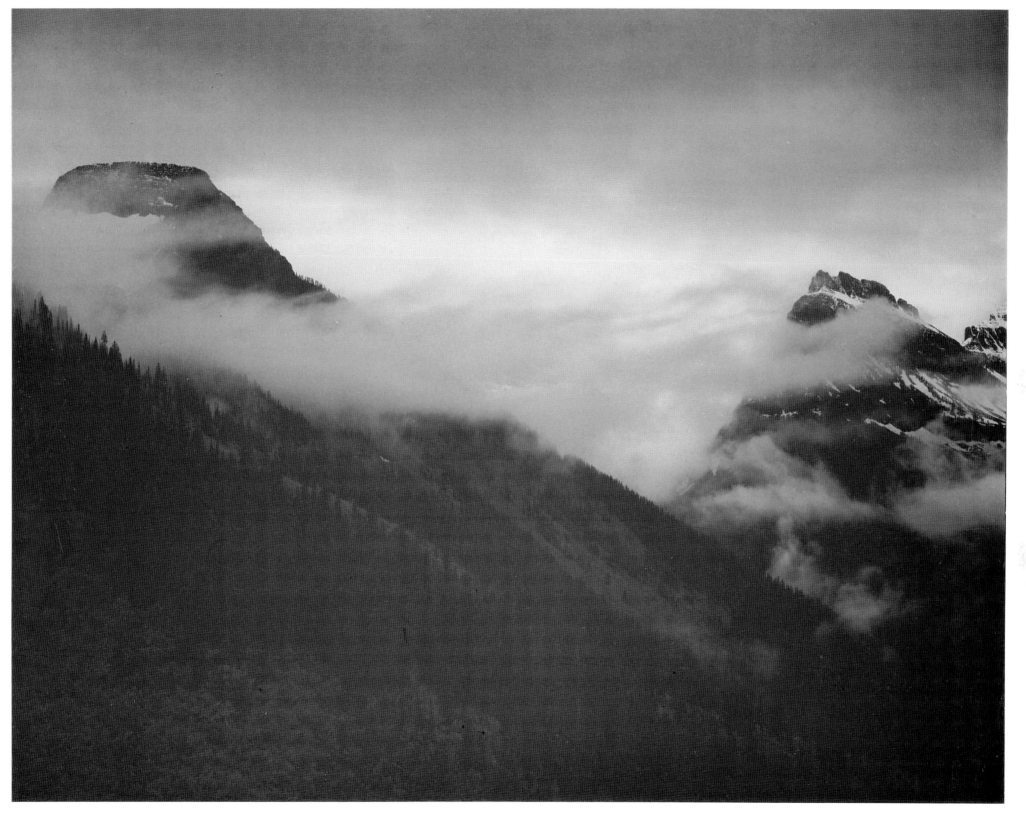

"In Glacier National Park."

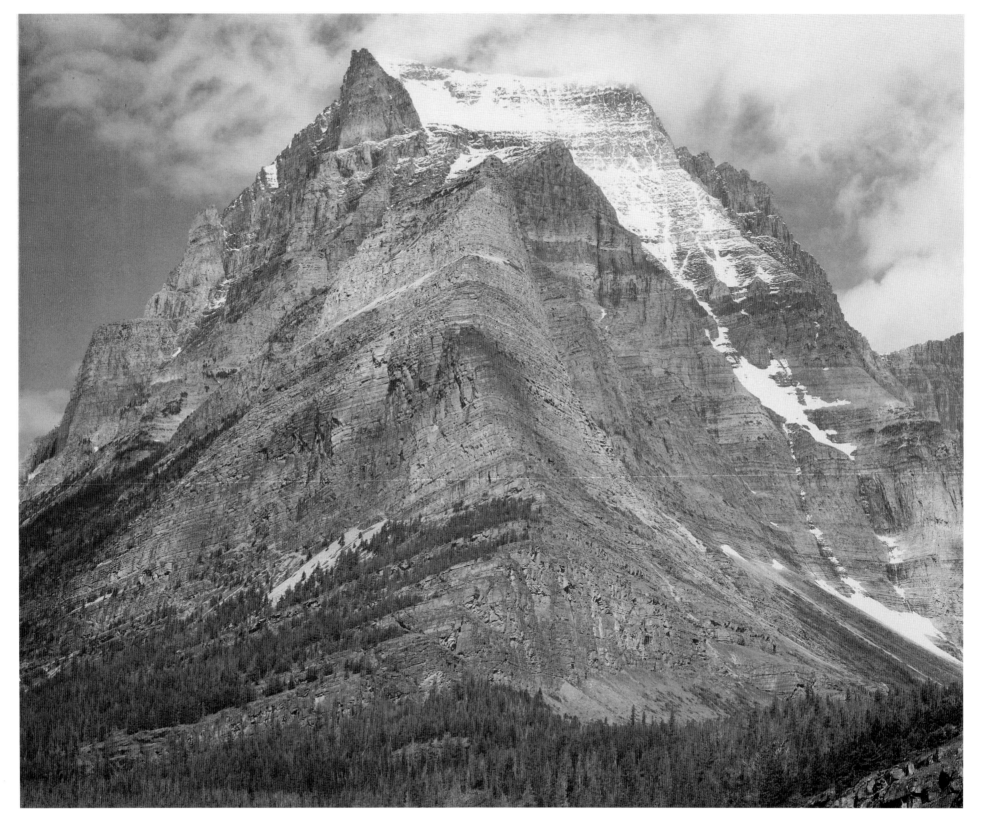

"Going-to-the-Sun Mountain, Glacier National Park."

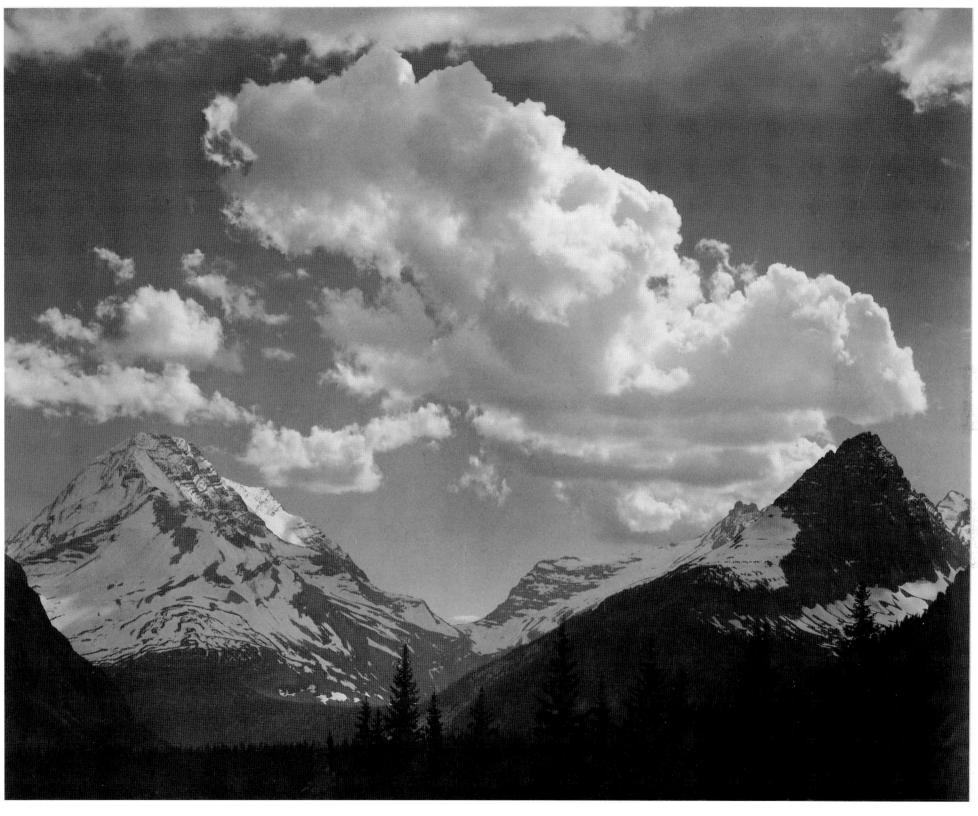

"In Glacier National Park, tops of pine trees, snow covered."

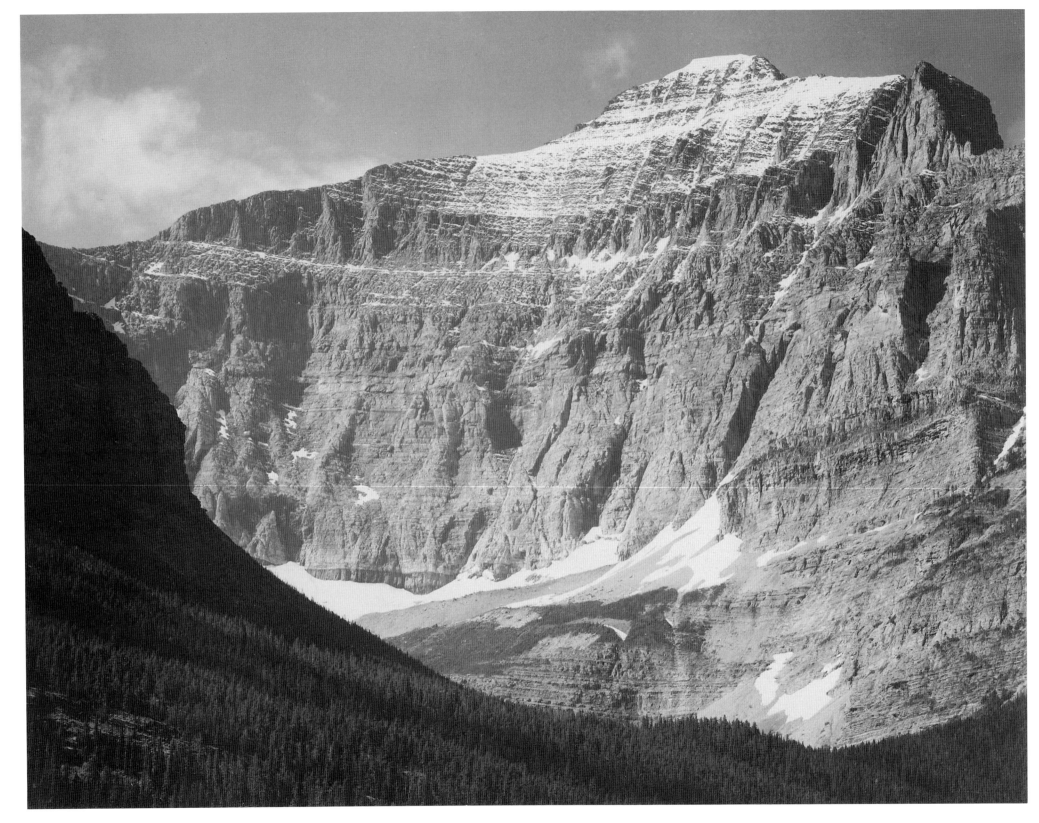

"From Going-to-the-Sun Chalet, Glacier National Park."

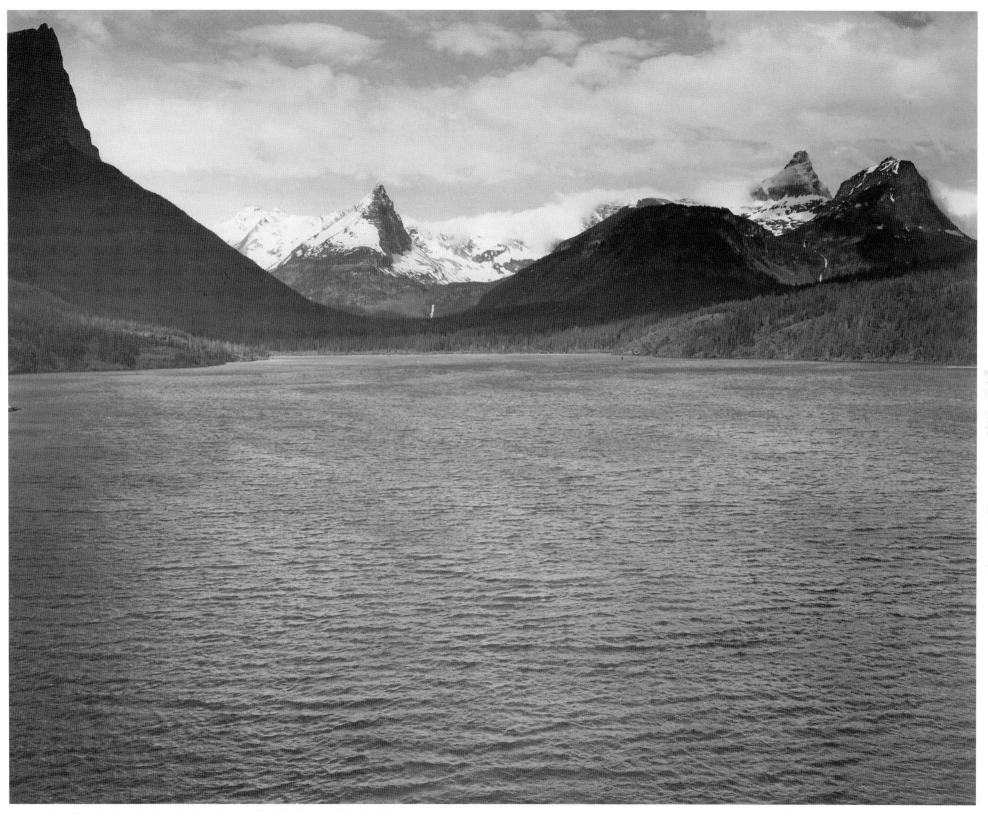

"St. Mary's Lake, Glacier National Park."

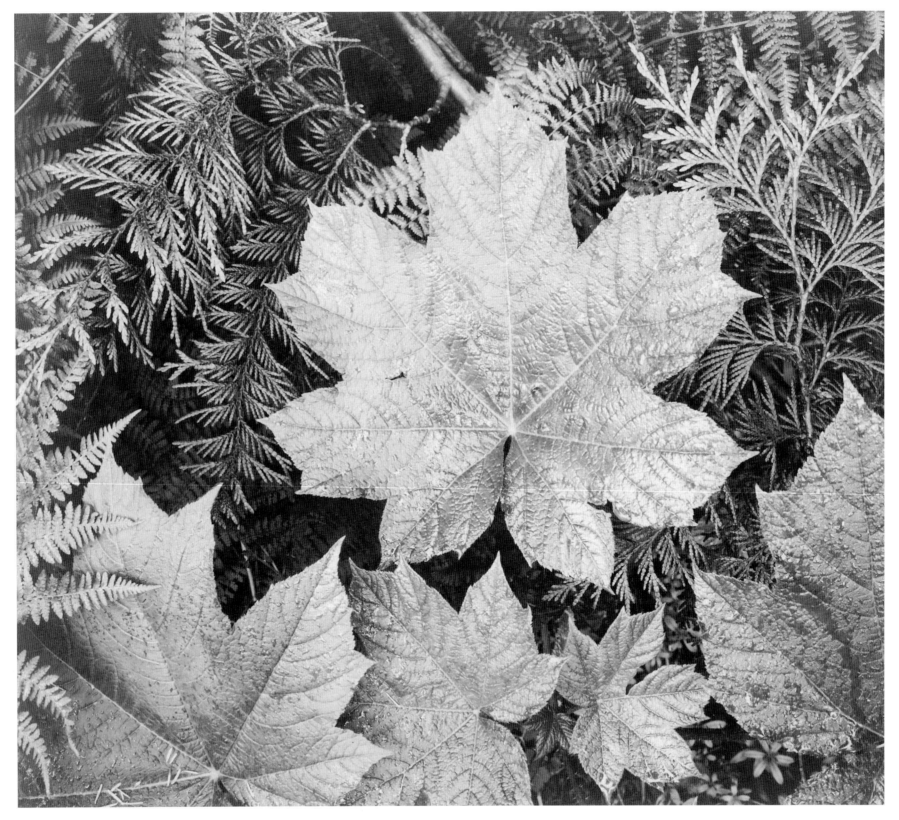

"In Glacier National Park."

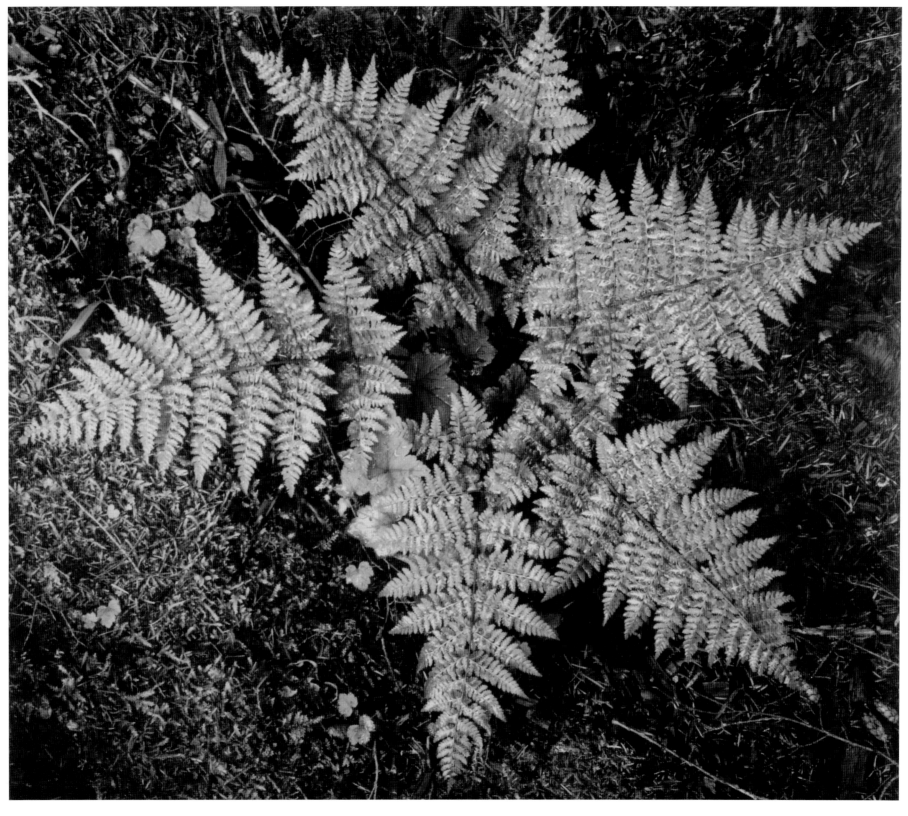

"In Glacier National Park."

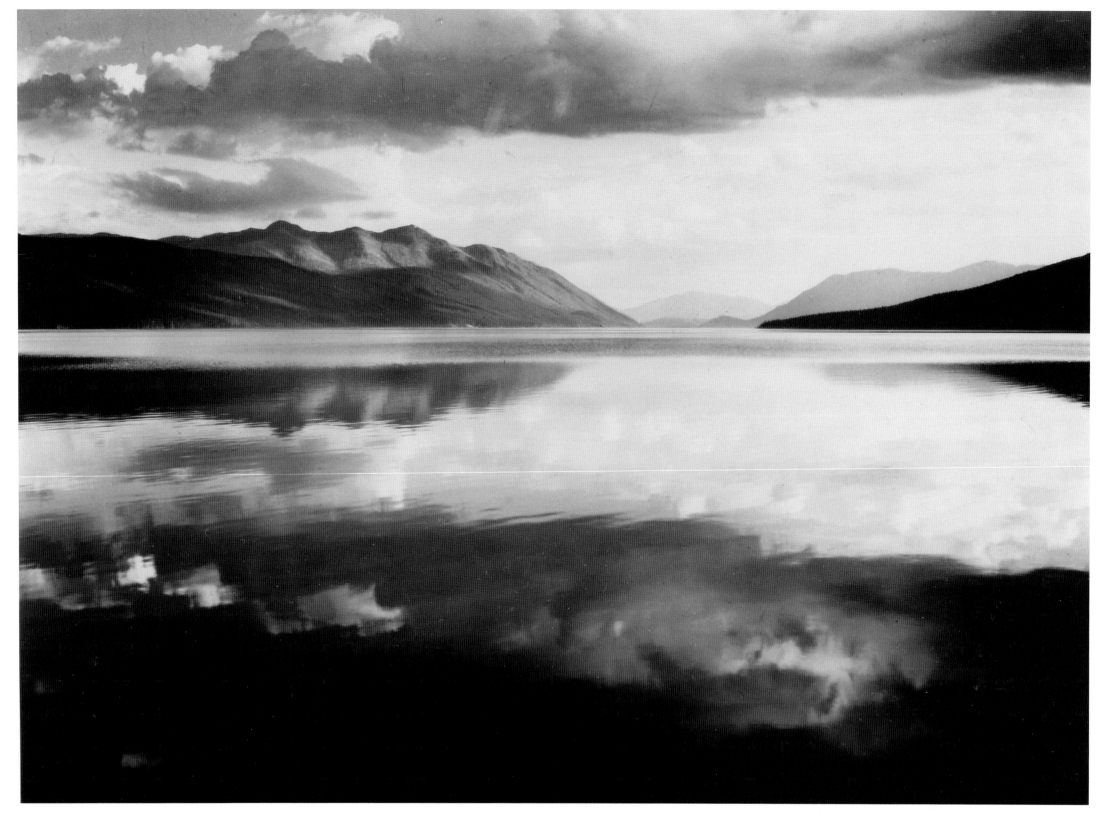

"McDonald Lake, Glacier National Park."

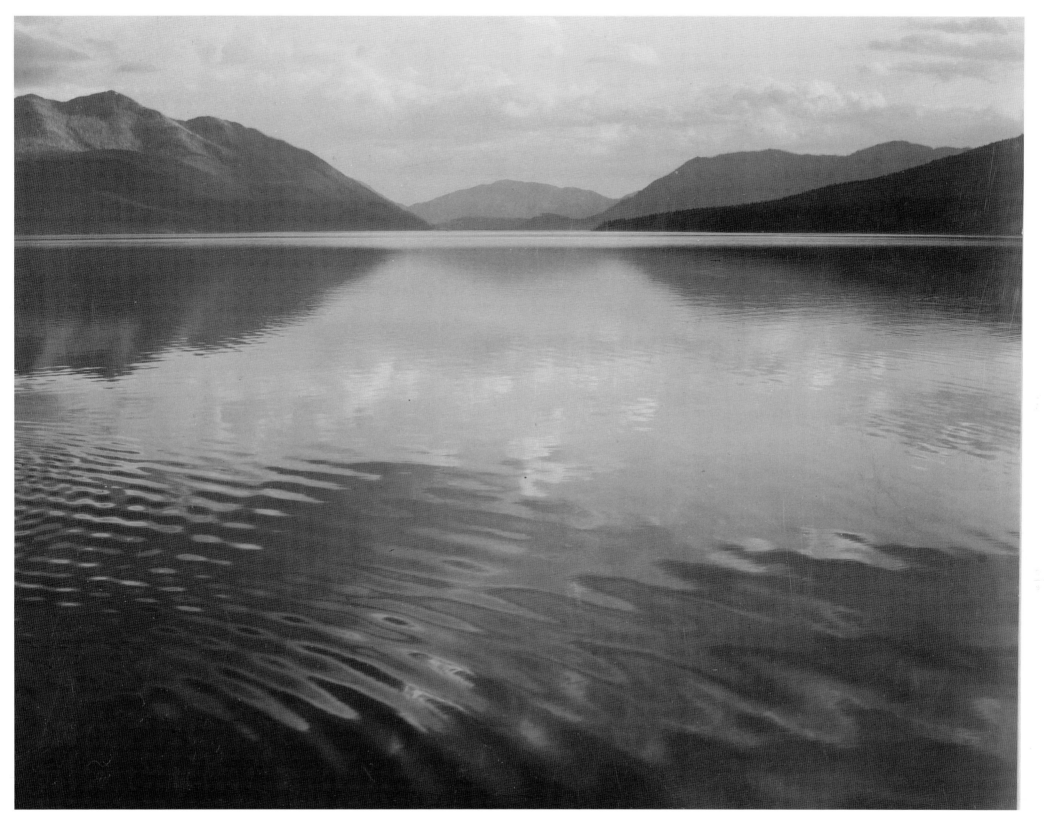

"McDonald Lake, Glacier National Park."

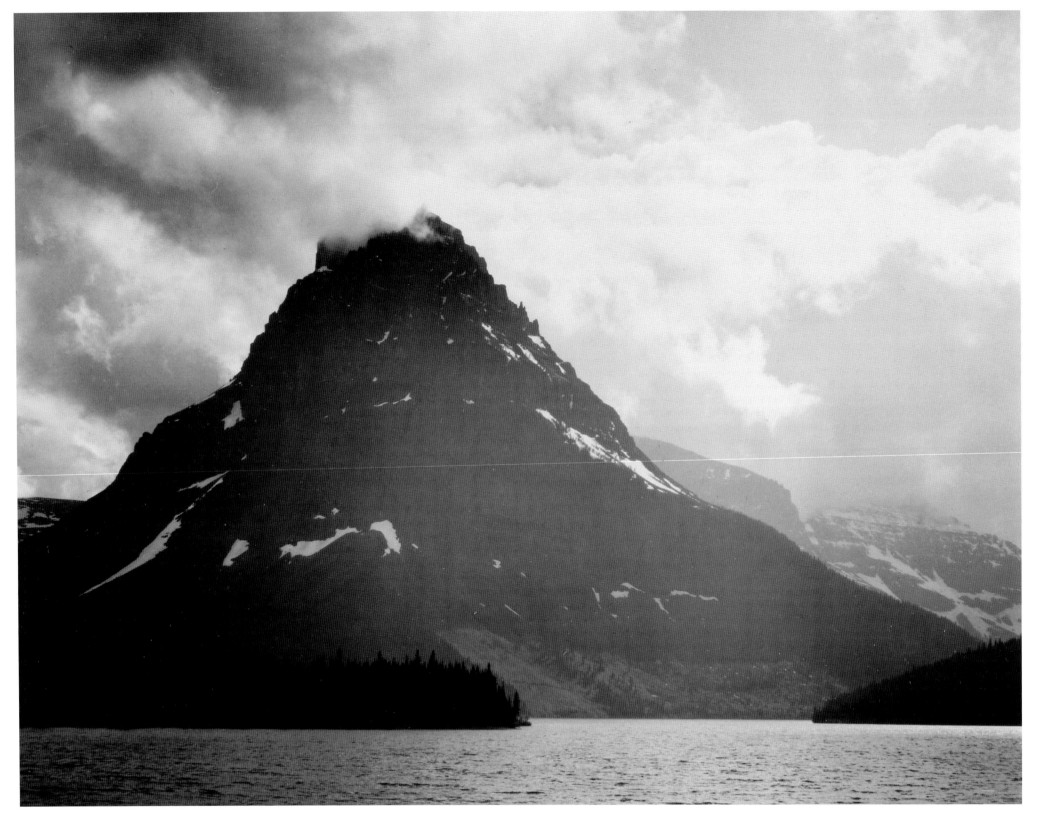

"Two Medicine Lake. Glacier National Park."

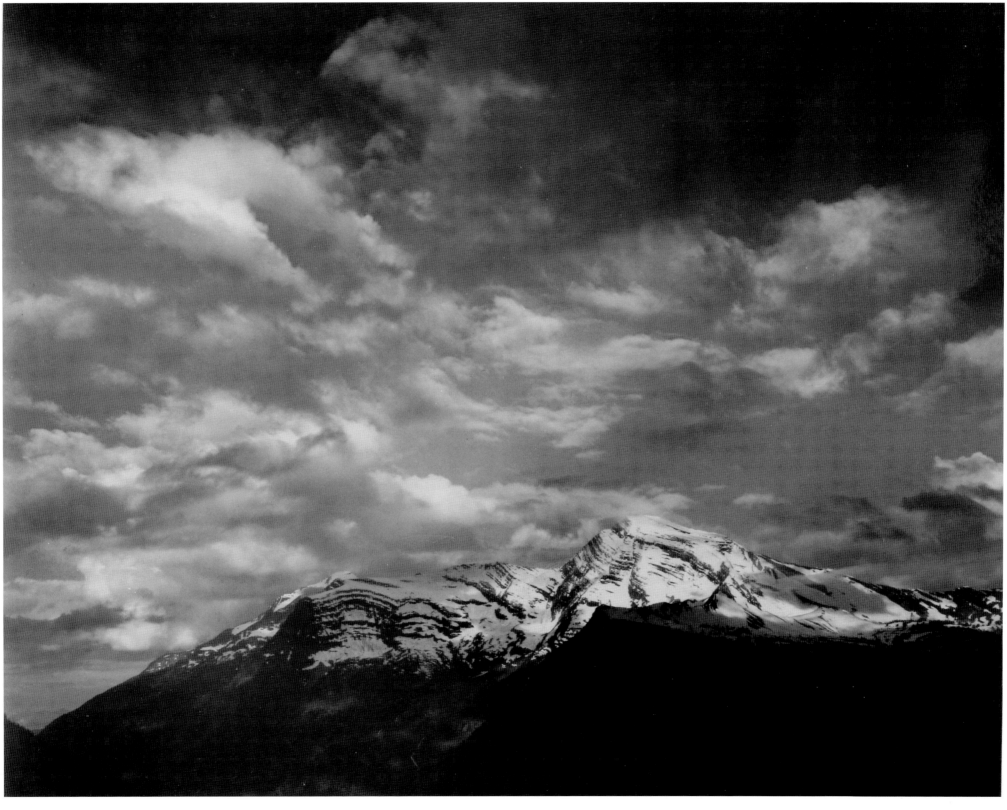

"Heaven's Peak."

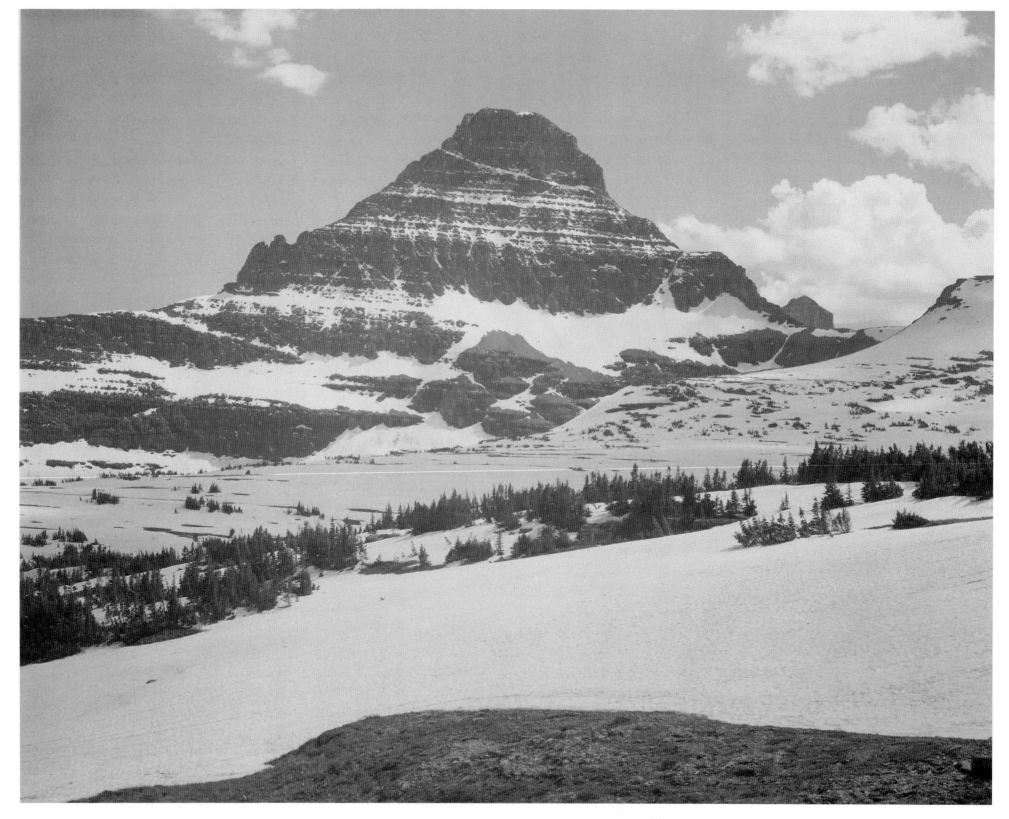

"From Logan Pass, Glacier National Park."

WYOMING

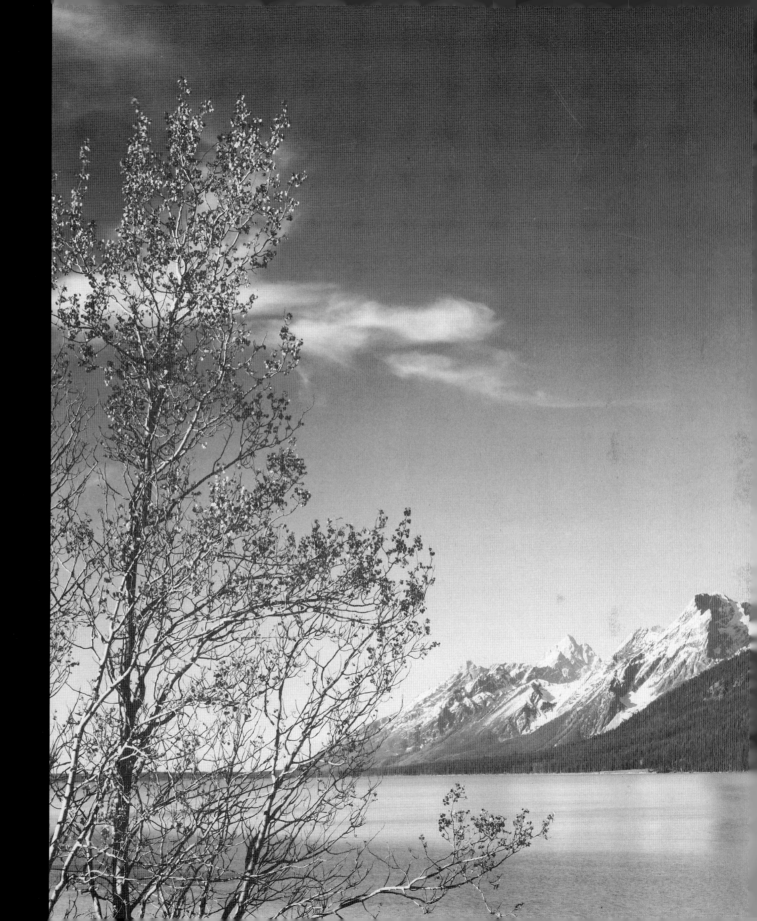

The state where the Great Plains meet the Rocky Mountains: Wyoming is a vast high plateau littered with mountain ranges. The highest point is Gannett Peak at 13,804 feet. As much as two thirds of Wyoming are covered with the mountainous foothills of the eastern Rocky Mountains. While in the southeast lie the High Plains prairies with its cold, semi-arid climate and extremes of day and night temperatures. In winter the wind chill factor from the prevailing westeries add considerably to physical discomfort. The Continental Divide crosses north-south across central Wyoming. Rivers to the west of the line drain into the Snake, Columbia, and Green Rivers and eventually to the Pacific Ocean; those east of the divide including the Yellowstone and Big Horn Rivers drain into the Missouri River Basin and eventually into the Gulf of Mexico. In southern central Wyoming the Continental Divide forks at the Great Divide Basin. Waters in this area are trapped and disappear by evaporation or into the soil. Ansel Adams photographed particularly in the fifty-mile long Teton Range which lies to the northwest of Wyoming.

Right: *"Grand Teton."*

GRAND TETON NATIONAL PARK

Grand Teton National Park in Wyoming was established in February 1929 to protect the mountain peaks and lakes around the Teton Range. In 1950 the adjacent valley floors and the Jackson Hole National Monument (created 1943) were added to the park to make an area of about 480 square miles. The Teton Range is a sub range of the Rocky Mountains and sits in the Snake River drainage basin. Grand Teton is the highest peak here at 13,775 feet, and along with Middle and South Tetons forms the heart of the range. The national park is part of the Greater Yellowstone Ecosystem that forms a vast contiguous mid-latitude temperate, near pristine, ecosystem with Yellowstone National Park, the John D. Rockefeller, Jr. Memorial Parkway, and surrounding national forests. Adams's photographs of the Grand Tetons include the classic "The Tetons - Snake River" which was one of the images sent aboard the Voyager spacecraft to tell any who find it about the planet Earth, its inhabitant—humans, plants, and animals, and geological features.

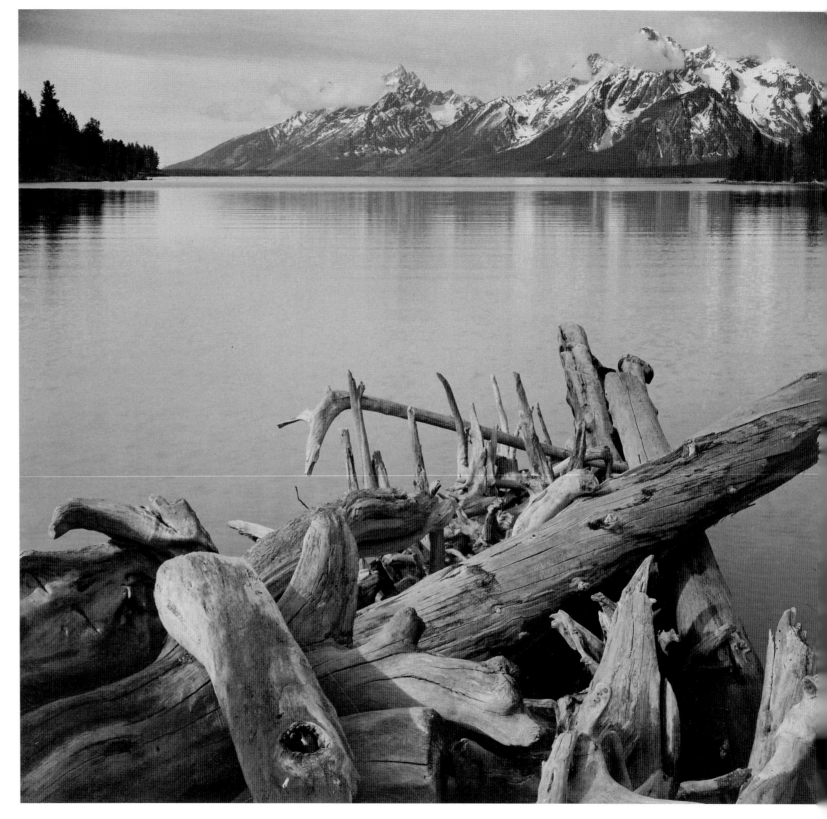

NARA photography says: no caption provided by Mr. Adams, but Jackson Lake in foreground, with Teton Range in background, view looking southwest from north end of the lake.

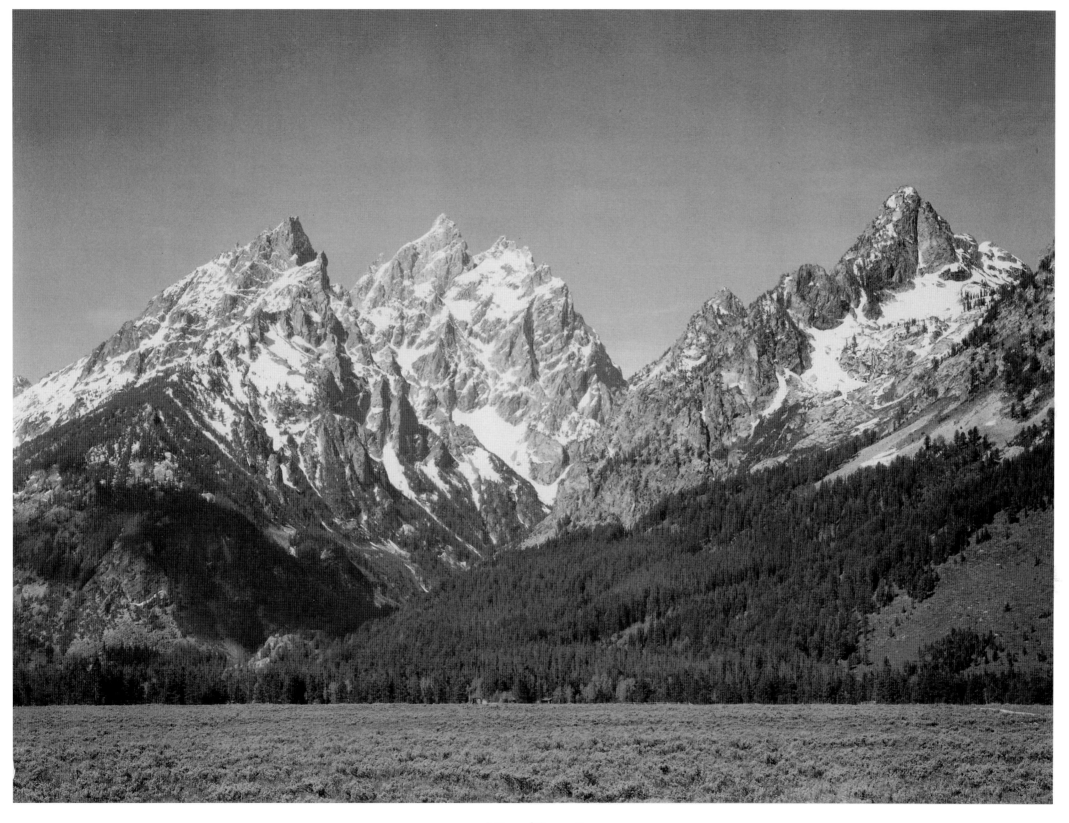

"Grand Teton."

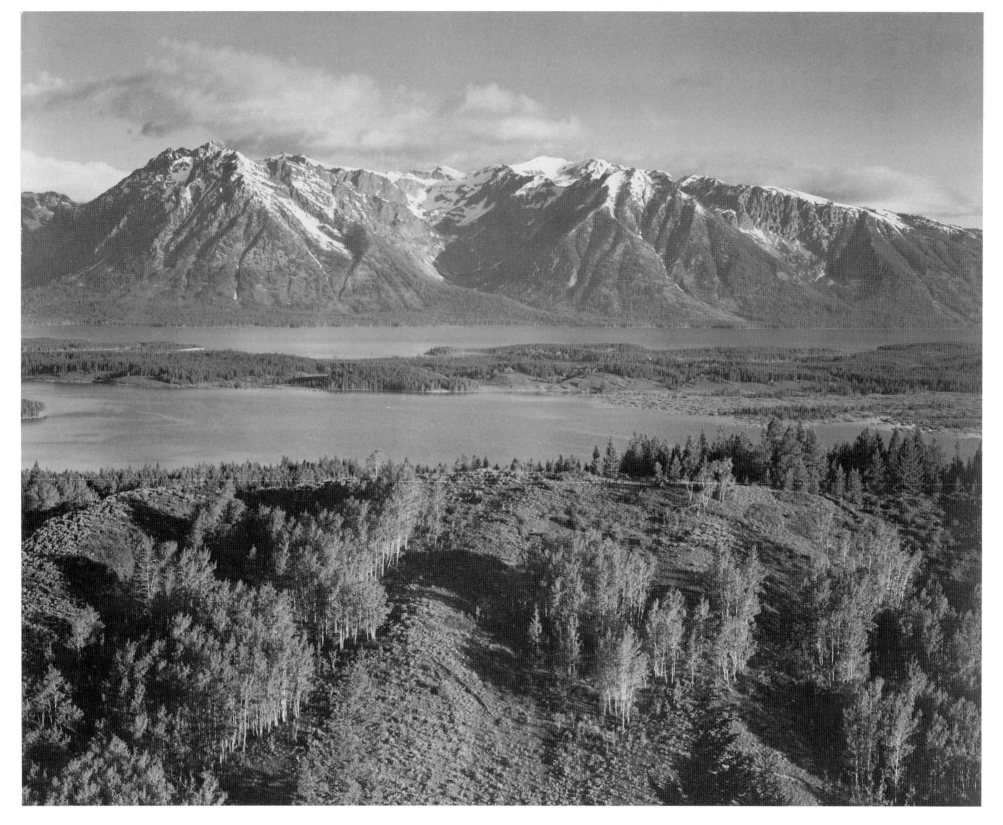

"Grand Teton."

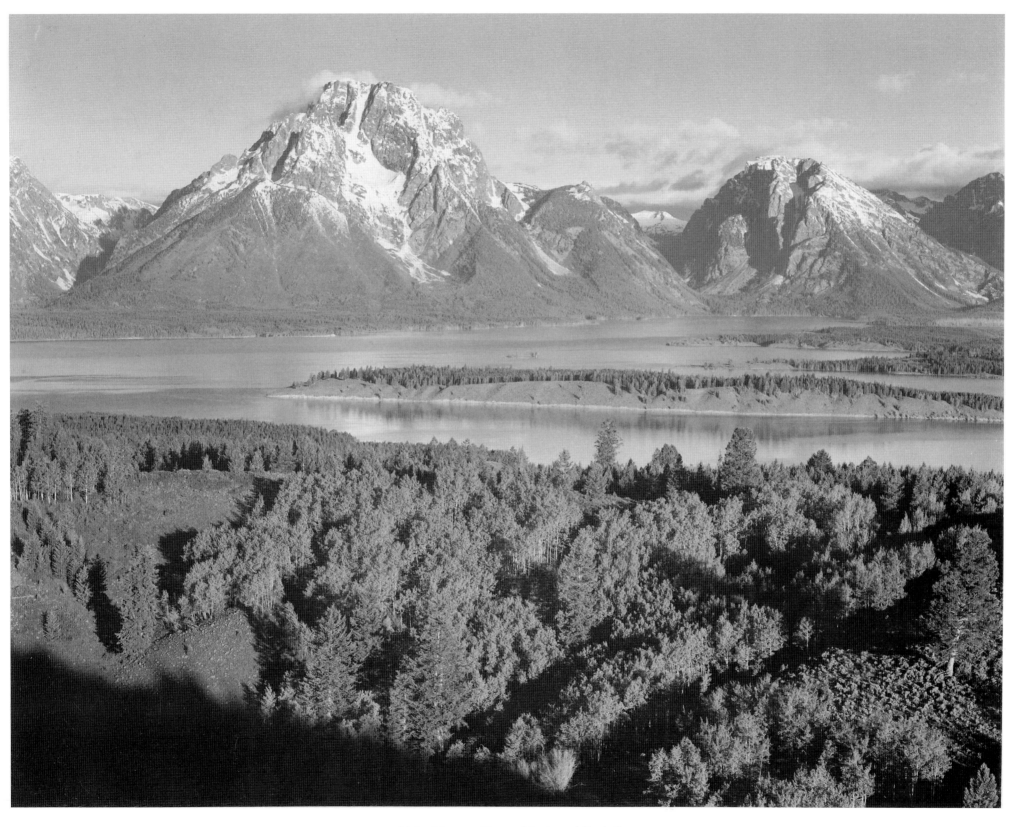

"Mt. Moran, Teton National Park."

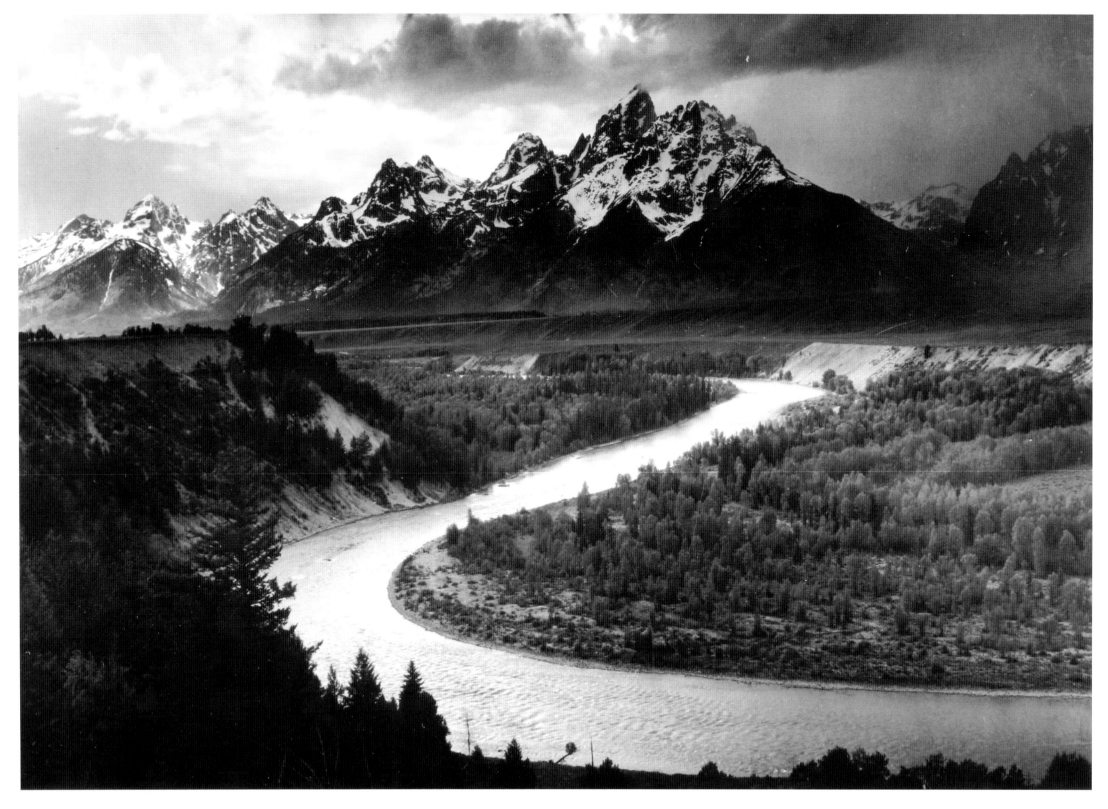

"The Tetons - Snake River."

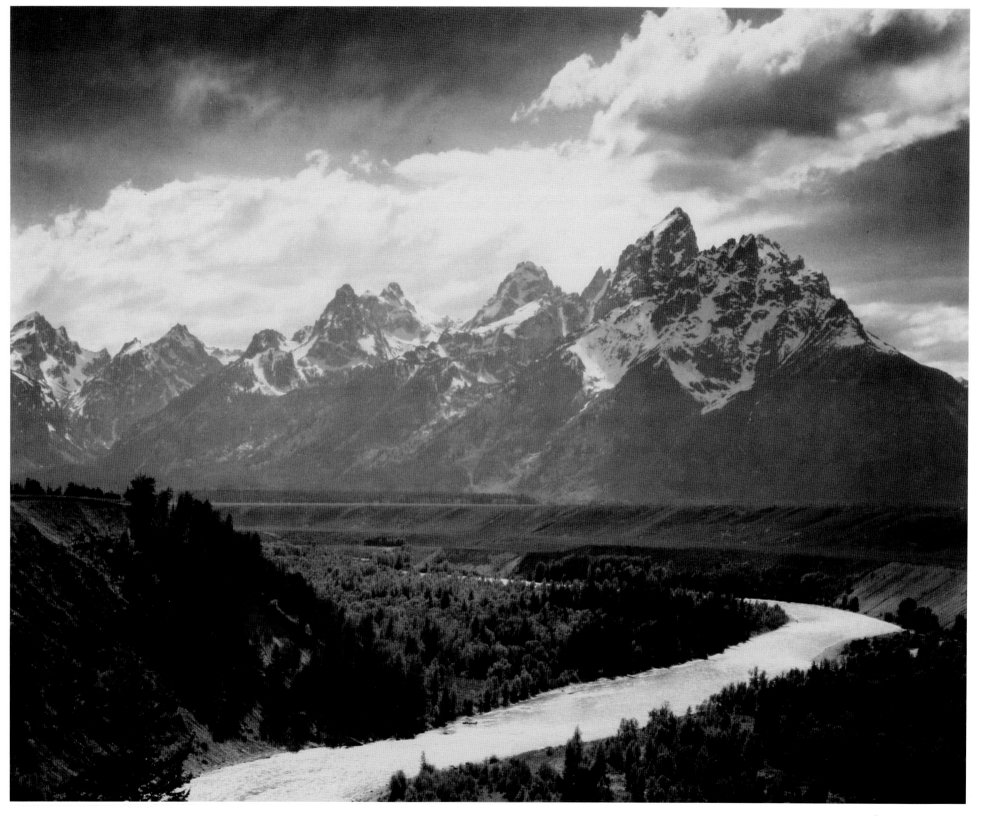

"Grand Teton."

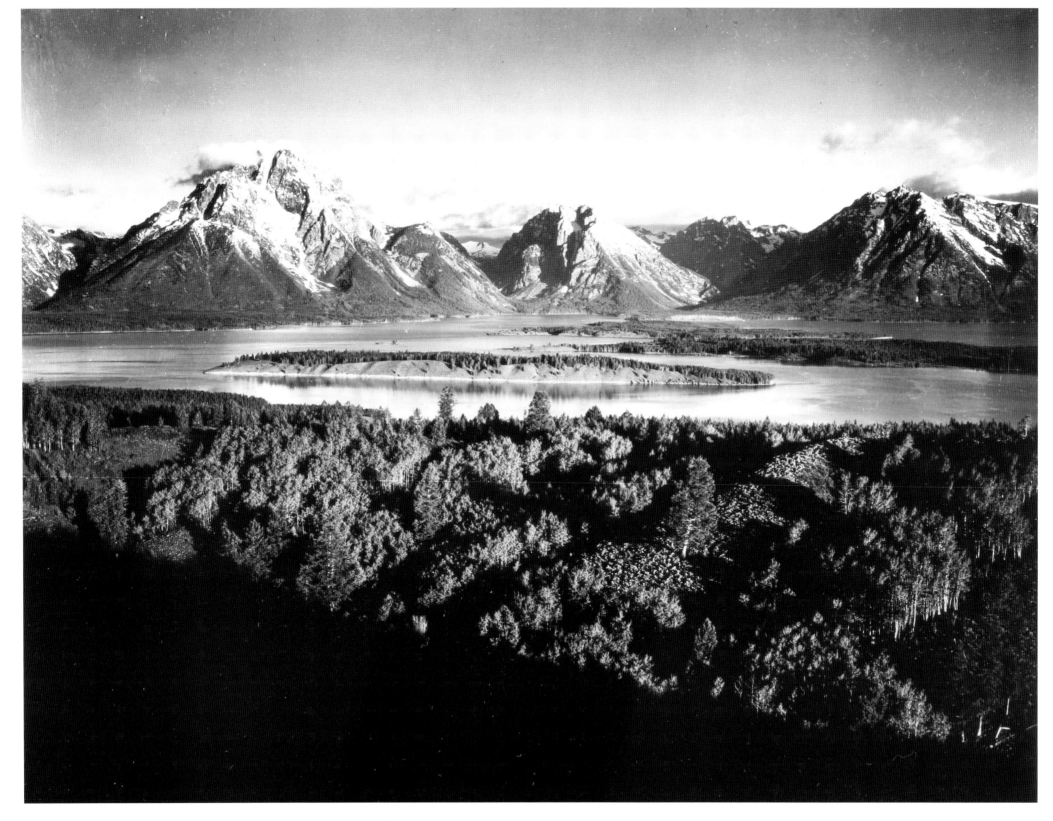

"Mt. Moran and Jackson Lake from Signal Hill."

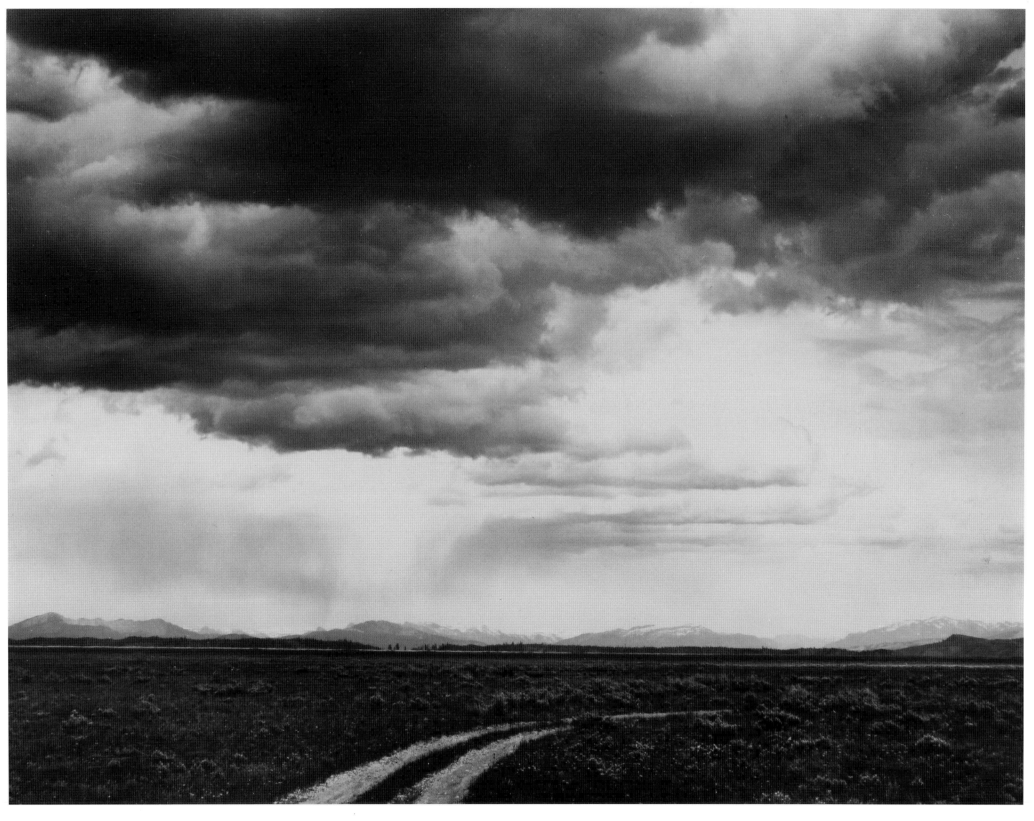

"Near [Grand] Teton National Park."

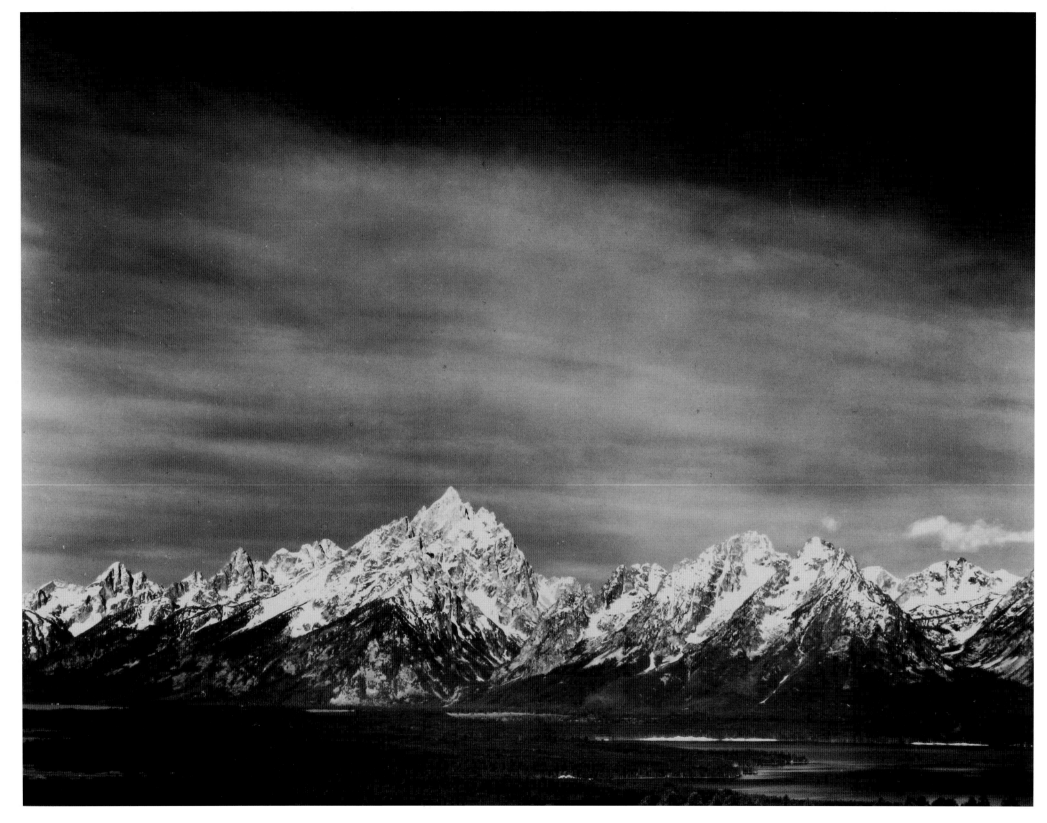

"Tetons from Signal Mountain."

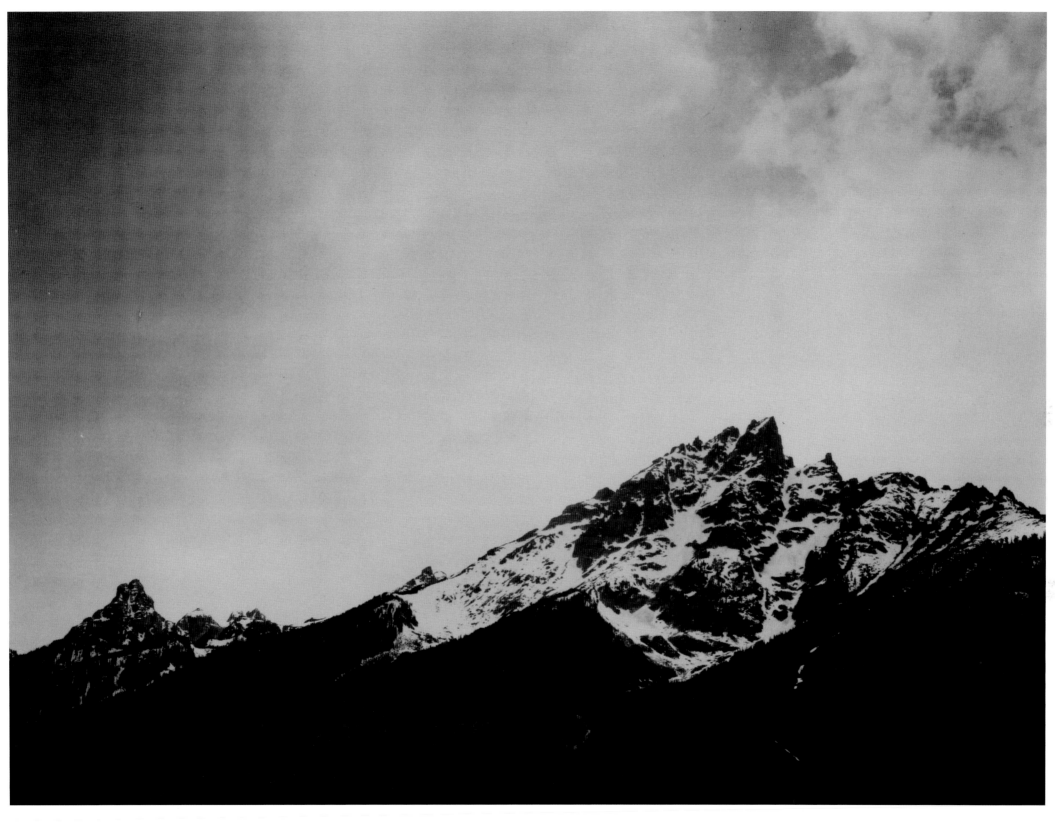

"In [Grand] Teton National Park."

YELLOWSTONE NATIONAL PARK

The national park was established on March 1, 1872 and signed into law by President Ulysses S. Grant: the first protected national park in the world. Initially administered by the U.S. Army, from 1917 its care was passed to the one-year old National Park Service. Yellowstone covers 3,468 square miles and includes mountain ranges, rivers, canyons, and lakes. Lava flows and volcanic rocks cover much of the land area of Yellowstone, and Yellowstone Lake lies directly over the Yellowstone Caldera, the largest supervolcano on the continent. The caldera measures about thirty-four by forty-five miles and was formed over the past 2.1 million years through three supereruptions. Geothermal vents are scattered across the area and remind onlookers of the underground thermal activity with the impressive geysers. The most famous geyser in Yellowstone is Old Faithful, shooting boiling water some 145 feet into the air each hour. However, the world's tallest, currently active geyser is Steamboat Geyser, also in Yellowstone. It can throw boiling water over 300 feet into the air with jets that can last for up to forty minutes in intervals between four days to a number of years. Adams photographed the geysers both at dawn and at sunset as the light played with the waters. Prewar visitors to Yellowstone National Park numbered around half a million a year; postwar visitor numbers shot up to over a million a year by 1948. The strain placed on the parks was immense. Adams remained closely engaged with the preservation of the wilderness and his photographs inspired many people to see his remarkable views for themselves. By the mid-1950s, an astonishing near 62 million Americans were flocking to the national parks and the wildernesses were buckling under the strain. Ansel Adams remained one of the most prominent fighters for these open spaces and remained one of the greatest supporters of the environment his entire life. Yellowstone delighted Adams, especially the geysers of which he said, "It is difficult to conceive of any substance in nature more impressively brilliant than the spurting plumes of white waters in sunlight against a deep blue sky."

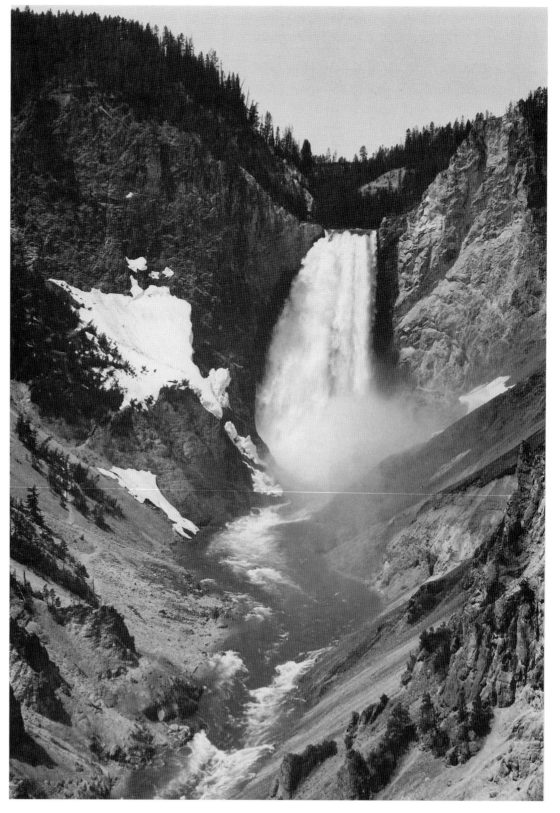

"Yellowstone Falls."

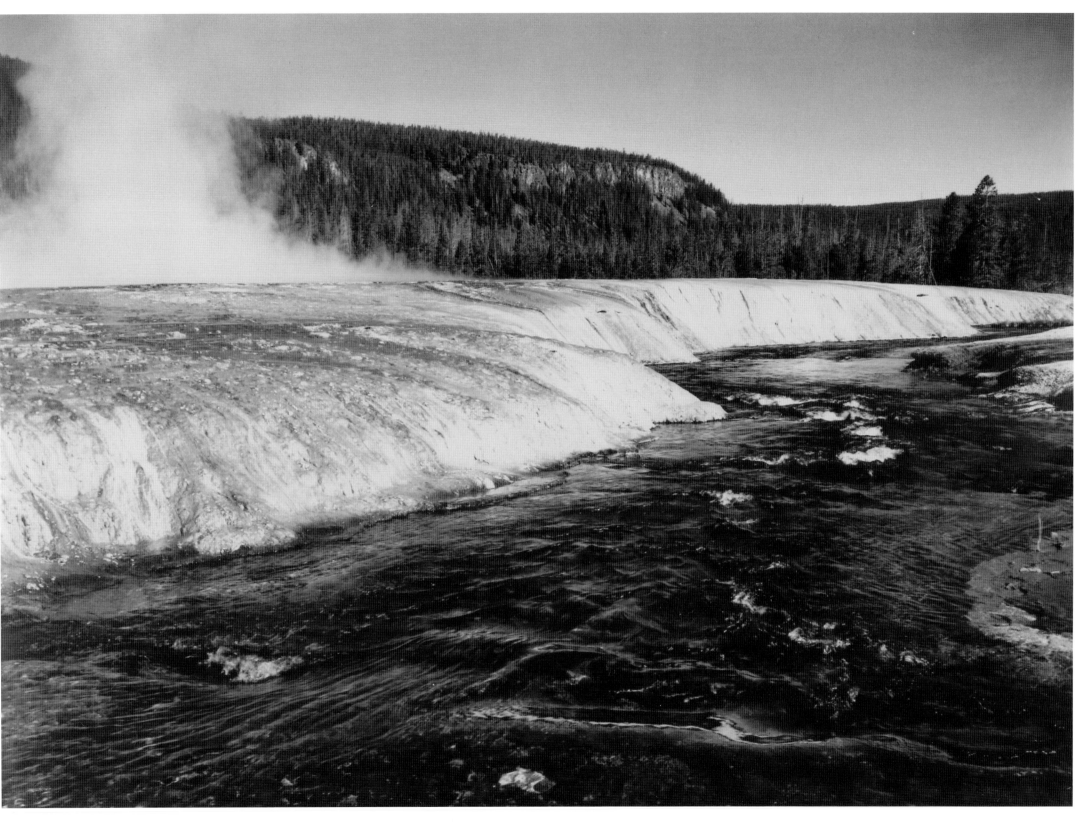

"Firehold River, Yellowstone National Park."

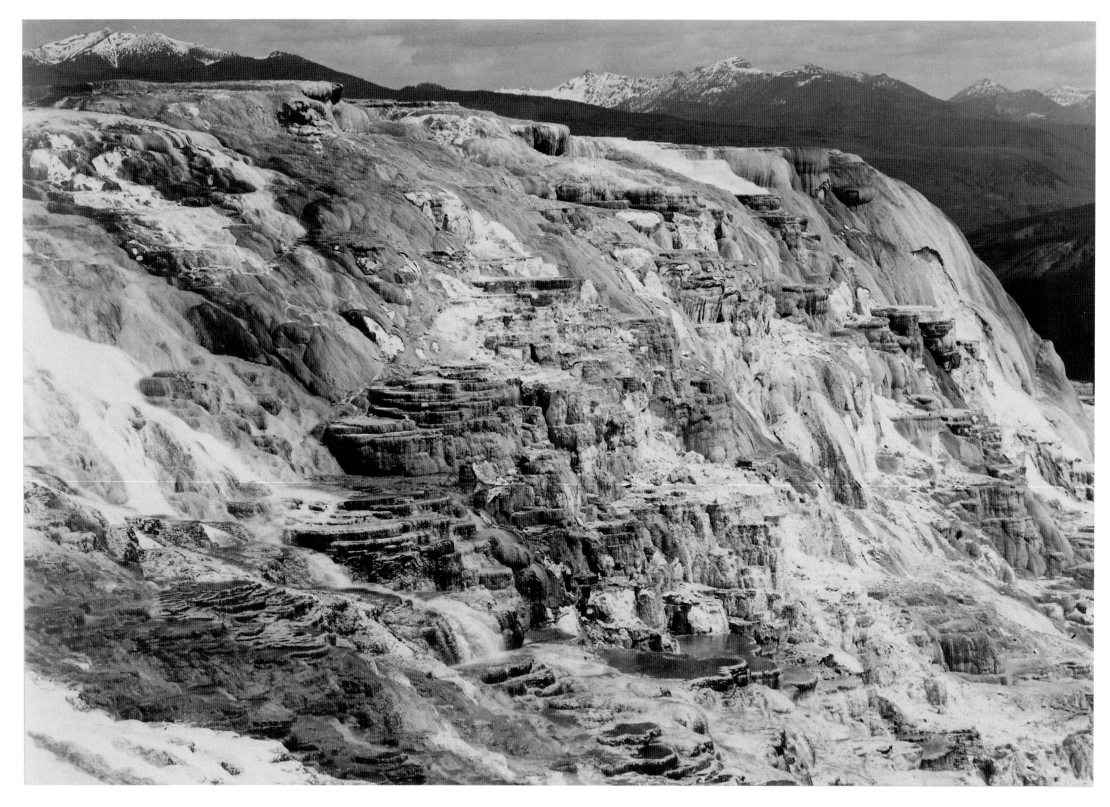

"Jupiter Terrace, Fountain Geyser Pool, Yellowstone National Park."

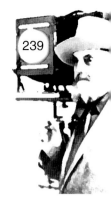

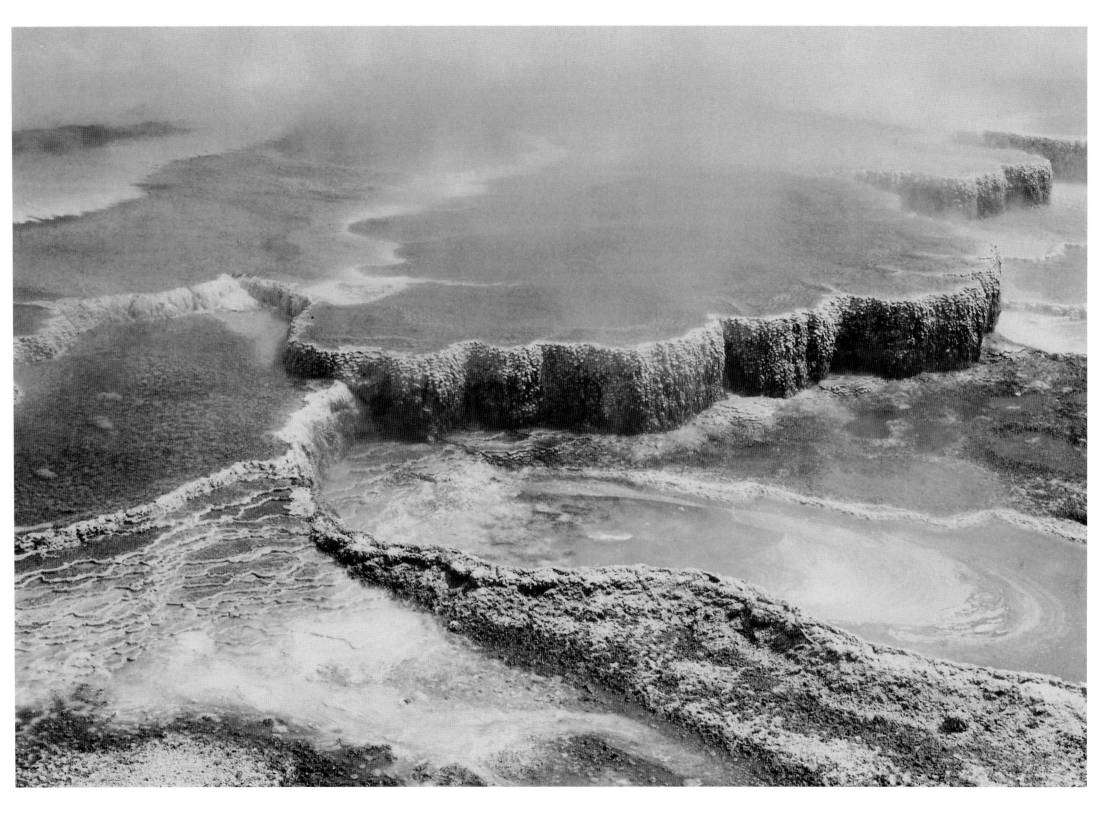

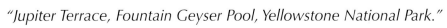

"Jupiter Terrace, Fountain Geyser Pool, Yellowstone National Park."

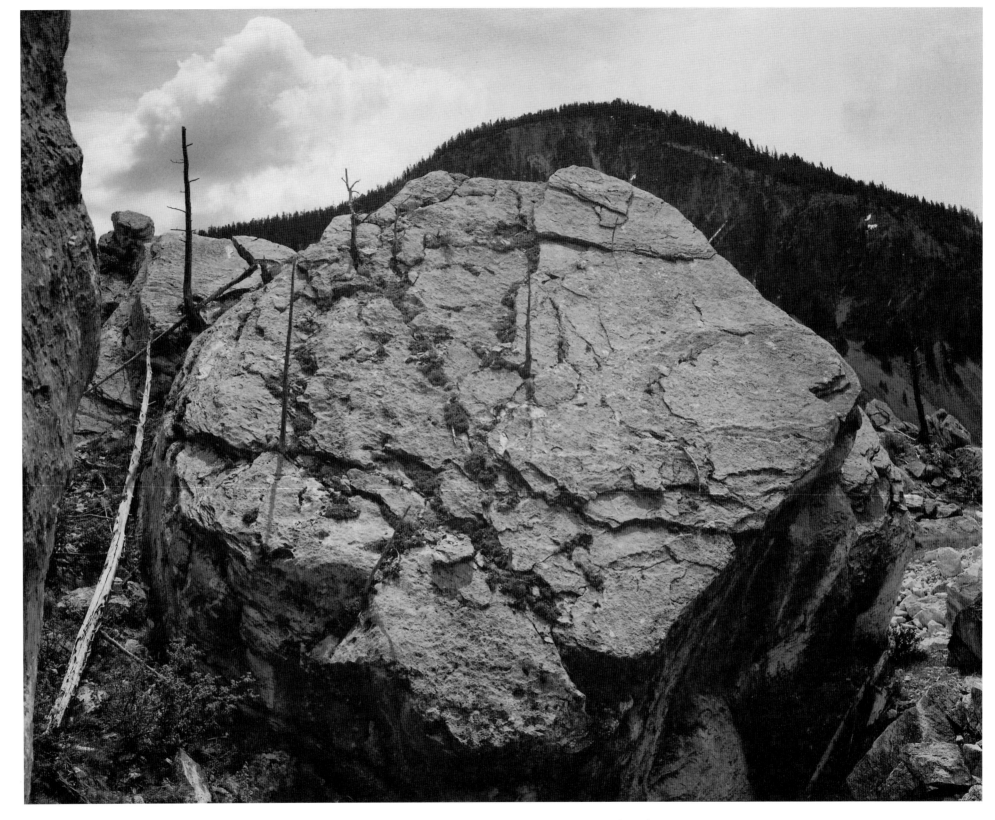

"Rocks at Silver Gate, Yellowstone National Park."

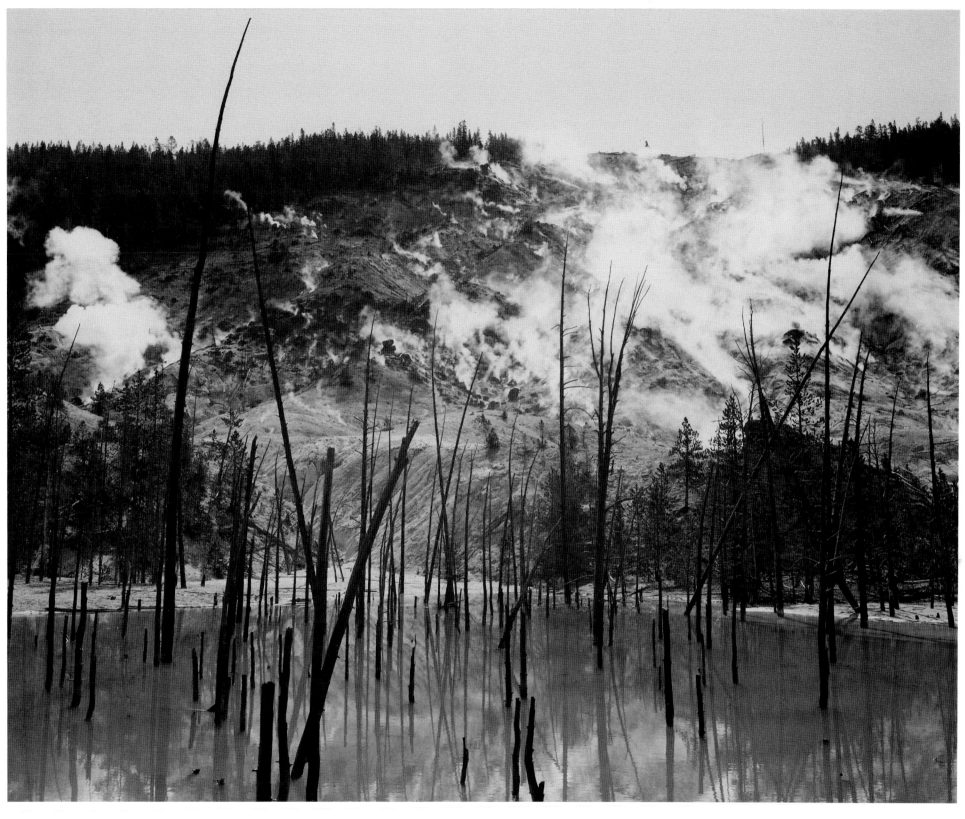

"Roaring Mountain, Yellowstone National Park."

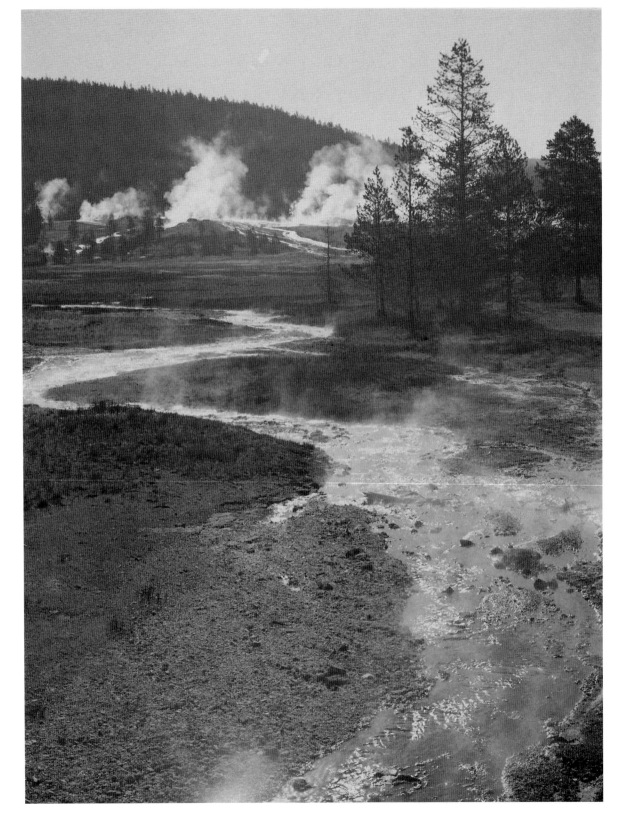

"Central Geyser Basin, Yellowstone National Park."

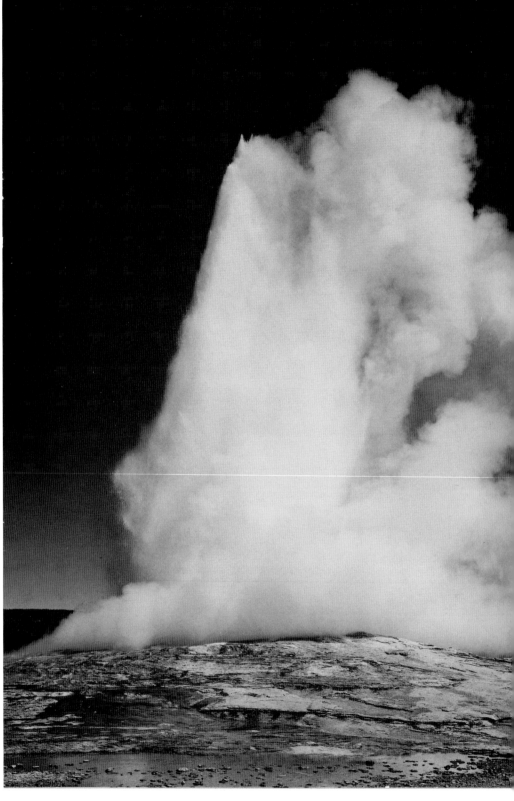

"Old Faithful Geyser, Yellowstone National Park,"

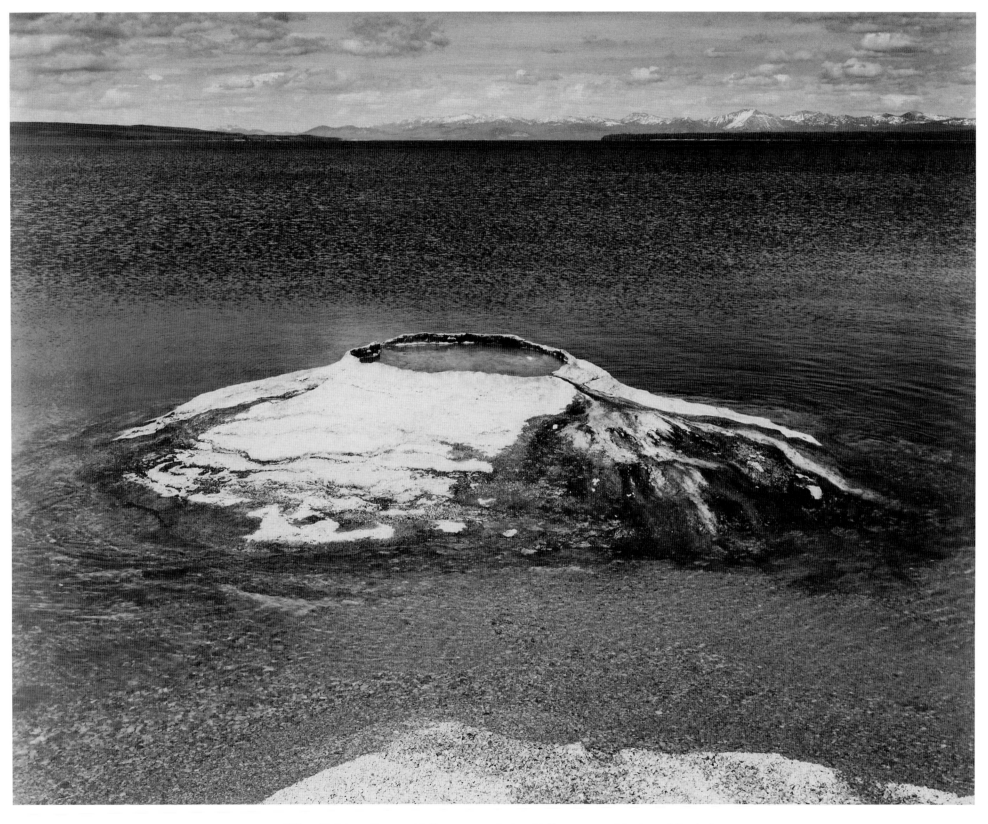

"The Fishing Cone - Yellowstone Lake, Yellowstone National Park."

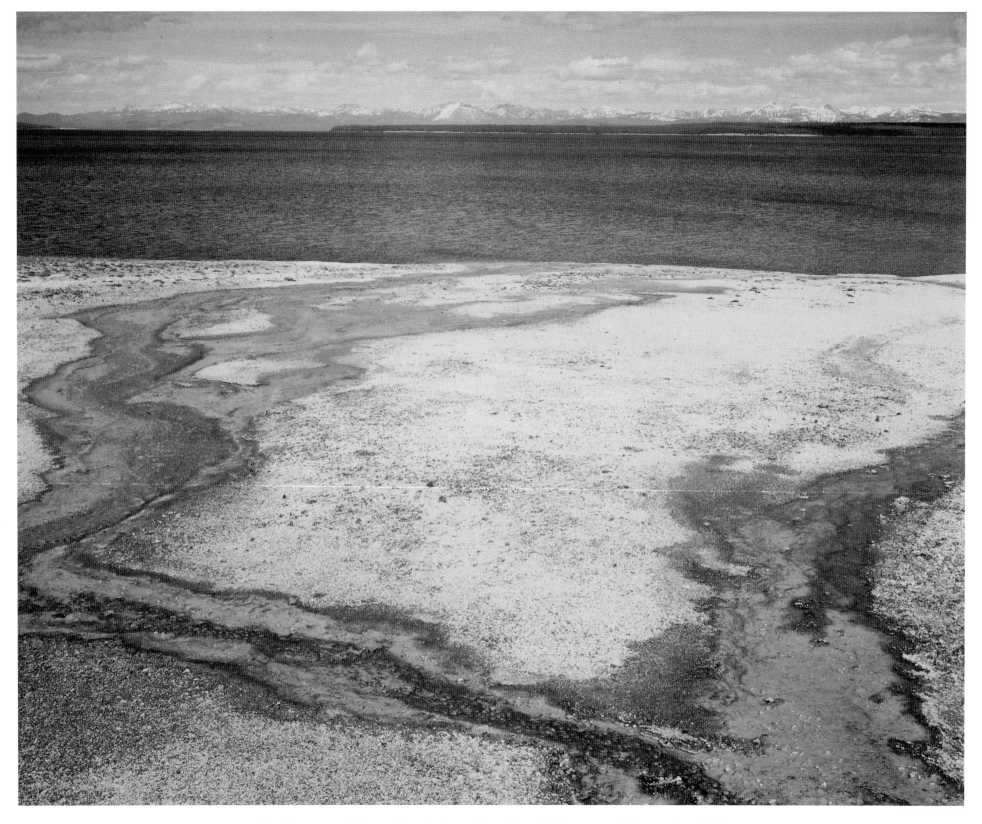

"Yellowstone Lake - Hot Springs Overflow, Yellowstone National Park."

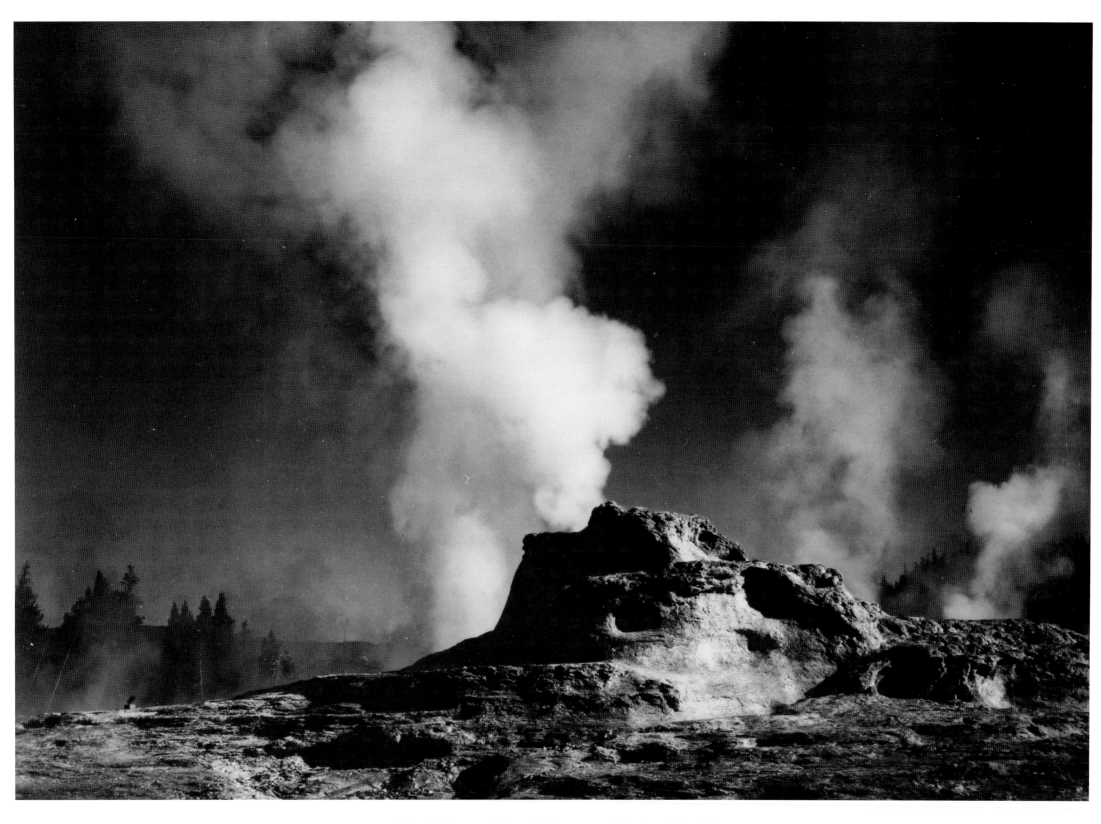

"Castle Geyser Coye, Yellowstone National Park."

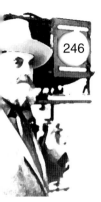

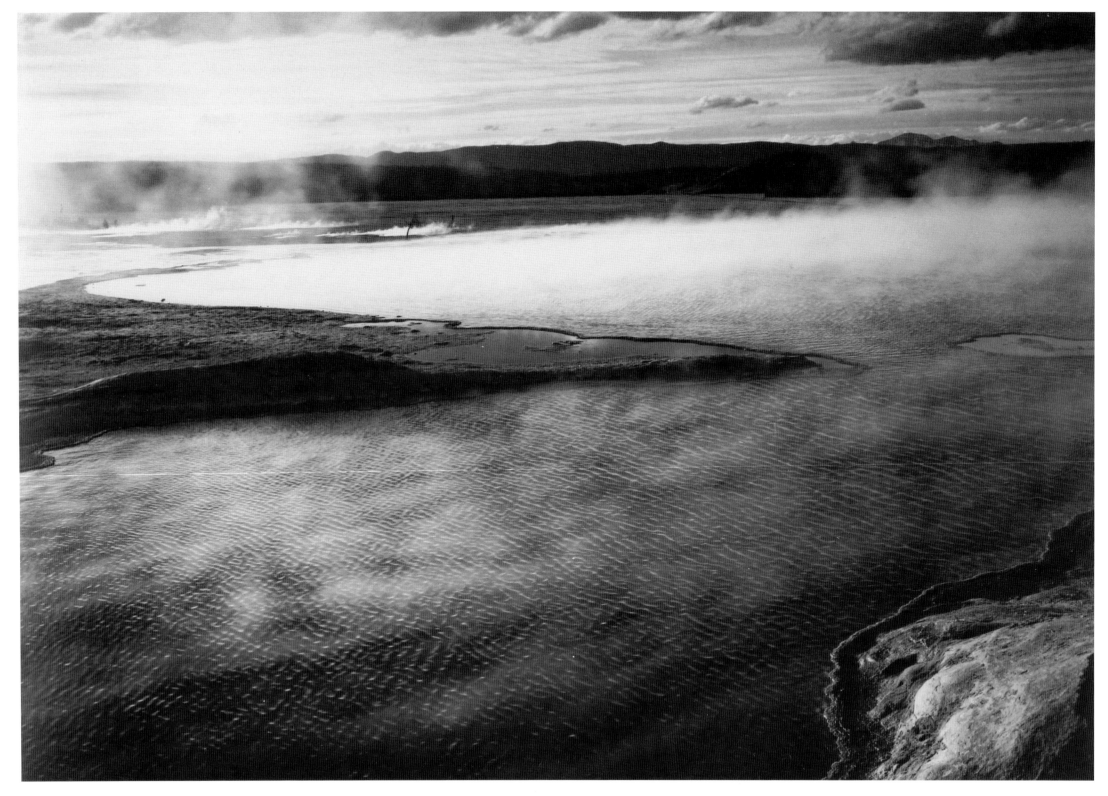

"Fountain Geyser Pool, Yellowstone National Park."

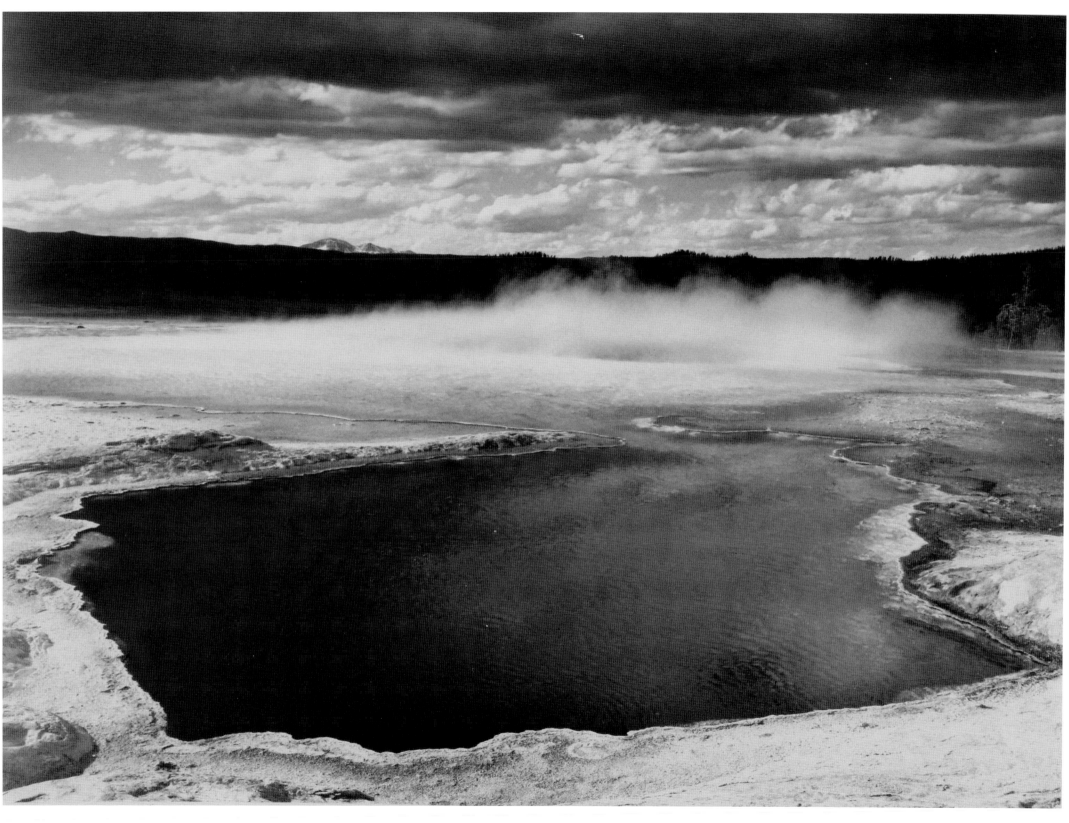

"Fountain Geyser Pool, Yellowstone National Park."

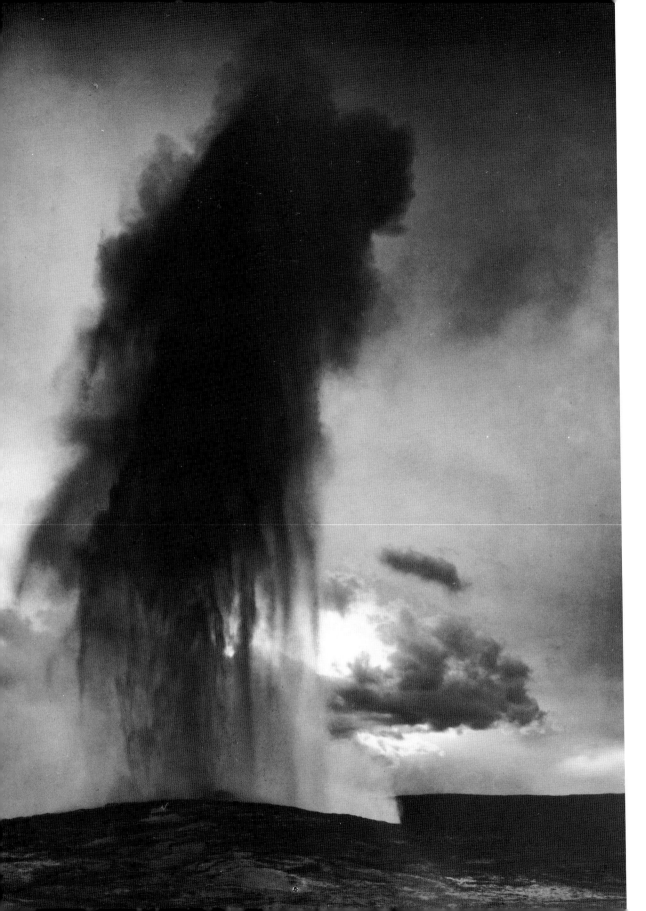

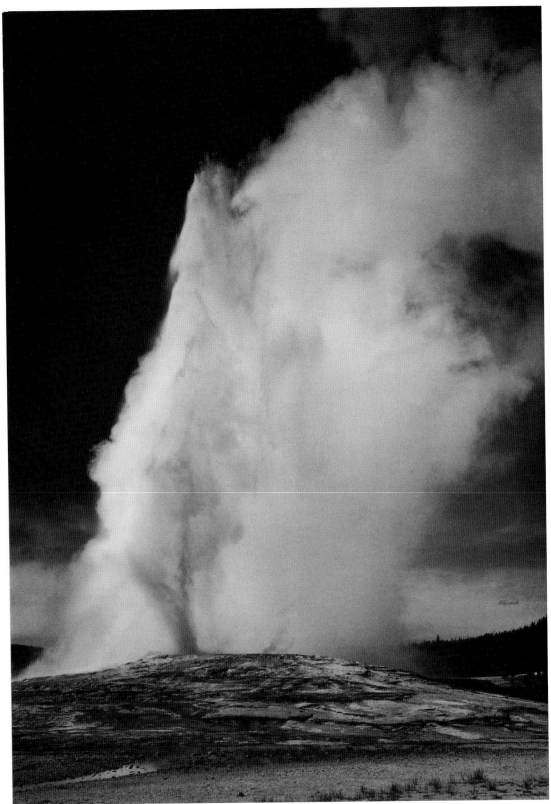

Both: *"Old Faithful Geyser, Yellowstone National Park."*

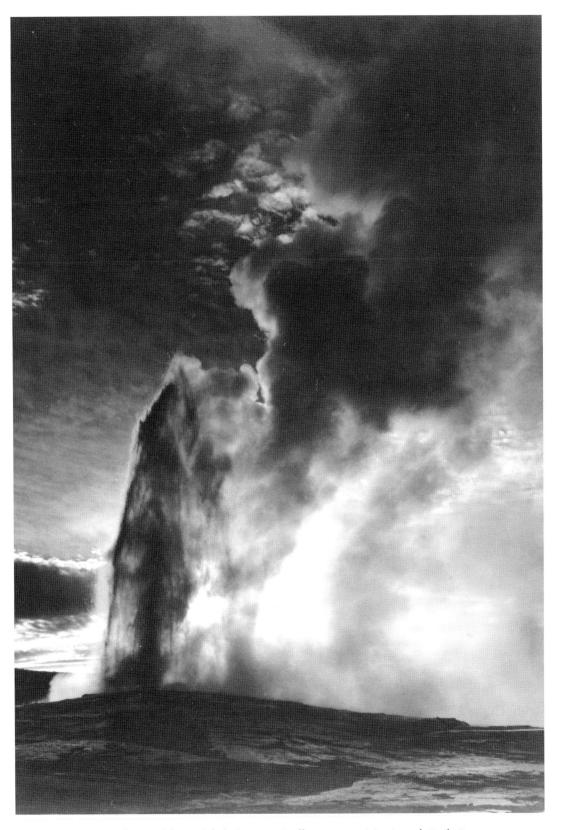

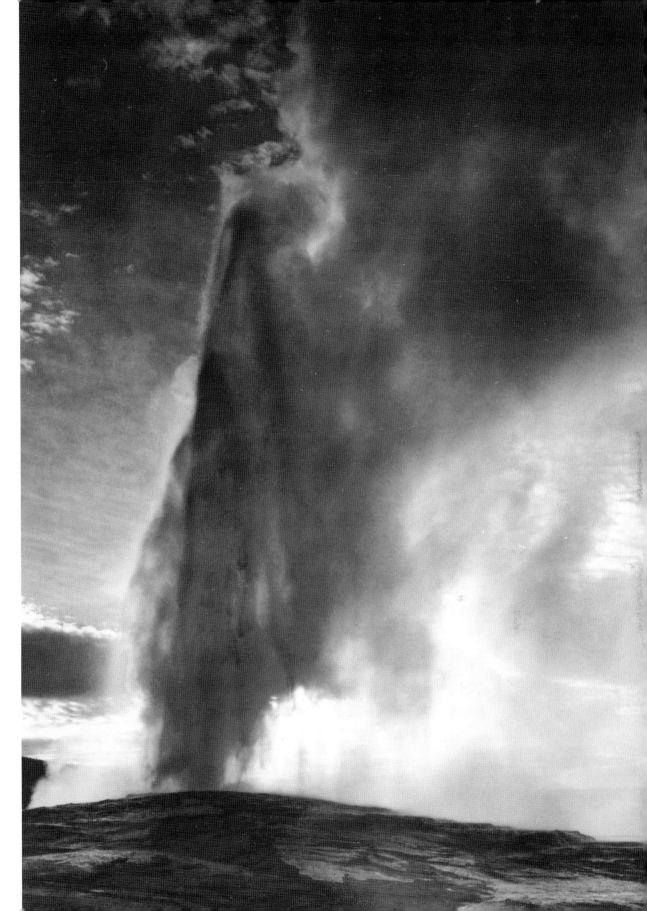

Both: *"Old Faithful Geyser, Yellowstone National Park."*

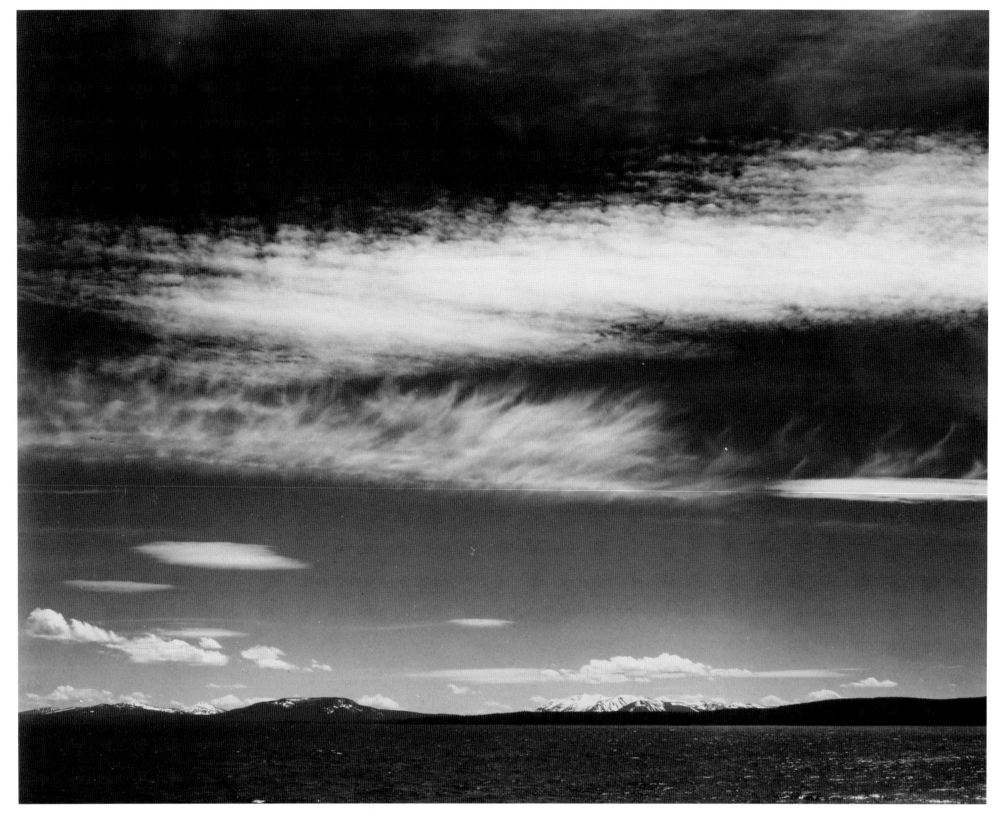

"Yellowstone Lake, Yellowstone National Park."

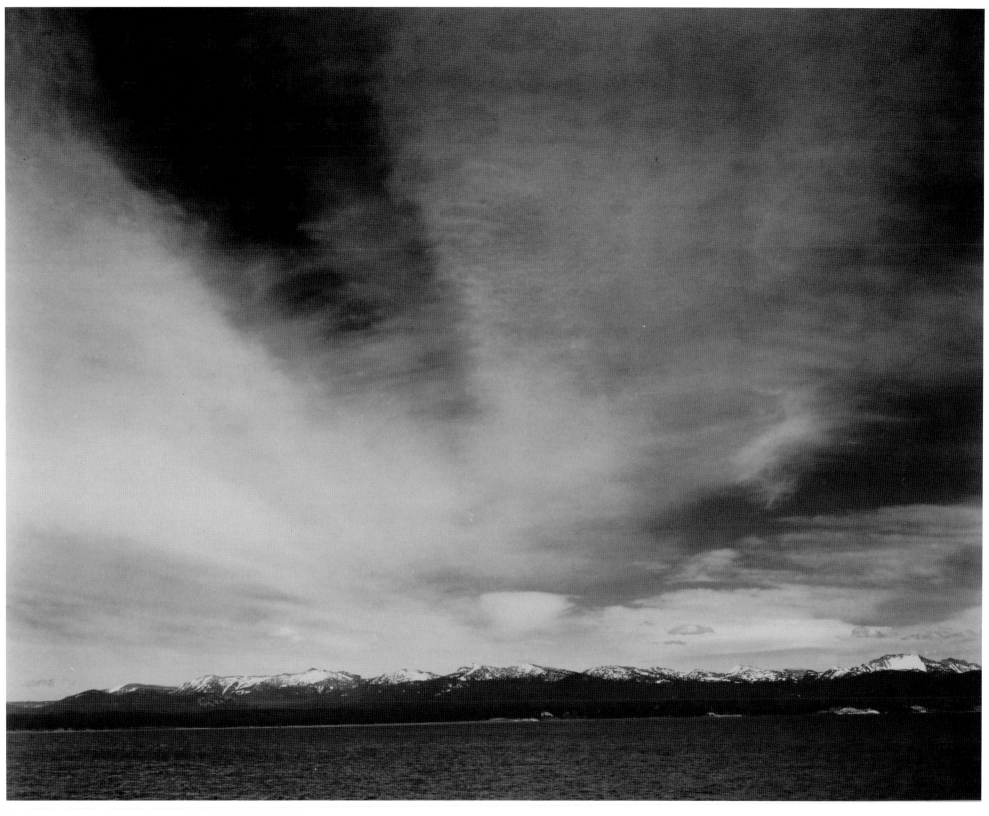

"Yellowstone Lake, Yellowstone National Park."

UTAH

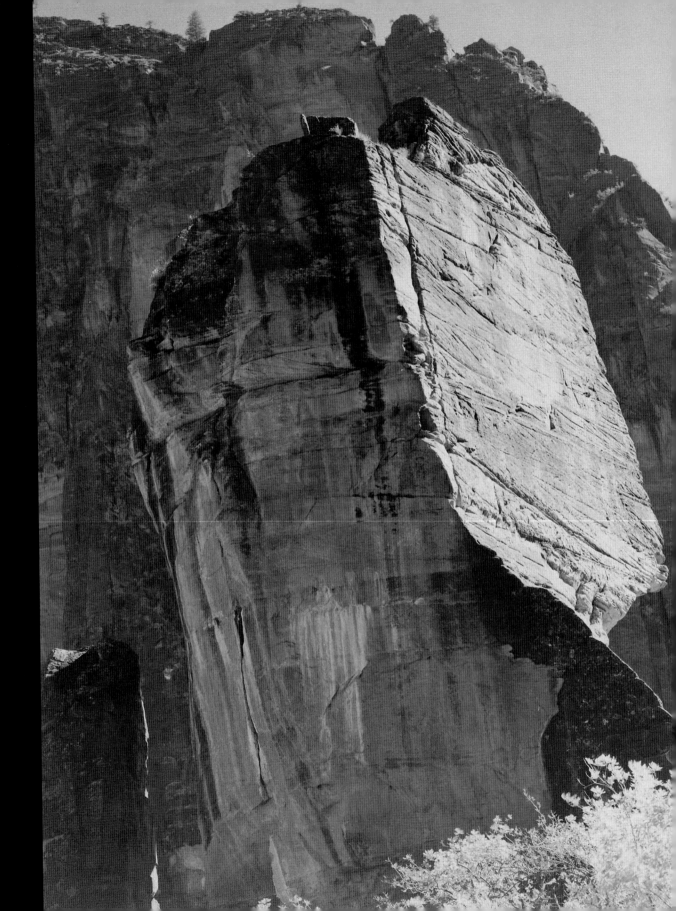

Utah is the thirteenth largest state and was admitted to the Union in January 1896, when it became the forty-fifth state. It is one of the least densely populated in the United States. It has always been famed for its stunning natural beauty. Two of the earliest state parks were established here—Zion National Park and Bryce Canyon National Park. The other national parks are Arches— with its remarkable balancing rocks, hundreds of pinnacles, and over 2,000 natural stone arches—Canyonlands, and Capitol Reef. In western Utah are huge areas of salt flats, the most famous Bonneville Salt Flats, is a remnant of the Pleistocene Lake Bonneville. The highest point in Utah is Kings Peak (13,528 feet) that lies within the Uinta Mountains, an east-west subrange of the Rocky Mountains in northeastern Utah. The rich mineral deposits in Utah attracted miners and big industry from across the US and from all over the world: deposits include gold, silver, copper, zinc, lead, molybdenum, beryllium, and uranium. These industries in turn attracted large numbers of immigrants. For these reasons alone it was important that the great natural wildernesses of Utah be protected at both state and national level. It was in Utah that Adams took some of his best color images such as Utah's Monument Valley circa 1950, in which—as Richard B. Woodward put it in the *Smithsonian Magazine*—"he captured the warmth of the sun on the dusty sandstone amid long shadows. The photograph is more about transience, atmosphere and time immemorial than bands of color, and it's one of the finest color pictures he ever made." Adams was of two minds about color photography. On the one hand he could see the obvious appeal; on the other, the vagaries of color processing and reproduction in the middle of the twentieth century meant that he would always prefer to use black and white film, which allowed him to control with precision each part of the development and processing process.

ZION NATIONAL PARK

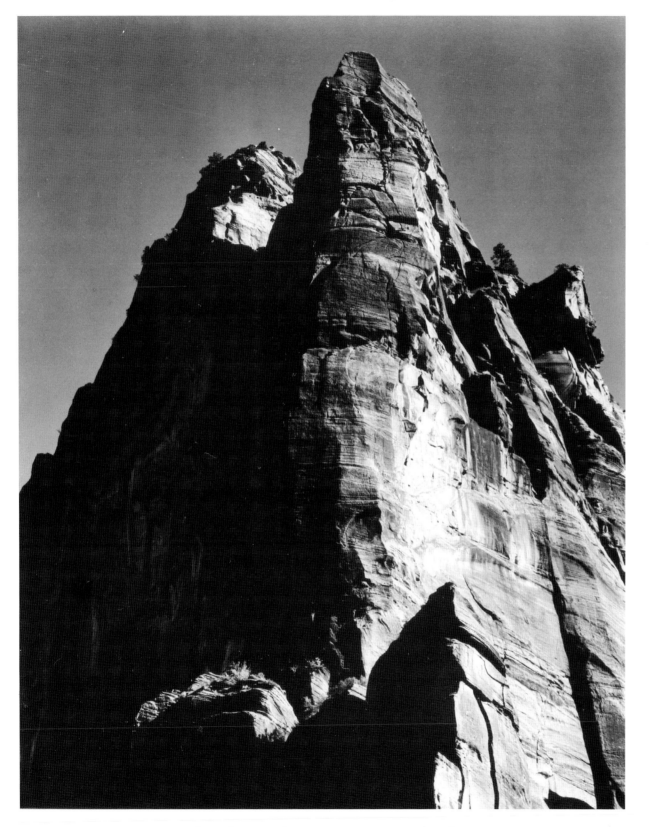

Zion National Park was the first protected wilderness to be established in the state of Utah, at the time it was a remote and inaccessible area with only wagontrain roads and virtually no accommodation. It was initially called Mukuntuweap National Monument by President William H. Taft in July 1909 and founded in particular to protect the spectacular canyon. Its status changed to become a national park in November 1919 at which time its name was changed to Zion, the name used by the local Mormon community, to appeal to a perceived wider demographic. The park covers 229 square miles of outstanding landscapes and habitats—including over 900 species of plants, making it one of the most diverse areas in the state. The prime feature is the fifteen-mile long Zion Canyon which cuts up to half a mile deep in places through red Navajo Sandstone that makes spectacular cliffs and domes and other geological features. Adams found the variety of rock formations—monoliths, slot canyons, natural arches, mesas and buttes, and mountains—constantly enticing.

Left and Opposite: *"In Zion National Park."*

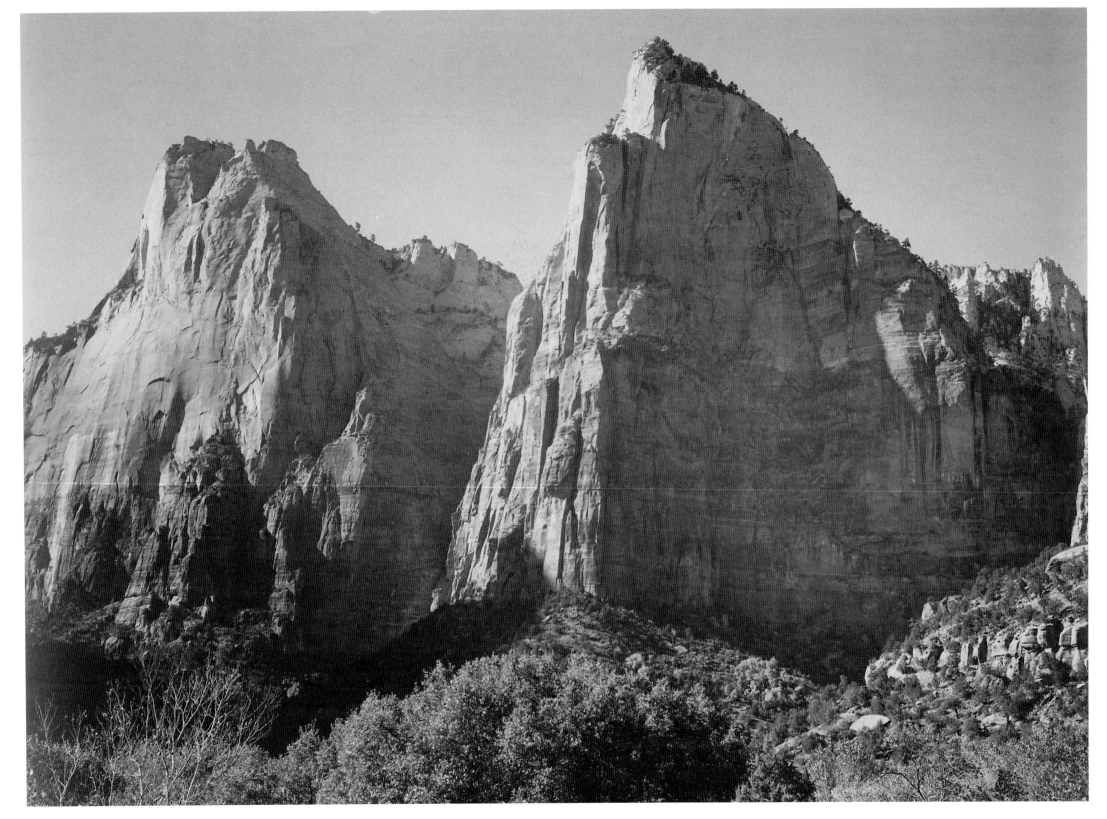

"Court of the Patriarchs, Zion National Park."

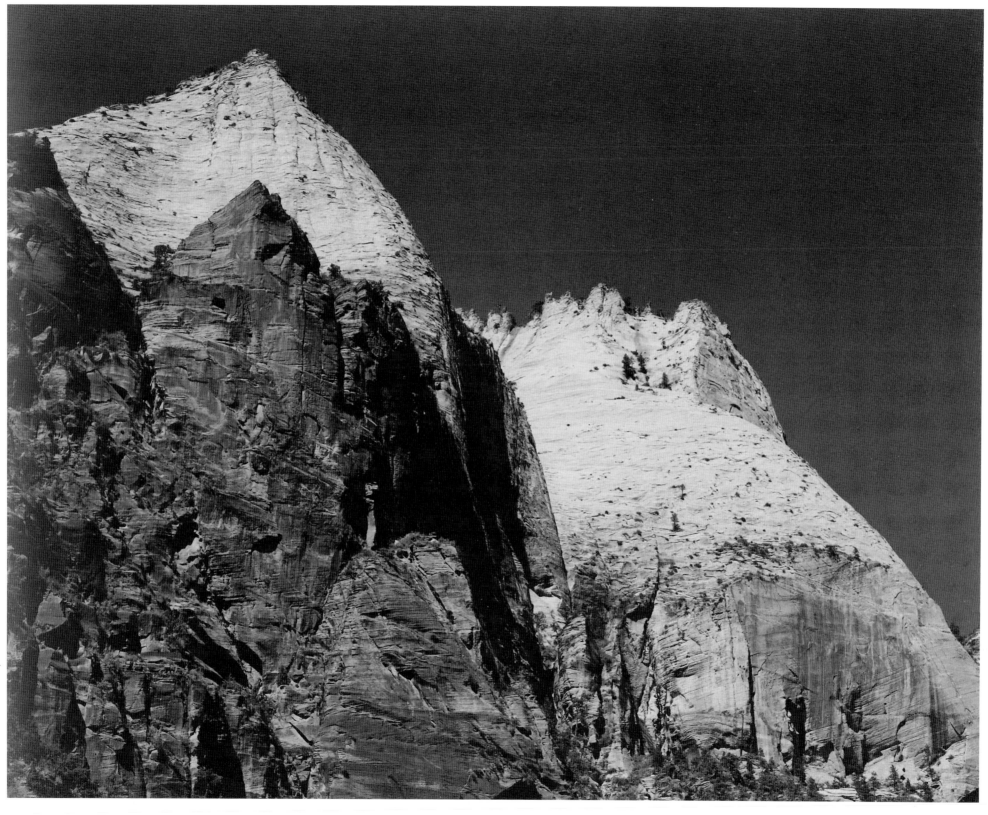

"Zion National Park, 1941, rock formation against dark sky."